INVISIBLE CITY

INVISIBLE CITY
THE HIDDEN MONUMENTS OF DELHI

Rakhshanda Jalil

Photographs:
Prabhas Roy

Foreword:
Khushwant Singh

**NIYOGI
BOOKS**

To
Mushirul Hasan

Published by

**NIYOGI
BOOKS**

D-78, Okhla Industrial Area, Phase-I
New Delhi-110 020, INDIA
Tel: 91-11-26816301, 49327000
Fax: 91-11-26810483, 26813830
Email: niyogibooks@gmail.com
Website: www.niyogibooks.com

Text © Rakhshanda Jalil
Photographs © Prabhas Roy
Editor: Supriya Mukherjee/Niyogi Books
Design: Nabanita Das/Niyogi Books

ISBN: 978-81-89738-77-8

Year of Publication: 2008
Revised Edition: 2011
Reprinted: 2012

Printed at: Niyogi Offset Pvt. Ltd., New Delhi, India

Contents

Foreword

You can love Delhi or hate it; you cannot be indifferent towards it. My attitude towards the city cannot be clearly defined. I started by loving it and continued to love it for many years. Then my passion for it began to abate. Now I resent living in it, but since I have to spend the time left to me in this city I have to perforce make terms with it. Of one thing I am certain: the date when I began to get disenchanted by Delhi. It was 15 August, 1947—the day of India's independence. It had nothing to do with the British leaving our country but what our new rulers did to the city I loved. Let me explain.

When I joined my parents in Delhi, we lived in Subzi Mandi, quite close to the Roshanara Garden where Emperor Shah Jahan's daughter is buried. There was greenery all around and the air was fragrant with *maulsari* blossoms. I had to take a tram that ran through Sadar Bazaar past the Fatehpuri mosque, down Chandni Chowk, along the Sunehri Masjid, Gurudwara Sis Ganj and ended near the steps of the Jama Masjid. I had never seen a mosque so grand and majestic as this one. I could see the huge battlements of the Red Fort. Then I took a tonga to get to my school in Daryaganj. There were other beautiful mosques on the way and the school was next to the massive grey stone city wall. After we shifted to New Delhi, which was in the process of being built, I had to go to the same school by tonga and later, on bicycle. The road ran along the city wall from Ajmeri Gate past Turkman Gate to Dilli Darwaza into Daryaganj. And still later when my father acquired a car, I was driven past the Khooni Darwaza and Kotla Ferozshah with its Ashokan pillar. The place was redolent with history from 600 B.C. to modern times. I wanted to know more of its hoary past. I did so in an unplanned manner. At times I cycled all the way from Safdarjung's Tomb past Vijay Mandal, Hauz Khas, Yusuf Sarai, walls of the Qila Rai Pithora to the Qutub Minar, Mehrauli, the mausoleum of Bakhtiyar Kaki, Shamsi Talab. It was strewn with parts of mosques, palaces and forts. Then by car along the same route to Sultan Garhi. I went to the Humayun's Tomb, the *mazaar* of Nizamuddin Auliya, on Thursday evenings to listen to qawwali and pay homage to Amir Khusrau and Asadullah Khan Ghalib. Many Sundays I went to Tughlaqabad and visited the tomb of its founder Ghiyasuddin Tughlaq or further to Suraj Kund. Once

I spent three nights in Qutub Minar's dak bungalow to look for Balban's tomb and the Jamali Kamali mosque. I wandered around the Qutub monuments, Alai Darwaza, Quwwat-ul-Islam mosque with its iron pillar and Iltutmish's grave. One moonlit night I felt ghosts of the past closing in on me and hurried back to the safety of my room in the dak bungalow guarded by a chowkidar.

All that changed in August 1947. Muslims who formed almost half the population of Delhi were forced out of the city. They took with them Urdu and the city's cultural life. Their place was taken by Hindus and Sikhs fleeing from the newly-formed state of Pakistan who brought with them the Punjabi language and *dhaba*s. They had nowhere to stay. So the government built as many new homes and markets in as quick a time as it could. The British had carefully planned New Delhi for a limited population. They left old monuments untouched. Independent India's new rulers did not have time to plan for the future. Huge parts of the old city wall were pulled down to make way for bazaars. New colonies sprang up everywhere smothering ancient monuments; they did not believe these were worth preserving. It was heartbreaking. More than roads perpetually clogged by vehicles of all sorts, it is the murder of some of our past heritage that saddens me most. The worst victims of our government's vandalism were monuments in the southern half of the city, stretching from the Purana Qila in the east to the Lodi Garden to Safdarjung in the west and going beyond Tughlaqabad and the Qutub Minar. This has fast become an invisible city, which is the theme of this book.

Rakhshanda Jalil has done a thorough job of research to locate these monuments and inform the readers about their builders, the time when they were built and the legends that grew round them. She does so in felicitous prose. This book should be made compulsory reading in schools and colleges. It will make the present generations aware of Delhi's glorious past.

Khushwant Singh
January 2008
Delhi

Introduction

I take great pleasure in writing these few lines for the revised third edition of *Invisible City: The Hidden Monuments of Delhi*. Both Niyogi publishers and I are extremely heartened by the success of this book.

While it is a truism universally acknowledged that a successful book is one that sells well, sometimes when a book like this does so exceptionally well, it is a cause of some cheer. For, it means there are still enough readers whose curiosity was piqued by this book, some of whom may perhaps have visited a few of the monuments described within these pages and, momentarily, lifted the cloak of invisibility that shrouds them. I can ask for nothing more.

I can only hope that this book will be used both by visitors to Delhi and those who live here. I also hope that both will draw in equal measure from this book and one day the distinction will lessen between the two Delhis—the one we see and the one we don't.

This other Delhi, which I have called Invisible Delhi, waits to be discovered. It holds an embarrassment of riches in the form of countless little-known, seldom-visited, largely unheard-of tombs, nameless pavilions, mosques, madarsas, pleasure gardens, baolis, cemeteries, and much else.

We have tried to make this a more user-friendly book than the previous editions. We have provided a better map and replaced the illustrations with photographs. The latter has been done upon feedback from booksellers, distributors and readers. We hope that the photographs will make these lesser-known monuments easier to identify and therefore better accessible.

Rakhshanda Jalil
January 2011
Delhi

PRE-SULTANATE

ONCE UPON A TIME

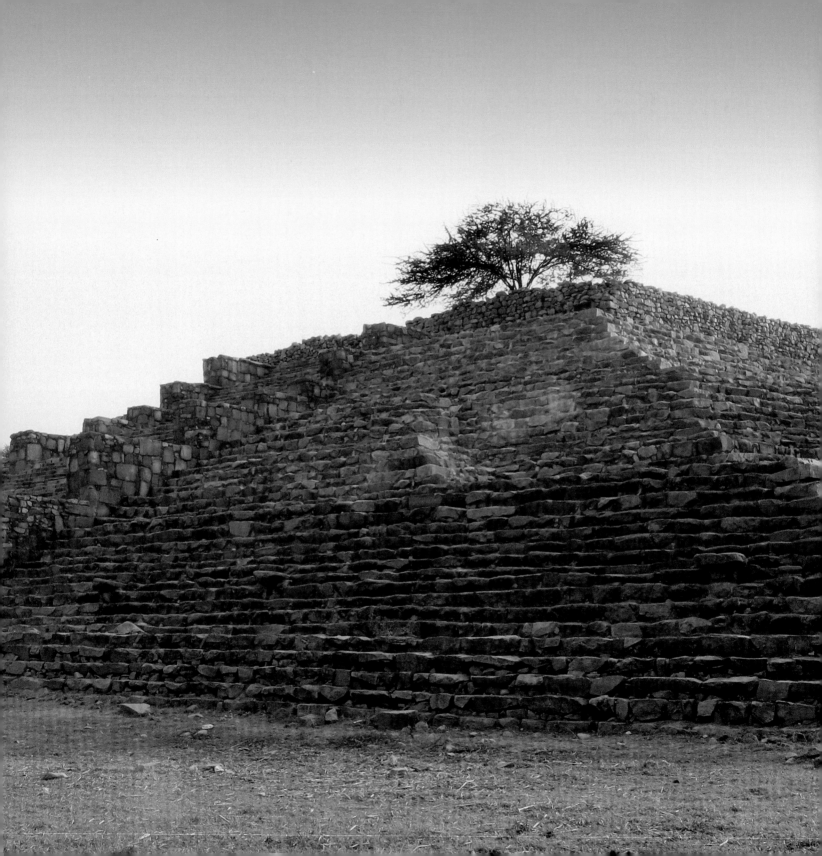

Suraj Kund

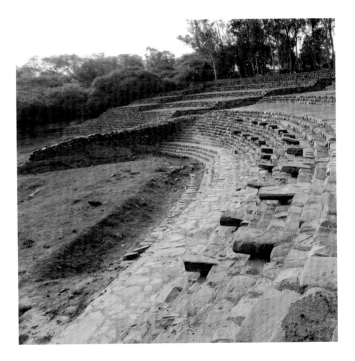

Between the villages of Baharpur and Lakkarpur on a side road branching off from the Mehrauli-Tughlaqabad highway and going past the Rifle Shooting Range built for the 1982 Asian Games, lies Suraj Kund. Suraj Kund and the scenic Badkal Lake nearby can also be approached from the Delhi-Agra highway, turning right just before Faridabad. Traditionally, the villagers around these nondescript parts had subsisted on grazing livestock among the semi-arid rocky outcrops and on quarrying stone. Over the years, extensive and indiscriminate quarrying has left the area pockmarked and, little by little, the desert has gobbled up everything except the hardy *keekar*. In 1981, Haryana Tourism decided to 'develop' 23 acres of land beside the tank and turn it into the venue of an annual crafts fair every February, giving the village a new lease of life but, unwittingly, taking away its age-old character.

Of the 30,000 entries on Suraj Kund available on the Internet, a bare handful mention the architectural significance of the landmark that has lent its name to the winter festival of crafts and in the process lost its own identity. Today, more people in Delhi have visited the Suraj Kund Crafts Mela and few have bothered to look at the ancient amphitheatre-shaped tank that lies just a little beyond the ferris wheels and the over-crowded parking lots. Screened by *keekar* trees and guarded by a virtual army of monkeys and langurs, a *vanar sena* of sorts, Suraj Kund has shrunk in every

sense of the word till it has become truly invisible except to those bent upon seeking it out. The water in the tank has lessened, the monkeys keep everyone except the most persistent away, and the motels and resorts advertise quick weekend getaways and day-long seminar facilities with maybe a 'ghazal night' thrown in but make no mention of the venerable old *kund* in their immediate neighbourhood. Till the resorts changed the landscape beyond all recognition, Suraj Kund was a delightful picnic option, close enough to be within driving distance and far away to still have a rustic charm. Families would come prepared for the day either with packed tiffin carriers or cars piled high with cane baskets and pots and pans to cook a meal. I remember coming here for picnics in the sunny winter months, wandering among the ruins that seemed frozen in time, serene beyond measure, but without even the most basic amenities. Things have changed drastically from those well-remembered days of childhood when scruffy boys tended goats among the low hills and ravines and rocky escarpments and shallow boulder-strewn depressions offered the only variation in an otherwise monotonous landscape. This was when the scattered spurs of the ageless Aravallis raised their magnificent weather-beaten heads. You now have manicured grounds rising in perfectly orderly mounds and dipping in proportionate shallows; aquamarine waters lapping in azure swimming pools;

emerald green golf courses and pampered guests stepping out of jacuzzis. But once you are past all that and have settled on the stone-cut steps leading down to the tank, there is still something about this place that evokes a goose pimple-like sense of awe.

There is a tangible link with history here; it marks the site of the oldest city of Delhi. Suraj Kund (pool dedicated to the sun) is said to have been built in the early eleventh century (*circa* 1020) by the Tomar chieftain Suraj Pal. It originally had a sun temple on its western side. The temple is now in ruins but the *kund* still stands.

Legends surround the pool. One such legend would have us believe that it was built for the daughter of Suraj Pal. Another avers that its waters had miraculous healing powers. Suraj Pal's existence may have been built on bardic tradition and the 'Dilli' of his times may have been no more than a provincial city, but the pool ascribed to him is no figment of popular imagination. There it lies, a millennia later, this great semicircle of masonry, with stone steps all around as in an amphitheatre.

On one side of this semicircle is a gap in the masonry; this is the spot where water flowed into the tank from the catchment area upstream. Further down, is a gap in the stone steps and a stone path leads down to the water. This was for the royal elephants when they came down to bathe in the water. In the middle of the straight side are steps to

what was the sun temple. Carved stones, once part of the temple, have been retrieved from the reservoir. Firoz Shah Tughlaq, the great restorer, had the steps all around the tank repaired by laying lime-concrete over them. The water in the tank never dries up, not even in the harshest of summer months.

The ideal time to visit Suraj Kund is mid-week; the profusion of hotels and leisure facilities tend to make the approach roads a bit chaotic on weekends. Since the sun rises behind the apex of the tank, late afternoons are a good time to take in its sun-dappled splendour. A pool of fresh water oozing from the rock crevices, called Siddha Kund, lies close beside and attracts pilgrims on certain holy days.

Other attractions include quaint thatched huts spread all over the site of the Crafts Mela as part of a permanent display, and a terracotta park containing toys and objects of daily use made by rural artisans from all over the country on display the year round.

Various rock-climbing clubs take adventure-seeking souls for climbing among the few basalt rock faces that still exist.

About 2 km west of Suraj Kund, close to the village of Anangpur, are the remains of a dam ascribed to Raja Anangpal of the Tomar dynasty. He is also said to have built the citadel of Lal Kot in 1060 in the Mehrauli area.

Here, too, rainwater was trapped by blocking the basin with a dam of local quartzite stones across the mouth of a narrow ravine. The natural lake, known as Anang Tal, formed by the impounded waters, makes it especially attractive during the monsoons.

...

PAGES 18-21: These steps are a tangible link with history. One can easily visualise what the Kund must have looked like a thousand years ago.

Channel for water to flow into the tank.

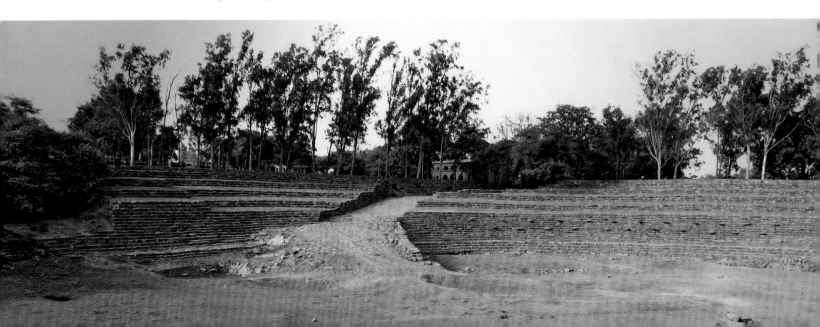

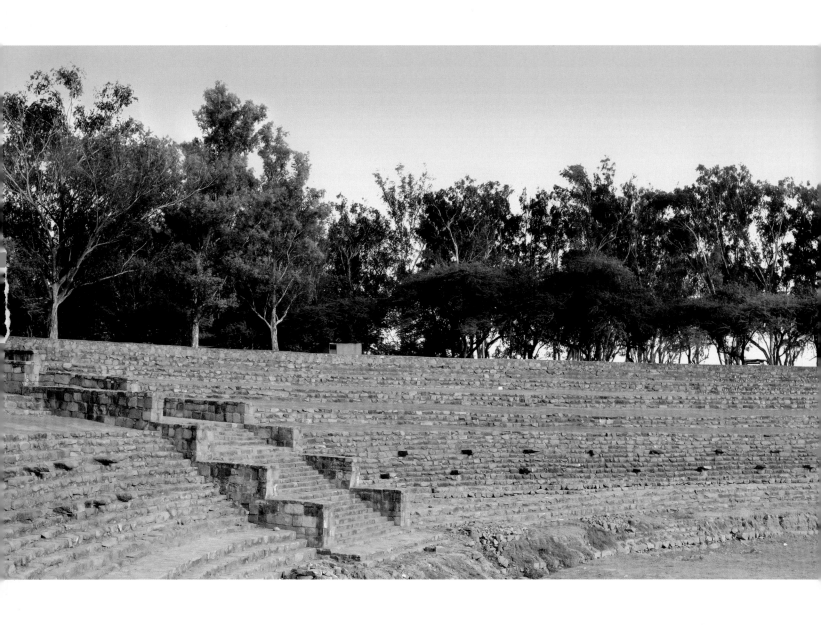

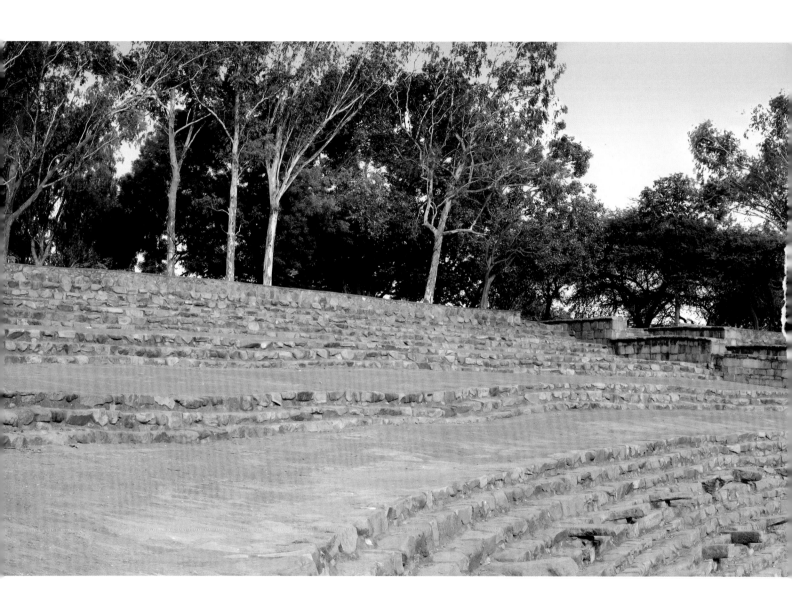

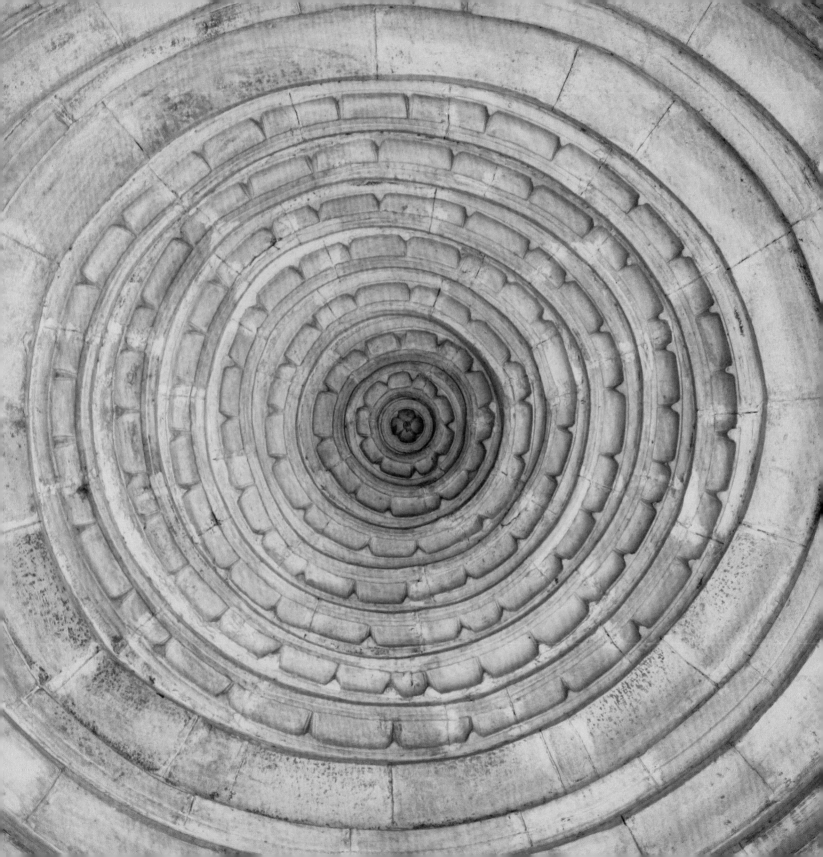

SULTANATE
YESTERDAY'S SPACE

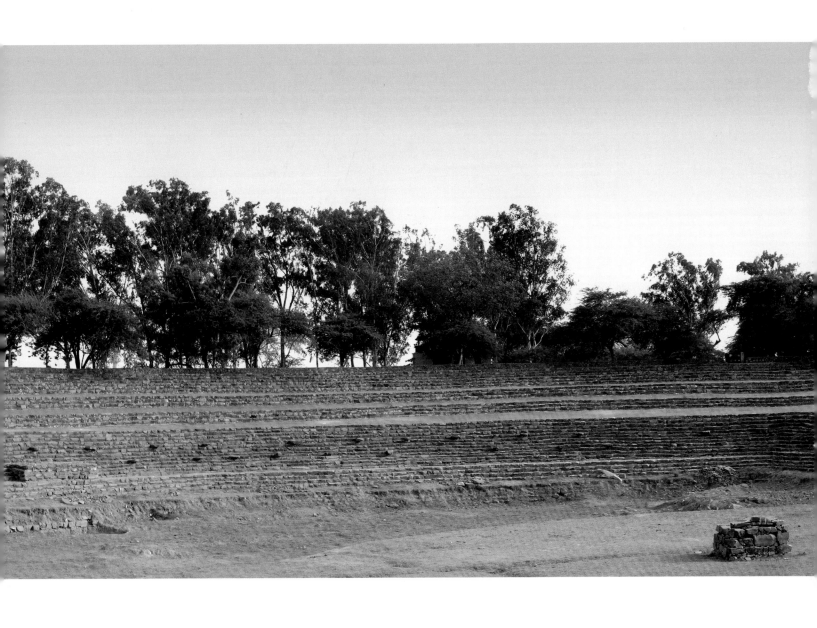

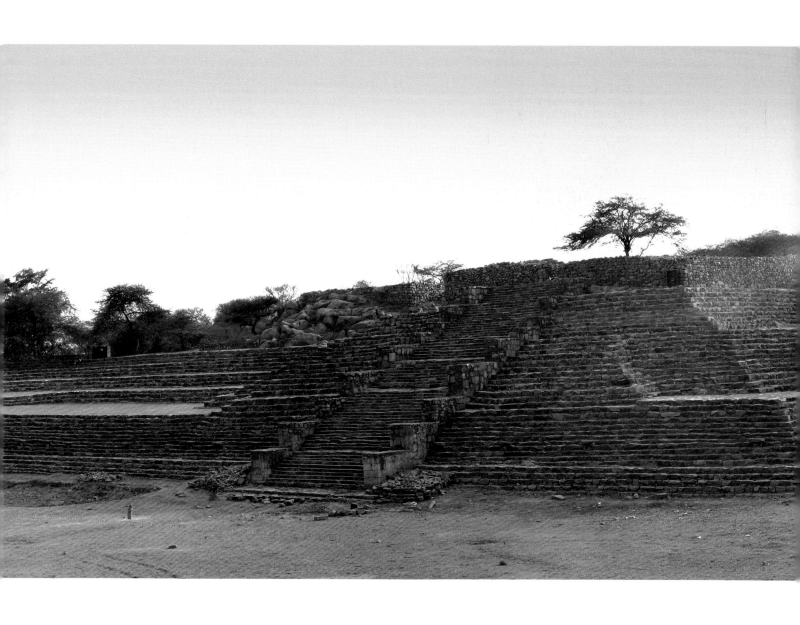

Sultan Garhi

FACING PAGE: A marble medallion.

The western colonnade.

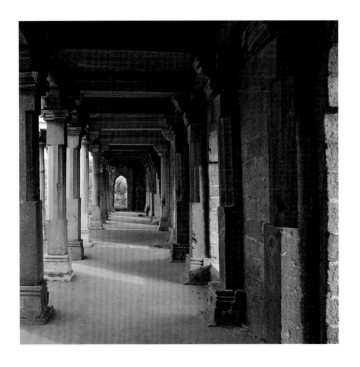

The 'various cities of Delhi' have many 'firsts' to their credit: the first of its kind step-well at Suraj Kund built by Raja Anangpal; the first Palace with a Thousand Pillars built by Alauddin Khalji; the first congregational mosque of unprecedented proportions built by Qutubuddin Aibak called the Quwwat-ul-Islam Masjid close to the Qutub Minar and the very first tomb—in fact the first monumental Islamic tomb in India except for some pre-Sultanate monuments in the Kutch area of Gujarat—the tomb of Nasiruddin Mahmud.

Head west along the Mehrauli-Vasant Kunj road, beyond Nelson Mandela Marg, till you come to the western edge of this vast urban jungle. Opposite Sector C, Pocket 9 of Vasant Kunj, you will come across the only so-called 'undeveloped area', that is, the only monument of any archaeological significance left intact. A dirt track goes off the road and meanders through rocky terrain and gorse and thorn bushes to reveal a most unexpected sight. A spectacularly unusual building made of mellow golden stones—like none other in Delhi—rises out of the wilderness. With its flat-topped low conical domes and round arches, it has an almost moorish air about it. Popularly known as Sultan Garhi, this is the tomb of Nasiruddin, the eldest son and heir apparent of Sultan Shamsuddin Iltutmish.

A steep flight of steps takes you in through a gateway on the east. Ample use of marble and floral

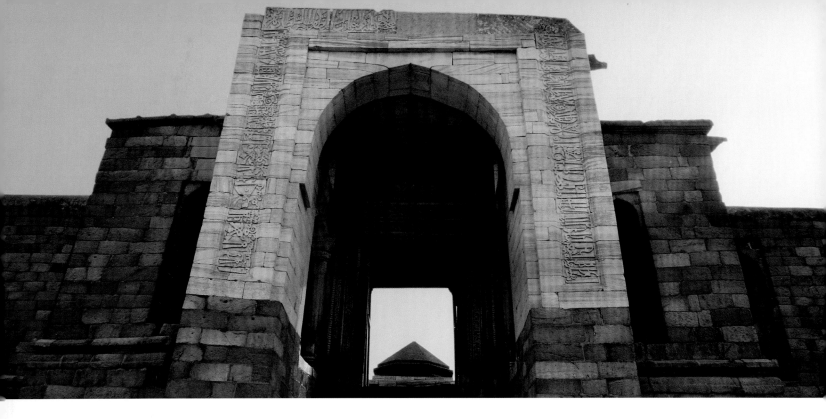

The entrance gate is in white marble, with an elaborately carved band of Koranic verses.

motifs make the projecting gateway stand out in relief against the golden stone of the outer walls. Inside the *sehan*, the walls on the north and south are pierced with rows of open, round arches, whereas the eastern and western walls both have colonnades supported on sandstone pillars. The western colonnade also served as a mosque. Its central *mihrab* has a pyramidal dome atop six white marble fluted columns and two marble pilasters. The *mihrab* also has an elaborately carved band of verses from the Koran. This being no congregational mosque, obviously it must have only been used to offer prayers at the time of burial. However, the elaborate use of marble and decorative motifs embedded in them make this a pretty place to pause and take in the rest of the courtyard. On each of the four corners are circular bastions crowned by flat conical domes. There is much evidence of the early Indo-Islamic style of architecture, the typical pointed Islamic arches having had not yet made an appearance.

Built in 1231-32, this tomb is a father's expression of grief for a son who showed immense promise of one day becoming the Sultan of Hindustan. Nasiruddin, also known as Abul Fatah Mohammad, was first given the fief of Hansi by his father, and later entrusted with Oudh. When Iltutmish wanted to consolidate his empire on

the east, Nasiruddin was despatched to Bengal to vanquish the usurper Ghiyasuddin. Nasiruddin managed to capture Lakhnauti, present-day Dhaka, but died soon after in 1229. His father constructed a tomb for him in faraway Delhi—the seat of power from which Nasiruddin would have ruled had he lived. An inscription on the tomb's eastern gateway gives him the title of Malik-i-Maluk-ush-Sharak, or Lord of the Eastern Countries. Iltutmish was the first Turkish Sultan to sit on the throne of Delhi and is regarded by many as the first to introduce hereditary rule—passing from father to son, with a few exceptions to daughters.

The tomb of Nasiruddin acquired its rather peculiar name because of the way it has been constructed. An octagonal tomb chamber was built around the grave. Its roof, supported by stone beams, juts out on to what is now the central courtyard. With the construction of the courtyard and enclosure walls on a raised plinth, the tomb itself has sunk. A flight of 15 steps through a low narrow door in the octagonal platform leads down to it. In effect, the tomb appears sunken, as though in a *gaddha*, which

explains the name. Or, it could also have been derived from *garh*, alluding to the bastions that mark the four corners of its outer walls, giving it the look of a fortified citadel.

Its sunken appearance, coupled with the overwhelming smell of incense and the bats clicking

..

BELOW: The octagonal tomb chamber in the sehan.

Entrance to the tomb chamber—with steps going down to the crypt.

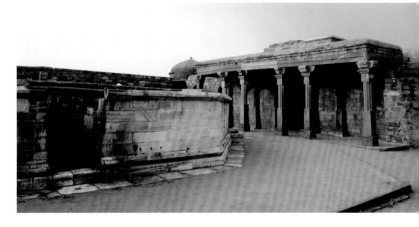

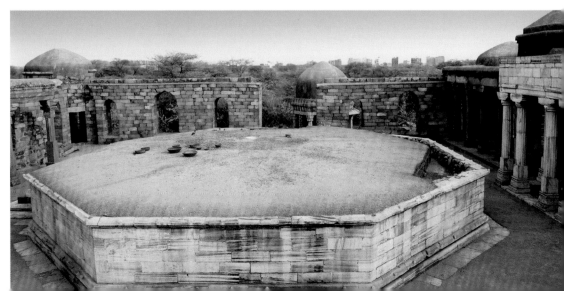

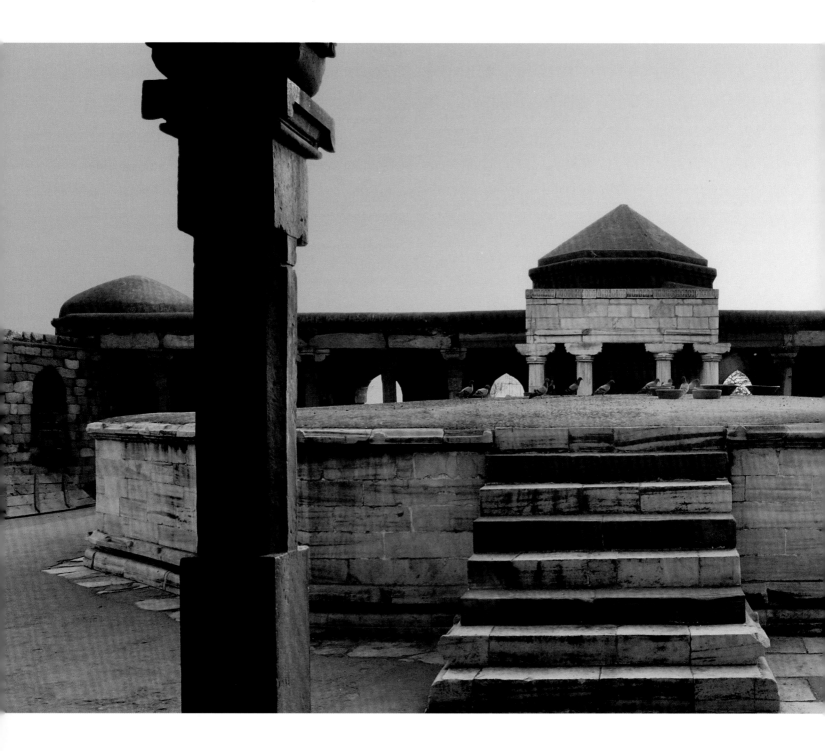

away in the crevices of its smoke-darkened walls, combine to make the tomb an eerie place. I went on a hot and humid Thursday and found the place teeming with devotees, both Hindu and Muslim, from the nearby villages of Mahipalpur and Milakpur Kohi who look upon this son of a Sultan as a *pir*, a holy man who answers their prayers. They come faithfully every Thursday, first praying and making offerings at a small altar with a faceless rough-hewn image of a Mother Goddess outside the courtyard walls, then making similar offerings at Nasiruddin's sunken tomb. They come bearing trays of flowers and tiny tumblers of milk. The sickly-sweet smell of crushed rose petals, the milk spilling over from the tomb into small fetid pools on the rough stone floor and the ceaseless chorus of the bats doesn't encourage you to linger inside. Outside, however, is another matter. The colonnades and arches flanking the courtyard on all sides make a pretty picture.

To the north and south, the arched openings look out at ruins of what once must have been a residential cluster. Houses so close to the tomb suggest that the area was reasonably populated during medieval times. To the south there is an extremely dilapidated octagonal *chhatri* housing the grave of Muizuddin Bahram Shah, another son of

A flock of pigeons on the roof of the octagonal tomb chamber.

Iltutmish, who ruled from Delhi for a year after the murder of his sister Razia Sultan in 1240. Further south, there are remains of an enclosure wall and a gateway made of local grey stone; whether this was an entrance to some ancient residential complex or the gardens that might once have surrounded Sultan Garhi, I cannot say. The amazing thing is that the cluster of dense housing colonies have stopped just short of this ruined compound, nibbling its skirts but not quite gobbling it up.

The wilderness of rock and thorny bushes that surround Sultan Garhi is a double-edged sword, both a curse and a blessing. While it stops the urban menace from encroaching upon this patch of ancient earth, it also makes Sultan Garhi and its surrounding monuments invisible to the residents of Vasant Kunj.

Bakhtiyar Kaki's Dargah

FACING PAGE: Here lies the martyr to the dagger of Taslim.

Haunt of the faithful.

By the early thirteenth century Delhi had emerged as the beating heart of the Sufi movement that had sprung in Central Asia and swept across much of North India. Sultan Shamsuddin Iltutmish (1210-35) had set himself up as the ruler of Hindustan and established his capital at Delhi. Central Asia and Iran had fallen to the Mongol hordes and a virtual exodus had begun—of scholars, holy men and wandering mendicants. While Ajmer and Nagaur remained important centres of the Chistiya *silsila*—one of the most popular and influential mystic orders of India—Delhi was fast gaining popularity as the axis of the Islamic East. And it was to Delhi that they came, to set up hospices, to gather the faithful around them, and to spread the word about a new kind of Islam. The Islam of the Sufis spread faster than the Islam of the sword. Soon it became the popular religion of the masses as opposed to the orthodox, often puritanical Islam of the theologian. So much so that medieval scholars referred to Delhi as Qubbatul Islam (the Cupola of Islam).

A mystically-inclined young man, Khwaja Qutubuddin Bakhtiyar, a native of Ush in Farghana, had heard of the fabled land of Hindustan. In a mosque in Baghdad he met Khwaja Moinuddin Chisti, one of the most outstanding figures in the annals of Islamic mysticism and the founder of the Chistiya *silsila* in India, and became his disciple.

Then, travelling through Khurasan, he reached Multan. It so happened that the Mongols invaded Multan and the ruler Nasiruddin Qubacha asked Qutubuddin for help. Qutubuddin gave him an arrow and suggested it be shot blindly into the enemy's camp. Qubacha obeyed. The arrow was duly shot and the very next day the Mongols retreated inexplicably. Qutubuddin's stock rose with both the laity and royalty. Yet he chose to leave Multan for Delhi where he was warmly received by Iltutmish and invited to set up a hospice. Qutubuddin, however, chose to stay at Kilokari near the Yamuna, only later shifting to Mehrauli, just outside the walls of Iltutmish's Delhi. Iltutmish also offered him the title of Shaikh al-Islam, which he declined.

The Qutub Minar, started by Qutubuddin Aibak and completed by Iltutmish in 1229, is believed to derive its name from Qutubuddin or Qutub Sahib as Khwaja Bakhtiyar was affectionately called.

Soon Qutubuddin's reputation grew to near-legendary proportions, aided in no small measure by the incredible stories of supernatural powers attributed to him. A story that highlights both the piousness of his persona and his awe-inspiring faith is the one about the construction of a tank. Iltutmish wanted to construct a tank to put an end to the chronic water shortage in Delhi but a dispute arose over its site. Tradition has it that Qutubuddin saw the Prophet Muhammad in a dream, and the Prophet indicated the exact spot for the construction of the tank. Hauz-e-Shamsi was duly constructed at that very spot and soon became not just a source of water, but a cultural and spiritual landmark of sorts for the denizens of Delhi. Every year, still, an annual procession called *Phoolwalon ki Sair* begins at this very tank and offers large, flower-bedecked *pankhas* first at Bakhtiyar Kaki's *dargah* and later at the Jog Maya temple in a unique display of syncretism.

The words 'Ya Khwaja Bakhtiyar Kaki' carved in stone.

How Qutubuddin acquired the far more popular moniker of Kaki has not one but two stories attached to it. The first says that in true ascetic fashion, Qutubuddin prayed, meditated and fasted to the extent that he had no time for either food or rest. His family would place small pieces of *kak* beneath his prayer mat and that was his only source of sustenance. According to another version, once when his wife complained of a chronic shortage of funds in the household, he pointed to a niche in the wall and bid her to go there, recite *Bismillah* and she would find as much bread as she needed. Both stories revolve around Kaki, the Man of Bread.

Soon Qutubuddin's *khanqah* began to attract large numbers of people. There would be regular gatherings where both the saint and his followers would strive to achieve spiritual ecstasy through repeated, ritualised chanting. In fact, it was at one of these gatherings that Qutubuddin was to meet his sudden end. A musician among his devotees had just finished reciting the following verse written by the celebrated Sufi, Shaikh Ahmad of Jam, when Qutubuddin was seized by ecstasy:

The martyrs of the dagger of taslim
Each moment get a new life from the Unseen World.

He was taken home in that state. He regained consciousness briefly and asked for the same verse

Carved sandstone jaalis around the grave.

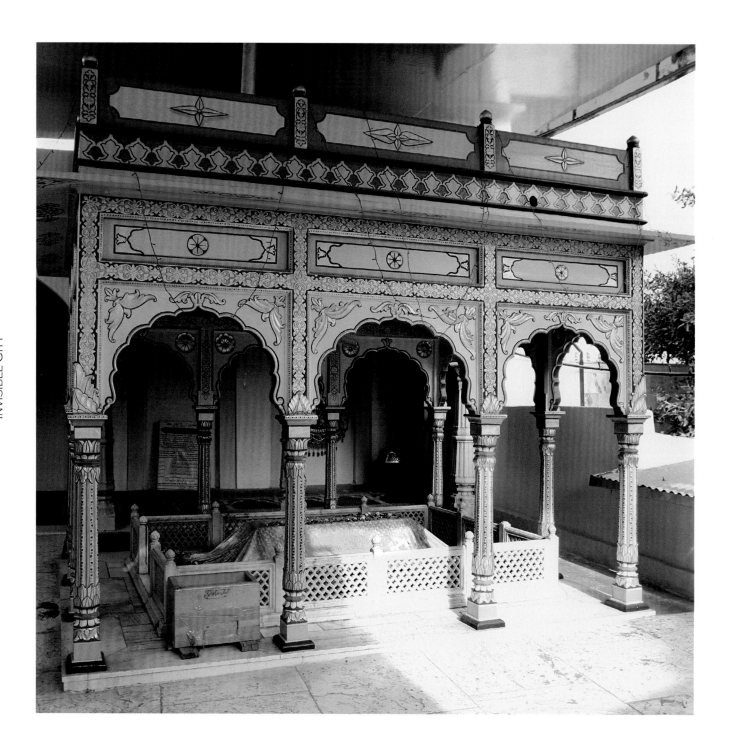

to be repeated over and over again. Qutubuddin then lapsed into a state of ecstatic reverie from which he never recovered.

Bakhtiyar Kaki died on 27 November 1235 and was buried at a place he himself had chosen and a humble tomb was erected over it. Later a pavilion supported by 12 fluted columns was raised. The present structure has a bulbous dome and there is a copious use of marble *jaali* screens and mirror-studded walls. The ostentatious *dargah* that now exists was built upon by later rulers, most notably Aurangzeb who provided the rather lovely floral multi-coloured mosaic on the western wall. An enclosure wall came up as more and more disciples, and later rulers, chose to be buried close beside the saint's tomb. Soon, the entire complex came to look like a vast, though somewhat opulent, necropolis. Among those buried here are Bahadur Shah I, Shah Alam II, Murad Bakht (wife of Shah Alam II), Mirza Fakhru (son of Bahadur Shah II), Akbar II and various members of their families. The one to share the closest proximity with the saint's resting place is the tomb of Khwaja Abdul Aziz Bastami.

FACING PAGE: Mazar of Hazrat Qazi Hameeduddin Nagauri.

LEFT: Intricately carved marble jaali.

Gateway of Maulana Fakhruddin.

Bastami was a saint of the Suhrawardi order but not much is known of him. A marble balustrade runs around the saint's cloth-covered grave and a marble arched pavilion encloses it. Another saint to share a similar privilege was Qazi Hameedudin Nagauri, a contemporary and associate of Bakhtiyar Kaki. His grave is surrounded with a pretty red sandstone and marble enclosure. There is also the grave of Bibi Hambali, better known as Daiji, the wet nurse of Qutub Sahib. Only women are allowed to enter this enclosure.

The *dargah* has several gates, halls for different purposes such as a Naubat Khana (drum house), Majlis Khana (assembly house), Tosha Khana (which served both as a robe chamber and to store assorted supplies), mosques, tanks and a *baoli*. The main northern gate was erected in Sher Shah's time by Sheikh Khalil, a descendent of Baba Fariduddin

Ganj-e-Shakar. Farrukh Siyar is said to have built two gates. The first gateway is built entirely of marble and is profusely decorated and inscribed with the names of Allah, the Prophet and the first four Caliphs. You cross the second gateway, also built by Farrukh Siyar sometime during 1713-19, and enter the *dargah*. Close to the Gateway of Maulana Fakhruddin is the grave and mosque of Motamad Khan. Motamad Khan was a noble in the court of Aurangzeb and his mosque was built during 1673-74. Decorated with kangura patterns and cusped arches in relief, the mosque has quite regrettably been painted over with *surkhi*.

The exquisite little Moti Masjid peeps out from a clutter of buildings at the western periphery. Built by Bahadur Shah I (1707-12), it has three domes with marble pinnacles. Just outside the western entrance, known as the Ajmeri Gate, are the ruins of the Zafar

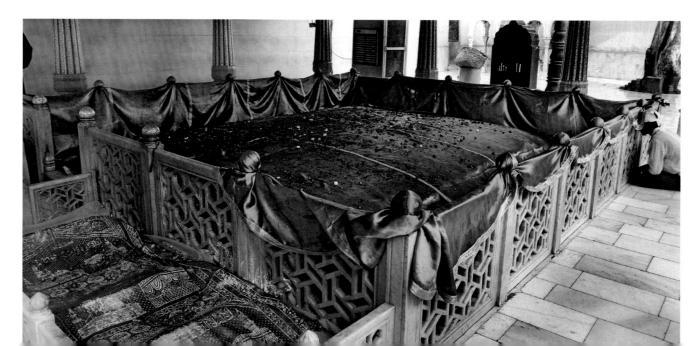

Mahal, a palace built by Akbar II but used extensively by Bahadur Shah Zafar as a summer retreat and a weekend getaway from the Red Fort in Delhi. Built of red sandstone relieved by marble, it is an imposing three-storey structure, now sadly in ruins and hemmed in from all sides by the pernicious encroachments. Within the Zafar Mahal lie the ruins of a much older building—the tomb of Alauddin built during Iltutmish's reign. Its grey stone pillars and small squat dome speak of a far more austere architectural style.

After the death of Khwaja Moinuddin Chisti of Ajmer, the mantle had clearly fallen on Qutubuddin Bakhtiyar Kaki. He became the beacon of the Chistiya *silsila*. The Chistis scrupulously avoided identification with the centre of political power, refused to accept *jagir*s and government service, or perpetuate spiritual succession in their own families. Yet, in the Era of the Great Shaikhs, a clear line of succession can be traced: Khwaja Moinuddin Chisti of Ajmer was followed by Qutubuddin Bakhtiyar Kaki of Delhi, then Farid al-Din Ganj-e-Shakar of Pakpatan, Nizamuddin Auliya of Delhi and, finally, Nasiruddin Chiragh-e-Dilli. After Nasiruddin, the central organisation of the Chisti order broke down and provincial *khanqah*s sprang up all over the country—in Hansi, Kalyar, even in faraway Gujarat, Deccan, Bihar and Bengal. The golden age of the Chistis is aptly illustrated by the life—and death—of Qutubuddin Bakhtiyar Kaki.

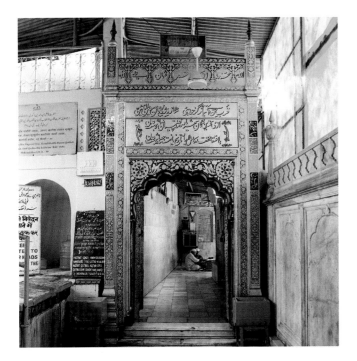

Entrance gateway.

FACING PAGE: The mazar of Bakhtiyar Kaki.

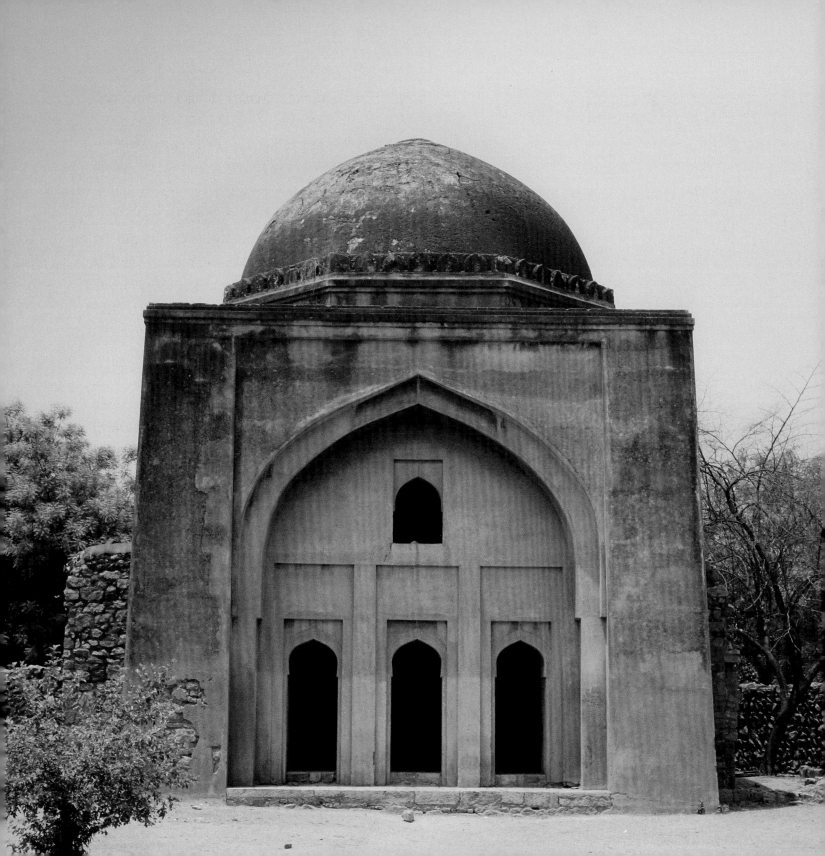

City of Siri

Broken ramparts of the Siri walls.

Eight thousand severed Mongol heads were said to have been built into the walls of a new city. And this new fortified Delhi, built by Alauddin Khalji in 1304, came to be called Siri from the Hindi word for head, *sir*. This popular explanation is lent historical credence by the fact that Alauddin Khalji, who came to the throne in 1296, could do little to protect his Delhi from the Mongol menace. Finding his own city inadequate to withstand the brutality of the Mongol hordes who mounted a series of attacks on Delhi, he decided to build a new fortified city with sturdy walls and bastions.

But as luck would have it, no amount of fortification could save Delhi from the curse of the pillaging invaders. Wave upon wave of Mongol attacks culminated with Timur unleashing a terrible scourge upon the hapless citizens of Delhi in 1398. After Timur, the Mongol invasions eased up but the looters did not stop. The sultans and emperors at Delhi kept fuelling their own paranoia and carried on building newer cities, imagining each to be stronger, safer and sturdier than the others. So we had Mohammad Bin Tughlaq's Jahanpanah, Firoz Shah's Kotla, Humayun's Dinpanah, Sher Shah Suri's Shergarh, Salim Shah's Salimgarh and Shah Jahan's fantasy in marble and red sandstone.

To come back to Siri and its fierce and ruthless builder Alauddin, it is important to appreciate the extent of the Mongol menace by the late thirteenth

century. Frequent raids had bolstered the Mongol courage to such an extent that during one of their raids in 1298, they managed to march right up to Delhi, forcing Alauddin to retreat to old Delhi, to the area around the Qutub Minar. The Mongols occupied and looted the suburbs of the city, and the gardens and palaces of the nobles on the outskirts. While one wave retreated, many Mongols chose to stay back. Upon reclaiming his throne, Alauddin had thousands of Mongols beheaded, their heads displayed on the nearby Chor Minar (in present-day Hauz Khas) and the rest built into the walls of his new city. Within these city walls, Alauddin built his fabled Hazaar Sutoon or Hall of a Thousand Pillars. The pillars are said to have been of wood but, unfortunately, nothing is left of this once-wondrous edifice. Whatever little remained of architectural value of the structure within the fortified walls of Siri were destroyed when the Asiad Village came up to house the participants of the Asian Games in 1982.

The wall that was built to withstand the marauding invaders is now nothing more than a few stretches of broken-down masonry. Of the seven gates piercing its sturdy rubble-built exterior, only one remains. A flame-shaped bastion in the south end of Shahpur Jat village (accessible from the Panchsheel Park side) still sports three rows of slits for arrows to be aimed at intruders. Today, not only is it sadly tumbledown, it is also encroached upon. A board near the Siri Fort Residential Complex proclaims its protected status. Like everything else inside Siri, the wall was plundered for building material from the time of Sher Shah Suri who is said to have carted away chunks for building his city. To see what remains, turn into Asiad Village (off August Kranti Marg, earlier known as Khelgaon Marg) and take a drive round the Village. You will spot some fragments of the wall in the neighbouring colony of Panchsheel Park as well. A *baradari* inside the village of Shahpur Jat is also said to belong to the Khalji period but, with tethered buffaloes and encroachers, a close look is impossible.

There are other monuments, dating from the Khalji to the Lodi period, dotted about the sports complex and its vicinity, that make this place come alive. Inside the green area, close to the entrance of the residential complex, is a small

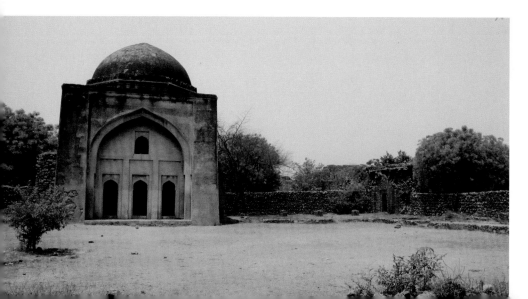

stone bridge dating to the early fourteenth century. With three vaulted chambers beneath, it must have once spanned a stream flowing into the city of Siri from the catchment area upstream. At the west end of Shahpur Jat village, near the Government Girls' Senior Secondary School, there is the Tohfewala Gumbad (there is another one of the same name in Green Park). Like the many tombs in Green Park and R.K. Puram, it is hard to tell why and how it acquired its name. Simple and spartan, it stands in complete anonymity within a large enclosure.

Close to the entrance of the Siri Fort Sports Complex is the very striking Muhammadi Wali Masjid. You enter through a stone gateway with traces of ornamentation and red sandstone facing and come upon a pretty mosque with arched niches in red and blue tiles on the walls of the prayer chamber. Decorative pendentives and intersecting red bands adorn the ceiling. A single dome, typical of the Lodi style, sits atop the central bay. A row of brackets indicates that once a *chhajja* must have run along the outer walls, of which not a slab remains. Again, who might have built it or how it got its name is destined to remain a mystery forever.

Across the road from the Siri Fort Auditorium, inside a park facing Gulmohar Park stands the Lodi-period mosque of Darwesh Shah. Unlike the mosque and tomb of Makhdum Sabzwari in the nearby Mayfair Gardens, this is in a sorry state. The mosque stands on a raised platform and has seven *mihrab* recesses, the central one accentuated with raised arches and flanked by minarets. Several graves are scattered about the courtyard that is now virtually an oasis of isolation since the steps leading to it have disappeared. A row of arched *dalan*s makes the mosque of Darwesh Shah a picturesque but mysterious spot on a busy thoroughfare.

FACING PAGE: A mute testimonial—standing in a bare enclosure.

The walls of Siri near Khel Gaon.

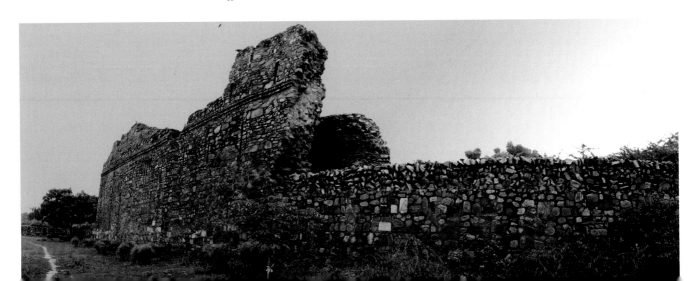

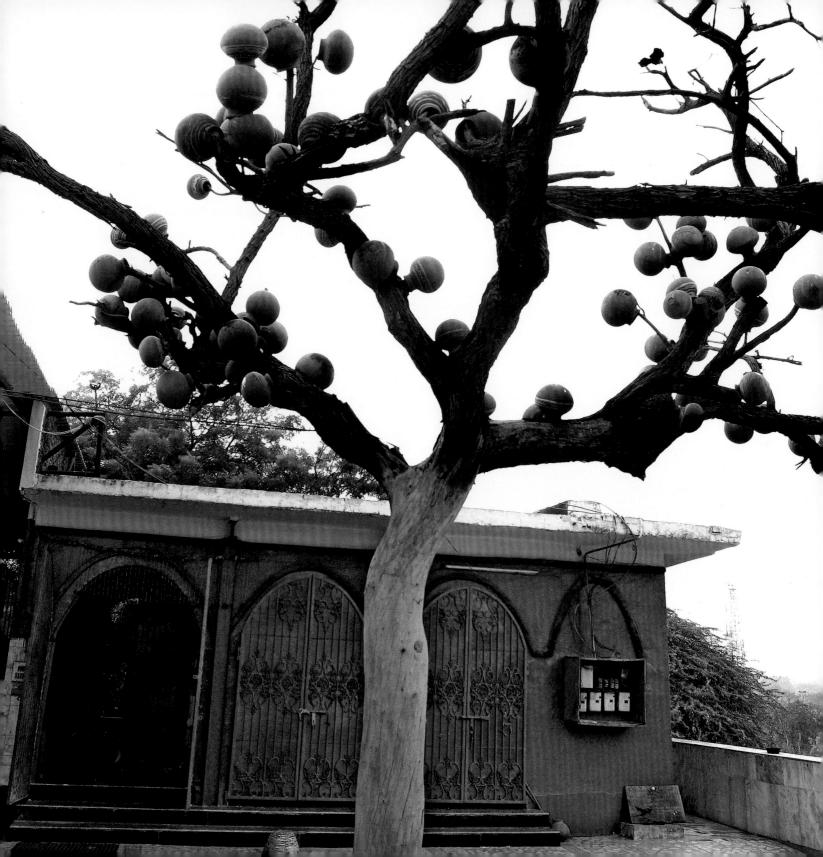

Matka Pir

I am the mystic gypsy called qalandar;
I have neither fire, home nor monastery
By day I wander about the world, and at night
I sleep with a brick under my head.

It was the *qalandar*, the Sufi-at-large, an earlier-day hippie as it were, who made the history of Islam in India so colourful. Belonging to the Qalandariyya sect, an order of Sufism originating in Iraq, the *qalandar*s sought to do away with custom and religion and live their own rather idiosyncratic life as vagabonds.

Renouncing all worldly possessions, they wore a coarse garment of horse hair reaching the knees, tied about the waist with a sash. Some shaved their head, beard, moustache, even eyebrows—to fully reveal the beauty of the face—and wore a profusion of iron rings around their neck and arms. Their distinctive appearance—a cross between a Sufi saint and a Naga yogi—provoked some, attracted others.

From the thirteenth century onwards, the *qalandar*-type dervishes had started coming to Delhi from Iran and Iraq and begun to arouse much curiosity because of their odd appearance and behaviour. One such wandering mendicant was Shaikh Abu Bakr Tusi Haidari, who settled in Delhi in the mid-thirteenth century. He set up a *khanqah* on a mound beside the Yamuna and began to attract fame that matched that of the legendary Hazrat Nizamuddin

FACING PAGE: Trees laden with matkas surround the shrine.

Praying to Shaikh Abu Bakr Tusi Haidari.

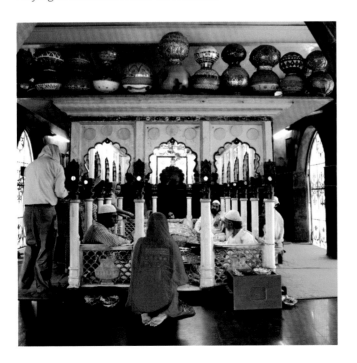

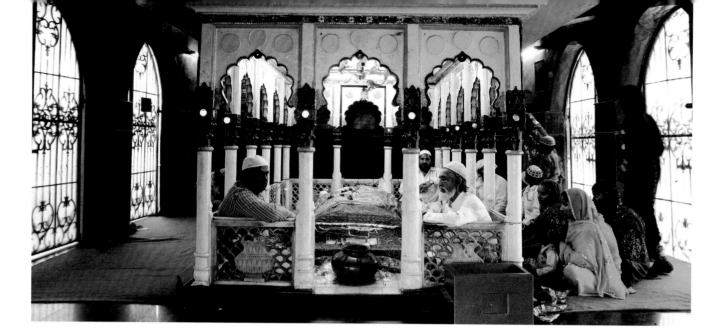

Auliya who had his own *khanqah* not far away. Few would know Sheikh Abu Bakr by his proper name today, though many in Delhi venerate him as Matka Baba and go to his small shrine on Mathura Road, known locally as Matka Pir. Delhi's Chief Minister, Sheila Dikshit, is an ardent devotee and a frequent visitor to this shrine that attracts over fifty visitors from diverse backgrounds every day.

Situated opposite the National Sports Club, occupying the southwestern corner of Pragati Maidan, it is hard to miss Matka Pir because of the small *matka*s or clay pots hanging from the branches of trees that screen the shrine. Next to a petrol pump, you enter a gate and park your car besides stalls selling the usual paraphernalia of offerings. You may or may not buy any of the wares being sold here but do remember to take off your shoes as you climb the steep flight of stairs leading up to the small *dargah*. The devout come here to seek the saint's blessings, make offerings of rose petals and *shakar dane*, and when their wish comes true, make an offering of a *matka*—usually filled with sherbet—at the shrine. According to the caretaker, this often causes problems of plenty. Once the trees around the shrine have taken all the *matka*s they can possibly bear on their slender branches, the pots have to be taken down to create space for new ones. The old ones are then re-sold for Rs. 5/- each!

Legend has it that Shaikh Abu Bakr had an earthen pot that he would fill either with the water from the Yamuna nearby or with *gur*-sweetened sherbet and offer it to those who thronged his hospice. This was said to have *karamati*. Soon, stories of his amazing powers reached Sultan Ghiyasuddin Balban. This was a Delhi when power was short-lived and sultans were skittish about being usurped

by the next more ambitious nobleman or soldier of fortune who might grab the throne. In such an unstable and volatile climate, the sultans and the Sufis were naturally wary of each other; each formed parallel centres of power, one where people went for civic and social redress and the other for spiritual respite.

In a sense, this was a near-perfect arrangement where the twin centres ensured that no single force, either political or spiritual, ever held sway. While the Sufi saints, content in their own ecstasy, did not bother too much with whoever happened to be the current incumbent on the throne, the sultans, for their part, were invariably leery of the Sufis whose popularity they saw as a threat to their own intransigent authority. In Matka Baba's case, it is said that Sultan Ghayasuddin Balban, instead of coming himself to pay obeisance, sent a slave girl called Tamizan to seduce the saint. Instead, Tamizan became a devotee and spent her entire life tending to the saint. She lies buried close to the grave of Matka Baba.

Undeterred, the Sultan then sent an emissary carrying a clod of earth and iron pellets. Far from being offended, the saint miraculously turned them into *gur* and *chana*, which was then distributed among the devotees. To this day, people make offerings of *gur* and *chana* at the shrine. Matka Baba, it is said, put the *gur* into a pot of milk and sent the sherbet to the Sultan. Much chastened, the Sultan became a believer in the Sufi saint who in his lifetime had acquired the appellation of Baz-i-Safid (White Falcon) for his rare mystical achievements.

There are numerous stories attributed to the saint and to his fondness for holding *sama*, gatherings where the quest of Truth, hitherto confined to the exclusive domain of the spiritual elite, was made a part of the public audience. *Sama* was an occasion for the saint to mingle with not just those who stayed in his hospice but even those who gathered from villages and hamlets far and near.

It was through these gatherings that the Sufi saints expressed their understanding of Islam, and it was possibly through these that Islam spread across much of northern India during the medieval period. However, with time, the various convents and hospices established by the dervishes fell into ruin or were run over by squabbling heirs. Shaikh Abu Bakr was stabbed to death by one of his own disciples. And with that, his proud lineage descending from the Haidariya-Qalandariyya *silsila* died out, for he had appointed no one as his spiritual successor.

FACING PAGE: Where the devout come to pray, seek blessings, and make mannat.

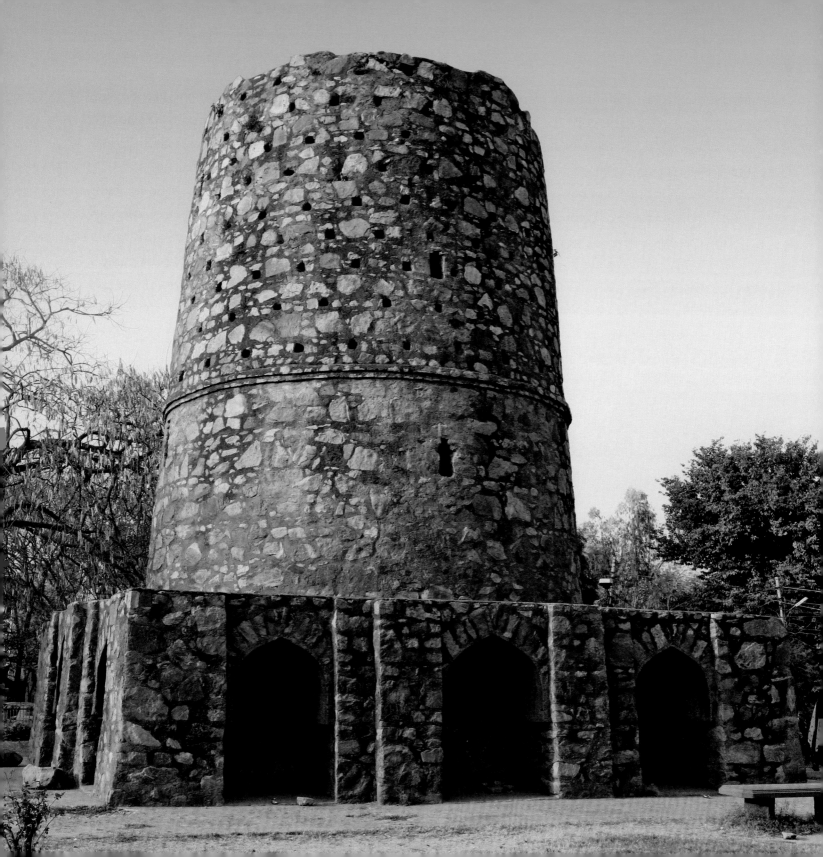

Chor Minar, Idgah and Neeli Masjid

FACING PAGE: Chor Minar—the holes were supposedly meant to hold the severed heads of thieves.

Mini minarets flanking the central archway of Neeli Masjid.

A round tower, made of rubble, no more than two storeys high, stands at the R Block roundabout in Hauz Khas Enclave. A stone's throw to the north is the solemn and rather splendid *idgah* (mosque) standing in a park by itself. And less than a kilometre away, in A Block Hauz Khas, is the Neeli Masjid. Built by different people in different times, certainly for different purposes, these three buildings in a way symbolise the spirit behind this book. There they stand, in the middle of bustling prosperous neighbourhoods. Yet, save for the space they occupy in a strictly physical sense, they may as well not exist. Bit by bit, not so much the ravages of time as the city itself is nibbling away at them and hemming them into smaller spaces.

Built by Alauddin Khalji, the Chor Minar has a grisly *raison d'être*. It is said that thieves were beheaded and their heads stuck on poles and displayed on it! Hence the name—the Tower of Thieves. This 26-feet-high tower with a base diameter of 21 feet tapers up to 18 feet. Standing on a raised terrace with arched recesses on all four sides, its outer walls are pierced with 225 holes, that is, at any given time 225 heads of assorted thieves, criminals and bad characters could be effectively displayed for the discerning public. Heads of prisoners of war could be similarly displayed—the toll at such times rising to thousands of dismembered heads. Contemporary chronicles and travelogues are full of gory accounts of how at

the time of the Mongol invasions that battered Delhi all through the fourteenth century, the number of heads far outnumbered the slots, so the heads of the chieftains or 'prominent' men would be so displayed; while the heads of the 'common' folk were simply heaped in a pyramid close by, sufficient no doubt to evoke both terror and awe and to serve as eminently efficacious deterrents for those inclined towards mischief of any sort.

The historian, Perceval Spear, has another interesting twist to the tale that paints a telling picture of the terror of those times. According to him, near the Chor Minar lived a colony of Mongols who had settled down in Delhi (presumably this colony was far removed from Mongolpuri in West Delhi, believed by many to be a Mongol settlement dating to the thirteenth century). Lest the Mongols from this colony be tempted to join their brethren during the next invasion, Alauddin Khalji, the then ruler of Delhi, regarded them as a danger to his city. Being a fierce and ruthless king not given to half measures, he had them all beheaded. Their severed heads were stuck on spikes fixed to this tower as a warning to traitors.

The Chor Minar stands on an elevated square platform.

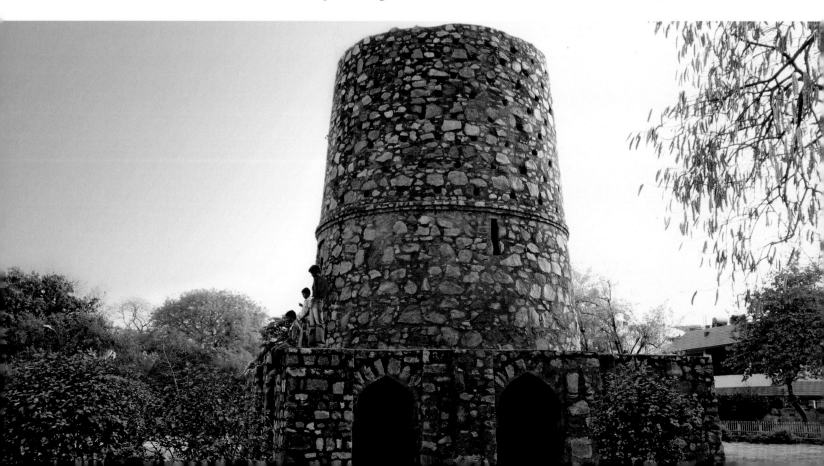

A few yards from the Chor Minar stands the remains of an *idgah*, a congregational mosque used primarily on the occasion of the two Ids—Id-ul-Fitr and Id-ul-Zuha. *Idgah*s are usually located west of and at a distance from the city and are seldom used for Friday prayers, so for the better part of the year they stand unused. An *idgah* is usually, though not necessarily, built close to a graveyard and may also be used for the Namaz-e-Janaza or the last prayers for the dead. Like much of South Delhi, probably an ancient graveyard lies beneath the posh Hauz Khas Enclave.

Built by Iqbal Khan, a powerful noble popularly known as Mallu Khan, who was the virtual ruler of Delhi during the reign of Nasiruddin Mahmud Tughlaq (1392-1412), the *idgah* was raised in 1404-05. An inscription on the southern bastion eulogises the builder but laments the desecration of Delhi by Timur in 1398. Inscribed on a red stone slab and protected from the elements by a *chhajja* supported on stone brackets, it mentions the desolation wrought by Timur and his pillaging hordes:

> *When the pious city of Delhi, the metropolis of the country, was desolated by the evil of the accursed Mughals [here, referring to the Mongols] and had become an abode of wild beasts and the mosques, schools, convents and all the charitable foundations deserted … Iqbal Khan alias Mallu Sultani had the divine guidance to repopulate the capital of Delhi …*

Compare this severe building built of random rubble masonry with not a bit of marble or fine inlay work with the other *Idgah* in Shah Jahan's city and you can see that the people who built it were poor. From a distance, it looks like a wall standing by itself in the middle of nowhere—for *idgah*s traditionally do not have a courtyard or any other enclosed space

The Neeli Masjid with three bays and a central dome rising from an octagonal drum.

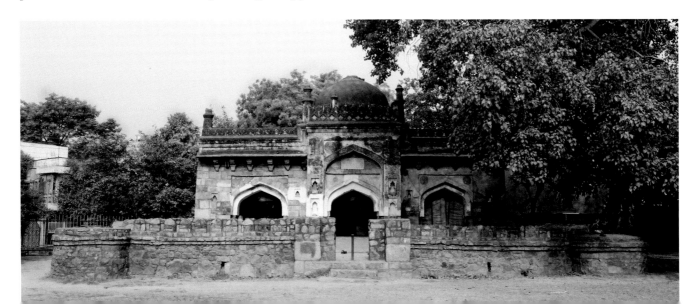

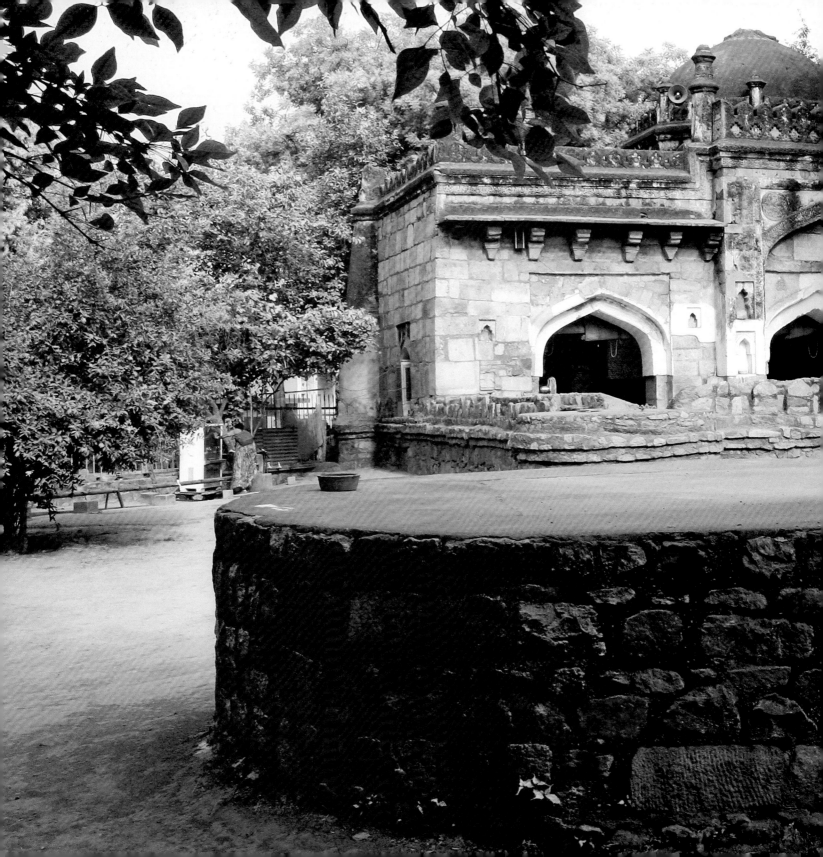

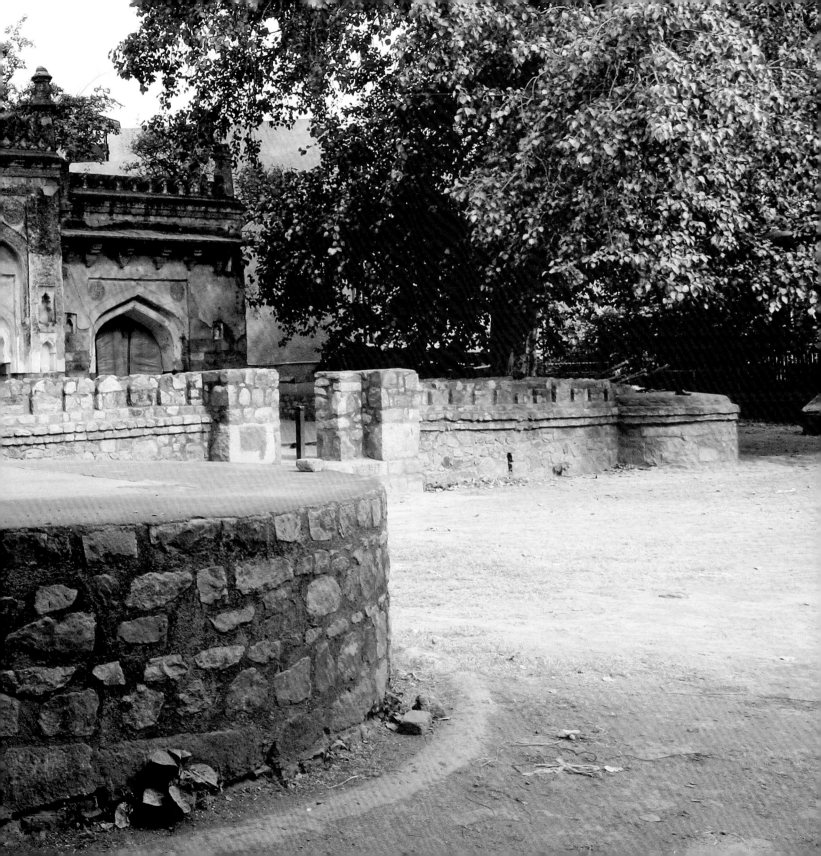

as other mosques do. Closer inspection reveals 11 *mihrab*s in its western façade. Slightly to the north of the central *mihrab* is a high pulpit reached by 13 steps; underneath the pulpit is an arched opening. This arched opening, a common feature in all *idgah*s, has been boarded up.

The Neeli Masjid in A Block Hauz Khas is more 'visible', in the sense that it is situated on a busy road connecting Aurobindo Marg with Khel Gaon Marg. An inscription above the central arch dates the building to 1505-06 and attributes its construction to Kasum Bhil, the nurse of Fath Khan, son of Khawas Khan who was the Governor of this area. This small but pretty mosque has three bays with a shallow dome sitting atop the central one and small minarets marking the octagonal base or drum of the dome. Striking blue tiles run along the drum, thus causing it to be called Neeli Masjid, or the Blue Mosque. Though no more than a dozen or so of these tiles remain, they must have once created a strikingly effective border against the stone roof and the rubble masonry walls. The outer western wall is embellished with Koranic inscriptions. There are also inscribed medallions studded on the *kangura* pattern running all along the roof. A boarded-up well stands in the desolate courtyard.

The Neeli Masjid is a mosque in use. People from nearby areas come to pray, as is evident from the rolled-up mats stacked in one corner, a few copies of the Koran placed in an alcove and the motley collection of jerrycans containing water for the ritual ablutions. In the absence of municipal water supply, Guru Nanak Motors from across the street provides water to the large numbers, who come here for Friday prayers. This small gesture speaks, perhaps more effectively than a thousand campaigns, on how monuments can be retrieved from lost memory, preserved and made a part of our lives.

PAGES 52-53: In the foreground, a well now filled up and closed over.

FACING PAGE: Remains of striking blue files are visible along the drum of the dome.

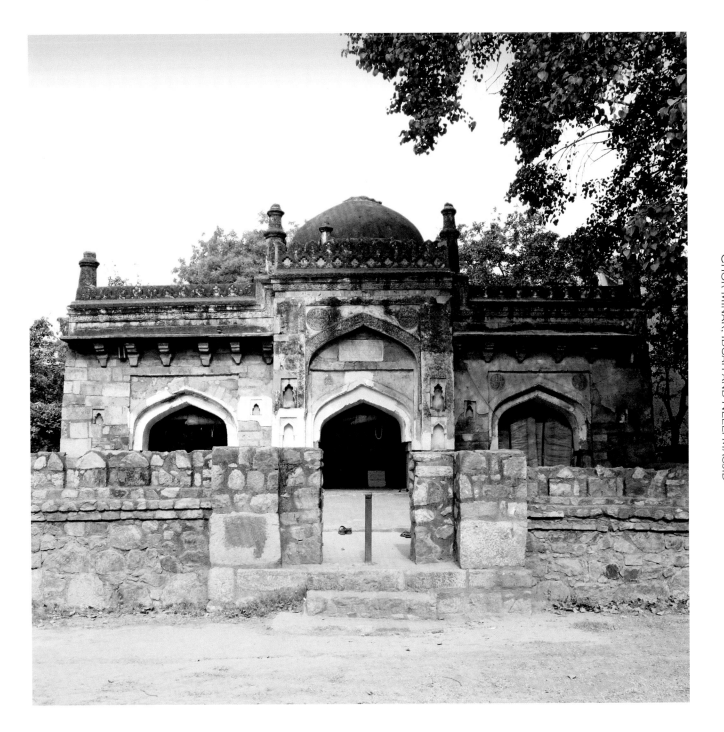

TUGHLAQ
Set in the Past

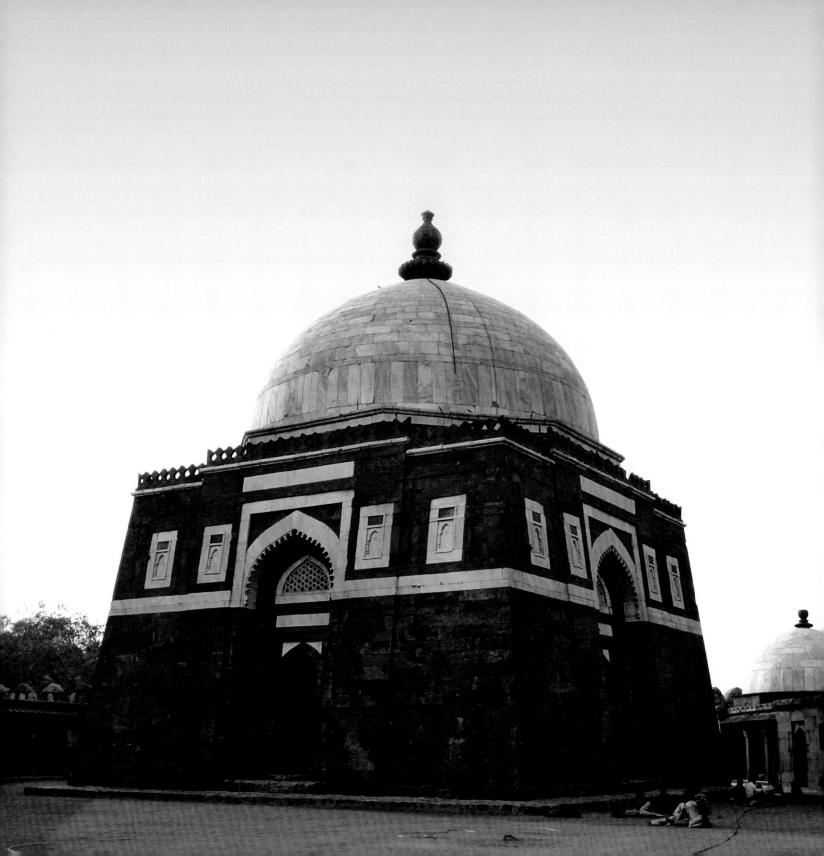

Ghiyasuddin Tughlaq's Tomb

FACING PAGE: A symphony in marble and red sandstone—Ghiyasuddin Tughlaq's mausoleum.

Inside the tomb chamber.

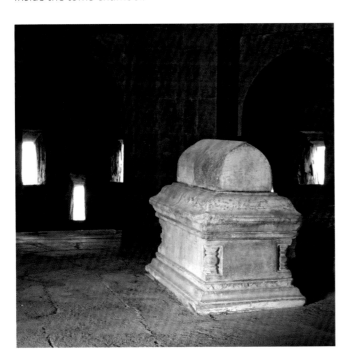

Ghiyasuddin Tughlaq built a mausoleum for himself. Its high pentagonal walls, strengthened with bastions, make it look more like a small fortress than a conventional tomb. Once upon a time, it stood in the midst of a vast reservoir and was connected with the nearby fortress of Tughlaqabad by a causeway. Now, the Mehrauli-Badarpur road runs between the two—flanked on either side by a tangle of thorny bushes and scrub vegetation. In the distance, colonies of rhesus monkeys boo and pull faces at those foolhardy enough to leave the safety of their cars to venture for a closer look at this marvellous building.

But venture you must, if you are a serious student of the architecture of death. I, for one, never cease to wonder at the sheer numbers of tombs, mausoleums and graveyards in Delhi and the loving attention to detail lavished upon them. Despite the deep-rooted disapproval of monumental tombs in traditional Islam and the tendency to favour simple *kuchcha* graves as a mark of humility and acceptance of mortality, large parts of Delhi look like crumbling sites with tombs of every shape, size and scale of extravagance dotted about in vast profusion. INTACH's *Delhi: The Built Heritage* lists 189 tombs. There are, of course, countless other small unlisted unvisited tombs, *dargah*s and graves. Of all these, Ghiyasuddin's self-built elegy in stone is significant for several reasons: its fortress-like

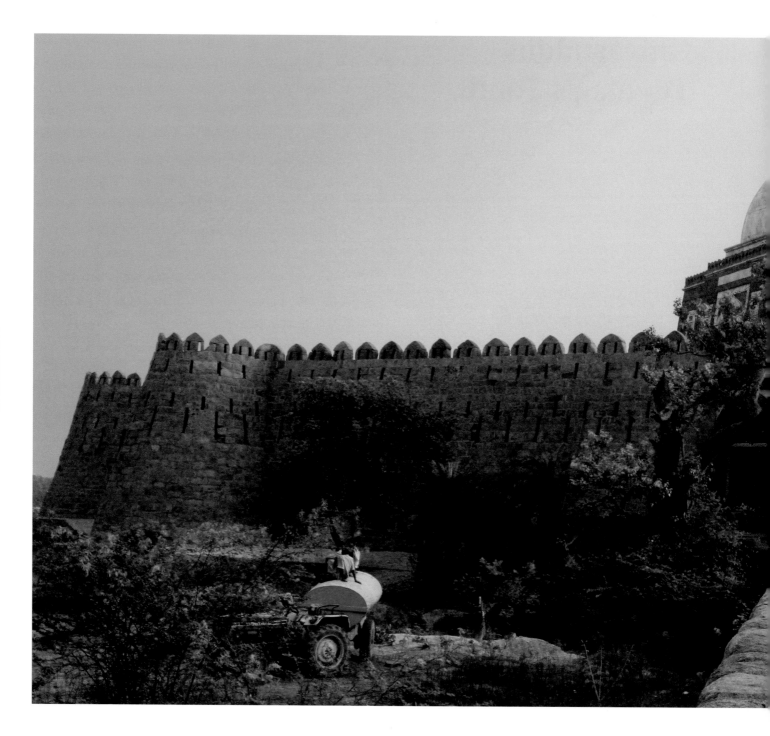

appearance, its situation in the midst of a water body and its striking use of red sandstone and white marble.

It is also the first significant Tughlaq-period building in Delhi and, unlike other Tughlaq monuments, also the most ornamented.

Ghiyasuddin was the Governor of Samana, near Panipat. When commotion broke out after Alauddin Khalji's death and the usurper Khusrau Khan seized the throne from Alauddin's son Mubarak Khan, Ghiyasuddin marched to Delhi, killed Khusrau Khan and declared himself the Sultan in 1321, thus laying the foundation of the great Tughlaq dynasty. An able soldier, a stern ruler and an ambitious builder, Ghiyasuddin restored order, kept the Mongols at bay and expanded his empire. After the four years of anarchy following Alauddin's death, Delhi needed a firm hand at the helm, which it found in Ghiyasuddin Tughlaq.

Perceval Spear describes the Tughlaq dynasty in the following manner:

> *The Tughlaq period is essentially a continuation of the previous age, only with increasing difficulties and reduced resources. It is a soldiers' age, stern and pitiless, and its spirit is reflected in its buildings, the unique and grim Tughlaq style. Sloping walls*

A self-built elegy in stone which was once surrounded by water.

of massive strength, plain undecorated surfaces in place of the rich ornamentation of the Khaljis, rough hewn stone for red ashlar are the marks of this style.

You see all of this in the fortified city of Tughlaqabad, the fourth city of Delhi, spread over six sq. km., built for pressing reasons of dynastic pride and defence. Not much remains of the city except the walls with the pronounced batter built out of locally quarried stone. The sloping walls, built for sturdiness, were to become in later years a leitmotif of all Tughlaq architecture, leaving its imprint on countless big and small, grand and not-so-grand buildings found all over Delhi. Despite the desolation, Ghiyasuddin's tomb is an imposing edifice befitting a warrior-king.

The sheet of water that once surrounded the tomb is, of course, long gone. The stone causeway, too, was breached to construct the highway. Built of large local stones, supported by 27 arches, some of which can still be seen at the north end, parts of the causeway serve as a footpath. The fortified outer walls of the tomb, however, stand pretty much upright and intact. A massive gateway of red sandstone, approached by a steep flight of steps, leads into the tomb enclosure. The square tomb has sloping red walls with white bands, white blind arches and white ornamentation on the *mihrab*s. A white dome rises from a low octagonal drum. It is topped by a red sandstone finial. Inside there are the plastered graves of Ghiyasuddin, his wife Makhdumai Jahan and son and successor Muhammad Shah. Called Darul Aman (Abode of Peace) in contemporary accounts, there is a sense of stillness and tranquility here. The marble lattice screens in the arched openings and exquisitely ornamented *mihrab* on the western wall make it a place of both opulence and serenity.

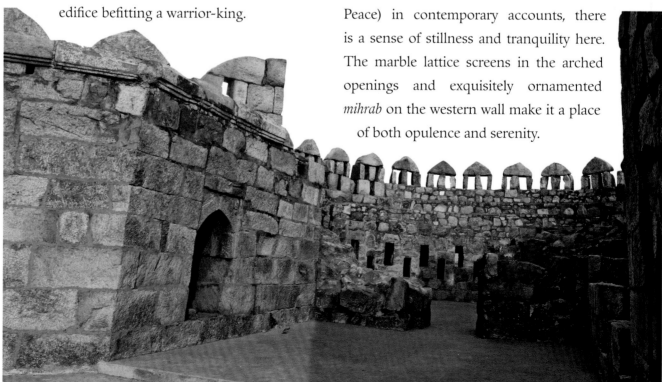

In the bastion on the north lies the tiny octagonal tomb of Zafar Khan. An eight-pillared pavilion, with a verandah running on all sides, topped by a small marble dome, it is a quaint, picturesque little place—perfect for the unknown Zafar Khan who died while still a child. An inscription on a red sandstone slab affirms that Zafar Khan died 'a mere child'.

It is believed that the Sultan, having built this small tomb, may have been so enchanted with its location and its vantage point that he decided to construct his own tomb close by in his own lifetime. That he would lie there sooner than he imagined is the subject of speculation. Contemporary chroniclers have made much of his ill-advised vendetta with the great saint Nizamuddin. Like all Delhi sultans, Ghiyasuddin was both envious and fearful of Nizamuddin's popularity and missed no opportunity to engage in small skirmishes with him. When the saint was getting a tank built in his hospice, he ordered all the workers to come away and instead work on building the walls of his Tughlaqabad. The workers, in defiance of the Sultan's orders, continued working at their beloved saint's tank. Ghiyasuddin was in distant Bengal, fighting to consolidate the eastern limits of his burgeoning empire, when word of this flagrant disobedience reached him. He vowed to punish the saint who had so insulted his authority. Nizamuddin's well-wishers advised him to flee Delhi to escape the Sultan's wrath. Every time the suggestion was made, Nizamuddin's answer would be: *Dilli hunooz door ast* (Delhi is yet afar).

At long last, Ghiyasuddin reached Afghanpur, a mere day's march from Delhi. There his son, later to be crowned Muhammad Bin Tughlaq, had

..

FACING PAGE: Fortified outer walls.

Precariously balanced stones creating a perfect pattern.

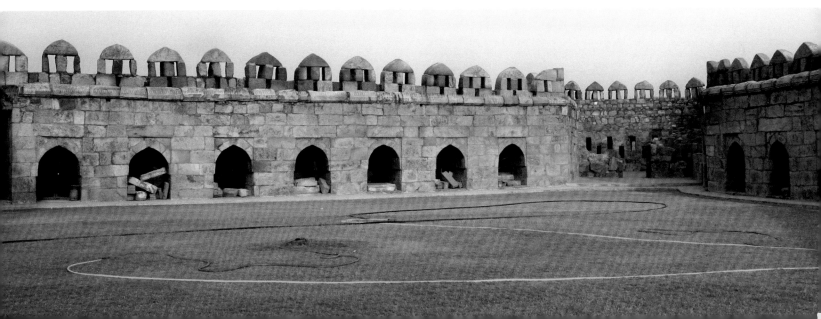

arranged a lavish reception for him. Muhammad had been sent by his father to the Deccan to campaign against the Kakatiya king Pratapa Rudra of Warangal. As the Sultan sat reviewing the troops, the roof of the pavilion fell down and crushed him.

While Muhammad maintained it was an accident and was caused when one of the elephants nudged against a wooden pillar, thus bringing it down, others believed that it was caused by Muhammad's greed and ambition to sit on the throne of Delhi. Still others read the fulfilment of a prophecy in this incident. For, Nizamuddin had prophesied that Ghiyasuddin's grandiose building project would never become a human settlement, that it would remain the abode of jackals and Gujjars.

Upon Ghiyasuddin's death, his body was brought overnight to Delhi and buried in the tomb lying ready. Muhammad seized the crown and built first his own fort called Adilabad close by and later

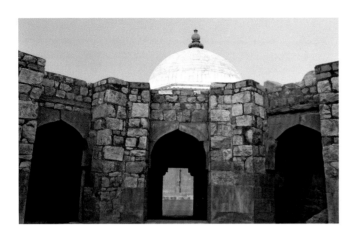

his own city, the fifth Delhi, called Jahanpahna. Tughlaqabad fell into rack and ruin, desolate save for the wild jackals and the Gujjars. The brackishness of water in this area had as much to do with its desolation as the saint's curse. Today, nothing survives of the city, except the walls—and Ghiyasuddin's spectacular tomb.

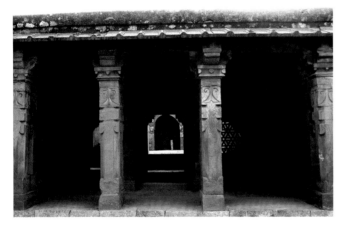

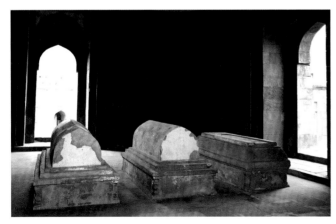

ABOVE: A gleaming white dome peeps from the northern nook.

MIDDLE: A colonnaded verandah.

BELOW: The grave in the centre is Ghiyasuddin's.

FACING PAGE: The tomb of Zafar Khan tucked away in the northern bastion.

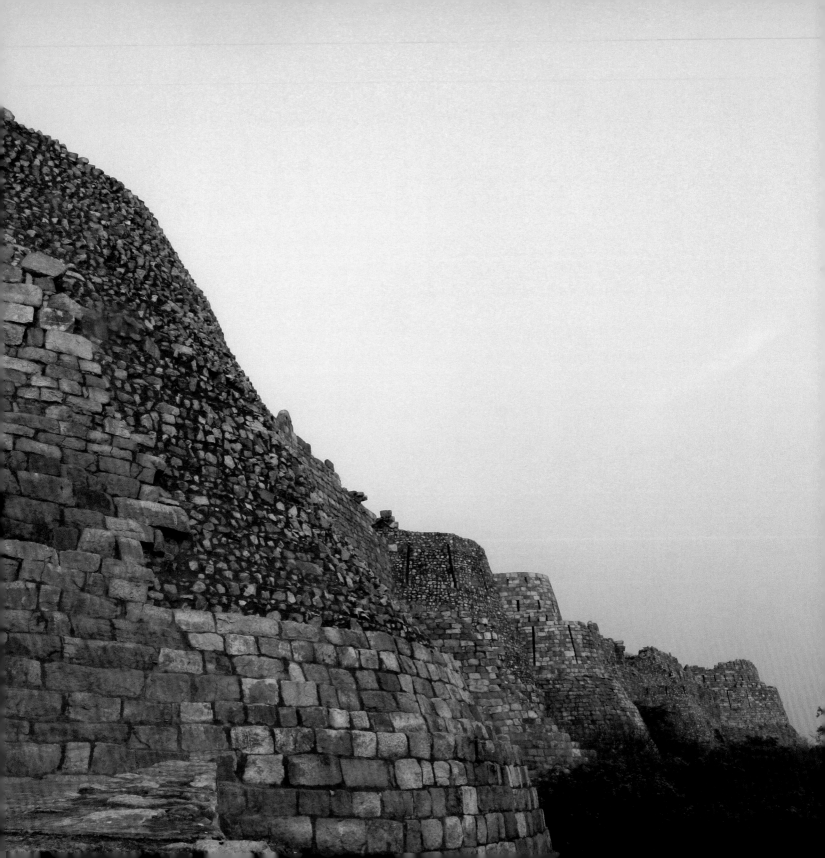

More on the Tughlaqs

All that remains of a once-mighty citadel.

Muhammad Bin Tughlaq, who declared himself the Sultan of Delhi in 1325, proved to be a mercurial colourful figure—by far the most eccentric and controversial ruler Delhi had known till then. While he worked tirelessly to introduce the much-needed administrative reforms in the burgeoning Muslim empire, he earned the wrath of the powerful *ulema* of his time and the ill will of his subjects. History remembers him as a mad genius, a poet and a philosopher, a man of quicksilver impulses who acted upon his madcap ideas without fully thinking them through, often to change his mind midway.

The subject of a play by Girish Karnad, the inherent duality of Muhammad Bin Tughlaq's character is best described by the intrepid traveller Ibn Battuta, who visited India during his reign, in the following words:

> This king is the fondest of all men of making gifts and shedding blood. His gate is never without some poor man enriched or some living man executed, and stories are current amongst the people of his generosity and courage and of his cruelty and violence towards criminals.

Modern-day historians are divided on the extent of Muhammad's wilfulness and eccentricities. While contemporary chroniclers such as Burni were unequivocal in their condemnation of Muhammad and portrayed him as a near-villainous king bent upon inflicting ill-thought-out strategies upon

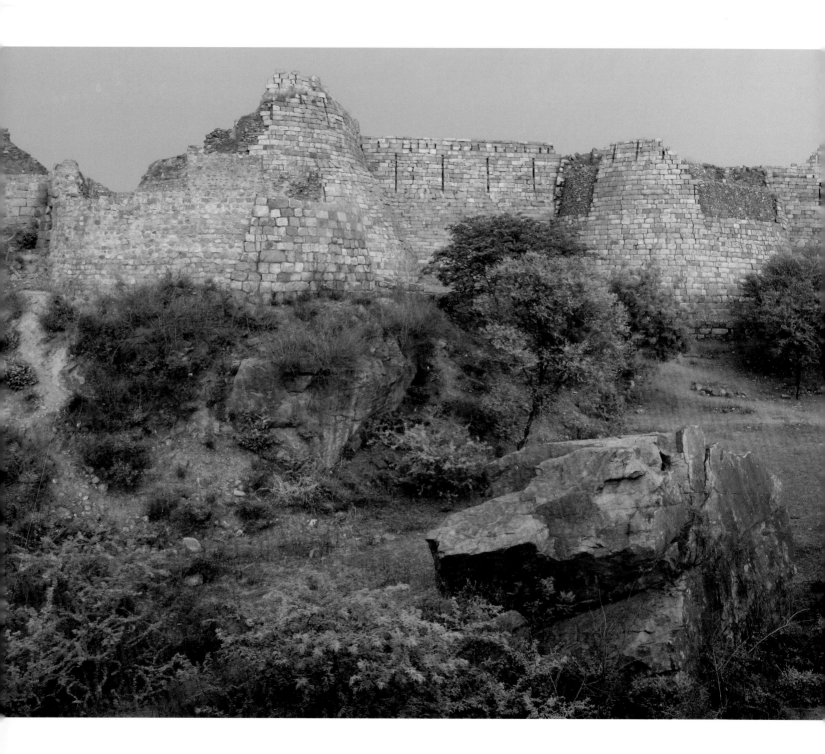

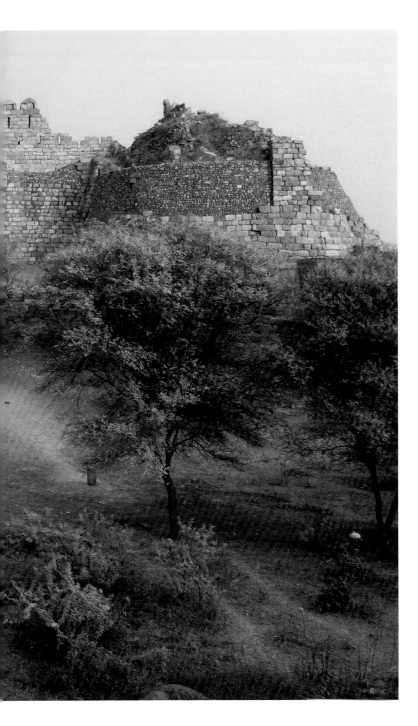

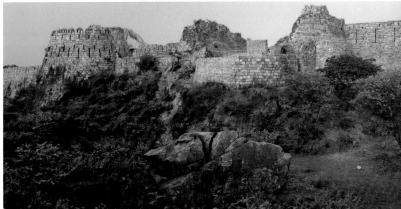

his hapless subjects, modern historians have re-visited Muhammad's legacy and, upon seeking the truth from among heaps of exaggerations and apocryphal stories, found Muhammad to be a bundle of contradictions. Perceval Spear describes Muhammad as cruel and changeable but also brave and very clever.

Among Muhammad's visionary schemes was the introduction of brass and copper coins instead of gold and silver ones and sending envoys to China, Khurasan, Egypt and many such places. While the former was a flop because people refused to turn in their gold and silver, the latter was a success and resulted in missions pouring into India from all over Central Asia and China, heralding a new era in cultural and bilateral exchange. About the Sultan's

LEFT & ABOVE: Tughlaqabad today lies amidst a wilderness of stones and keekar trees.

decision to shift his capital to the south, Spear has this to say:

> *This brilliant and eccentric monarch soon tired of the grim security of Tughlaqabad. In 1327 he abandoned Tughlaqabad and transferred the capital to Daulatabad, 700 miles away in the Deccan. In view of Alauddin [Khalji's] vast southern conquests this was a more central situation, but it neglected nevertheless the essential fact that the strength of the empire and its most potent dangers lay in the north.*

The Mongol menace was still very real and the threat from the *ulema* and the feuding Persian nobility no less, for Muhammad had antagonised the powerful courtiers and generals by his high-handedness. Being away from Delhi, the centre of power in every sense of the word, was not a great idea. To add to the Sultan's woes, the citizens of Delhi, who had been dragged to the Deccan, hated their new city. Muhammad was forced to abandon Daulatabad in 1344 and return to Delhi. Shortly afterwards famine struck Delhi and its neighbourhood and he ordered another exodus, this time to Sargadwari near the ancient Khor beside the Ganges. But in the intervening years, he turned his attention to Delhi. Unlike other emperors before him, he chose not to build a new city but to fortify the existing cities of Delhi behind a protective wall, a bit like the Great Wall of China built to withstand medieval marauders.

And so the mighty walled city of Jahanpanah was envisaged. It included Lal Kot, Siri and Tughlaqabad and all the suburbs between them. The meticulous planner in Muhammad ensured that these cities were served by a well-laid system of water canals fed by especially constructed tanks. A dam with elaborate sluice gates survives, known as Satpula, as do portions of the wall, near Press Enclave. The fortifications, meant to extend all the way up to Tughlaqabad, had to be abandoned mid-way since money ran short and Muhammad had to turn his attention to the many uprisings in different parts of his by-now sprawling empire. Muhammad died in 1351 at Thatta in Sindh where he had gone to personally quell a mutiny.

For all its trials and tribulations during the 26-year reign of Muhammad Bin Tughlaq, Delhi remained a city without comparison. To quote from Ibn Battuta, who lived here from 1334-42:

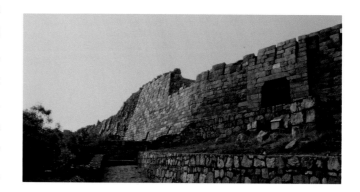

All that remains of the dream of a 'mad genius'.

...Dihli, the metropolis of India, [is] a vast and magnificent city, uniting beauty with strength. It is surrounded by a wall that has no equal in the world, and is the largest city in the entire Muslim Orient.

Despite Muhammad Bin Tughlaq's love-hate relationship with Delhi, this man, upon whom the jury is still out and the verdict teeters between 'misunderstood genius' and 'capricious despot', left his imprint upon the architectural landscape of Delhi. Apart from the sites within Jahanpanah, he built the fort of Adilabad near his builder-father's city of Tughlaqabad. Adil being the title Muhammad assumed soon after gaining the throne, Adilabad was built in a similar style, with thick sloping walls and rounded bastions. Like Tughlaqabad, it is in a ruined condition and strewn with rubble and blocks of stone and similarly deserted, except for colonies of rhesus monkeys. Once connected to Tughlaqabad

...or was he a 'capricious despot'?

by a rubble masonry causeway, it is a mystery why Muhammad should have built another fortress so close to the one begun by his father not very long ago. Also, given the shortage of water in this area, Adilabad had no hope of being a populated city.

To add to the enigma are the ruins of yet another fort close by—also said to have been built by Muhammad but known variously as the Nai ka Kot (Barber's Fort), or Washerman's or Sweeper's Fort. No satisfactory explanation is available as to how a fort acquired these plebeian monikers. Similar to Adilabad but built on a much-smaller scale, INTACH's *Delhi Listing* attributes it as a private residence built by Muhammad for himself. Built on a rocky outcrop, surrounded by dense scrub vegetation, the Nai ka Kot beckons the adventurous, its broken arches visible above the huddle of truck garages and mechanic shops. Like the Siren of Calypso, it calls out to the unwary. Only the very brave or the very foolhardy would trek through the thorny terrain.

I, for my part, am content to look up at the Nai ka Kot and marvel at a time when the fluid fabric of Delhi society allowed barbers to have fortresses of their own. Or, at the very least, named after them!

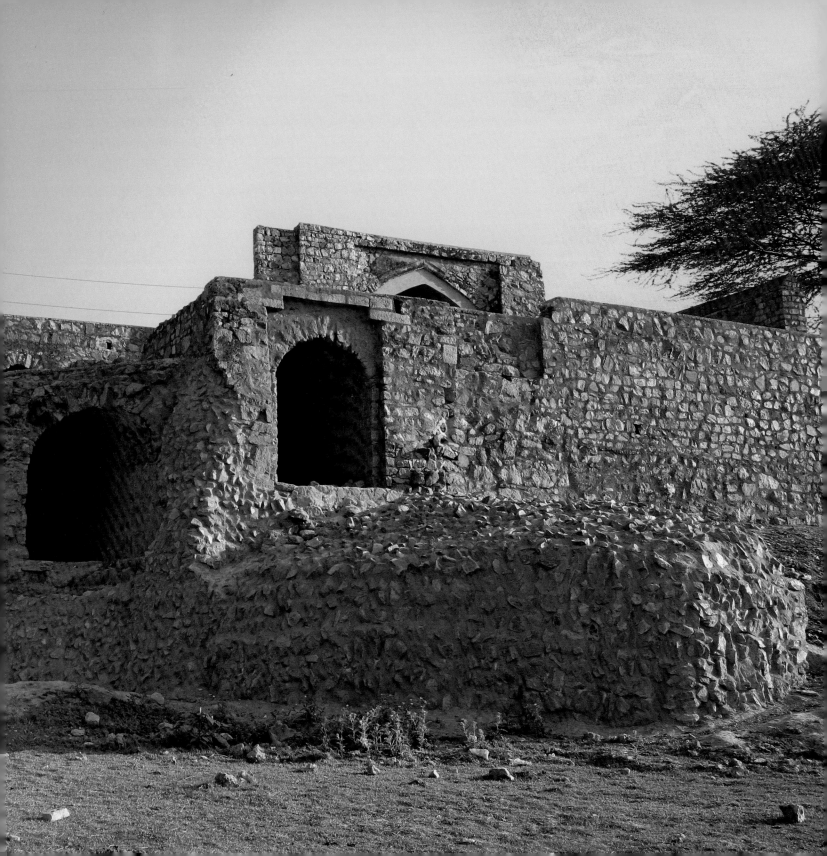

Waterworks at Satpula

FACING PAGE: Square bastions on either side of satpula.

A lonely sentinel to a city long gone.

The rulers of Delhi combatted the dry arid landscape by harnessing the Yamuna upstream and carving out an elaborate network of canals, not just to meet the requirements of the many cities of Delhi that came up from time to time but also feed the orchards of fruit-bearing trees that these emperors from cooler climes planted instead of the *keekar* and gorse that grew wild hereabouts. Linked to numerous rainwater reservoirs, natural catchment areas and *baolis*, remnants of these canals can still be found in many parts of Delhi.

In some places these nullahs have been covered up and built over, but elsewhere they run clear and strong as in Defence Colony, along Mathura Road, near Khirki village, Soami Nagar, Panchsheel Enclave, the CGO Complex near Lodi Road, among other areas.

As early as the thirteenth century, skilled engineers knew how to best harness Delhi's assets—the southeast-northeast Ridge formed out of a finger of the Aravalli Range that jabbed Delhi rather judiciously, giving it both elevation and variation from the otherwise flat topography of the surrounding plains, and also the regular monsoons that lashed the area. This water, if adequately harnessed and channelised to link with the Yamuna, could easily meet the demands of the burgeoning city, rather the cluster of cities that came into being. Much of this water was diverted to the green hinterland of the

successive cities of Delhi, for interspersed with the many Delhis were the green, almost entirely rural pockets. Where there are urban villages today were once sprawling village greens and acres of cultivated land. The fields and pastures are gone now, of course, gobbled by the housing estates that came up soon after Independence. The Ridge, too, has been levelled, chopped off, carted away in bits and pieces, often rock by ancient rock. What remains is a masterpiece of innovation and medieval technology known locally as the Satpula. As you drive along the road leading from Press Enclave to the Sheikh Sarai Community Centre, you will come upon an arched rampart right beside the road. Closer inspection reveals the structure to be not a wall but an elegant, beautifully proportioned dam. Believed to have been built by Muhammad Bin Tughlaq, this dam with sluices is a unique structure. There are 11 arched openings and a flanking tower at the eastern and western ends. The arches, the towers at either end and the sturdiness of construction make it look like a fortified wall. It also served as a lookout tower and part of the fortification of the city of Jahanpanah, including present-day Sarvpriya Vihar, Soami Nagar, Chiragh Dilli and Sheikh Sarai in the south, spilling right up till Aurobindo Marg in the west, joining up with the walls of Siri. Portions of the fortified wall of Jahanpanah remain, some in the vicinity of the Satpula, the rest seen in parks and built-up areas as patches of unexpected ancient rubble masonry among the urban sprawl.

The Satpula or seven-bridged weir is an engineering device to regulate the flow of water into the city of Jahanpanah. On its southern side, the side facing the Press Enclave road, are acute-angled knife-edged projections. A nullah passed through

Seven sluice gates give the dam its name.

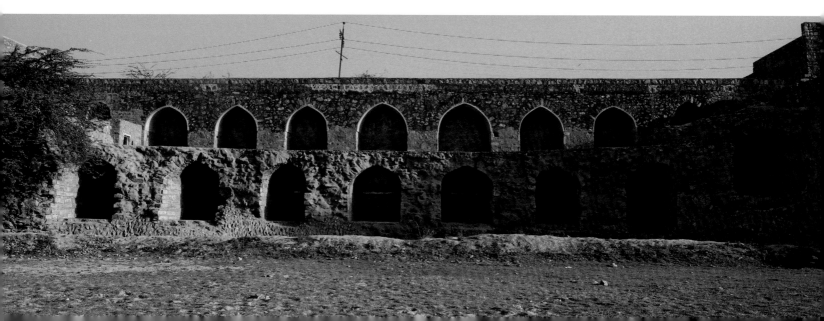

its seven arched openings and into the city. At the point where the flow of water cut through the wall of Jahanpanah, seven sluice gates were erected. Of the 11 arches that are visible from the road, four are subsidiary and the seven main ones give the dam its name. Along the upper level, runs a wall that is broken by recessed arches corresponding with the arched openings below. The sidewalls of these arched openings have niches or grooves to fix the windlass whenever the sluice gate was not being pulled up or brought down. If you wanted to close a particular gate you could take the windlass out of the grooves and let the gate fall down. If you wanted to half-open it, the gate could be pulled up to half-open position and then fixed in the grooves. Ropes coming from the sluice door would go up to the roof level, pass through the two holes in the roof, before coming down and joining the windlass. The ropes would be reeled on the windlass. Floods are said to have damaged some parts of the structure and a rubble wall was later erected to its south.

Water from the catchment area upstream from present-day water-starved Tughlaqabad and Vasant Kunj flowed here in abundance. The sluice gates could regulate its flow. The flanking towers at either end have deeply recessed arches facing north. Inside, there is an octagonal chamber with arched recesses on each of its sides. Since the Satpula was located at the wall of the fortified city of Jahanpanah it had

to be protected. That explains the rear wall being pierced with defensive arrow slits and the towers at either end being square instead of the customary round ones. A square bastion was handy since a catapult could be placed on its square roof base. Catapults called *maghrib* or *manjarik* were used from such defensive positions. There are staircases going up to the roof of the Satpula.

It is said that at one time the square bastions also housed a school, hence its alternate name of Madarsa. There was also a well nearby whose waters were believed to have talismanic properties because of the long association of this entire area with the hospice of Roshan Chiragh Dilli. An annual fair was once held here around Diwali time, but now nothing of the sort seems possible. Stagnant rainwater collects in a dirty pool where water from the weir must once have gushed. All around there are wild *keekar* trees and thorny bushes. The tops of houses from the nearby Khirki village peep from a distance. The desolate and dusty Jahanpanah Protected City Forest spreads all around—stretching from Chiragh Dilli right up till Alaknanda. The nullah that once nudged the waters of this dam with such force that knife-edged projections had to be erected, has been built over. It lies buried somewhere beneath the tarred road and the smart houses beyond. With no water to feed it, the Satpula stands as a lonely sentinel to a city that has long since disappeared.

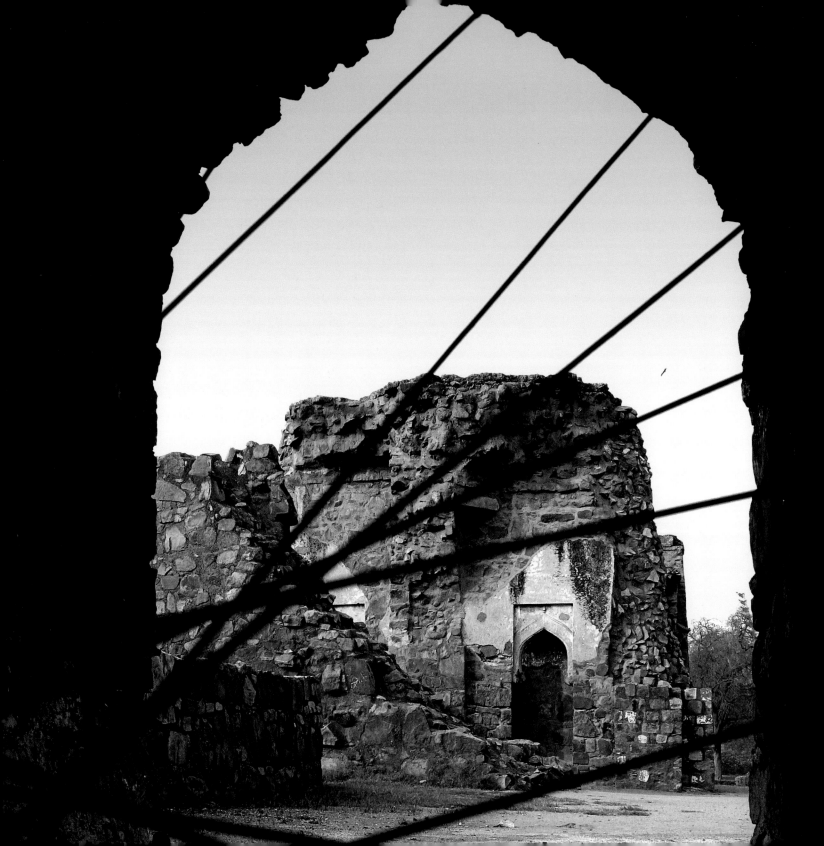

Firoz Shah Kotla

FACING PAGE: Remains of the day.

Framed in time.

For a mere Rs. 5 you can explore a whole new city; if you are not an Indian, for a paltry Rs. 100. For, that is all that you have to pay to enter this enchanted wilderness of tumbledown arches and broken columns. Hidden behind the barricade of newspaper offices at Bahadurshah Zafar Marg and the Kotla Stadium is a fortified city, the fifth city of Delhi. Built by Firoz Shah Tughlaq in 1354, it lay just a few km northeast of the existing cities of Siri, Jahanpanah, Tughlaqabad and Lal Kot. It extended from Hauz Khas to Pir Ghaib near the present-day Hindu Rao Hospital.

Why so many Delhis, you may well ask. After all, what compelled ruler after ruler to build and rebuild, sometimes one upon another, sometimes at the outskirts of the old Delhis, more and more new Delhis? Some ascribe it to an old tradition that expects each new ruler to institute extensive building programmes partly to provide large-scale employment and partly to demonstrate his might and glory. Then there is also the belief that in Islam, building a city is seen as an act of piety. A popular saying attributed the building of a new city to *darya*, *badal* and *badshah*. Delhi qualified on all counts: the Yamuna flowed close by, the monsoon clouds brought sufficient rains and each successive ruler wished to outdo his predecessor.

Firoz Shah ascended the throne in 1351, after the death of his much-misunderstood and maligned

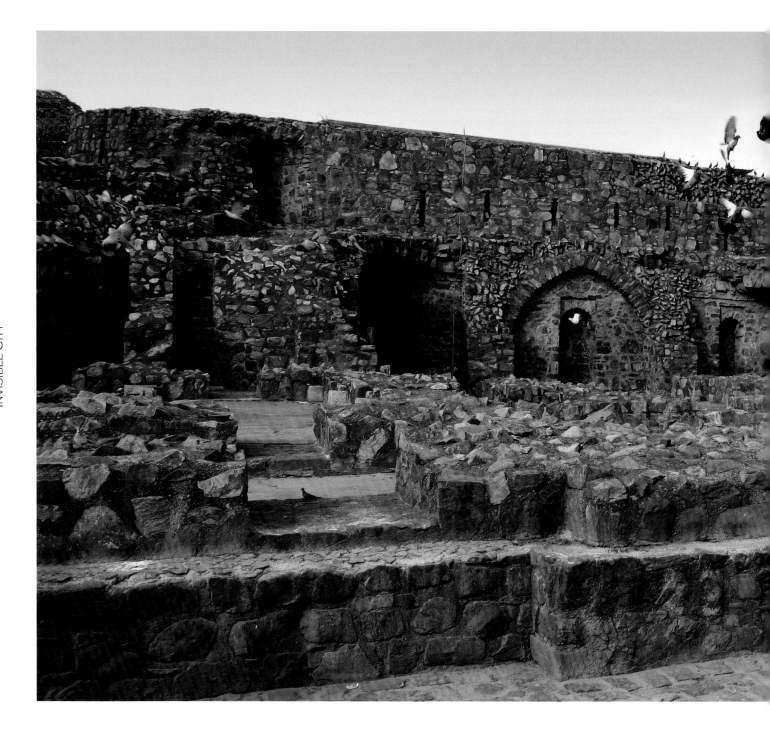

cousin Muhammad Bin Tughlaq, and spent the first few years consolidating his empire. Then, he set his sights on repairing existing monuments, building new ones, renaming cities, constructing *baoli*s, caravan-*sarai*s, hospitals, baths, bridges, canals and his most ambitious project—the Kushk-i-Firoz or the Citadel of Firoz. A barbicaned main western gate flanked by a bastion on each side led to a large compound containing palaces, pillared halls, mosques, a pigeon tower and a *baoli*—all set amid lush landscaped gardens. Nothing remains of the palaces, each with exotic names such as Palace of the Clayey Court, Palace of Grapes and Palace of the Wooden Gallery.

Firoz Shah was quick to understand the significance of the Yamuna. A prolific builder and conservationist, he is called the 'Patron-Saint of the Irrigation System' because of the sheer number of canals constructed for irrigation during his reign, the biggest being the one now known as the Western Yamuna Canal. Firozabad, too, was not just an emperor's whim to enjoy fresh river breezes but was actually the first of the river-based Delhis. This ensured adequate availability of water and also provided an easy means of transport and hence facilitated trade. Unlike the first four Delhis, Firozabad had only a fortified inner citadel, the rest of the city being virtually without any protection.

A city without fortification was doomed to fall prey to dacoits, looters and invading armies. And that was precisely the fate that awaited Firozabad after Firoz Shah's death in 1388. Less than 50 years later, Mubarak Shah, the second king of the Saiyyid dynasty, came to the throne and decided to build a new city called Mubarakabad in 1433. And so it went on … Humayun built his Dinpanah using material from the old city of Siri; Sher Shah Suri filched from both Dinpanah and Firoz Shah Kotla to construct Shergarh that covered large parts of the previous 'cities'; the worst culprit was Shah Jahan who cannibalised what remained of Firozabad to build Shahjahanabad from 1638 to 1648.

The way to reach this ghost city now is to go past the Kotla Stadium and the recently landscaped Shaheed Park on Bahadurshah Zafar Marg and enter through a barricaded gate. Nothing remains of the public part of the palace. All you see are green lawns with amorous couples. On the left is a circular *baoli* that was apparently the Emperor's personal swimming pool. It has a ring of small arched cells all around it and narrow flights of steps to take you to the balcony on the first floor. Plentiful fish and turtles swimming in its murky waters bob up

PAGES 78-79: A wilderness of tumbledown arches and broken walls.

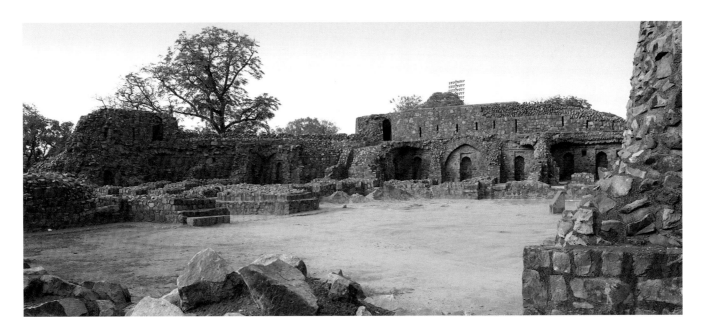

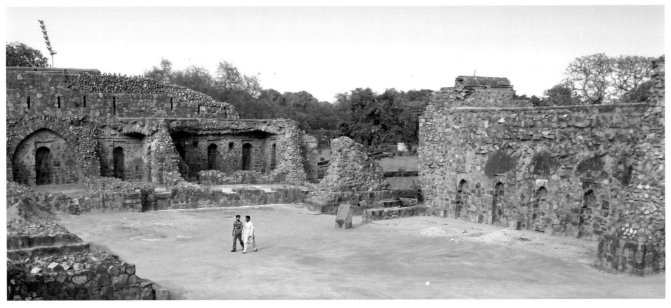

ABOVE: Inside a ghost city.

BELOW: The mosque constructed atop a series of cells on the ground floor.

energetically to catch the grain being thrown in by *burqa*-clad ladies from the nearby Purani Dilli. It is *sabab ka kaam*, a pious act, they believe, to feed these creatures.

A short distance away stands the tapering 14 m high Ashokan pillar made of polished sandstone. Dating to the third century B.C., it was brought here from Topra near Ambala on Firoz Shah's orders in 1367. There was once a ball and crescent made of gold fitted atop the pillar, but that was looted during the eighteenth century.

The Pali inscriptions on the pillar record Ashoka's good deeds in planting trees beside roads, digging wells, erecting *sarais*—all the deeds that 16 centuries later Firoz Shah could lay claim to. Known as Bheema's Walking Stick when it was 'discovered' by Firoz Shah, it soon came to be called Firoz Shah's Walking Stick.

Planted atop a pyramidal three-tiered structure within the royal private apartment, the site now houses the shrine of a mysterious Saint Jalaluddin. There are flowers, incense sticks, wax droppings and a swarm of the fattest wasps this side of the Yamuna. Hordes of women show up on Thursdays to take charms and amulets from a charlatan dispensing miracle cures for budget-conscious believers.

Close beside is a ruined mosque, once the Jama Masjid or Grand Mosque of Firozabad. Said to be the largest of the seven mosques built during this

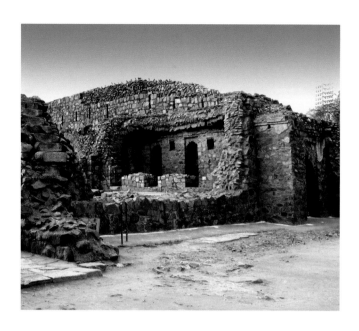

Ruins of the Grand Mosque.

time, nothing is left standing except its western wall. Due to its proximity to the river, the mosque was constructed atop a series of cells on the ground floor. There was once an octagonal structure in the central courtyard now gone like the rest of the monument. In his *Malfuzat*, Timur, the Mongol conqueror, writes:

I started from Delhi and marched three kos to the Fort of Firozabad, which stands upon the banks of the Jamuna and is one of the edifices erected by Sultan Firoz Shah. There, I halted and went in to examine the place. I proceeded to the Masjid-e-Jami and offered up my praises and thanksgivings for the mercies of the Almighty.

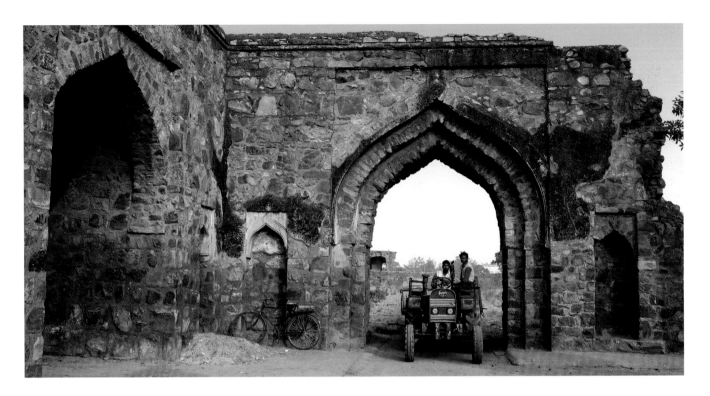

A tractor trolley rumbling in through one of the gateways of Firoz Shah's once-mighty citadel.

Timur is said to have been so impressed by what he saw that upon his return he took back artisans to erect a similar mosque in Samarkand.

Firoz Shah's many good deeds are forgotten, his achievements overshadowed by those who came after him, his palaces cleared and levelled.

Across the chaos of the Ring Road, snaking past the walls of his once-magnificent Kotla, the tall chimneys of the Indraprastha Power Station belch smoke into the eastern skyline.

Close beside is the Indira Gandhi Indoor Stadium. The Ashokan pillar mocks the cities that come and go.

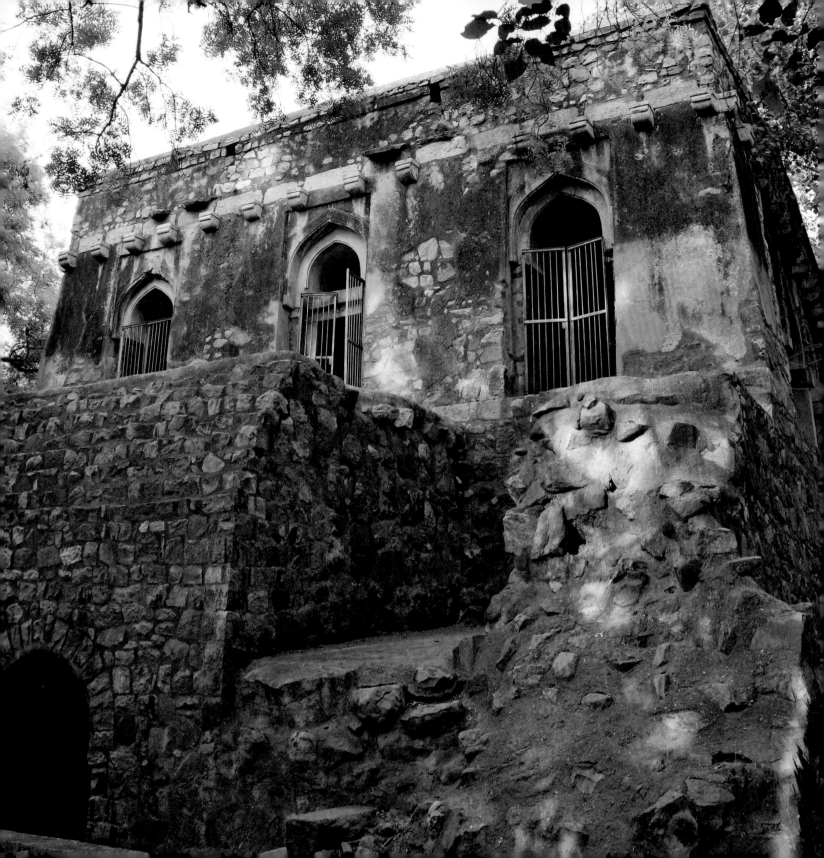

The Hunting Lodges of Firoz Shah Tughlaq

FACING PAGE: Iron-barred gates strike the wrong note.

Firoz Shah's hunting lodge inside the Teen Murti House compound.

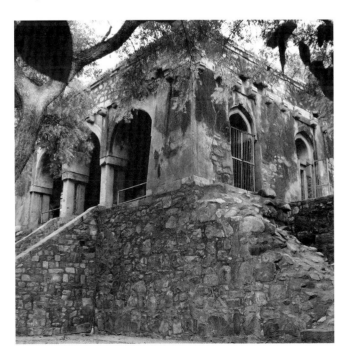

Imagine a Delhi that was not an over-built warren of densely packed houses; a Delhi that was still untamed and undeveloped, its landscape gently undulating, dotted with *taal-tallaiya*, replete with forests where wild animals roamed, a Delhi studded with stately mansions, lodges and pleasure gardens. Imagine a time when rainfall was plentiful and rainwater was harvested in natural catchment areas in the dips and valleys of the Aravalli Range as it criss-crossed much of Delhi. If you can imagine all this, you will find it easy to visualise the environs of the *shikargah*s, the remains of which can still be found scattered across the city.

The densely forested woods are gone, as are the wild animals. The tanks and lakes have long dried up and been built over. But these monuments stand, in various states of disarray, in mute testimony to a time when the call of the wild could be heard across the landscape of Delhi.

Sultan Firoz Shah Tughlaq built his Kotla Firoz Shah in 1354 on the banks of the Yamuna. Fanning out from this model, new city were three tunnels: one going to the river, the second towards the Jahan Numa Palace (in the vicinity of Teen Murti House) and the third towards the old city of Qila Rai Pithora. Firoz Shah, the great builder that he was, built a mini palace—a hunting lodge-cum-pleasure house and called it Kushk-e-Jahan Numa or Kuskh-e-Shikar. The tunnel that connected his Kotla with

the lodge was reportedly wide enough to allow the ladies of the royal household to ride through it. Over time, the nobles also raised their mansions in the neighbourhood of the Sultan's lodge and a miniature, elitist city grew up around it. Firoz Shah had an Ashokan pillar brought from the vicinity of Meerut and erected in the grounds of his *shikargah*. Another Ashokan pillar, from near Ambala, stands in the grounds of his now-derelict Firoz Shah Kotla. When the Mongol conqueror Timur came knocking at the gates of Delhi, he is said to have first dismounted at this very spot.

Situated inside the Teen Murti House compound, Firoz Shah's hunting lodge is well maintained and immaculately kept. This typical Tughlaq-style building stands on a raised platform and is accessible by a steep flight of steps. The walls are made of random rubble masonry, the stone roof is vaulted from inside but flat on the top. Unlike other Tughlaq buildings, it has no dome. Inside, there are three open bays containing arches supported by stone shafts. Each bay is, in turn, divided into three compartments. The building is open on all four sides and must have afforded a great view when there were wild jungles all around it. Originally, there was also an embankment in line with the building that was built to retain water. This must have served as a watering hole for animals such as deer, antelope, *neel gai*, among others, especially for the sultans' hunting pleasure and also to attract other animals to the vicinity of the lodge. The embankment is long gone, but a large tank still exists, probably to harvest surface run-off water from the Teen Murti House grounds.

Teen Murti House contains the Nehru Memorial Museum and Library. The building was designed by R.T. Russell, the chief architect of the Government of India in the 1930s, and was meant to serve as the residence of the Commander-in-Chief of the forces stationed in British India. After Independence, it became the residence of the first Prime Minister, Jawaharlal Nehru. The massive house is connected with an axial vista to the Rashtrapati Bhawan and is definitely worth a visit not just for the contents of its museum and library but also for its interesting colonial architecture.

The statues that lend their name to this road and roundabout also merit a close look. Opposite Teen Murti House, at the intersection of Teen Murti Marg, Kushak Road and Willingdon Crescent, the statues were constructed in 1922 'in memory of the officers, non-commissioned officers and men of the 15th Imperial Service Cavalry Brigade … who gave their lives in the Great War of 1914-19 in Sinai, Palestine and Syria'. They were sculpted by Leonard Jennings. The names of the officers who died are inscribed on the surface of a tall white-washed obelisk. Three bronze statues of soldiers from the princely states of Hyderabad, Mysore and Jodhpur stand around the obelisk.

A short distance away, on Bistadari Marg off Sardar Patel Marg, stands another hunting lodge. Known locally as the Bistadari Mahal or Malcha Mahal, this was once a Tughlaq *shikargah* but is now used as a residence by a family that claims descent from the former Nawabs of Quad. Since access is not permitted, not much is known of its interiors or the present state of its preservation, but according to historical accounts, this lodge was constructed on the same lines as the *shikargah* at Teen Murti House. It is built on a raised terrace, probably to afford better sighting of game, and has three main bays, each containing three rooms. It had a *bund* close by to retain water.

The Bistadari Mahal has, incidentally, become the cradle for a host of 'urban legends': ranging from a mysterious old lady who goes around brandishing a gun to a family of ferocious dogs that have a free run of the place and serve to keep unwelcome visitors at bay.

In water-thirsty Delhi, it is important to note that our forefathers had a better sense of water management and had installed far better water-harvesting mechanisms. They also knew how best to utilise the unique topography of the area around Delhi.

Few of us would know that Tal Katora, better known for its stadium, once had a pleasure garden and a *baradari* set amid its rolling grounds. It got its name from the *tal* in a shallow basin enclosed by hilly ground on all sides that harnessed the natural flow of water in its *katora* or bowl-shaped concavity.

Firoz Shah also had a couple of other hunting lodges built—at Mahipalpur near Vasant Kunj and one near present-day Rajendra Nagar, called the Bholi Bhatiyari ka Mahal. Over a period of time, several of his lodges were taken up by squatters as residential areas and came to be known locally as *mahal*s, thus losing in public memory the original purpose they served.

The Bholi Bhatiyari ka Mahal is reached from Dayal Chowk, between Link Road and Ridge Road. It was once occupied by Bu Ali Bhatti whose name was corrupted to Bholi Bhatiyari, and that is how the building has been called ever since. It had a *bund* once like the other *shikargah*s, with staircases on either side of a sluice channel. Its eastern and southern walls had bastions and there was a gateway as well. All that remains is an east wall.

..

Another view of Firoz Shah's hunting lodge in the Teen Murti House compound.

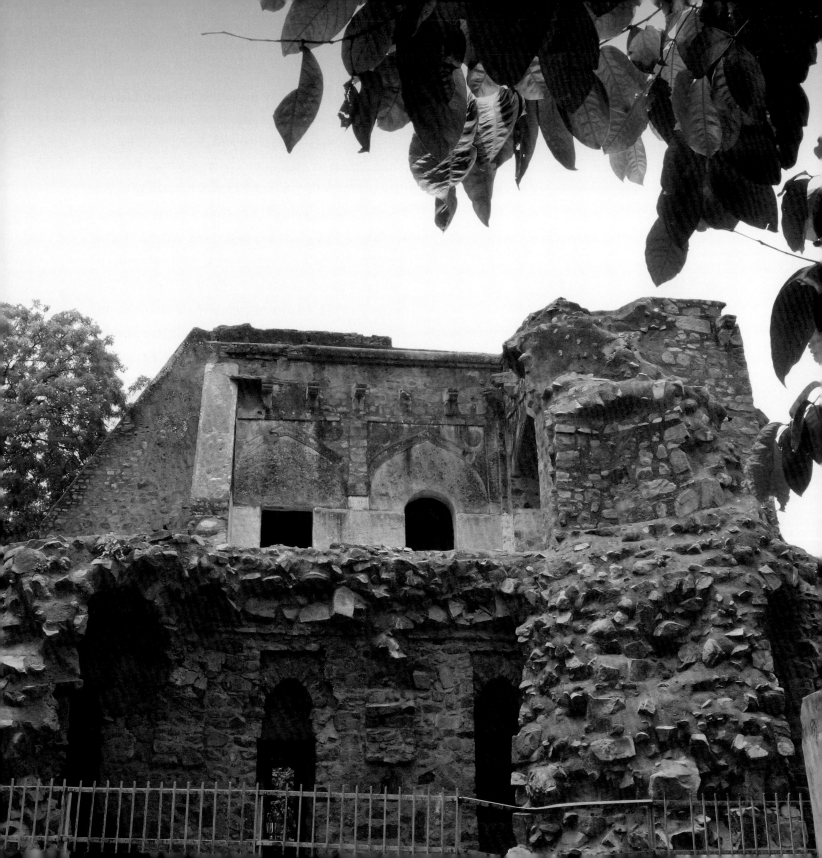

Pir Ghaib

FACING PAGE: A coming together of history and science.

Pir Ghaib—an enigma wrapped in a mystery.

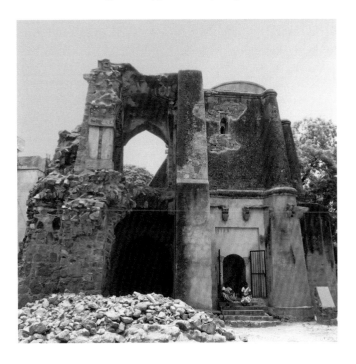

Myth and memory, history and science, fact and fantasy come together in the oddest possible way in a monument called Pir Ghaib. Nestling in a clump of trees close beside the Hindu Rao Hospital on the Ridge Road in North Delhi's Civil Lines, this blackened pile of stone and random rubble masonry is a bit of a mystery wrapped in an enigma. Called Pir Ghaib because of a Sufi saint who mysteriously disappeared into thin air while doing his 40 days of prayer and meditation in one of its peculiarly shaped chambers, it was originally built as a hunting lodge and astronomical observatory by Firoz Shah Tughlaq. But that's not all. Thanks to its strategic location on high ground, this two-storey building played a significant role during the Revolt of 1857.

While its role in the events of 1857 is well documented, the exact purpose this structure might have served in the early fourteenth century when it was originally built is the subject of much speculation. Contemporary chroniclers have referred to it as Kushak-e-Shikar (hunting lodge) and Kushak-e-Jahan Numa (world showing palace).

Two narrow chambers run like a passage in the middle of the building. Two steep flights of stairs take you to the roof where the two chambers have arched openings on the east and *mihrab*s on the western wall.

A grave, belonging to a later period, is found in one of the chambers on the first floor of the palace-cum-

hunting lodge. Interestingly, it is not placed north to south as is the usual Muslim practice but east to west.

Tradition would have us believe that this chamber was the *chillahgah* or meditation room of a certain *pir* or saint who had adopted this crumbling Tughlaq period hunting lodge. One day, he disappeared mysteriously and since there was no body to dispose of, an artificial grave was constructed by his disciples with little heed for orientation. Hence the 'wrongly' oriented grave and the name by which this building came to be known for posterity. In 1830 or so William Fraser, Agent to the Governor General at Delhi, decided to build a house for himself on the Ridge, which reminded him of the hills of his native Scotland. A modern European-style double-storey building was built first by Edward Colebrooke and later modified by Fraser.

After Fraser was murdered on 22 March 1835, the house was bought by Hindu Rao, a wealthy Maratha nobleman and brother of Bija Bai, the wife of Maharaja Daulat Rao Scindia of Gwalior. First taken over as a military base by the British in 1857, it was converted into a hospital for the British soldiers, and after Independence became a government-run hospital.

On its grounds is a *baoli* built at the same time as Pir Ghaib but in a far more dilapidated state. It is sadly run over with vegetation and used as a dumping ground for hospital waste. There is said to be a tunnel that connects its northern wall with the hunting lodge. Also, there were once many drains attached to the *baoli* that supplied water to the Kushak-e-Shikar. All of these have disappeared.

Firoz Tughlaq had a third century B.C. Ashokan pillar brought from Meerut and installed close to his Kushak-e-Shikar. During the reign of Emperor Farrukhsiyar, it was thrown down and broken into five pieces by the explosion of a powder magazine. In 1838, it came into the possession of Hindu Rao who sent it to the Asiatic Society in Calcutta. It was eventually brought back to Delhi, pieced together and erected once more beside Firoz Tughlaq's hunting lodge on the Ridge. You can see it a little south of Hindu Rao Hospital on Rani Jhansi Road.

In 2007, when the country celebrated 150 years of India's First War of Independence, the cobwebs were removed from everything that had anything to do with the events of 1857. And so, the curtain of anonymity has momentarily lifted and Pir Ghaib finds itself thrust into the spotlight.

There is renewed interest not just in its potential to throw light on India's astronomical heritage but also in the part it played during the Siege of Delhi. From 11 May, when the sepoys trooped into Delhi from Meerut, the action gradually shifted from the Red Fort to strategic locations on the Ridge when the mutineering Indian sepoys and the citizens of Delhi engaged in combat with the Imperial forces.

The Siege of Delhi lasted from 30 May till 20 September and all through this period Pir Ghaib saw action—first as a stronghold of the Indians and after the tide turned in June as a bastion and vantage firing spot of the British.

Another reason why Pir Ghaib might step out of the shadows—and remain in public memory long after the 1857 brouhaha is over—is recent research conducted by scientists from the Nehru Planetarium. Apparently, the fourteenth century astronomers who designed this monument had sufficiently sophisticated knowledge to construct an early prototype of the Ram Yantra built by Sawai Jai Singh. A long cylindrical structure with a hole at the top may have been used as a Zenith Tube to view the highest point in the sky. The same tubular structure could also have been used to study the moon and the stars that crossed the highest point in Delhi's skies.

The tube is supported by two arches that let in fresh air and also allow hot air to escape. This cross-ventilation, considered a technological marvel for its age, allowed Delhi astrologers to observe a greater number of stars than the aperture of the hole would ordinarily have allowed. It is said that the observatory also housed a water clock and the accumulated errors of the water clock and the sundial could be rectified through the Zenith Tube when certain stars passed exactly overhead. This tube was perhaps the only device of its kind, 700 years ago, that could study the northward swing of the moon.

Witness to the siege and sack of Delhi.

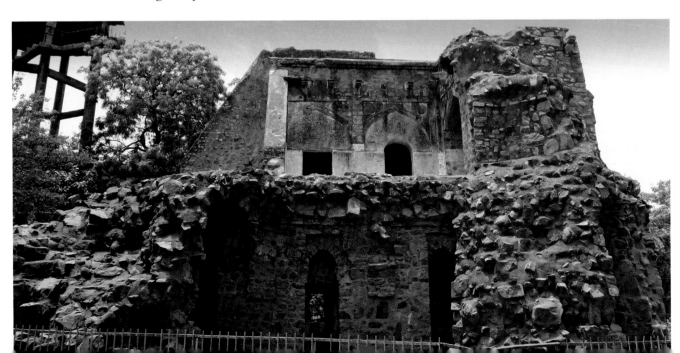

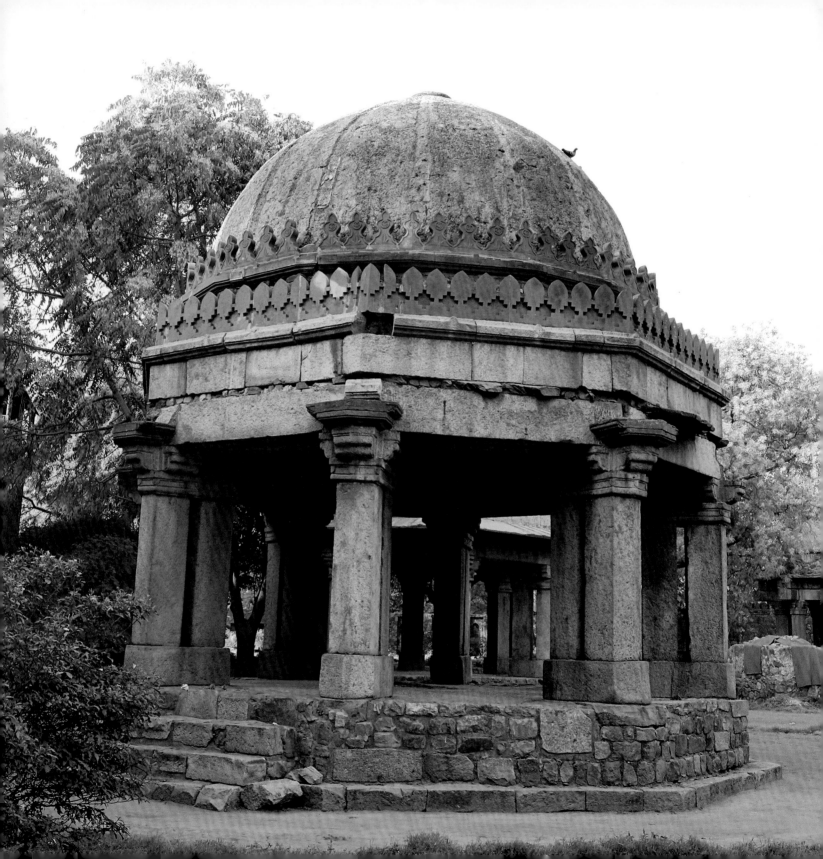

Firoz Shah Tughlaq's Tomb and Madarsa

A typically Hindu gateway inside the Islamic arch.

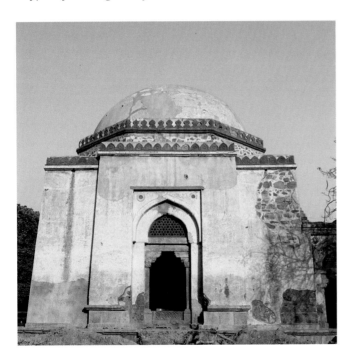

Firoz Shah, the son of a Hindu princess, came to the throne by default. Upon the death of his much-disliked cousin, Muhammad Bin Tughlaq, he became the Sultan of Delhi in 1351. He spent the first few years fighting battles in the distant corners of his empire. From 1354 onwards, till his death in 1388, he consolidated his empire and launched extensive and expensive construction activities. For his efforts, he earned for himself the moniker of Royal Archaeologist. It would not be an exaggeration to call him the patron saint of the Conservation Society of Delhi, for it was Firoz Shah who initiated some of the city's most laudable conservation and repair drives.

During those turbulent times, Firoz Shah's 37-year reign was a landmark of sorts. For one, it allowed this architecturally inclined Emperor to build and rebuild and repair to his heart's content. For another, it allowed ample time for the angularities of previous, hastily implemented architectural regimes to be ironed out. During Firoz Shah's reign, the Tughlaq style of architecture had the time and leisure to hone and perfect itself, shed some of its early stolidness and acquire a new elegance. While the tombs, mosques and pavilions built during Firoz Shah's reign are nowhere close to the refinement and symmetry of the Mughals, they have certainly lost the 'blockishness' of the Pathan style of architecture of a century ago. Ornamentation, muted and sparse

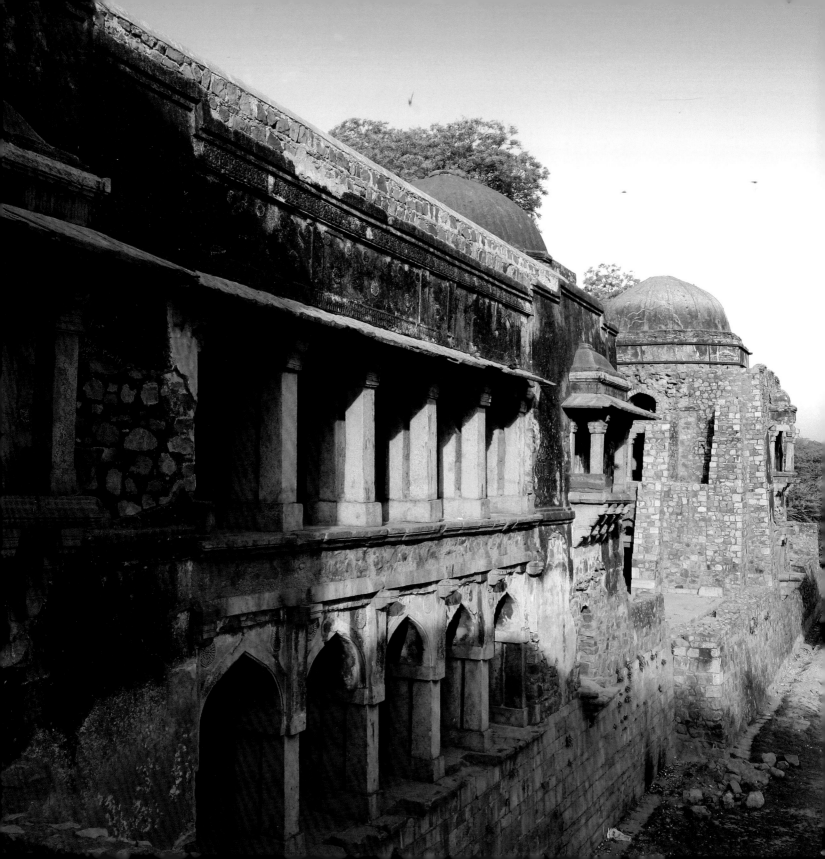

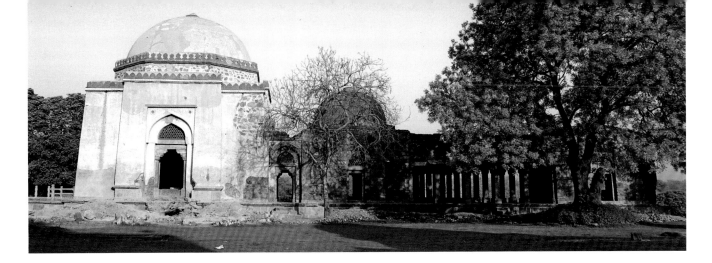

though it still was, had begun to make an appearance, softening the austere stone-built facades and bulky exterior walls. The sloping walls are still there, but increasingly they are studded with an oriel window here or a bit of intricate *jaali* there.

The tomb that Firoz Shah had built for himself is a perfect example of this architectural coming of age. It is interesting that Firoz Shah chose to be buried so far away from his beloved Kotla and the new city enshrined within its brand new barbicaned towers. Alauddin Khalji had excavated a large tank close to his city of Siri and had it called the Hauz-i-Alai. Roughly 50 years later, Firoz had it de-silted, *pucca* embankments constructed, renamed it the Hauz Khas or Royal Tank and built a *madarsa* on its fringes. He chose to have his tomb constructed during his lifetime at one end of an L-shaped cluster of buildings.

At the far end of the road from Aurobindo Marg, a handsome gateway brings you into an archaeological complex of great beauty. There are two other gateways, but they are not accessible due to fallen debris. You skirt various tombs and domed *chhatris* to reach Firoz Shah's tomb. Standing on a grey stone plinth, this square structure with sloping rubble-built walls and a lofty dome rises majestically above the other buildings. Its austere look is broken by a string-course of red sandstone and marble and carved battlements. The tomb is entered through a door on the south, past a courtyard enclosed by stone railings reminiscent of early Buddhist stupas.

A fine gateway shows the co-mingling of Hindu and Islamic styles—a Hindu gateway comprising lintels and supported by stone railings is placed inside a typical Islamic arch. The north and west walls have recesses with narrow arched openings giving access to the *madarsa*. Inside the tomb chamber there are four graves—the one in the

..

Stone railings in the foreground reminiscent of Buddhist stupas.

FACING PAGE: The Madarsa overlooking the tank.

centre is believed to be Firoz Shah's; the others being his two sons' and grandson's. The ceiling in the central chamber is decorated with incised plaster and Koranic inscriptions in Naskh characters and fine paintwork. The inscription over the southern

gateway was incised in 1507 during Sikandar Lodi's reign, when he undertook some repairs.

Scattered in the grounds of the tomb are graves, pillared *chhatri*s and miniature tombs of several worthy personalities from the Tughlaq period, notably Nasiruddin Mohammad Shah, Alauddin Sikandar Shah, Sultan Abu Said, principals and teachers from the *madarsa*.

Close by is the earliest surviving residential building that probably housed the principal of the school, Sayyid Yusuf, who died in 1388 and is buried in the courtyard of the *madarsa*. Attached to the *madarsa* is a mosque that was intended for use by the students and teachers. It has nine bays and arched

LEFT: Gateway to the Hauz Khas monuments.

BELOW: Domed chhatris are dotted about in the grounds of the Tomb.

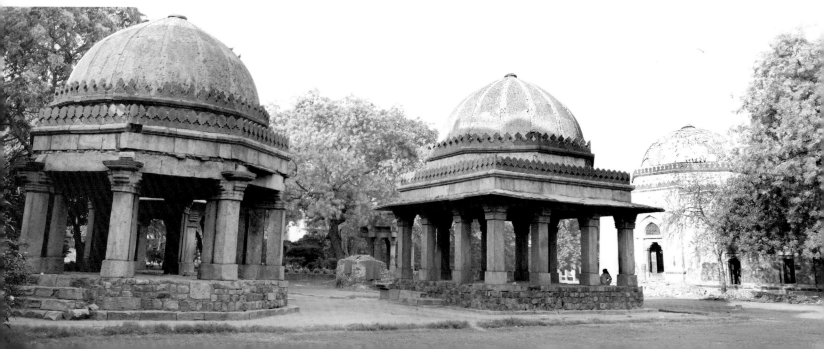

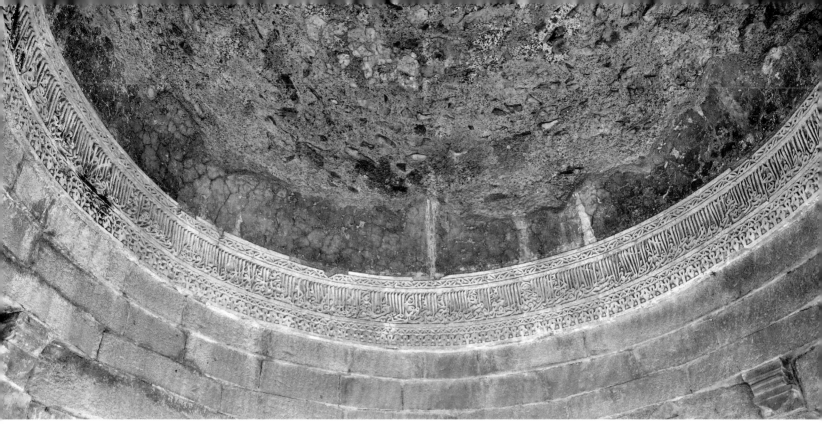

*dalan*s around a central courtyard. A flight of steps leads down to the tank, and another, in the southern *dalan*, leads up to the roof. Its distinctive features are the many *jharokha*s on the northern wall, a most unusual element in a mosque, which served not just a decorative function but must have provided both natural light and ventilation.

The *madarsa*, immediately to the north and west of Firoz Shah's tomb and bordering the tank, was in its time the largest school of its kind. It attracted students and teachers from far, its location beside the scenic tank making it a haven for the scholars of Islam. The lower storey has small cell-like rooms while the upper storey, comprising largely of

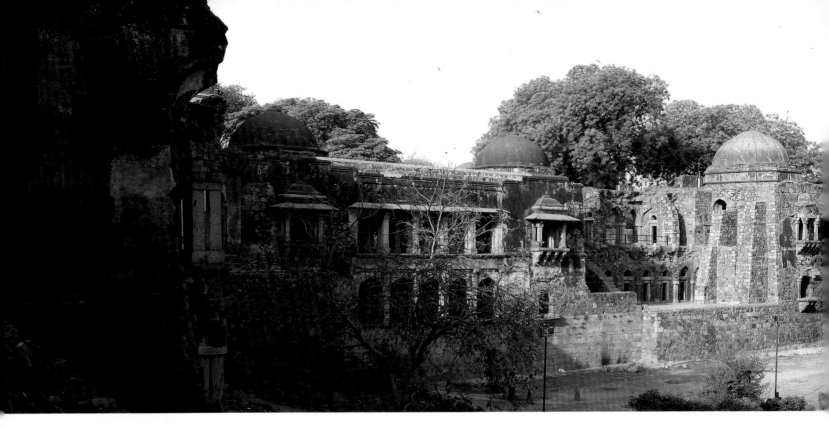

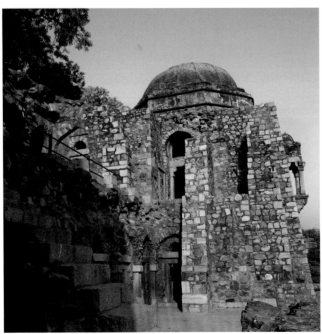

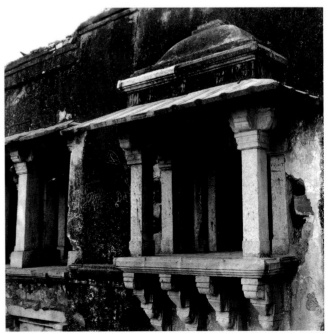

colonnades, is virtually a series of pillared halls, with alcoves in the walls for keeping books and other material. This served as a lecture hall.

Stone steps lead down to the tank. Timur, who camped close beside the tank before he laid siege to Delhi, observed, 'The Hauz Khas is so large that an arrow cannot be shot from one side to the other.' The area all around it has been developed and it has a rose garden and a walking track.

The *madarsa* was supported by the grant of rent-free lands. After Timur's invasion, many scholars fled or were killed; the lands were seized and the revenue dried up. It was not until several centuries later, till the time of Shah Jahan and Aurangzeb, that Delhi once again became the seat of learning it had been in medieval times. This *madarsa* at the bank of a great water-filled tank and landscaped gardens all around was an important university of its time where Arabic was studied, the Koran taught and theological debates held.

It was from *madarsa*s such as these that the *maulvi*s and *kazi*s of the empire came.

FACING PAGE:
ABOVE: A series of pillared halls on the first floor.

BELOW LEFT: Stone steps leading down to the tank.

BELOW RIGHT: Jharokhas jutting out of the first floor study halls.

PAGE 97:
ABOVE: Bands of Koranic verses on the inside of the dome.

BELOW: A typical Tughlaq period bracket.

A 'slice' of history.

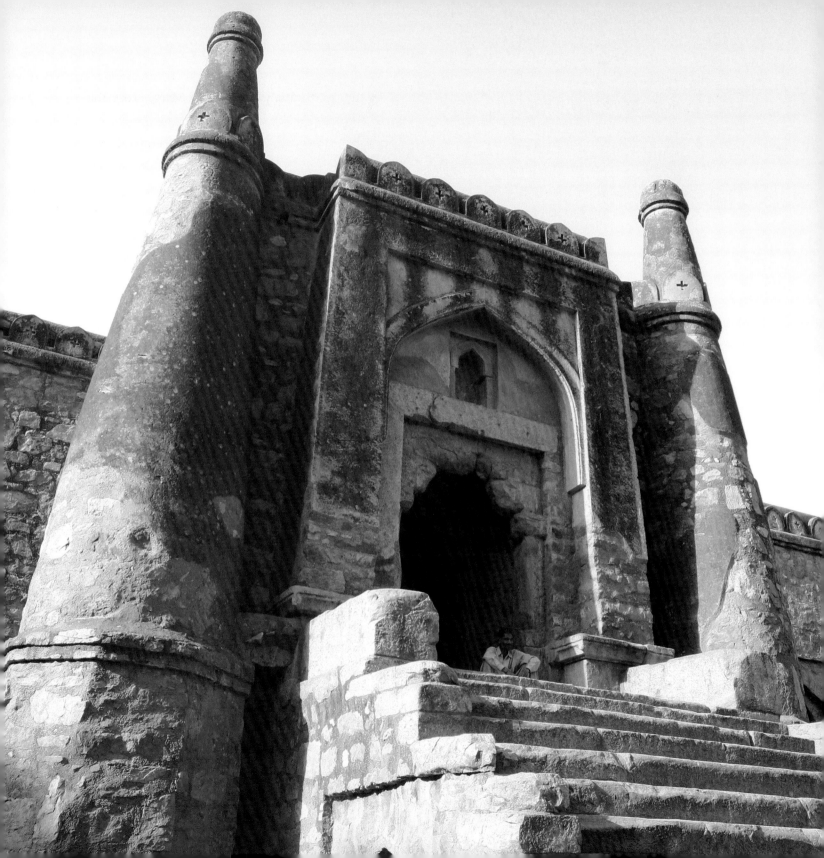

Khirki Village

D rive south along Aurobindo Marg, cross the Outer Ring Road at the IIT crossing and a little further down, take the left turn going towards Saket. Sections of the ruined wall of Siri can be seen along the road. Or, you can come from the Malviya Nagar side, take the road past Yusuf Qatal's tomb, park in the village of Khirki and make your way through twisting narrow lanes. All around there is evidence of rugged grandeur in the many buildings that pervade the landscape. Tombs, mosques, *chhatri*s and bits of broken walls and enclosures make this area one of the most historically vibrant, second in significance only to the Qutub complex.

The magnificent little mosque tucked away in the vicinity of Press Enclave is one of Delhi's better-

FACING PAGE: Massive arched gateway flanked with tapering pillars.

A vista of pillared arches.

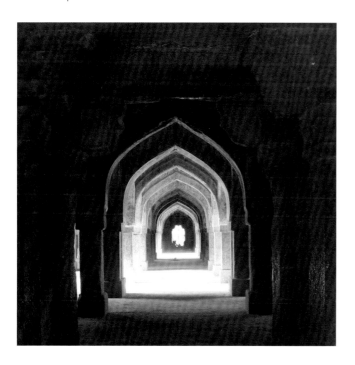

kept secrets. Crane your neck and maybe you can see the tops of its turrets peeping behind the houses of Khirki village. A tight ring of impossibly tall houses rising uncannily from narrow gullies makes it practically 'invisible'. Droves of people drive past this connecting road that feeds a gamut of housing colonies. Some might stop to buy bits of pottery and other knick-knacks from the potters of Khirki village who have put up stalls all along the main road, but few would bother to explore this intriguingly named building. The mosque and the village that came up around it during the reign of Firoz Shah Tughlaq are so named because of the numerous *khirkis* that pierce the north, south and east walls. The red sandstone grills covering the windows soften this otherwise

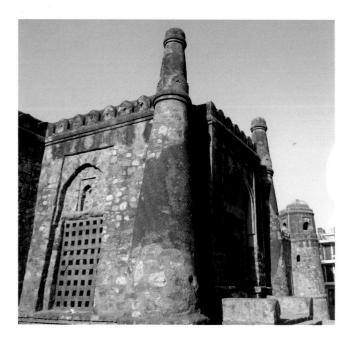

stern façade that looks more like a fortress than a conventional mosque. Perhaps that is why the locals refer to it as a *qila*. Ask for directions and you will get blank looks till someone figures that it is the *qila* you are looking for!

Of the five surviving mosques built by Junah Shah Telangani, the wazir of Firoz Shah Tughlaq, Khirki is certainly the most picturesque. You enter through a massive arched entrance flanked by tapering pillars and a formidable high wall all around. Sloping domed towers mark the four corners, adding to the citadel-like effect. The north, south and east sides have domed gateways jutting out from the main building, each topped with mini minarets. These minarets are little more than an embellishment at this stage in the development of the mosque. Conventional minarets seen in Mughal-style buildings were to make an appearance several centuries later. The eastern gateway, which is the main entrance, is seven-metre tall and has two staircases cut in the sidewalls leading to the roof.

As you enter, the overwhelming smell of rotting garbage and stale bat droppings takes your breath away. This takes some getting used to, but once you have recovered, the play of light and shade inside

Sloping domed towers on the four corners.

PAGE 101 RIGHT: Red sandstone grills covering the windows.

this partially covered and partially open courtyard is spectacular. Instead of a *sehan* that one sees in most congregational mosques, here are four arched arcades in a cross formation with domes on top, leaving four small open quadrangles. Slanting beams of sunlight create a wonderfully dappled effect in this maze of arches. Open quadrangles alternate with covered arches to create a checkerboard of darkness and light, space and enclosure, earth and sky. A vista of pillared arches stretches in every direction. The larger squares and those in the centre are covered by a cluster of small, low domes (85 in all)—reminiscent of the Begumpuri mosque. Some of the domes on the northeastern side have collapsed like broken eggshells but the rest of the building is intact. The pilaster covering the interior is all gone, making it a dark, dank, somewhat forbidding place. The only air and light inside the building is from the numerous *khirki*s and the four open quadrangles. There are just two instances of partly covered mosques in northern India—this one at Khirki village and the Kali Masjid at Nizamuddin.

All mosques built in the Tughlaq period have a certain ruggedness and severity; this one particularly so. The sloping walls, a certain massiveness of construction, the rough-hewn stone pillars—all are

An endless play of light and shade.

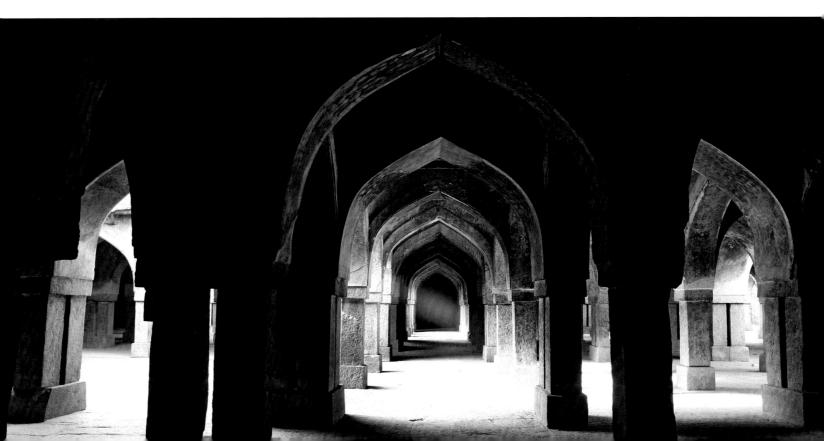

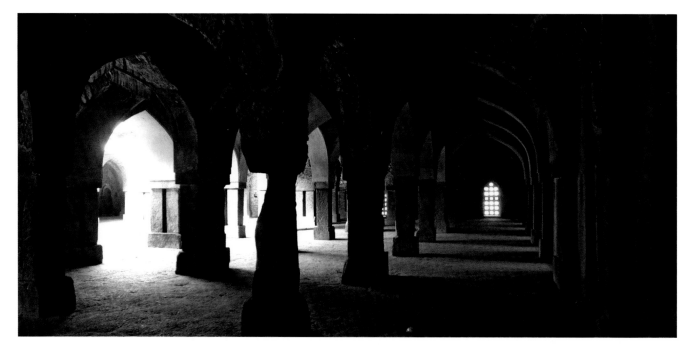

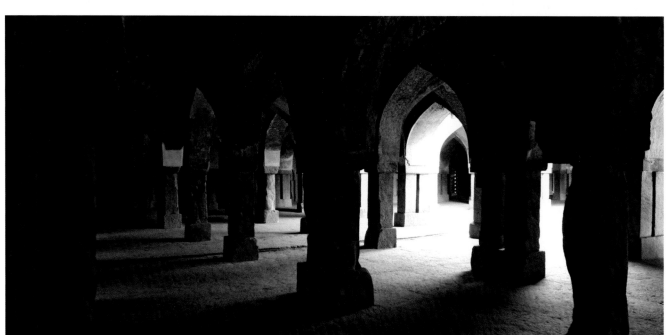

typical Tughlaq features. Where this one differs is in the distinctive window openings and its height. Taller than most mosques of this period, Khirki mosque has been quite ingeniously built on a *tahkhana* of over a hundred vaulted cells. The lower storey is a quadrangle of vaulted arches on top of which the mosque has been raised.

If you can walk diagonally across the village, taking the road that leads to Malviya Nagar, you will come across a striking red sandstone building standing in a desolate park. This is the tomb of Shaikh Yusuf Qatal, the disciple of Qazi Jalaluddin of Lahore. The tomb, built sometime after 1527, is a 12-pillared *chattri*. The spaces between the pillars are fitted with intricate *jaali* screens, giving the building an ethereal beauty. A red sandstone parapet with *kangura* design runs all along the top of the screens. The drum of the dome has the remains of some spectacular blue glazed tiles. When all the tiles were in place, the effect against the red sandstone must have been indeed very striking.

Ruins of other buildings dot the nondescript park and all around there are the usual signs of suburbia. In a nook of Khirki village, facing B and M blocks of Malviya Nagar, is the domed tomb of Shaikh Usman Saiyah, a contemporary of Roshan Chiragh Dilli. He acquired the name Saiyah (traveller) since he was fond of travelling to distant places. Interestingly, he came to Delhi to die and today he lies buried in this dilapidated obscure tomb that no one ever seems to visit.

One has come to accept a certain amount of looking the other way where building bylaws are concerned in urban villages or *Lal Dora* areas. Most of the lesser-known monuments that fall within these areas, though protected equally by the law, are in varying stages of neglect and ruin. In theory these are protected monuments, yet they are anything but protected from vandalism, neglect and encroachment.

Facing page:
Above: A checkerboard of darkness and light.

Below: Slanting beams of sunlight create a wonderfully dappled effect.

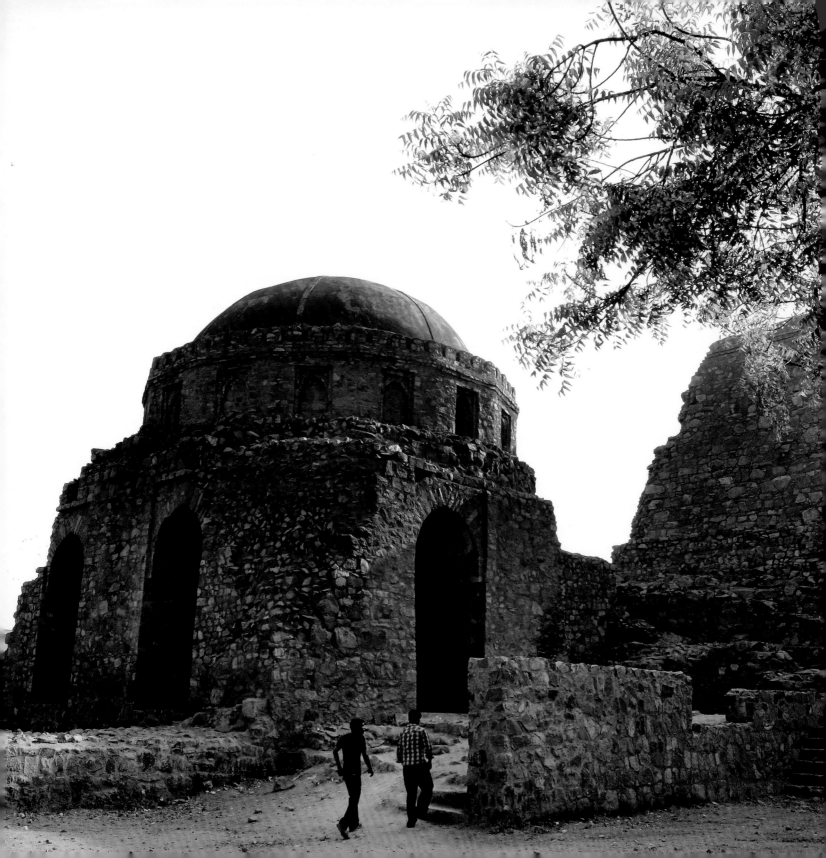

Begumpuri Mosque and Vijay Mandal

FACING PAGE: Domed building near Vijay Mandal.

A flight of steps leading up to the eastern gateway of Begumpuri Masjid.

Standing in the courtyard of the Begumpuri mosque, you feel disoriented. The silence and stillness here is immense. It is hard to tell that you are a stone's throw from the warren of Delhi Development Authority (DDA) flats and the typical South Delhi neighbourhood of Sarvodaya Enclave, the avant-garde Mother's International School and the prestigious Indian Institute of Technology. Its namesake village hides it so completely from view, making it so effectively invisible, that all you see from the dusty potholed track that leads up to it are the ubiquitous Xerox/Fax/PCO booths, the sundry small offices, shops, garages, old-fashioned *halwai* shops with the owner himself sitting beside a huge cauldron and tiered rows of sticky, impossibly colourful sweets, itinerant roadside tailors, cobblers, key-makers and ragtag others plying their trade. Like most urban villages in Delhi, Begumpuri is built in several concentric circles. As you pierce through each one to reach its heart, in this case the mosque, you can still catch glimpses of village life encircled and hemmed in, though it is in a tight loop of modernity.

There are no road signs leading up to the Begumpuri mosque. You need to stop and ask for directions several times. You are usually met with a shrug or: 'Which mosque? There are so many old buildings around here ...' till you narrow your search to the village. That is easier. People

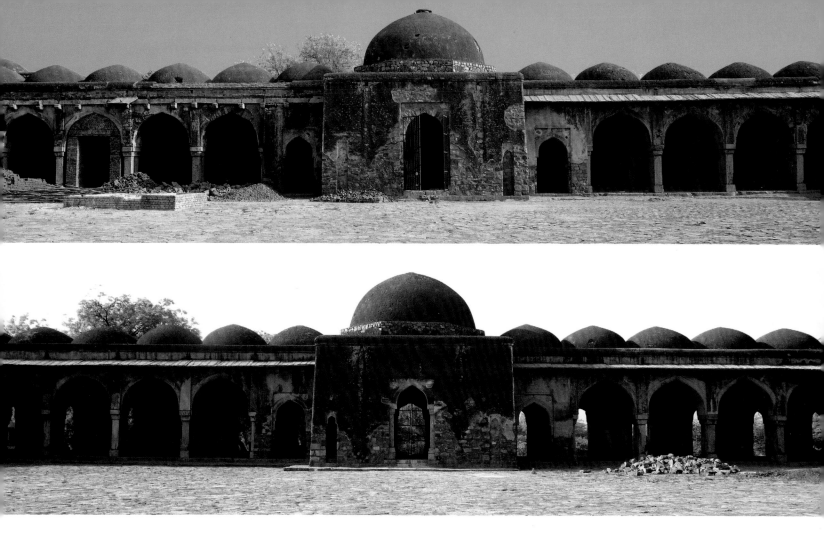

Arched verandahs topped by twin rows of egg-shaped domes.

ABOVE: An echoing desolation.

keep pointing. The track keeps getting narrower. People's dress sense changes imperceptibly. You begin to see more dhoti-clad men and women with *ghunghat*. Here, when you ask for directions to the mosque, not only do they know the way, they are eager to walk beside you and take you along. The blackened walls loom just ahead. You round a corner, climb a flight of steps to enter through an iron gate and a huge eastern gateway that transports you into another world.

The Begumpuri mosque, as it stands today in its vast echoing desolation, is a mute testament to the might of evangelist Islam, to the passage of time and the ravages it can wreak even on the mightiest and grandest. It was built in 1387 by Khan-e Jahan Telangani, Prime Minister of Firoz Shah Tughlaq, who is said to have built seven mosques in Delhi of a similar type such as the nearby Kalan Masjid, Khirki mosque and Kali Masjid. By virtue of its immense courtyard and spacious corridors, the mosque at Begumpuri served as a congregational mosque, or Jama Masjid, for the newly built city of Jahanpanah. The good days of Firoz Shah Tughlaq's reign were the last that Delhi was to know for a very long time. This lull before the storm of Mongol invasions saw relative prosperity and the construction of several mosques.

Unlike the smaller and prettier mosques that were built around then, such as the Khirki mosque, the Begumpuri mosque is built in the severest no-frills Tughlaq style with no ornamentation and very little use of coloured stone or marble. Two rows of egg-shaped cupolas create a ripple-like effect along its austere plaster-coated walls. The western wall has a huge vaulting arch, its surface blackened with age but impressive nonetheless for its sheer size, its near-colossal massiveness. On either side of this arch stand sturdy tapering minarets, again shorn of all ornamentation and black with age like everything else here. Two craters, like gouged-out eyes, betray that perhaps once there might have been a flower-like emblem embedded in this blackened façade. All around the huge central courtyard run arched verandahs, topped again by the twin rows of egg-shaped domes and supported by rectangular blocks of grey ashlar stone. The southern roof has collapsed in several places, the domes have cracked to reveal the rubble and mortar beneath, and the calligraphy that once adorned the insides of the vaults is gone. Crude brick walls have been put up to prop the domes and the scaffolding is in place to stop the roof from coming down altogether. Sacks of cement lie

Light at the end of an arched colonnade.

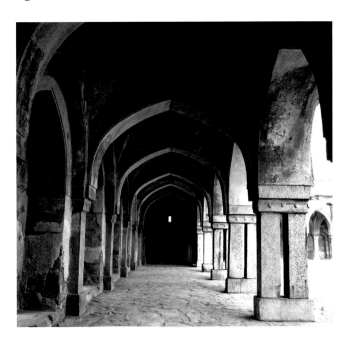

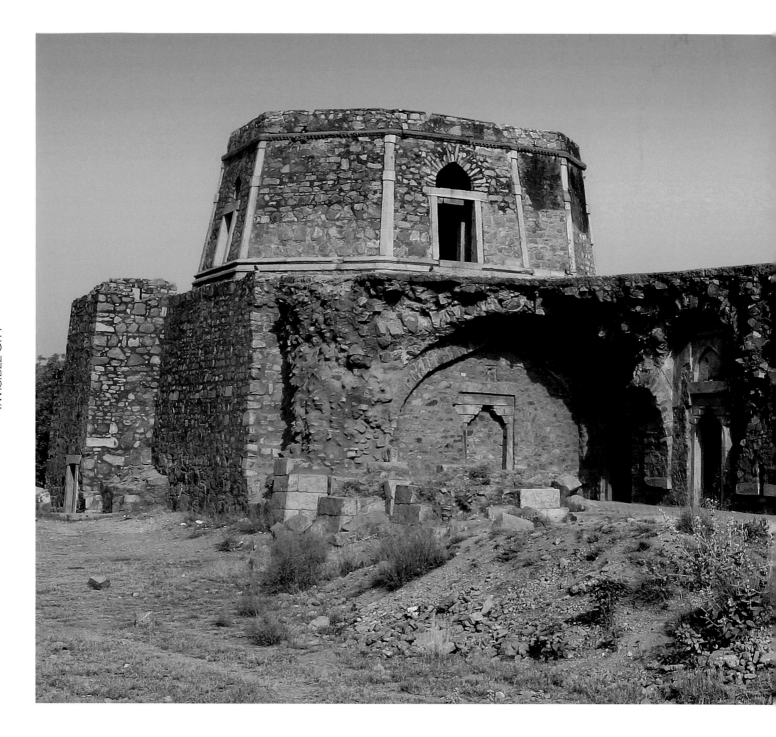

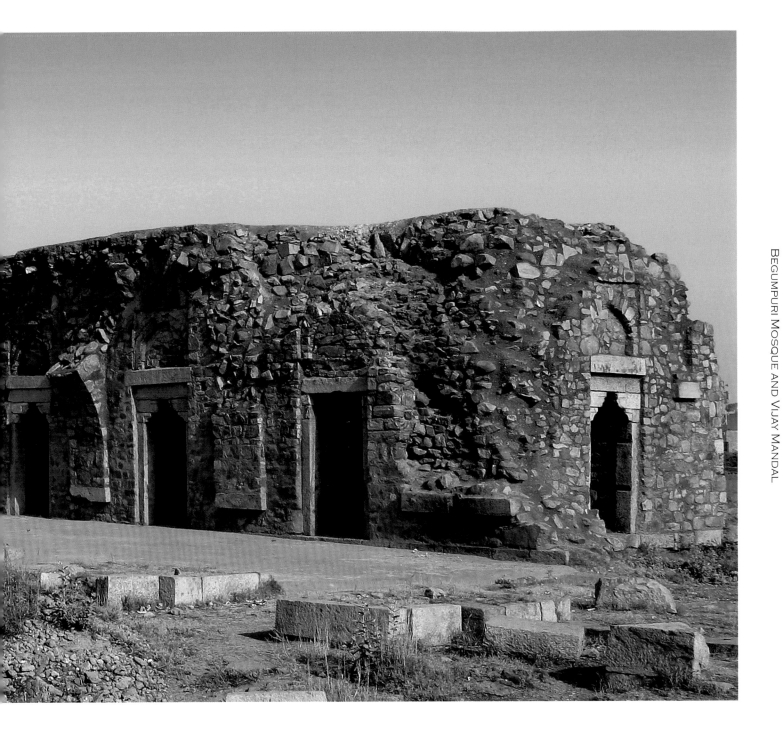

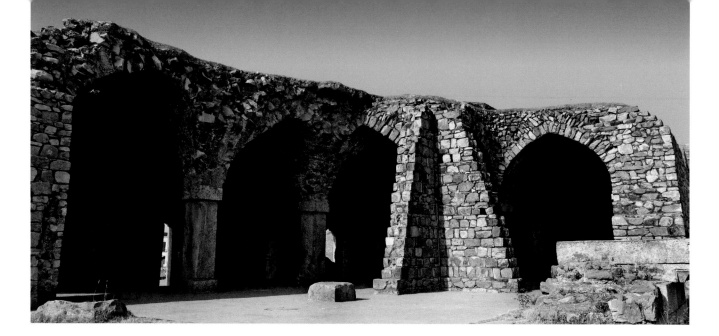

in one of the enclosures. Work was stopped a long time ago. The contractors were sent somewhere else, possibly somewhere more visible than the Begumpuri mosque.

Perhaps one reason for the decay and degradation in this mosque, more so than others, is because it was occupied by villagers from the neighbouring areas. They simply left their homes and moved in! Till the turn of the last century every time there was threat from looters or dacoits, the villagers were prone to move into the nearest stone enclosure where they felt more secure. The Archaelogical Survey of India (ASI) finally moved them out in the early 1900s and gave them land to build their homes. Maybe, when they moved out, they walked away with bits and pieces of this venerable old monument. Which explains why you see bits of carved stone, slabs of ancient marble and pieces of masonry scattered all over the village.

In an *atta chakki* just across the mosque, there are three carved pieces, nearly equal-sized fragments from a column, placed in a row to serve as stools for waiting customers. Further down the road you will see them all over—beside someone's front door, near the *kabadi-wallah*'s den, even serving as a workstation for the *press-wallah*.

According to an ASI-appointed chowkidar, not even the bravest lad in the village would dare to step inside the mosque after dark. There is no electricity here and the bustling city seems very far away after sunset. The pillars, the shaded verandahs, the recesses in the walls, the arches and the nooks, according to the watchman, become distinctly

ABOVE: Remains of the Khanqah.

PAGES 110-111: Vijay Mandal—the Tower of Victory.

spooky in the dark. You leave the Begumpuri mosque to its sombre stillness and walk a few yards to the Vijay Mandal, also spelt as Bijai Mandal. It is interesting that something that was called 'lofty' in contemporary chronicles appears so small now. The usual clutter and encroachments have swallowed all the empty space, so that now the octagonal tower and its adjacent chamber seem to have shrunk into a tight little ball.

An unusual rubble-built octagonal structure atop a high platform with grassy slopes on three sides and stone-cut steps on the fourth, this is a most intriguing building. Once part of the fabled Hazaar Sutoon, or Hall with a Thousand Pillars in the city of Jahanpanah, the Vijay Mandal served as a platform for the Sultan to view his troops or grant public audiences.

It was also the highest point in the city of Jahanpanah, a sort of personal watchtower for the Sultan to watch over his beloved newly built city. The Diwan-i-Khas or Hall of Private Audience was in the chamber abutting the tower. The grassy slope that leads up to the Vijay Mandal was to enable the royal elephants to bring the Sultan up to his chambers.

Close to this are the remains of rooms that were once royal private apartments. During the Lodi times, they were used as a residence by Sheikh Hasan Tahir, a prominent religious figure during the reign of Sikandar Lodi. A *khanqah* built during the Lodi period has a long *dalan* and side chambers on the east and west. Two stone vaults once contained the royal treasure chambers. A little further away, a row of holes at regular distances are all that remain of the Hall with a Thousand Pillars—the pillars being made of wood are long gone. A graveyard has come up in its place, removing all evidence of Muhammad Bin Tughlaq's fine palace. The Vijay Mandal, the Tower of Victory, is all that remains.

Part of a support column at Vijay Mandal.

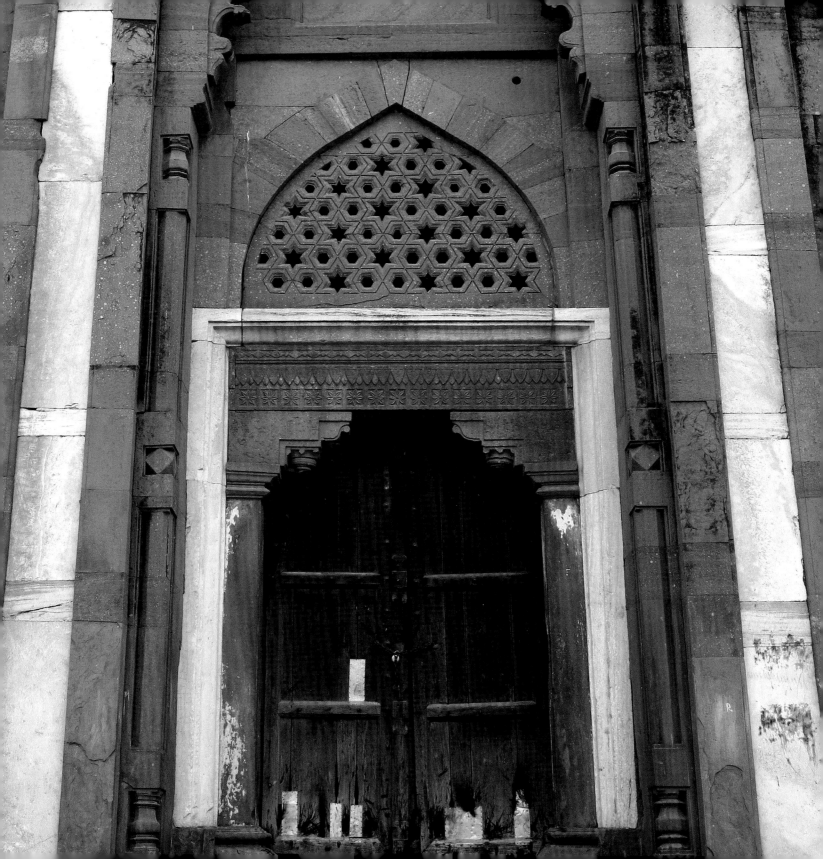

Lal Gumbad and Madarsa Zeenatul

..

FACING PAGE: The great wooden door embedded in the eastern gateway of Lal Gumbad.

Lal Gumbad—a conical dome springing from a low octagonal drum makes it strikingly different.

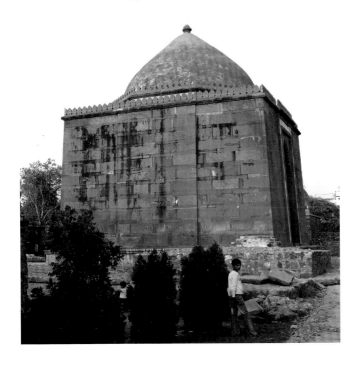

Head east along Outer Ring Road and turn right after the Khel Gaon Marg T-junction. As you drive on the road leading towards Malviya Nagar, you will come upon a rather severely elegant building occupying a curve of the road. It stands in its own grounds, aloof from the clutter of its surroundings, occupying an island of grandeur among the hustle and bustle. Here the road bifurcates into two, one going towards the Malviya Nagar Market and the other to Savitri Nagar and Sheikh Sarai.

Time has a way of effacing history, throwing away bits and pieces that no longer enamour or interest, retaining only those parts that have a meaning and relevance to our lives. It is also interesting how monuments 'acquire' names, names that are often not even accurate. The Lal Gumbad, for instance, does not have a red dome as its name implies. There is certainly a most uniquely fashioned, somewhat pointed dome atop a sturdy building with sloping red sandstone walls, but the dome itself that was once white has turned black with age. The sloping walls and the squarish box-like appearance are more like a mini fortress than a tomb, and the single not-quite-round dome is reminiscent of Ghiyasuddin Tughlaq's tomb in appearance.

While the latter is a perfectly appropriate resting place for a warrior king, the Lal Gumbad purported to contain the grave of a Sufi saint called Kabiruddin Auliya seems an unlikely resting place for a saint of

the Chisti *silsila*. The Sufis, known for their piety and love for simplicity, never had tombs built over their graves, certainly nothing as grand as this edifice of marble and red sandstone. All the other *dargah*s of the Chisti saints have modest enclosures, usually open from the sides, and the buildings, such as the ones at Bakhtiyar Kaki, Nizamuddin Auliya and even the nearby Roshan Chiragh Dilli, came up much later. The Sufis of the Chisti *silsila* were usually buried in the ground in an open area on which later *chhatri*s were added, and other motley graves, wall mosques and the like came up over a period of time. Also, much money has been spent on constructing the Lal Gumbad—on the red sandstone, the lotus bud motifs on the arches, the marble bands, pierced *jaali* screens and, according to local lore, the gold finial atop the dome now long gone. Yet there is a plaque inside the tomb that ascribes it to Kabiruddin Auliya, a disciple of the great Roshan Chiragh Dilli. So, the Lal Gumbad is a bit of a mystery wrapped in an enigma.

Built in 1397, this is in many ways a typical example of Tughlaq architecture. Standing on a raised plinth, its outer walls are faced with red sandstone and have a distinct slope. The four sturdy walls turn slightly inwards as they go up but are perfectly straight from the inside. The Tughlaqs built the base of their walls thicker than the top, perhaps making it easier for them to balance the single domes that sat atop their squat buildings. The domes, at this point, were still at a fairly experimental stage and lacked the grace and proportion of the Mughals but they were one step ahead of the rows of small egg-shaped domes such as the ones you can see at the Begumpuri mosque.

The conical dome springing from a low octagonal drum makes the Lal Gumbad strikingly different from the other domed tombs of the Tughlaq period that you see all over South Delhi in such abundance. The Lal Gumbad once had an

Massive sandstone walls showing a distinct slope.

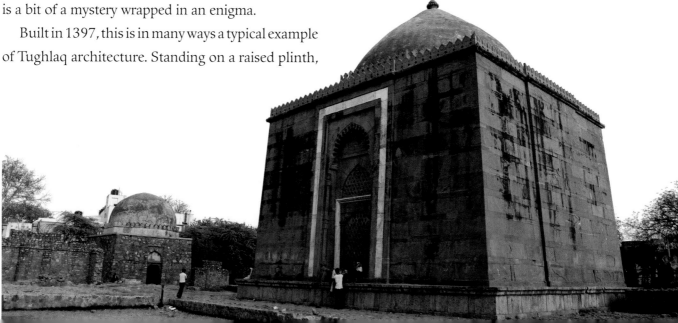

elaborate domed gateway that led into the tomb enclosure from the east. The enclosure walls have all but disappeared; instead there is a fence put up by the ASI on two sides. Encroachments have caused the domed eastern gateway to be in a far more dilapidated condition than the Lal Gumbad itself; its floor is completely eroded and the building is in dire need of repair. Once inside the enclosure, you will find several scattered graves and remains of wall mosques, all belonging to the Lodi period. Overgrown with weeds and grass, open to the sun and rain, their sturdy construction allows them to remain upright. Some of the wall mosques were probably erected along with the graves in their immediate vicinity. Nothing is known of these, except the surmise that these people chose to be buried in proximity to Kabiruddin Auliya.

There are *mihrab*s fitted with ornate red sandstone *jaali*s on the north and south walls of the tomb. The west wall is without ornamentation on the outside, but the inside has a deeply recessed arch. Lotus bud motifs in marble embellish the arches and below them are false decorative pillars. As you enter the tomb enclosure from the elaborately carved and embellished eastern archway, you enter a hushed, somewhat dark, funerary chamber occupied by a large number of graves that seem to have come up at different times. Of these, one grave is more modest—a male grave in the centre with a *qalamdan* and *takhti*, presumably of the saint for whom the tomb was constructed. There is more marble inside and the lotus bud motif, an innovation of the Khalji period, spills over from the archways outside. The great pity, however, is that someone allowed lime mortar to be stored inside, thus ruining the floor and walls.

The great wooden door on the east ought to be kept open longer during daylight hours to avoid dampness. Thieves are said to have made away with the gold finial that once adorned the dome. It is believed that they fixed *rakab*s on its western walls and scaled up the sloping walls. For this reason, some people also refer to the Lal Gumbad as the Rakabwallah Gumbad.

Not far from the Lal Gumbad, the areas around Panchsheel Enclave, Soami Nagar and Malviya Nagar are profusely speckled with monuments in various stages of neglect. Not much is known of them or the circumstances in which they were

RIGHT: A close-up of a supporting column carved in the wall on either side of the entrance.

LEFT: Kangura pattern.

built. For instance, not many know that Delhi was once a great seat of learning and its rulers, regardless of dynasty, were usually generous patrons. Scholars were rewarded with pensions, royal gifts and charters. *Madaris* were supported by the grant of rent-free lands known as *madad-e-maash*. Arabic, the Koran and Islamic theology, law and philosophy were taught.

There are, of course, the remains of the grand seminary built by Firoz Shah Tughlaq at Hauz Khas but there are also the ruins of several smaller, lesser-known *madaris* scattered among the tombs and pavilions that you see all over Delhi. One of these is the Madarsa Zeenatul, north of Soami Nagar. As you come in from the Outer Ring Road, from the Khel Gaon Marg side, turn left from the traffic light and take the curving road as it loops around Soami Nagar. You will find the Madarsa adjacent to the nullah that runs along one end of Soami Nagar, standing beside a desolate overgrown park and close to a small cremation ground.

From the outside it looks like a typical Lodi-period mosque with a turreted western façade. Made of random rubble masonry, it has been extensively re-modelled from inside, to keep it from falling down and also to keep it 'alive'. Some 30 students,

ABOVE: The words of God inscribed in stone.

All that remains.

young boys of different ages, live and study here. Inside, a stunning red sandstone *chhatri* stands in stark contrast to the rather makeshift renovations all around. A crude staircase blocks its view.

The sonorous chanting of young voices learning the Koran wafts peacefully. Gone are the days of royal patronage, grants and pensions. The Madarsa Zeenatul struggles to uphold the tradition of learning and imparting education.

...

RIGHT: Life dominates death and ruins.

Scattered graves in the compound.

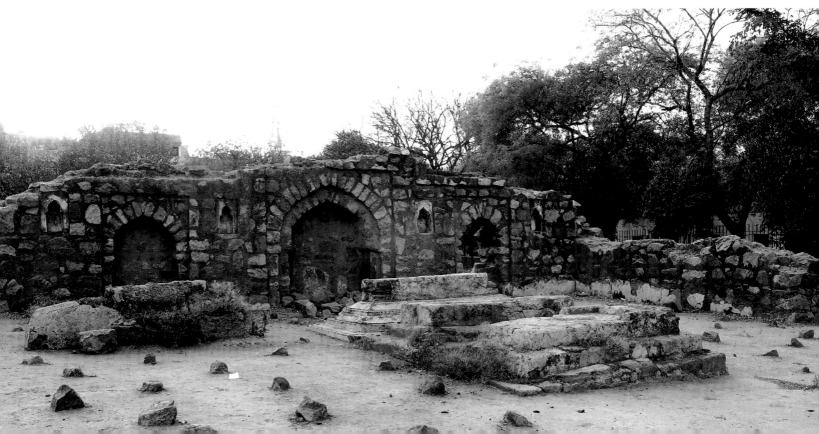

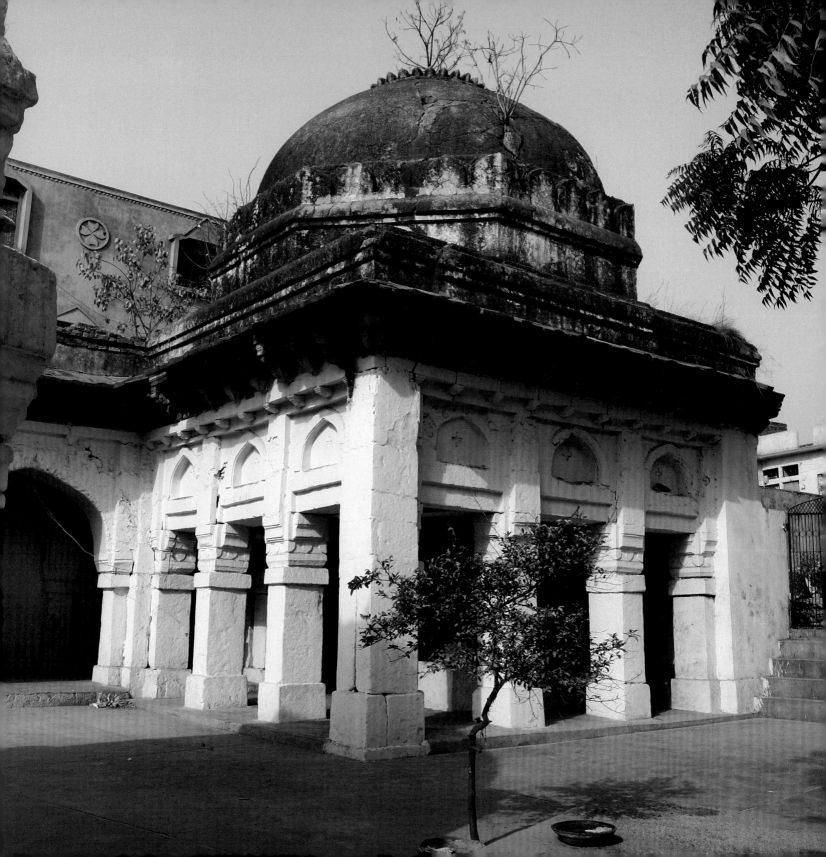

Chiragh Dilli and Bahlol Lodi's Tomb

Framed piety.

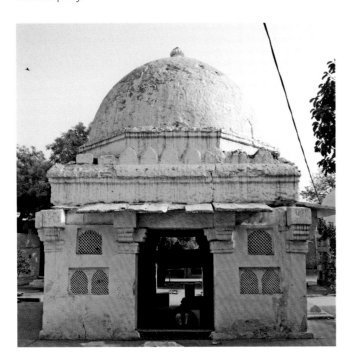

Sometime in the fourteenth century, a humble settlement sprang up beside a nullah that flowed through the sluice gates at the Satpula into the city of Jahanpanah. This was the abode of Sheikh Nasiruddin Mahmud, better known as Roshan Chiragh Dilli or the Bright Lamp of Delhi. He chose to be buried in the room in which he had lived. And with him were buried all that he cherished most in life—the cloak, the staff, the cup and the prayer carpet bequeathed by his Master, the great Hazrat Nizamuddin Auliya.

Some say it was his self-denying life and pure religious zeal that earned him the epithet by which he lived. Others ascribe many miracles and apocryphal stories to this much-loved patron-saint of Delhi who headed the Chistiya *silsila* after Hazrat Nizamuddin Auliya. Chiragh Dilli appears a typical South Delhi urban village. Along the periphery there are the DDA housing societies. You pierce those and come to a formidable array of timber shops, electric repair shops and motley commercial establishments. Dive into any of the openings between the seemingly impenetrable façade of shops that display all the accoutrements of urban India. A network of ever-narrowing lanes, winding and snaking, twisting and turning, will take you deep into a sub-culture far removed from the twenty-first century.

Garishly printed nylon saris and synthetic frilled and buckramed children's dresses flutter over shop

doorways. An itinerant bangle seller goes from house to house with glittering glass bangles looped over his shoulders. Open drains run beside narrow lanes, occasionally spilling over. With every twist in the gully, past crumbling monuments, scattered tombs, ruined arches, canopies and fragments of battlemented walls, you reach the heart of this urban village. In a clearing stands the *dargah* of Chiragh Dilli and peeping over its shoulder, the tomb of Bahlol Lodi, the founder of the Lodi dynasty.

Peace and quiet reign over this green-domed *dargah*. There is none of the hustle and bustle of Nizamuddin, certainly none of the commercialisation and 'token' system for feeding the poor that so distract the visitor at most big *dargahs*. In fact, there are no beggars here. No one pesters you to buy flowers or joss sticks as offerings, though you may do so if you wish from the row of shops at the entrance. Take off your shoes at the cool, high arched gate and you are on your own. No one 'offers' to show you around as it inevitably happens in most shrines. There are no *qalandars*, dervishes or qawwals as you would find in the *dargah* at Nizamuddin. Nor is there the cacophony and rose-scented claustrophobia.

You enter a large open courtyard with a massive tree growing close beside the entrance and several scattered graves, some surmounted by *chhatris* and a ring of buildings and residential quarters. In the middle stands the *rauza*. It consists of a 12-pillared square chamber with pierced *jaali* screens. Much of the original structure built in the fourteenth century has been changed, including the *chajja*, columns, floor, roof and *jaalis*, giving it a surprisingly more recent appearance. The grave chamber is surmounted by a plastered green painted dome rising from an octagonal drum with small turrets at the four corners of the roof. A golden bowl hangs from the soffit of the dome, just above the grave. Incongruous symbols of modernity are the fairy lights that twinkle inside the sanctum and a large wall clock. Women

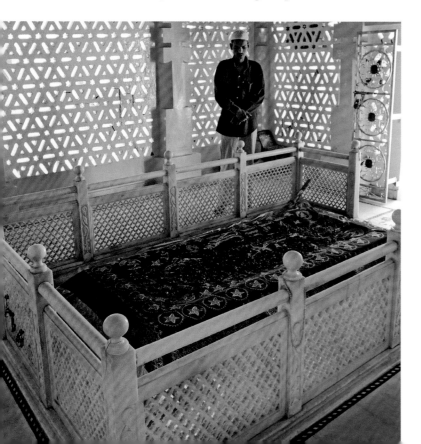

The grave of Roshan Chiragh Dilli—the bright lamp that remains lit.

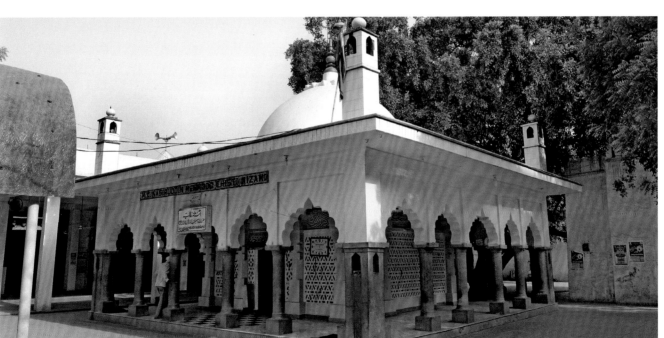

seeking the saint's blessings, especially those praying for a child, tie bits of thread to the *jaali* around the enclosure. These serve both as a reminder and a pledge. A wooden cot, said to be 700 years old and made from special wood bought from Bengal, is housed in a small fenced-in enclosure. Legend has it that the saint prayed on this very cot.

The site has been continuously venerated, renovated and built upon from the time of the great Sufi saint. Several mosques were built over the years in and around the *dargah* complex, including one built by Farukhsiyar. This Mughal-style mosque with three bays was built in 1713-19 and has been inexplicably whitewashed like everything else inside the complex. There are also several tombs belonging to the Lodi period including that of Sheikh Zainuddin and the granddaughter of Sheikh Farid Ganj-e-Shakar, illustrating what a great honour it was to be buried beside the saint. A single-domed rubble masonry tomb at the southeast corner of the complex has been encroached upon from three sides. Modern-day multi-storeyed houses have been constructed, belonging probably to the caretakers' extended families. A Majlis Khana has been partly walled up and converted into a residence.

Random rubble masonry boundary walls were erected in the Tughlaq period shortly after the *dargah* came up. No signs of these walls remain today as they seem to have been 'integrated' into the walls of shops and houses that ring the *dargah*. Emperor Mohammad Shah Rangeela (1719-48) had an outer enclosure erected with four imposing gateways. These survived till the 1950s. Sadly, except for a ruined *chhatri* or two, a few broken fragments of these battlemented walls and the southern gateway, nothing survives.

The northern gateway built of Lahori bricks is in ruins. Its western pier has been altered for residential purposes while the eastern one has shops and stores. The eastern gateway has its plaster peeled off, its brickwork gaping. It bears an inscription stating it was erected by Firoz Shah Tughlaq. Apparently this was renovated and included in the four-gated outer wall built by Mohammad Shah Rangeela. The western gateway is completely encroached. A printing workshop runs in the nearby tomb of Haji Khanam of whom nothing is known save her name. A turret juts out from the warren of closely built houses, probably part of the enclosure wall of Haji Khanam's tomb. A late Mughal-period Jain temple near house No. 341 speaks of a syncretic culture, now dying, as does the Hanuman Mandir just outside the eastern gateway.

..

PAGE 123:

ABOVE: The tomb of Shaikh Zainuddin.

BELOW: The rauza of the Sufi master.

Once a domed *chhatri*, it was part of a Lodi-period tomb; over the years it has been much altered, the spaces between the *chhatri* filled in to take its present avatar as a temple. All around there are tombs and monuments of unknown vintage being used either as residences or 'integrated' into homes.

On the western side of the *dargah* complex is the small but exquisite tomb of Bahlol Lodi. This pitifully neglected and completely hemmed-in structure is a far cry from the Lodi Garden where Bahlol Lodi's sons and successors lie in regal splendour. Bahlol Lodi ruled from 1451-88 and founded a dynasty that has left its mark on Delhi through the many buildings that survive. It seems a shame that his own tomb is in such a sorry state. Built by his son, Sikandar Lodi, it was once surrounded by a garden, of which no signs remain.

A rather fine gateway with traces of corbelling and moulding stands nearby, but it is completely encroached upon.

Bahlol Lodi's tomb has a cluster of five domes, the central one being fluted and higher than the others. The north, south and east facades have three archways shielded by protruding *chhajja*s, while the west wall has only two archways flanking the central *mihrab*. Niches above the *chhajja*s and incised plaster medallions are the only outer decorations. A family of squatters has free run of the place.

Sheikh Nasiruddin was the fifth in a line of the Chisti saints. With his death, not only did the Chisti *silsila* come to an end but the focus of power shifted in Delhi—from the saint's hospice to whoever

...
Graves of the unknown are found all over the dargah complex.

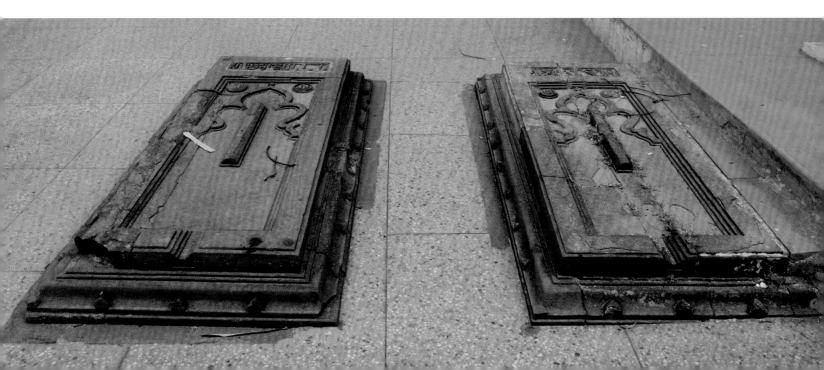

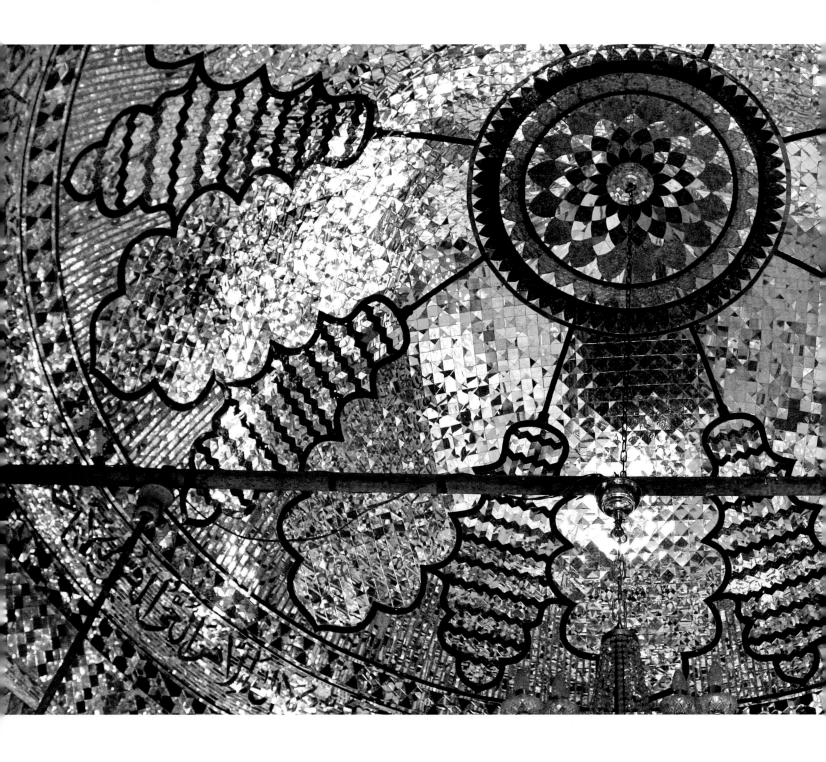

happened to be the current ruler. All five of the Chisti saints wielded considerable power in their times. They provided effective checks and balances against the temporal powers and the common man looked upon them as the alternate means of redress.

With Sheikh Nasiruddin's death in 1356, this 'Lamp' was extinguished forever.

The dome atop the funeral chamber has elaborate mirror work embellishment.

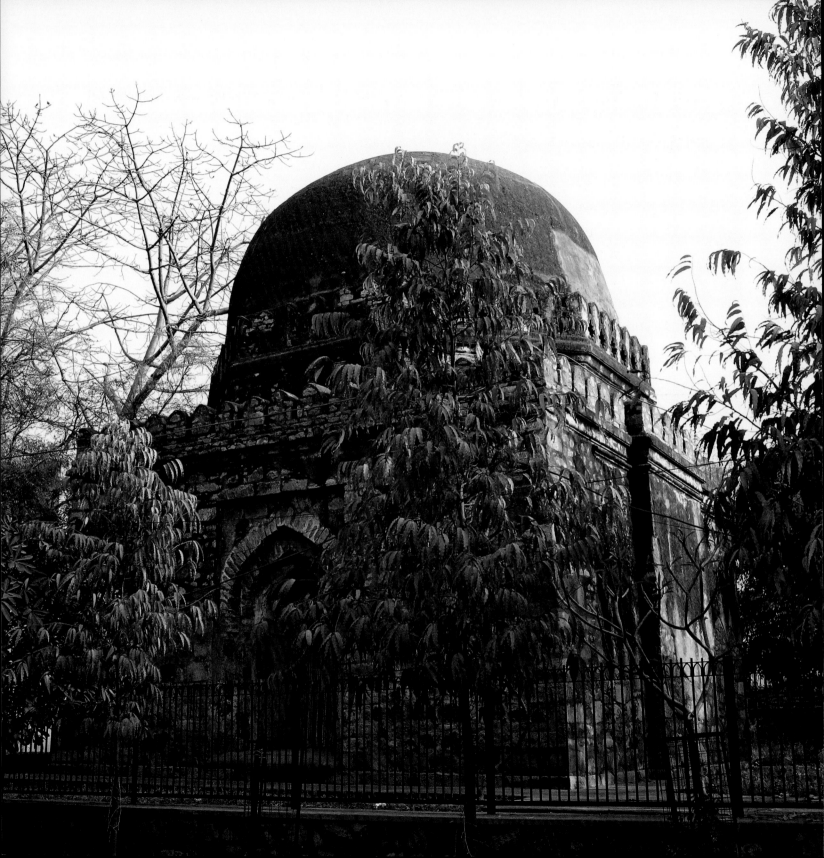

In and Around Sadhna Enclave

A Lodi period tomb.

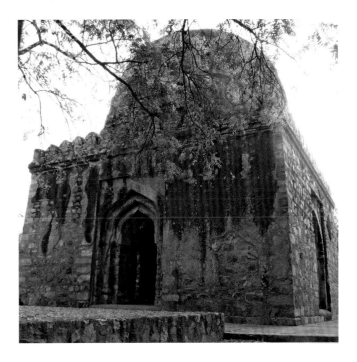

Tucked away in a green, leafy nook of Panchsheel Park is the very private and posh Sadhna Enclave. The houses are large and discreetly grand, attractively laid around well-maintained parks and enclosed green spaces. The streets are wide and well marked. All around there are signs of money well spent, a perfect proportion of town planning and private spending. There are various old monuments, curiously nondescript and 'effaced', everywhere.

None of the buildings here, in the radius of Sadhna Enclave, Savitri Nagar and Soami Nagar, are grand enough to be tourist attractions or even serve as sufficiently spectacular landscape props. These are the dribs and drabs of history, left over and left standing and no one quite knows why. Occupying the northwest corner of Sadhna Enclave, Sheikh Sarai, Phase I, right next to a cheerful yellow colony gate, is the squat gothic-looking Baradari. Literally meaning 'a house with 12 doors', it does not have 12 doors. Instead, there are seven bays from north to south followed by another two sets of bays, in all 21 arched pavilions within a rectangular setting.

Similar to other Tughlaq buildings in its solidness of construction and lack of ornamentation, it has withstood the ravages of time rather well. There must once have been a *chhajja* of which only a portion remains. The rest of it seems to be in good shape. Its walls are made of random rubble masonry and the floor and roof of stone. The insides of the

walls have arched niches, but no pronounced central niche on the western wall, so in all likelihood this was not used as a mosque.

Partly hidden behind a tree, a blue-painted sign peeps out. It bears the following legend: 'Tourists are advised to report their complaints, if any, to the Regional Director of India Tourism of the Department of Tourism …'

In times gone by, this arcaded hall must have served as a pavilion or assembly hall for religious discourses. Not too far from the caravan halts of Yusuf Sarai and Shaikh Sarai, the settlement of Khirki and the hospice of Chiragh Dilli, it might also have been used as a *sarai*. For there was a time when travelling from one Delhi to another meant a day's journey and a place en route from, say, Basti Nizamuddin to Roshan Chiragh Dilli must have been quite a relief.

Across the road from the Baradari and next to the Manav Bharti International School is an attractive square tomb. Like the Baradari, it has a fence constructed by the ASI and a barred iron gate that is kept locked. Inside the small patch of garden the grass grows wild and high. This small and squat tomb belongs to the Lodi period. No one seems to know who lies buried here. Its dome has a *kangura* pattern running along its base and the walls are decorated with double rows of blind arches.

A narrow service lane skirts the tomb and leads up to two of Sadhna Enclave's hidden surprises. You turn round the corner from the tomb, walk along a rough stone wall of hoary antiquity, past signs of servants' entrances and back-door activities to tall black iron gates. These open into the Gurudwara Dukh Bhanjan. From the outside the building looks exactly like any of the scores of nameless tombs and *chhatris* that you might have seen around Delhi and driven past, which is not surprising since it was once a *chhatri* belonging to the Tughlaq period. There is a dome rising from a squarish building, the dome topped with a stone finial and a *kangura* pattern running along the drum. But the resemblance stops there. A marbled pathway leads up from the iron gates. Stone benches are placed beside it. The whole building is swept clean and has a sense of being 'lived in' and in use. A family of retainers lives in the cluster of shacks at the back of the *chhatri*-turned-Gurudwara. The notice at the gate mentions the timings of the various prayer services.

The *chhatri* is inside an enclosure known in earlier historical texts as the Mittha's Tomb. The original enclosure walls with an arched opening remain intact. The inside of the *chhatri* reveals what it must once have looked like, with pillars supporting the dome-shaped roof. The spaces between the pillars—which once had red sandstone *jaalis*—have been filled in with brick masonry walls and the walls and the roof have been plastered and painted with *choona*. A vent has been left for the air-conditioner. The

floor is carpeted. Placed in the centre are the Granth Sahib, the sword and other religious paraphernalia. The Gurudwara Dukh Bhanjan, meaning the place that destroys sorrows, has an air of reverence. It offers repose and tranquillity. It also offers a glimpse into a syncretic past when a *chhatri* belonging to a Muslim tomb was converted into a Sikh gurudwara and caused no offence.

Right next to the Gurudwara Dukh Bhanjan is the Kharbuze ka Gumbad—the melon-shaped dome! This has been 'annexed' in the most blatant fashion possible, it stands *inside* someone's private garden. And if you do not go armed with reading about it, you are likely to miss it altogether. It is said that Kabiruddin Auliya who lies buried in the Lal Gumbad (the beautiful red building near Malviya Nagar) supposedly spent his days under this intriguingly-shaped canopy. The structure has a miniature *chhatri* of grey stone standing on four pillars on an octagonal platform. An amazing melon-shaped dome is precariously balanced on top. The proportions of the canopy and the size of the platform are perfect for one man to sit in solitary splendour and meditate. Close your eyes and you can imagine the long dead Sufi saint doing just that.

A little further, near 40 Sadhna Enclave, there is another enclosure that now houses a factory of some sort. Part of its wall in a public park has been encroached upon. Similar stories of encroachment are repeated all over the neighbourhood. There is the tomb of Sheikh Alauddin, a popular saint of his time, near house No. 202 in Savitri Nagar. Built in 1507, this was a tomb once, built by the saint himself during his lifetime; it is now a shop with traces of *kangura* pattern in red sandstone, inscriptions in incised plaster and medallions still visible.

Another tomb is owned by a government agency and yet another is 'included' within a private building. The green area northwest of Savitri Nagar is littered with mosques, tombs and enclosures of the Tughlaq and Lodi periods—some broken down, others illegally occupied.

But the story is the same everywhere, be it Sadhna Enclave or the uninhabited green belts, the present is heedless of the past.

Agrasen ki Baoli

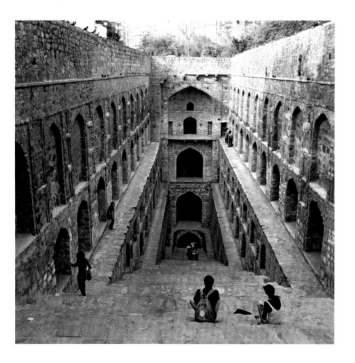

FACING PAGE: A hundred steps lead down to the Baoli.

A rare day of visitors.

Deep in the heart of Delhi lie many secrets. Some are so well concealed, that they are practically invisible. Raja Agrasen ki Baoli at Hailey Lane, off Hailey Road, off Kasturba Gandhi Marg, is one such well-concealed secret. Even those who live in the many high-rise apartment blocks lining Hailey Road would be hard pressed to give a faithful account of this nugget of history tucked away in their backyard.

There is no sign to guide you, certainly no vestige of the complex is visible from the road. It is screened completely and effectively from view by a ring of tall buildings. You can turn in from the main road or approach from the rear, navigating your way through labyrinthine back streets. Going by the sheer numbers of clothes hung out to dry and the rather professional-looking clotheslines festooning the service lanes, a thriving dhobi's colony seems to operate deep from the innards of this neighbourhood. A woman selling vegetables from her modest pavement patch, children playing hopscotch and groups of loitering boys, all combine to create a mellow ambience. Nothing in the urban sprawl of Connaught Place and its environs prepares you for the sight that awaits you.

As you come upon a stone wall pierced with arches and step in through the small barred iron gate, you feel caught in a time warp. Were it not for the tops of the buildings silhouetted all around,

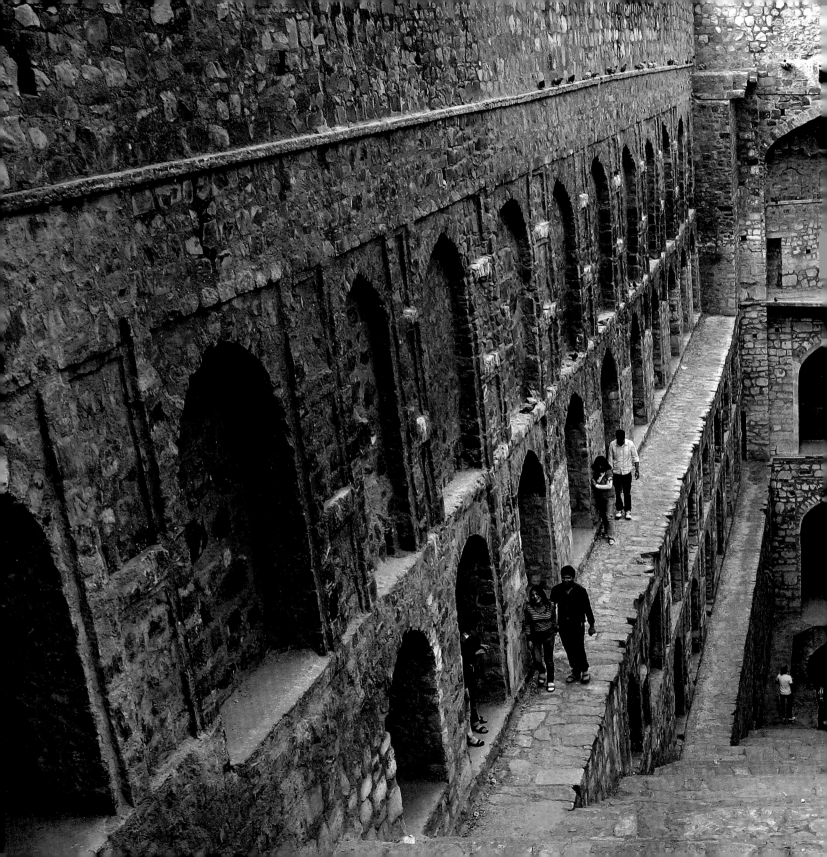

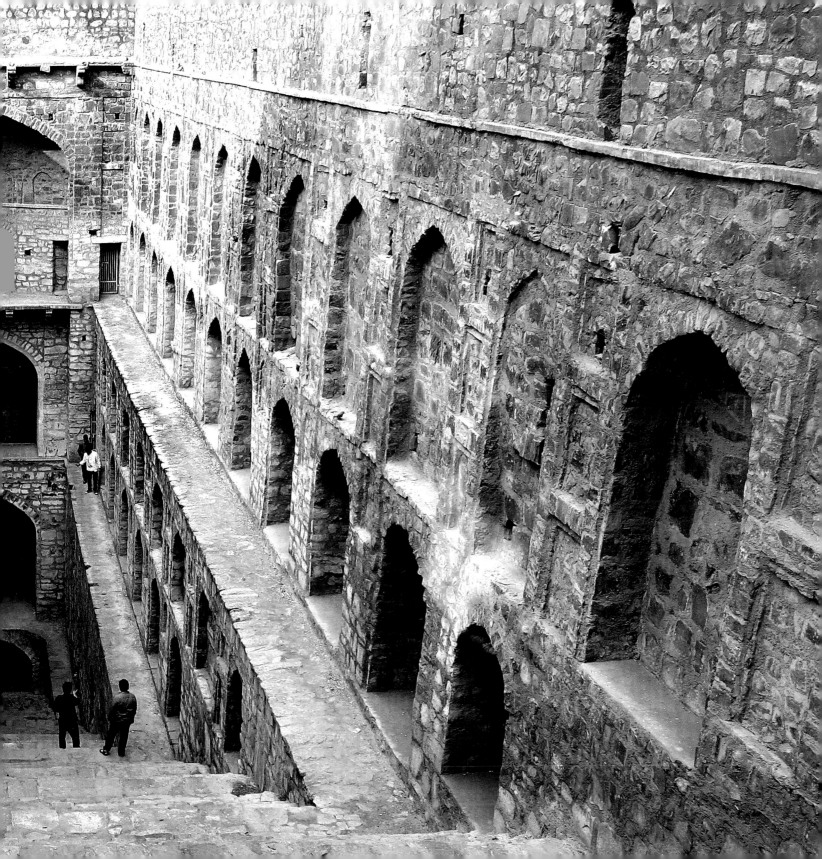

you might well think you have been transported to medieval times. For here is a *baoli* as remarkably well preserved and handsome you are ever likely to find. Either built by Raja Agrasen, said to be the founder of the Aggarwal community, or named after him, this is one of the finest *baoli*s in the city of Delhi. Long and rectangular, measuring 60 m x 15 m, it has 100 stone steps leading down to it from the southern side. At the north end there is a circular well and covered portion, reached by tip-toeing across the two steep sides. Arched niches flank the length of its eastern and western walls, making it look bigger than it actually is. Colonies of pigeons flutter in and out of these niches, their cooing the only sound in this oasis of calm. Miraculously, the din of traffic from the major arterial roads running up to Connaught Place does not penetrate the thick walls of this ancient structure.

Believed to have been built sometime in the pre-Lodi period, the walls of the *baoli* are made of random rubble masonry, its floor and vaulted roof at the northern end of stone. Conservation experts have long been decrying the rapid deterioration of this complex since the 1980s, particularly with the building of skyscrapers in its immediate vicinity. Some evidence of repair work is now visible along its outer walls. The water in the step well has been de-silted and refilled, though it still looks murky.

A small mosque built on a mound adjacent to the *baoli* is in far greater need of attention. This small vaulted building originally had three *iwan*s but the southernmost wall has partially collapsed, in the process revealing a compartment beneath floor level. At the northern end, there is a room, dilapidated and forlorn like the rest of this tiny mosque.

In all likelihood, the mosque must have been built close to the *baoli* to provide for the wayfarers—a mute symbol of the once vibrant *Ganga-Jamuni* way of life when two cultures were so inextricably intertwined. There are remains of medallions and arched niches in the walls of the mosque that was also built in the Lodi period. Like the *baoli*, stone is used for the floor and the vaulted room. Unlike the *baoli*, however, rapid deterioration caused by time has been lent a willing hand by man. Part of the dome has been neatly chopped off to accommodate the building nearby that till recently housed the Consulate of Malta.

FACING PAGE: The ceiling of the topmost arch of the baoli.

PAGES 134-135: The stone-wall is pierced with arches.

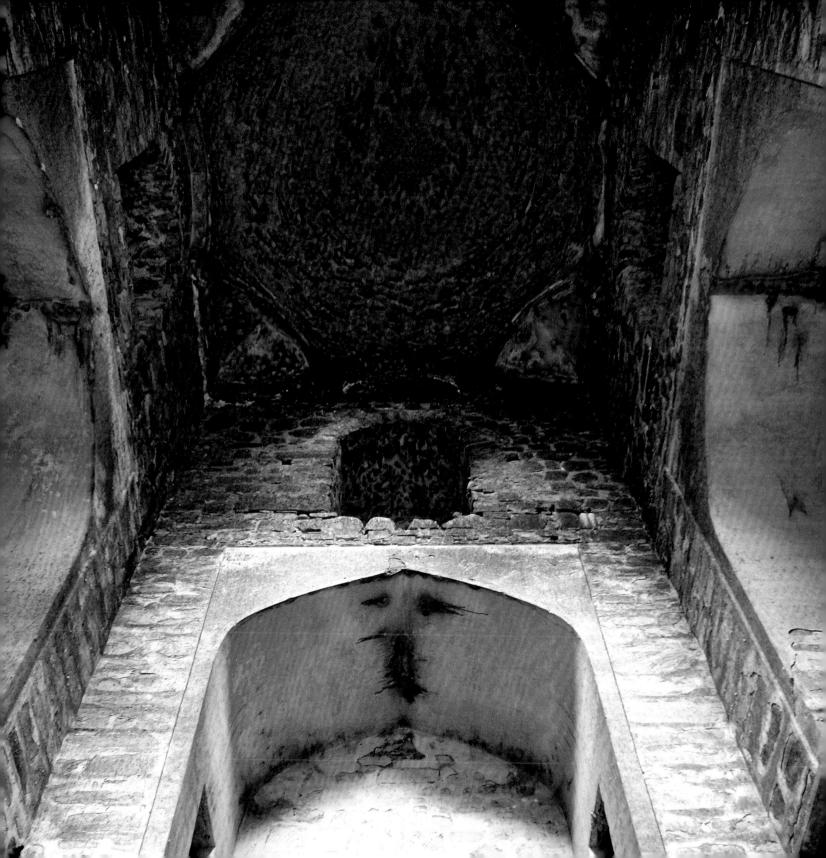

SAIYYID
CONFINES OF TIME

Kotla Mubarakpur

At Kotla Mubarakpur, history is caged and confined like a beast, as in the case of the tomb of Mubarak Shah. Or else, it is brutally cannibalised, stone by stone, brick by brick, as the nearby mosque. When all else fails, it is simply swallowed up, as the *baoli* is by mounds of dung.

An amateur conservationist and history buff is prone to exaggeration, you might well think. Do go to Mubarakpur. A word of caution though: Don't make the mistake of wearing *chappal*s, as I did the first time, for your feet will be covered with filth.

At one level, Kotla Mubarakpur is like all the other urban villages in Delhi. It too is a stone's throw from urban, prosperous Delhi. Yet, once you enter its winding, narrow gullies, the swanky showrooms, the wide roads and flyovers, the smart houses and well-dressed people of Delhi seem to belong to another era.

Here are the stray cattle, the snorting pigs, the bedraggled children, the *halwai*s frying impossibly yellow *jalebi*s, the potters' shops with their half-baked wares drying in the sun and the usual bric-a-brac of rural India incongruous in twenty-first century New Delhi.

And, on top of it all, there is also an oppressive squalor, a lack of basic civic amenities and a complete disregard for the law. The houses are so densely packed that they seem like an impenetrable shield to keep the modern world out.

The alleys (some so narrow that a cow and a human being cannot walk abreast) are a little more than open sewers with an occasional stone to step over. Piles of rotting garbage sit outside open doorways. No garbage retrieval system seems to be in place. The maze of gullies leads to Mubarak Shah's magnificent but crumbling mausoleum. A tall iron fence surrounds it and a locked gate makes it virtually an unscaleable citadel, a *kotla* in the real sense.

The place has not been swept for a very long time. No one knows what the state of affairs inside the tomb chamber is, but you can plainly see shrubs and small trees sprouting from the roof and minarets.

From what you can make out through the fence, the tomb stands on an octagonal stone-paved *chabutra*. An open verandah runs all around the tomb chamber with three bays on each side of the octagon.

The dome springs from a 16-sided battlemented drum with a decorative minaret at each of its angles and is surmounted by an octagonal lantern of red sandstone.

Surrounding the dome over the verandah are eight *chattri*s of grey stone, now severely disfigured by the gnarled roots of trees

sprouting from every nook. History books tell us there was an enclosure of rubble-built walls here and you entered through two gateways on the south and west.

The tomb was once surrounded by a garden and is believed to be the first enclosed garden tomb built in Delhi. The enclosure walls, the garden and the gates are long gone and the houses jostle so close to the monument that it is obvious no one has paid heed to the mandatory distance of a hundred metres to be kept from a protected monument.

An entrance to the tomb chamber can be seen on the southern side, while the six other openings are fitted with sandstone *jaali*s. The remaining eighth side—the western one—is closed with a *mihrab*.

..

Hemmed in from all sides.

The southwest opening is a doorway with a flight of stairs leading up to the roof. Internally, the dome is ornamented with intersecting bands of red sandstone and Koranic inscriptions in incised plaster.

There are seven marble graves inside, each without any inscriptions on them. The central one is believed to be Mubarak Shah's.

Mubarak Shah, the son of Khizr Khan, was the second sultan of the short-lived Saiyyid dynasty to rule from Delhi. He proclaimed himself the Sultan of Delhi in 1421 and, like all ambitious sultans before him, decided to lay the foundations of a new city— the fifth Delhi so far—to be named Mubarakabad.

Work began on this city in 1433 on the banks of the Yamuna but in less than a year, Mubarak Shah was murdered by conspiring nobles. Ironically, this dastardly act was perpetrated when Mubarak Shah had ridden out to inspect the progress of the upcoming buildings in his new city.

Today, not the slightest trace remains of Mubarakabad, said to have been near Khizrabad

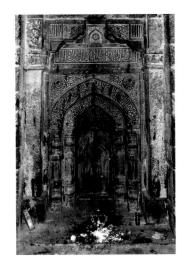

at the village known as Mubarakpur Reti. His tomb in Kotla Mubarakpur stands, but only just!

Not far from the tomb is a mosque, belonging to the same era, probably built as a mosque for the adjacent tomb. The houses all around it form an impenetrable wall. Its narrow entrance is practically invisible in the clutter of habitation. The fate of the *baoli* nearby is worse. A 28-year old resident tells us that he remembers seeing water lapping its edges till his childhood. Forget water, now there is not even a depression of any sort here. Instead, the local Gujjars have stocked their dung patties along its walls. The *baoli* is gone, buried somewhere behind that malodorous heap. The state of affairs at Kotla Mubarakpur begs the question: Is history expendable? Must it always make way for the present?

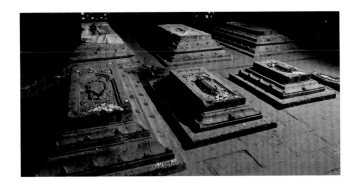

..

ABOVE: Locals believe Mubarak Shah has the powers of a saint and leave offerings.

LEFT: Inside the funeral chamber. Many Hindu devotees pray and leave offerings here.

LODI
TRACING THE SPIRIT

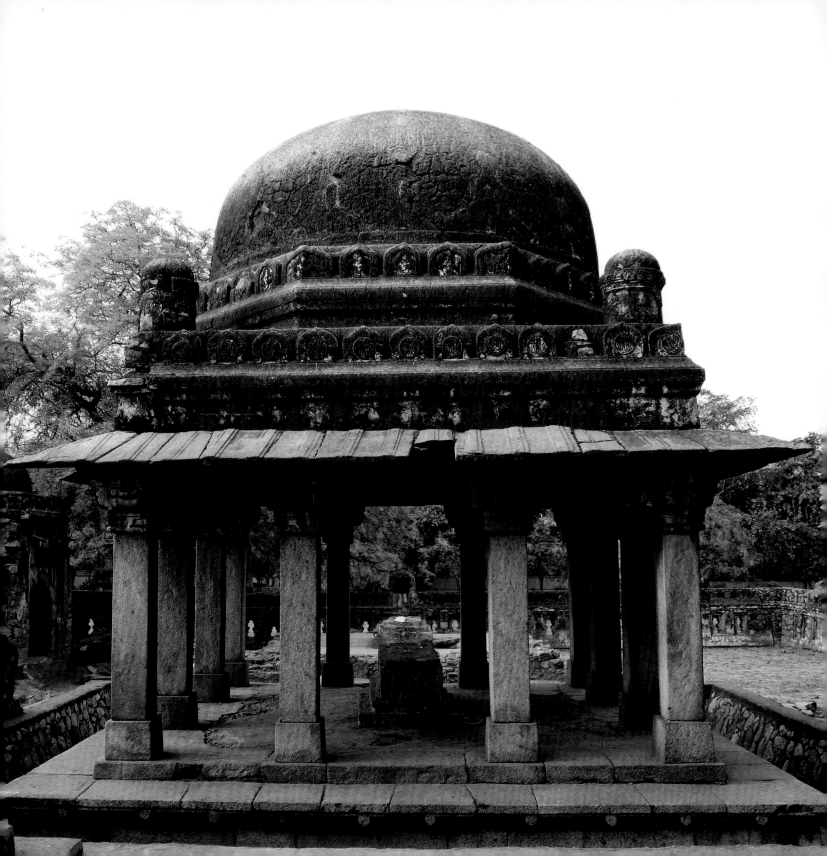

Makhdum Sabzwari's Dargah

FACING PAGE: The grave of Makhdum Sabzwari.

A fine carved gateway.

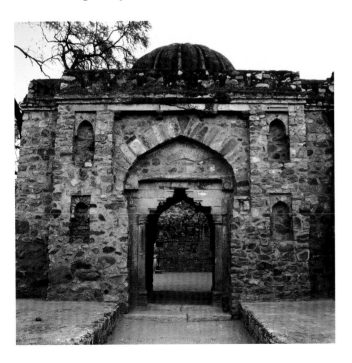

West of the ruined walls of Siri stands a little-known but extremely picturesque enclosure. Set in the midst of gently rolling parkland and surrounded on all sides by posh bungalows in the very upmarket neighbourhood of Mayfair Garden in South Delhi, the Dargah of Makhdum Sabzwari is an oasis of tranquillity. Barely a few yards away from the frantic August Kranti Marg, screened by tall trees, it lies under a cloak of invisibility. According to the chowkidar, no one comes here much except on Thursdays, when some people come to seek blessings from the saint.

Built in the late fifteenth century, this building is in many ways typical of the scores of monuments that can be seen all across the cityscape of Delhi. Not flamboyant or remarkable enough to attract busloads of gaping tourists, at the same time not dilapidated enough to come down in bits and parts in the rainy season, it remains standing, stout and spare, sturdy and impervious to the passage of time, yet forlorn and forgotten.

The Pathan style of architecture, of which the Dargah of Makhdum Sabzwari is a fairly typical example, usually has an air of studied gloom. Sloping walls, a certain roughness or rather massiveness of construction, squat domes with none of the elegance of the Mughal mausoleums, an absolute minimum of ornamentation, a simple severity of outline all

combine to give such buildings a stern, clear-cut purity of design. All these characteristics are visible in the monuments constructed by the Tughlaqs who were considered the puritans among the architects of Delhi. Built in the time of the Tughlaqs but after Timur's invasion of 1398, this obscure little *dargah* and adjoining mosque form a fitting link between the spartan early Islamic style of architecture in India and the more 'humanised' type adopted by later Indian emperors such as the Saiyyids and Lodis. The superiority that came with conquest had mellowed and they learnt to mingle harmoniously with indigenous styles of architecture. In its hushed silence, in the flutter of alarmed pigeons, in its broken *jaali*s, the Dargah of Makhdum Sabzwari speaks eloquently of just such a mingling of two cultures. But is anyone listening? The interior is approached by a fine carved gate built in the Hindu style that shows the remarkable degree to which early Islamic architecture had softened and learnt to incorporate indigenous elements to suit its own designs. The grave of the little-known saint, Makhdum Sabzwari, is built on a *chabutra* facing a spacious courtyard lined on three sides by pillared cloisters forming part of the mosque. Like most mosques built in India at that time, this building is laid down on a fairly standard plan. The most intriguing feature of a mosque is the concept of 'enclosed space'. In this mosque, too, there is a *sahn* defined by *iwan*s on three sides that lend the illusion of both openness and enclosure. The *iwan*s on the western wall (in India, the faithful bowing towards Mecca face west) are given more prominence. The prayer chamber is internally divided into seven bays, the central one and those at the extreme ends are domed. The domes are typically squat and add to the solidness and implacability of the entire structure. The building is constructed of rubble masonry coated with plaster but the pillars of the arched openings are of hard compact granite roughly chiselled into rectangles. A balcony with seven arched cells underneath runs the entire length of the outer western façade. The façade also has two extremely slim turret-like structures on either side of the main dome and one on each of the ends. It is interesting that this mosque has no minaret for the *muezzin* to summon the faithful to prayer, the minaret

A broken red sandstone jaali.

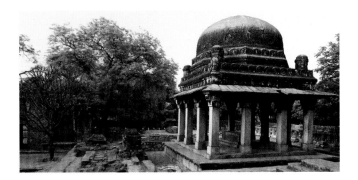

being a later feature added by the Mughals. The main gateway, with its typically Hindu-style arch, comprising carved rectangular slabs and pillars reminiscent of a temple, has a short squat dome on top and a passage allowing access through the northern side of the mosque. The enclosure has only one entrance that has been barricaded by a rickety wooden gate painted a rather nondescript blue. The already cramped passage is littered with broken masonry and what appear to be remnants of a fine red sandstone column.

The inside of the building is at once symmetrical and yet articulated towards a focal point—the *mihrab* in the *qibla* wall. An early innovation of Islamic architecture, the *mihrab* is simply a recess or alcove indicating the *qibla*. It is kept empty at all times. Not sacred in any way except in the direction it expresses, this concavity occupies the middle space in the deeply recessed central arch on the western wall. On the right side of the *mihrab* is the *mimbar* from where the prayer leader could address the congregation. The *mimbar* is regarded as much as a symbol of authority as a device for acoustic improvement. In a mosque of this size, the two-step *mimbar* served the first function more effectively than the second since neither the courtyard nor the

...

ABOVE: The saint's rauza.

Unknown graves—probably of the saint's disciples.

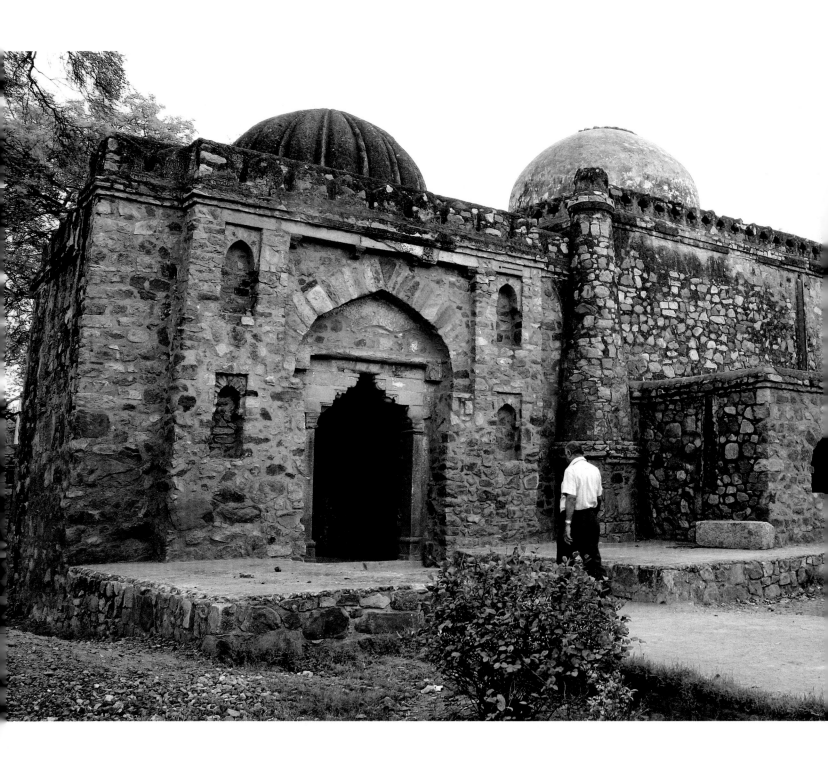

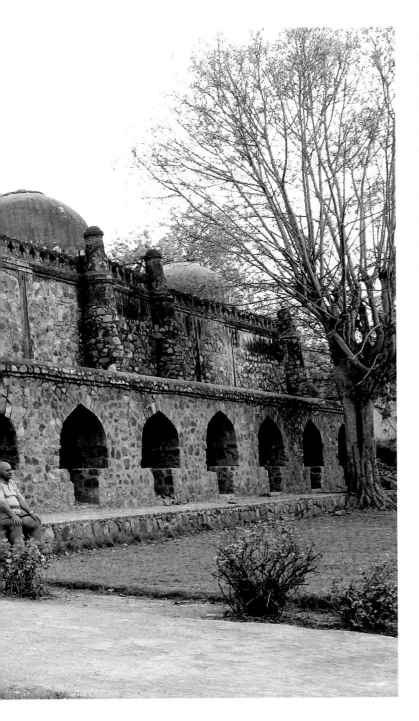

cloisters are vast by any standards. In the mosque there are further evidences of the passing away of the puritan period of architecture in Delhi imposed by stern conquerors. The arches, the red sandstone dripstones, the architraves and brackets speak of the mixing of two styles of architecture as two races of people came together. But a simple severity of outline still remained, as is evident from the thick walls and the rows of unornamented pillars. The external walls of the *iwan*s and the vaulted insides of the domes bear evidence of inscriptions (mostly the word 'Allah') cut in plaster of such fine quality that the sharpness of the lines is perfect to this day. There are two narrow domed *hujra*s on either side of the open pillared cloisters that probably served as secluded chambers for meditation or performing austerities. One of them still has the remnants of an intricate red sandstone *jaali*. It was perhaps in one of these rooms with the sunlight filtering in through the red *jaali* that the long-forgotten Sufi saint Makhdum Sabzwari prayed and meditated upon the beatitude of God.

Facing the mosque is a walled graveyard. The *rawda* is traditionally organised around a *baraka*, the focus being the tomb of the saint. When the tomb stands in the midst of a funerary garden,

The eastern facade with two slim minarets flanking the central dome.

its effect is incomparable, both aesthetically and conceptually. Traditional Islam has developed, to a remarkable degree, the architectural forms associated with death, such as tombs, shrines and *dargah*s. The connection between burial and landscape lies in the Islamic vision of the Paradisal Garden, which is none other than the primordial garden that Man lost through sin but whose image is recoverable from the *anima mundi*. This explains the care and attention given to funerary gardens such as in the Taj Mahal, Safdarjung's Tomb and Humayun's Tomb. The walled enclosure containing the grave of Makhdum Sabzwari is, however, a humble and modest one. The grass

BOTH: Medallions bearing the name of Allah studded into the kangura pattern.

grows high and wild and no flowers can be seen in the unkempt rubble-strewn grounds.

Practically nothing is known of the man who lies buried here. The plaster on his grave has fallen away in places, exposing the bare bricks beneath. The *chhatri* that covers the grave has remnants of some beautiful blue inlay work that is visible through bald patches on the lintels and the crest of the dome. Interestingly, the *chhatri* evolved as an architectural ornamentation over graves in India because of the Islamic conviction that a grave not exposed to the rain and the dew was unblessed. (Compare this with the Mughal mausoleums that invariably had the graves in a hidden lower chamber well below the ground.) Scattered around the canopy, with its quaint squat dome built atop a drum-like piece of masonry, square colonnade and red sandstone dripstones, are several other graves in various stages of disrepair—probably of the saint's disciples. A *mazaar* containing the grave of a Sufi saint, such as the one here as well as in Nizamuddin Auliya's *dargah* and in countless other big and small *dargah*s across the country, has a religious significance; in contrast, a *rawda* or *maqbara* such as the one inside the Humayun's Tomb has a primarily architectural significance. Though suffering from the effects of time and accident, the *Dargah* of Makhdum Sabzwari is nevertheless in a reasonably good form. This is in large measure due to the solidity of its structure and the sturdy good sense of its architects. This serene little *dargah*, one of the most picturesque in Delhi and by far the most remarkable for its clean, pure lines and unembellished singularity of form, has bravely withstood the ravages of the elements for over five centuries.

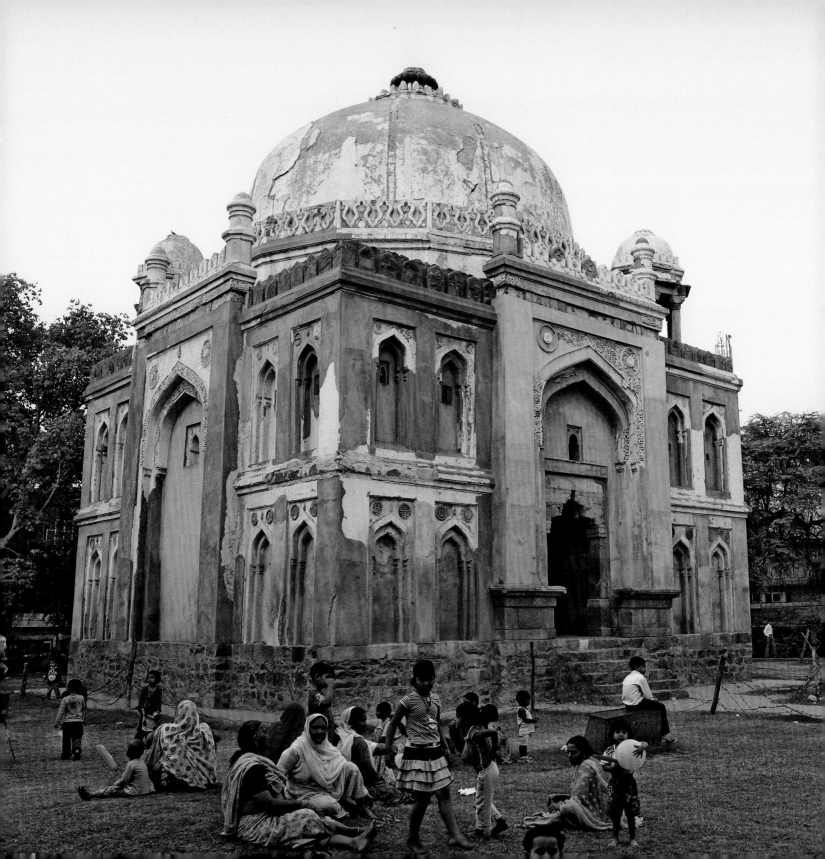

Tombs of Kale Khan and Bade Khan

FACING PAGE: Kale Khan ka Gumbad in J Block, South Extension-I.

Bade Khan ka Gumbad, D Block, South Extension-I.

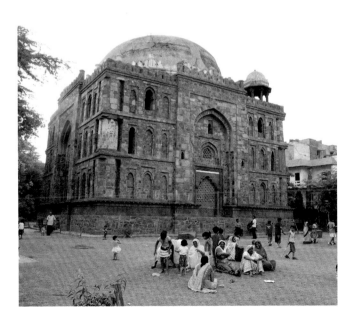

The Lodis were inordinately fond of building tombs. This was not just a morbid fascination with the funerary arts; some of it also had to do with the exigencies of the times. Timur had ransacked Delhi in 1398. Times were hard and finances lean. Mubarak Shah did launch an ill-fated and short-lived project to build another Delhi in 1493—the fifth so far—but his death put to rest all ambitious building projects. However, no one could stop the new mandarins of Delhi from building mausoleums to honour their dead and, in so doing, perpetuate their own names and the name of their newly initiated dynasties. And so you have scores of tombs from the medieval period in Delhi—of sultans, their kinsmen, nobles and wazirs. Often little is known of the men who lie buried in these grand and solemn mausoleums. Their inscribed names are often different from the plaques found in some of them, leading to some confusion even among historians.

Take the tomb of Kale Khan, for instance, in J Block, South Extension Part I, in the northwestern corner of the colony. This rather handsome tomb can be reached by taking the road close to the bustling South Extension Market. There is an inscription over the *mihrab* in its western wall stating that the tomb was built on 24 May, 866 A.H. (corresponding with 1481) during Bahlol Lodi's reign to inter the remains of Mubarak Khan. Despite the ascribed name, in all likelihood, this is the tomb of Mubarak

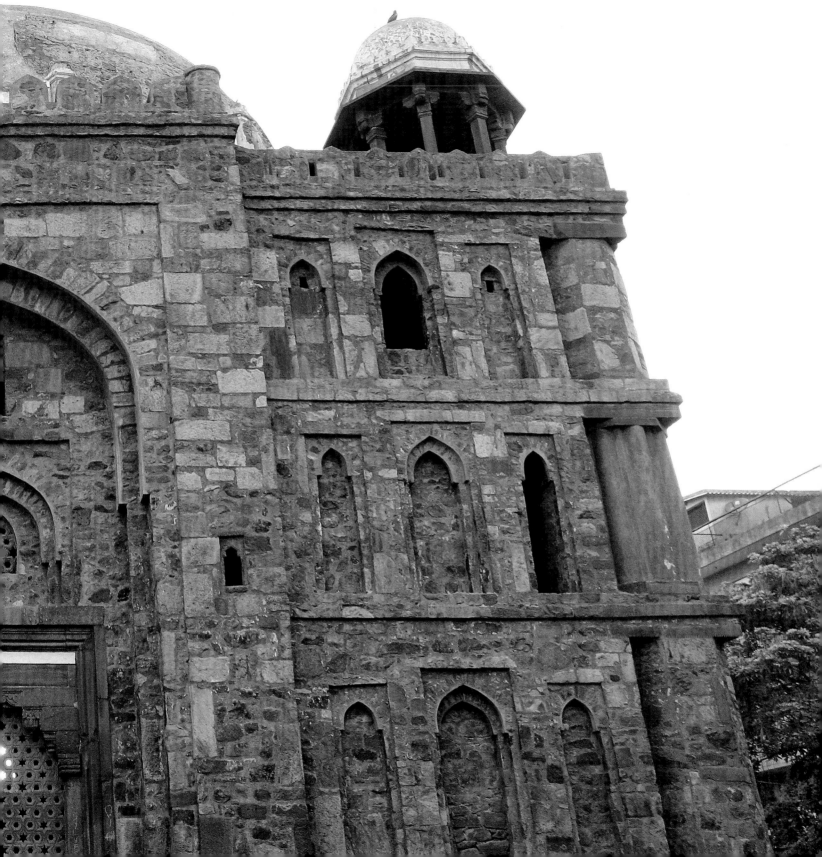

Khan Lohani, the father of Darya Khan Lohani who had served under three Lodi kings—Bahlol, Sikandar and Ibrahim. Darya Khan was given the title Mir Adal that was, in effect, a bit like a present-day Chief Justice. Darya Khan himself lies buried in Kidwai Nagar, slightly west of South Extension. This tomb of Mubarak Khan, which for the purpose of consistency we shall continue to refer to as the Kale Khan ka Gumbad, is the earliest dated square tomb of the Lodi period. Two rows of false niches adorn its outer walls. A flight of stairs takes you inside the grave chamber that is open on three sides and closed with a *mihrab* on the western side. Inside, there are two graves. The walls are decorated with red bands and Koranic inscriptions in pilaster. The sloping walls of the Tughlaqs are gone, as is the massiveness of construction. Here you have a perfectly square tomb with a well proportioned dome built on a raised platform bearing an inscription of its date and the name of the person lying underneath it. Yet, this being Delhi, history must give way to local lore. The watchman at the nearby Bade Khan's tomb spins a fantastic tale of five brothers—Bade, Chhote, Kale, Bhure and Darya—and that these tombs belong to them. He had no clue who they were.

A cluster of three Lodi tombs, known locally as Teen Burj, lies a little further away, in D Block. The stunning façade of the Bade Khan ka Gumbad rises majestically above the motley middle-class homes huddled in neat, narrow streets. The motif of rows of small recessed arches on the outer wall is picked up from Kale Khan's tomb and

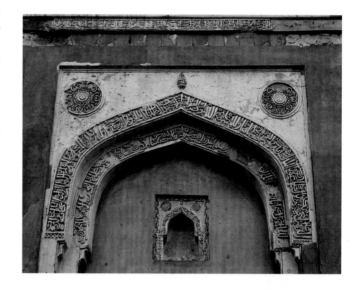

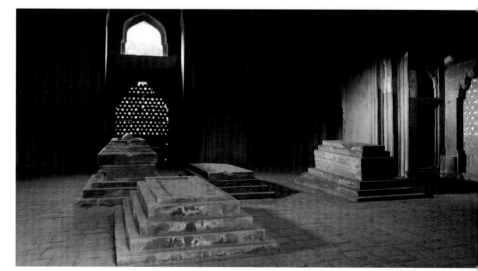

Two sides of the grave chamber are closed with star-and hexagon-patterned latticework in sandstone. The fourth wall—the western or *qibla* wall—is closed as in most tombs with a *mihrab*. Red bands cross each other over the inside of the tomb. The outer four corners have *chhatri*s, of which the eastern one has disappeared, giving the dome a somewhat skewed appearance. In the absence of an inscription, it is hard to say who lies buried here, but he was obviously an important personage to deserve such a large and imposing tomb—the largest Lodi-period tomb, in fact, outside the Lodi Garden complex.

The Chhote Khan ka Gumbad, which lies close beside, is smaller and prettier. Traces of captivating

expanded here to truly spectacular proportions. This is the largest and most beautiful of the three tombs of this complex—the other two being the Chhote Khan ka Gumbad and the Bhure Khan ka Gumbad. A deeply recessed arched gateway leads to the tomb chamber with five unmarked graves inside. Once again, the garrulous watchman has a wild theory—the man who lies buried here was extremely tall, over seven feet, hence the name. An opening in the thickness of the southern wall leads to a passage, which according to local lore, goes all the way to Agra.

Above: Chhote Khan ka Gumbad is smaller and prettier.

Facing page:
Above: Intricate calligraphy on an arch in Chhote Khan ka Gumbad.

Below: Inside Bade Khan ka Gumbad.

Pages 156-157: The southern façade of Bade Khan ka Gumbad.

blue tiles are visible around the neck of the dome, as are Koranic inscriptions in lime mortar. *Chhatris* decorate the outer corners of the roof. A staircase in the eastern wall leads to the roof where you can catch a glimpse of the tomb of Mubarak Shah rising above the dense cluster of houses in the east. Star- and hexagon-shaped grills made of sandstone are fixed on the northern and eastern walls.

A few yards away lies the Bhure Khan ka Gumbad. It is the smallest and also the most encroached upon. While the other two stand in well-manicured lawns and are reasonably well tended and clean, this one is in a sorry state. Some of the encroachments have been bulldozed and this

is evident from the debris lying around. Also, an ashram of some sort seems to have muscled in on its land, giving it a hemmed-in look. As in the case of the other two, nothing is known of the person who lies buried here. Though similar in style, it is smaller and has no *chhatris*. Glimpses of blue tiles redeem its 'brown mouse' appearance. These four tombs appear integrated with their neighbourhood. There are houses built around them, not on top of them and, except for the Bhure Khan ka Gumbad, there is no blatant encroachment.

LEFT: Rows of blind arches.

RIGHT: Stone jaali fitted in arched openings.

Children play cricket on the lush lawn and chowkidars keep vigil. Indeed, a welcome change from some of our neglected monuments.

Bade Khan—majestic and massive.

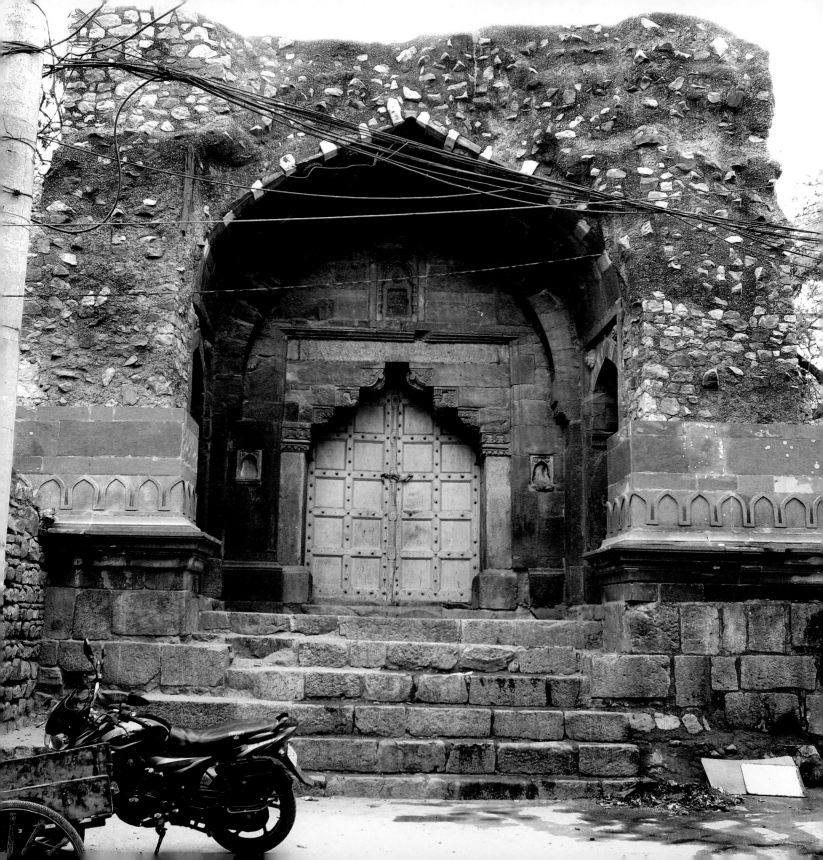

Moth ki Masjid

Carved supporting block in a corner of the ceiling.

Under the Lodis, a new type of mosque developed, one that ultimately became a model for many mosques built in Mughal India. Instead of the massive congregational mosques built by the Sultanate dynasties, smaller structures with intricate ornamentation and a finer eye for detail, showing the intermingling of Hindu and Islamic influences, came to be built. Occupying a small niche between the present-day South Extension Part II, Neeti Bagh and Uday Park, the Moth ki Masjid is a beautiful specimen of such architecture.

Built in 1488 during the reign of Sikandar Lodi, the Moth ki Masjid is said to have served as a model for the mosque built by Sher Shah Suri in the Purana Qila and the Jamali Kamali Mosque near the Qutub. Legend has it that one day Sikandar Lodi found a grain of *moth* lying on the floor of the grand mosque in Delhi—the Begumpuri Mosque that served as the congregational or Jami Mosque. He picked up that single grain and gave it to his wise and sagacious minister, Miyan Bhoiya, who deemed that a grain honoured by the Sultan's touch should not be forgotten; it should, instead, be used in the service of God. So he planted that *moth*, sowed the resultant 200 grains and sowed again and again till, from the proceeds of that one grain, he had acquired enough sackfuls of money to build a mosque. Hence the name—Moth ki Masjid—the mosque built from a single grain.

The Moth ki Masjid stands on a raised platform enclosed by a low wall and seems all but engulfed by the clutter of habitation that seems to be closing in on it, threatening to swallow it entirely one day. As you approach from South Extension, you can see the mellow golden walls and stately turrets of its western façade rise majestically above the squalor of its surroundings—the haphazardly parked tempos and vans, the public urinal, the strolling pigs, the bits and pieces of the auto repair workshops scattered in ever-widening circles and the stray cattle, not to forget the jostling mass of humanity from the nearby village bearing the same name as the venerable old mosque.

Instead of the minarets with which the Mughals were to later adorn their mosques, the western wall here is flanked by double-storey turrets with arched openings, reminiscent of Rajasthani *chhatri*s, that lend a delicate beauty to the otherwise stern and unembellished façade. You turn from the main road and walk along the north wall, pierced all across with low arches, to enter through a massive gateway on the eastern wall. The gateway is one of the most remarkable features of this mosque, colourful and eye-catching, though in a terrible state of disrepair with many of the red, white, blue and black stones missing from the intricate pattern. Perceval Spear has memorably described this arched gateway as 'a Hindu arch inside a Muslim arch'. There is a rectangular arch made of three stone slabs placed horizontally,

much as you would see in a temple doorway, placed within an Islamic arch. It shows that Hindus as well as Muslims helped to build this mosque and they pooled together their differing styles, knowledge and workmanship to create things of beauty. It is for this reason that many consider the Moth ki Masjid as one of the finest specimens of Indo-Islamic art and architecture; the Hindu and Muslim features are blended in perfect harmony. A look at these buildings today and you do not see only the 'Hindu' or the purely 'Islamic' parts; instead, you see a harmonious blending of styles, a symmetry of proportion and a pleasing use of contrasting colours.

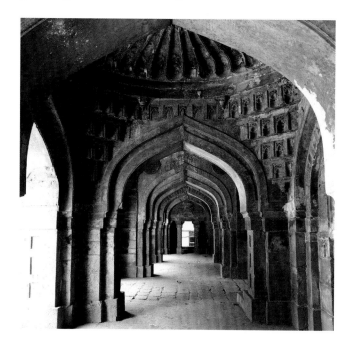

Arched niches in the squinch (inside corners of the bays).

In many ways, the gateway surpasses the main structure in beauty and craftsmanship. Bands of marble bearing Koranic inscriptions are set in the red sandstone amid flowering lotuses and brackets supporting the doorways carved in a style reminiscent of Hindu temples. To balance the turrets on the western façade, the eastern wall, too, is flanked by domed *chhatris*. Supported on eight red sandstone pillars, the *chhatris* show traces of tile decorations in a particularly vivid shade of blue.

The eastern gateway opens into a spacious courtyard. The prayer chamber, which lies west of the enclosure, is constructed of grey ashlar stone and is crowned by three domes. Five *iwans* mark its eastern façade, the central *iwan* being enclosed by a high and deeply recessed arch of red stone, ornamented with marble, with a small window under its apex. The façade is disfigured in many places where the bands of inscribed marble and coloured plaster medallions (also bearing inscriptions) on the central arch have broken or partially dropped away. The gaping holes give a desolate, almost sightless look to this otherwise beautifully proportioned mosque. It appears as though it has chosen to blind itself rather than look out and see the squalor and clutter of the urban sprawl all around it instead of the blanket of green fields that covered the landscape till half a century ago.

Internally, the mosque is divided into five bays, of which the central one and those at the extreme ends are domed. The ceilings of the side bays, once richly ornamented with incised plaster, now show many bald patches while the central *mihrab* has Koranic inscriptions engraved on the sandstone. A plain four-step *mimbar* stands to the right of the niche. Arched niches in the squinch (inside corners of the bays) are further evidence of the painstaking craftsmanship of the interior. It is evidence also of the passing of an age of frugality that had descended upon the citizens of Delhi after waves of Mongol

ABOVE: A typical Hindu archway.

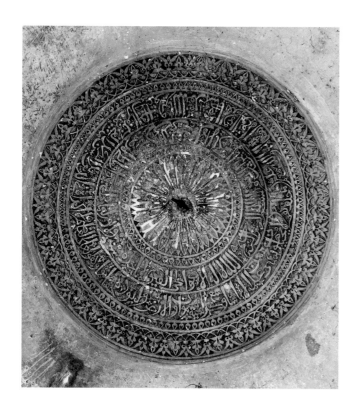

invasions of the preceding century. Patrons of art could afford to splurge on expensive marble unlike the spartan structures that were built shortly after Timur's invasion, or even the vast echoing vaults built in the Sultanate period that were meant to demonstrate the might of Islam. There is a mellowness in the Moth ki Masjid and a peaceful fusion of harmonious styles.

ABOVE: Incised plaster motif.

Five iwans mark the eastern façade. A spacious courtyard with a well in its centre.

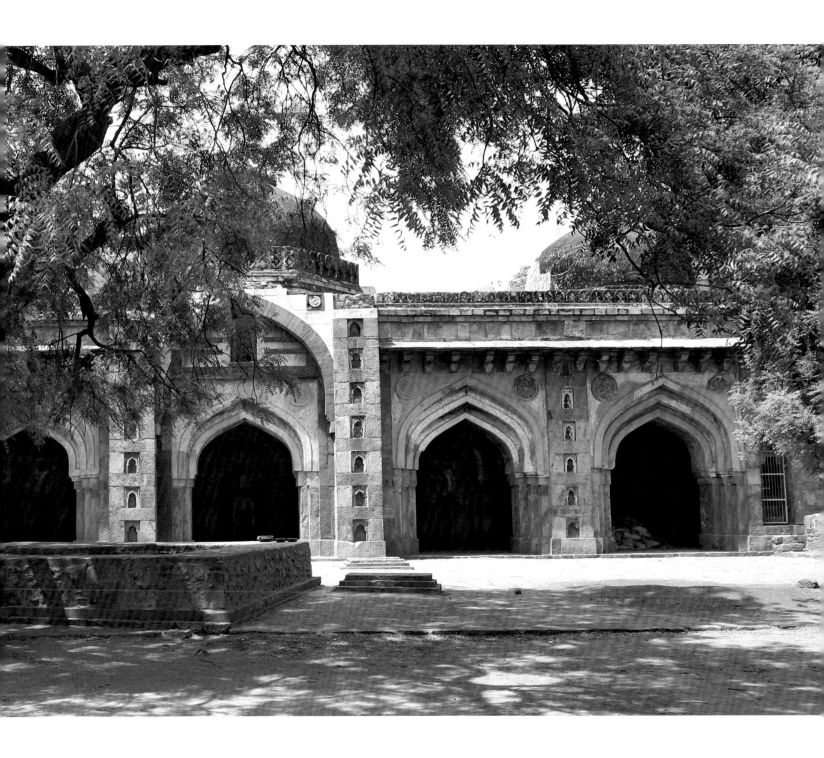

A part of the courtyard contiguous with the prayer chamber is paved with local grey stone. It contains three unknown graves and the remains of what was perhaps a sunken well, the well being in place of the tank that was later such an integral feature of mosques—a place for performing *wuzoo* before entering the mosque for prayers. Staircases cut into the thickness of the wall from each extremity of the eastern wall. The *mihrab*s in the side bays lead to the upper storey of the turrets and the roof. It is from here that the *muezzin* would have given the call for prayers since the minarets were to come much later, a device introduced by the Mughals to allow the *muezzin's* voice to float higher and further.

Standing in the middle of the courtyard, I was struck by the fact that the entire structure is beautifully symmetrical yet focussed towards a central point. The enclosed space of the courtyard, pierced by arches, is articulated towards the central *mihrab*, its hollow and empty concavity conveying the direction for the faithful to bow in prayer. While marvelling at this conjunction of symmetry and focus, I was also overcome by the air of desolation and neglect.

Squatters have taken over many of the arches below the north wall and pigs and other assorted animals are berthed under some of these recesses in the old wall. However, what is truly amazing is that the east and south walls are being used as 'common walls' or 'fourth walls' in several homes abutting this ancient structure. This is in complete violation of the Ancient Monuments and

ABOVE RIGHT: An interplay of marble and red sandstone.

ABOVE LEFT: A view of the central mihrab.

Archaeological Sites and Remains Act that prohibits any digging or commercial activity within 100 m of a protected monument.

Even in areas within 200 m of a protected site, construction activity is regulated and prior clearance is needed from the ASI. A notification to this effect was made in 1992 but no one seems to have heard of the law of the land in this part of town.

Domed chhatris on the eastern wall.

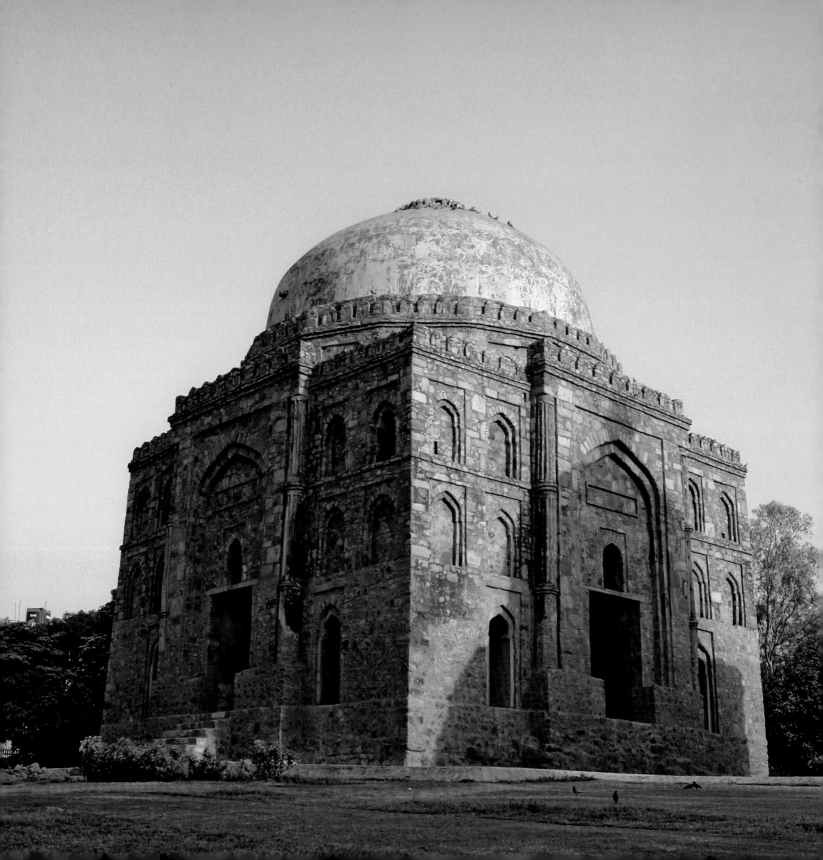

Around Green Park

From the twelfth century onwards, Delhi's rulers began to build buildings that were massive and beautiful, sturdy yet stylised. However, the profusion of building activity reached such a crescendo by the fifteenth century that only a handful of monuments came to occupy a place in history; the great majority ended up nameless and neglected. New Delhi was quick to discard most of them, choosing to validate a bare minimum with a name, an identity and a place of visibility.

All over Green Park there are tombs that follow the general Lodi plan and show most of the characteristics of the typical Lodi-period tombs. The great pity, however, is that practically nothing is known of the persons who lie buried in them. Often, the names are generic rather than particular, as in the case of the Biwi (wife) or the Dadi (grandmother) ka Gumbad or the Bandi (maidservant) or the Poti (granddaughter) ka Gumbad—the dual names are, in themselves, an indication of the complete lack of historical authenticity. Minor architectural variations exist such as thin, fluted minarets on either side of the central projecting arched gateway in the Biwi or Dadi ka Gumbad. The Bandi or Poti ka Gumbad is distinguished by an open hexagonal lantern right on top of the dome, a rather unique feature in itself. Biwi or Dadi ka Gumbad is the larger of the two and situated atop a small grassy knoll, both being right after the Green Park Free

FACING PAGE: Dadi ka Gumbad, near Aurobindo Market.

Poti ka Gumbad.

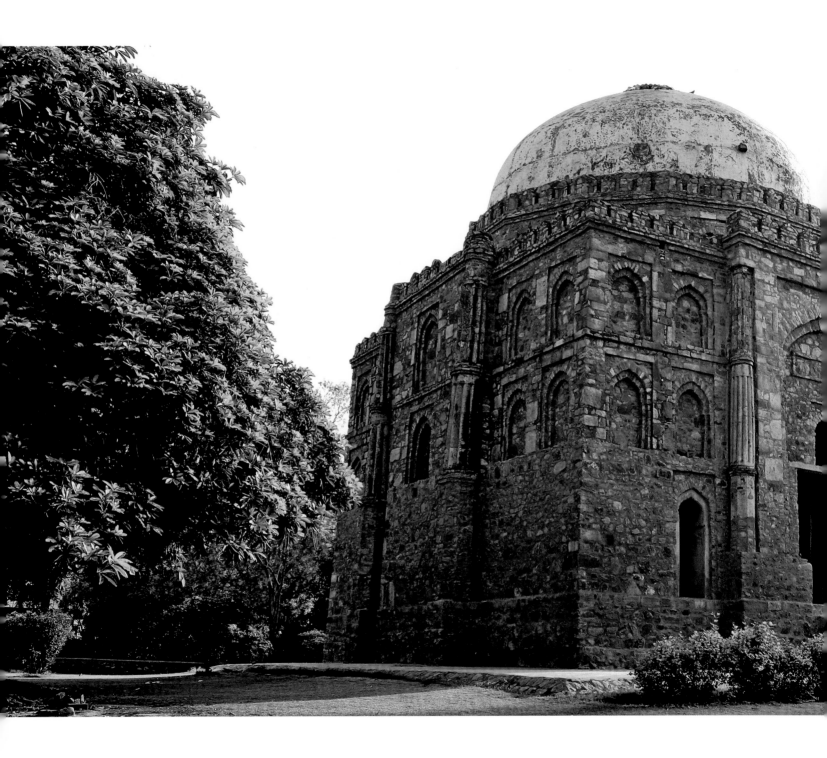

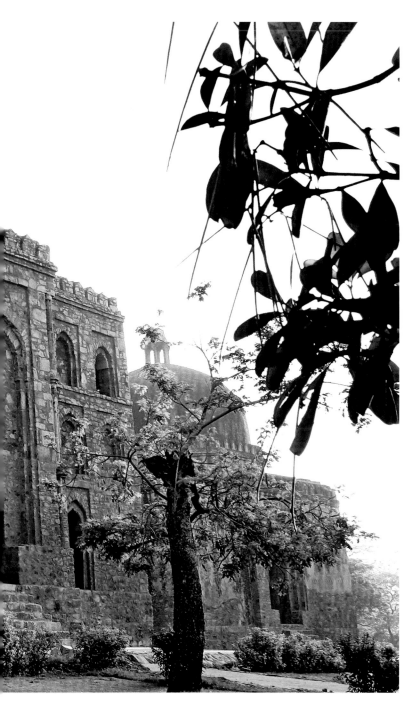

Church on the road leading to the Hauz Khas Village from Aurobindo Marg. The Biwi or Dadi ka Gumbad has panels of arched niches decorating its façade, while the Bandi or Poti ka Gumbad has none. Also, the latter has a slight batter or slope to its walls, making it a Tughlaq-period building. The granddaughter's tomb, architecturally speaking, predates the grandmother's!

Of the lot, the Bara Gumbad (big dome), on your left as you come down from Aurobindo Marg, is the least typical. Square like the others in its vicinity, it does not have the panels of arched niches decorating its façade. Also, the four walls have open arches, giving it the air of a large, handsome *chhatri* rather than a tomb. Then, just before a taxi stand, you will come across the Sakri Gumti (narrow dome), the Chhoti Gumti (small dome) and the Biran ka Gumbad (brother's dome)—all virtually within a stone's throw from each other. Again, the names, acquired no one knows when, give little clue to their history. There is nothing here to reveal who these people might have been or why they deserved these small but definitely picturesque tombs.

Situated in F Block, the Biran ka Gumbad stands on a low mound and has a well nearby. The Sakri Gumti, on the road leading to the Village but west of the Biwi or Dadi ka Gumbad, has arched entrances

Poti ka Gumbad peeps out from behind Dadi ka Gumbad.

on three sides and an open staircase leading up to the roof.

The Chhoti Gumti, on the same side of the road, is not a tomb since it contains no grave, but what purpose it might have served is not known. Much of its plaster has come off, revealing the random rubble masonry of its walls. The dome springing from an octagonal neck gives it a peculiarly elongated appearance. West of Aurobindo Market, on the road leading to the Village, stands the Barah Khamba (12 pillars). This one is clearly a tomb for it stands on a mound and is surrounded by graves. However, its local name is misleading as there is not a single pillar in sight. Incidentally, there are several monuments in Delhi called Barah Khamba.

Sheltering among the trees deep in the heart of the Deer Park at the far end of the road, the Bagh-i-Alam ka Gumbad presents a pretty picture, especially when viewed from the southern side where the entrance is located and where you can still spot vestiges of pretty coloured tiles. Built in 1501, during Sikandar Lodi's reign, it contains the grave of Mian Sheikh Shihabuddin Taj Khan, who some believe might have been a minor saint. An inscription on a black marble slab fixed on the western wall proclaims that it was built by Sultan Abu Said.

Like other tombs across much of South Delhi, there are arched openings on all three sides while

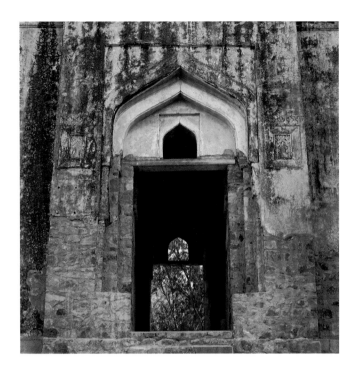

the western wall is closed with a prayer alcove in its centre. Also seen in the other tombs in the Hauz Khas area, South Extension and R.K. Puram are the tiers of arched niches decorating the outer walls—three in this case, giving it the illusion of a three-storeyed building. The use of red sandstone to ornament the main entrance signifies that the person buried here was of some consequence. Inside the dome chamber is a rather well preserved blue-painted interior with red bands running through, a bit like the one inside Mohammad Shah's tomb in the Lodi Garden. Several graves of

Entrance to the Poti ka Gumbad.

rubble and peeling plaster, and without inscriptions, offer no clue as to who else apart from Sheikh Shihabuddin lies beneath this picture-postcard pretty mausoleum. A staircase leading up to the roof on the eastern corner provides a bird's-eye view of dense green foliage and an illusion of a green oasis. Other features of the Bagh-i-Alam ka Gumbad are the *kangura* battlements and arched niches over doorways.

Also in the Deer Park, lie remains of several tombs, turrets and walled mosques—all belonging to the Tughlaq-Lodi period. There is the Kali Gumti with its dome sprouting a rooftop garden of weeds and grass. It contains no graves and old accounts say that villagers from this area—once called Humayunpur— used these *gumti*s to stock fodder. In the vicinity lie the Munda Gumbad (roofless dome), the Maluk Chand ka Gumbad and the Tuhfewala Gumbad (its name revealing nothing of whom it might have been intended for as a gift). This Tughlaq-period building with the quaint name has each side pierced by a doorway of grey local stone.

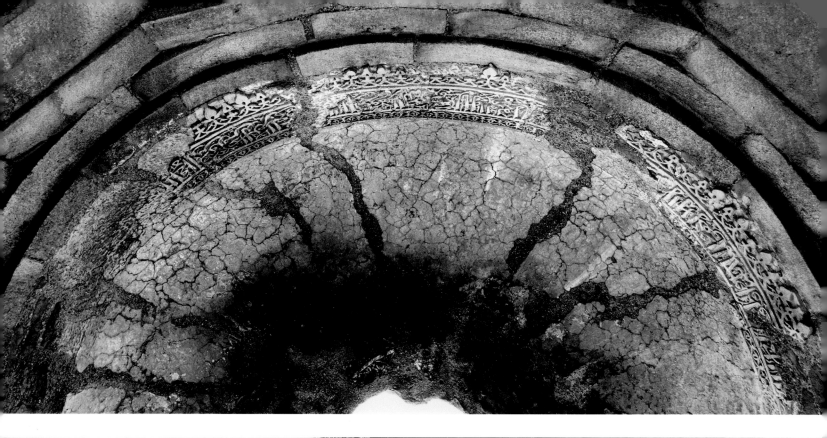
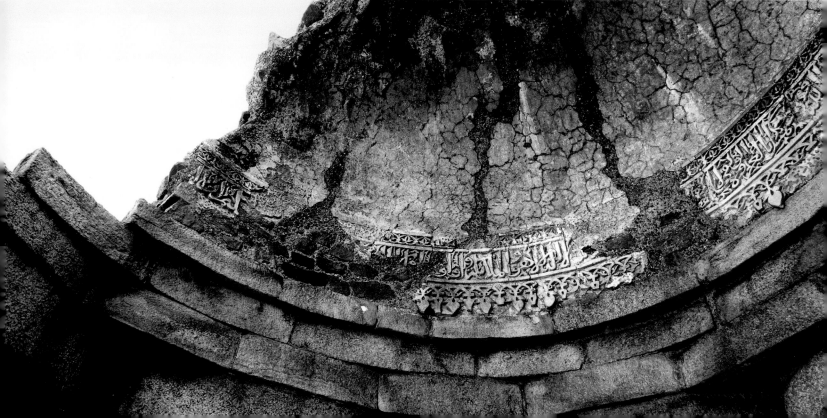

Darya Khan Lohani's Tomb and Teen Burji

Close to the market in Kidwai Nagar lie the remains of a grand three-tiered mausoleum. This is the tomb of Darya Khan Lohani, Mir Adil during Bahlol Lodi's reign and Minister during Sikandar Lodi's rule. Son of a nobleman called Mubarak Khan Lohani, Darya Khan died when Ibrahim Lodi was the emperor and was buried in this grand and spectacularly unusual mausoleum. Unlike any other tomb in Delhi, this is a majestic three-storeyed affair. For years now, its sole moment under the spotlight has been when the effigies of Ravan and his brothers Meghnad and Kumbhakaran are erected close beside it during the Dusshera festivities. For years no one paid any heed to the damage the noise and air pollution must have been doing to this already fragile monument, till INTACH moved the High Court to put an end to the onslaught in 2005.

Consisting of a platform made of three square tiers, Darya Khan Lohani's tomb on the top tier in the centre of the square, has a spacious, open-to-the sky look that is missing in the usual sepulchral Lodi-period tombs. Though bits and parts of the complex are not there any more, there is still enough to indicate that this must have once been a beautiful and sombre monument. Probably the only other tomb that has an open grave is the one of Najaf Khan in the Jor Bagh area.

Darya Khan's grave is in the centre of a large open platform set in a garden. The *chabutra* on the

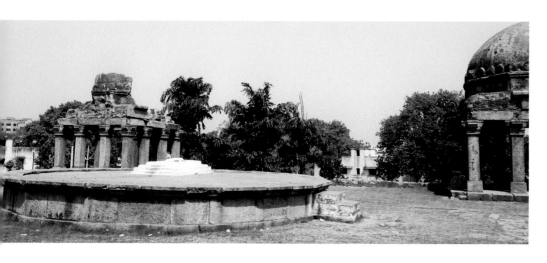

top has domed *chhatris* on its four corners. Of the four *chhatris*, only one has its dome intact. The 12 columns supporting the *chhatris* are present in each case. Traces of a colonnade and incised plaster on the roof of the *chhatris* also remain to tell the tale of a once proud-looking building. The

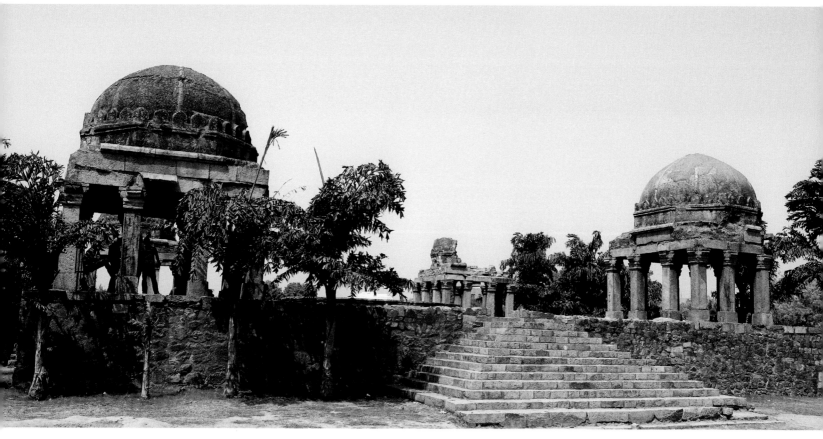

lower tiers show traces of rough stone staircases and a gateway on the east. Lying west of South Extension Part I, this area was earlier called the Ghatu Sarai and had several tombs and *gumti*s scattered about such as the tombs of Bade Khan, Chhote Khan, Bhure Khan, among others.

From Darya Khan Lohani's tomb, if you cross the Ring Road and drive along Africa Avenue, a little after the mammoth commercial complex of Bhikaiji Cama Place, on your right you will find an unusually large monument peeping out from behind some trees. It is called the Teen Burji (as distinct from the cluster of tombs in South Extension called the Teen Burj.) Situated in the village of Mohammadpur, this imposing Lodi-period tomb is built in an architectural style usually associated with mosques. It is possible that it was originally a mosque, and only later converted into a tomb. As its name implies, it has three domes—the central one being large and hemispherical and the

..

FACING PAGE ABOVE: An elegant Lodi-period tomb with a raised chabutara.

FACING PAGE BELOW: A maze of steps, tumbledown pillars and cracked platforms.

Steps leading up to a chabutara.

other two smaller and fluted. Built of large blocks of stone and finished with plaster (much of which is now gone), the structure has three chambers, each connected with the other with big archways. On the east is a small graveyard on a raised platform with several nondescript graves. On the west, private residences push and jostle their way virtually up to the monument. Along the south wall, a winding staircase leads up to the roof. Despite its high architectural value (INTACH grades it as Value 'A') and close-to-the-main-road location, it is woefully neglected. In fact, in May 2002 it briefly caught public attention when various conservation groups brought the flagrant building violations to the attention of the media. It is said, that till the early years of the last century, villagers had occupied the tomb, built small mud houses and used it as a cattle shed. Those were cleared out, but the village and its denizens have been nibbling away slowly and steadily at the space that the Teen Burji occupies.

A narrow gully leads straight from the rear of the Teen Burji to another tomb that is now a store of sorts. This pretty domed building, with arched niches on its façade, originally had doorways on three sides that have now been blocked by adjacent houses. Further up, a mosque is similarly broken down and assimilated into adjacent buildings.

Along the southern end of the Teen Burji is an octagonal tomb, virtually inaccessible due to the buildings close by. Only its eastern wall is visible, its roof has collapsed, while the rest has been absorbed into a private residence.

Along Africa Avenue, opposite Block B-2 of Safdarjung Enclave and to the north of St. Thomas Church at the southeast end of Mohammadpur village, stands a Tughlaq-period building with its distinctive sloping walls and small dome. This was once the tomb of Musa Khan, an unknown Afghan nobleman. Its north and south openings have been walled up, its eastern opening modified to a narrow doorway.

Teen Burji—a Lodi-period tomb.

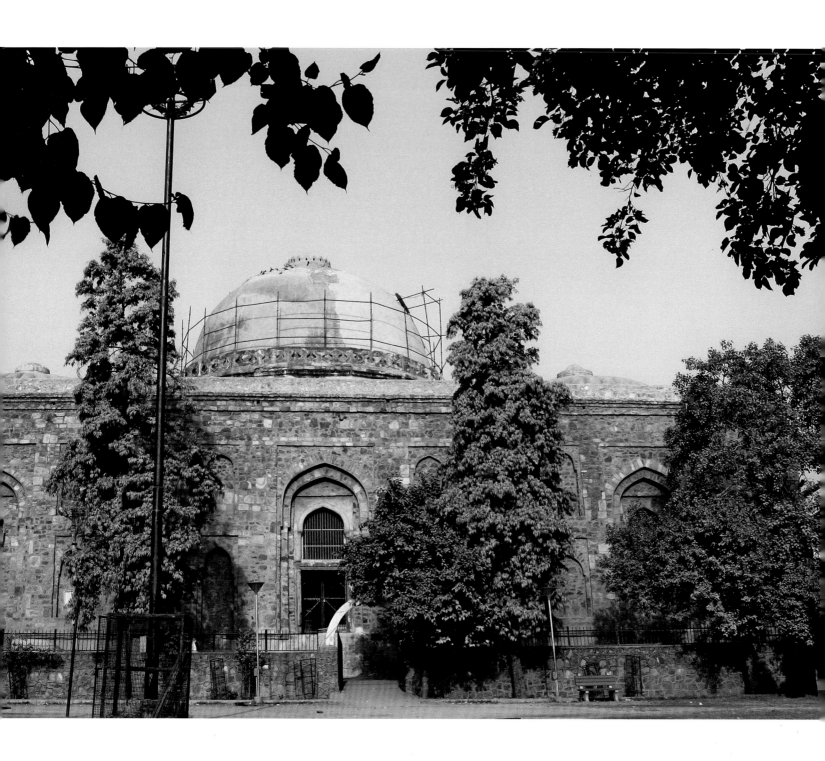

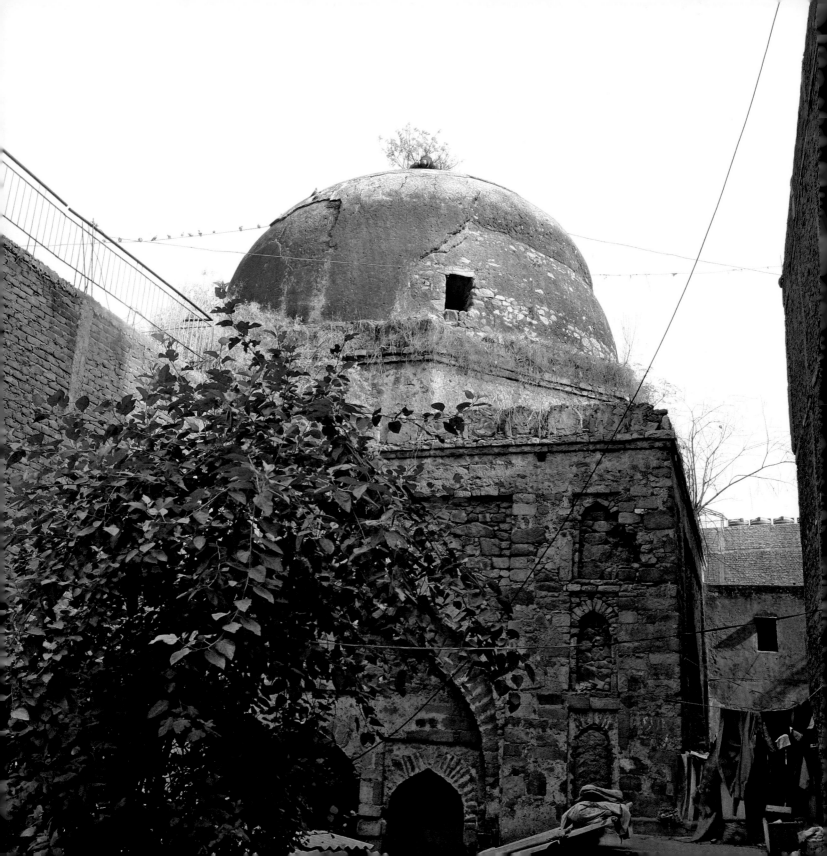

Tombs of Zamroodpur

FACING PAGE: Rising above the squalor of its surroundings.

Facing an unkind fate.

Opposite Lady Shriram College is the Bluebells School. A road on the right leads you to the village of Zamroodpur and its closely packed houses, shops and commercial establishments. Skirting the chaotic spill of this urban village are the well-tended homes and parks of Greater Kailash I. Zamroodpur and Greater Kailash cannot be more different from each other. An invisible cordon clearly demarcates the two spaces, labelling one as organised, the other unorganised.

A Lodi-period tomb inside Zamroodpur village speaks with all the eloquence of a caged mute animal. It stands hemmed in from all sides, all routes blocked and incorporated into private residential properties, with only the top of its dome and its mellow stone walls visible above the huddle. Despite the squalor and meanness of its surroundings, it tries to raise its head nobly above the congested byways. Its north, south and east walls once had recessed arches; they are now blocked and used for an assortment of domestic chores by those who have built their houses in unlawful proximity to its ancient walls. The western wall still has three *mihrab* recesses but the congestion all around does not permit close scrutiny. Nothing, however, can hide the high dome rising from an octagonal drum and the beautiful lotus cresting.

Close by, another Lodi-period tomb, similar in plan but smaller, faces a worse fate. It has been taken

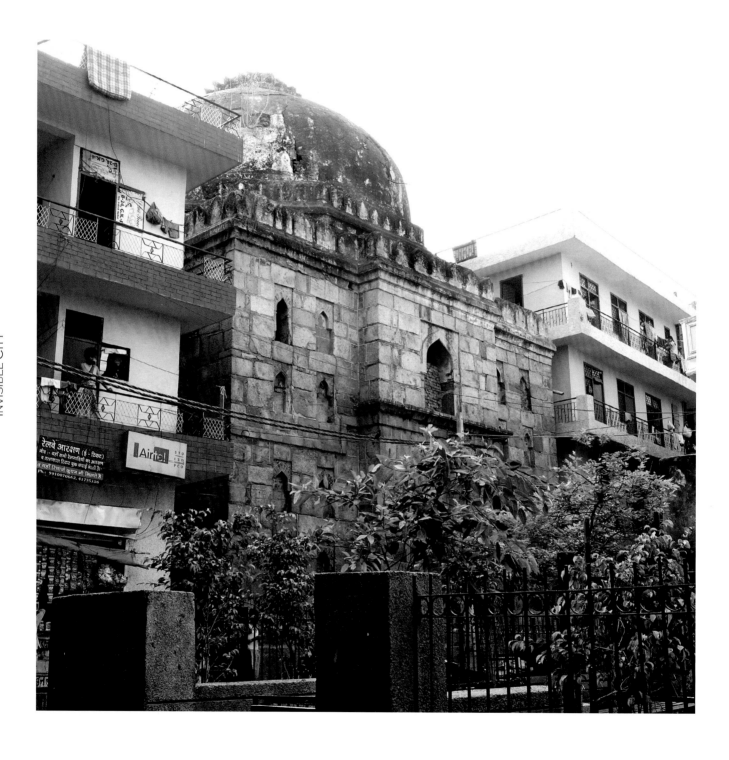

over by a *kabadi-wallah* and turned into a storehouse-cum-dump. While the northern side is blocked by new construction, you can slide in from a narrow gully from the south. The noxious fumes emanating from the various piles of assorted garbage do not encourage closer inspection. A small *gumti* houses cows and bulls. The brave, however, will be rewarded by a glimpse of still-intact incised plasterwork on its walls and ceiling. Wander about some more and you will come upon a pillared tomb near House No. 88. The tomb has 12 pillars of dressed stone and a small perfectly proportioned dome springing from an octagonal base. There are similar tombs in this area. In each tomb, you see very little of the walls since they are either hidden from view due to the clutter of buildings or incorporated into houses. The dome of each tomb, imperceptibly different in shape and size, yet uniformly proportionate and ornamented with lotus and *kangura* patterns, betray their presence in the midst of this sprawl.

If the rather belligerent bulls and cows do not chase you out of Zamroodpur village, the pungent, malodorous smells rising from the twisting-turning gullies will. You can seek the comparative serenity of a tomb set amid the landscaped lawns of Central Park and reflect upon the merits of crossing the *Lal Dora*. A little distance away, facing N Block of Greater Kailash I, stands a handsome Tughlaq-period building with characteristic sturdy sloping walls and a squat dome. There are red stone benches in the park, the grounds are clean and the tomb is reasonably well preserved. Yet, something about its appearance strikes you as odd. An asbestos-covered shed-like structure beside the dome disfigures the clean silhouette and rings the first alarm bell. Closer inspection reveals the boarded-up recesses and the white-painted doors with swastika and Om signs. This is no longer a tomb; it has been re-christened the Mahavir Library.

FACING PAGE: Speaking with all the eloquence of a caged beast.

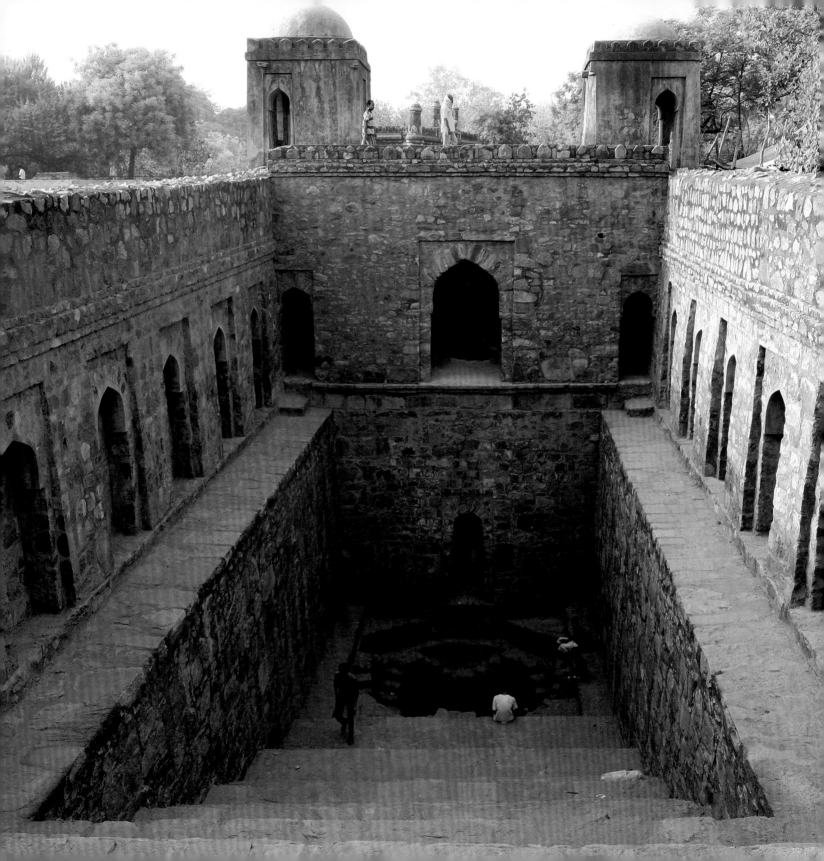

Wazirpur ka Gumbad

One of the seven tombs and mosques in the vicinity of Wazirpur ka Gumbad.

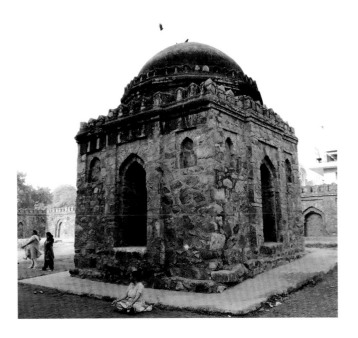

Government housing colonies are not exactly renowned for throwing up surprises. Sector V of R.K. Puram is a notable exception. Neither from the Ring Road nor from any of the arterial roads inside the colony, is there anything to indicate that a complex of rare architectural beauty lies hidden among its rows of solemn-faced houses with neat markings and fluttering laundry. Yet, you turn a corner and deep inside the cluster of government houses, a sight is waiting to catch you unawares. The Wazirpur ka Gumbad and seven other mosques and tombs stand in splendid isolation, forming an oasis of perfect calm and statuesque beauty amid the sheer ordinariness of their surroundings.

A school and a gurudwara on the western side of the complex flagrantly disobey building bylaws by encroaching upon the area around these Lodi-period monuments. Nibbling away at these buildings, not only do these unauthorised constructions obscure the monuments from view but also pose hazards to their conservation. Between the school and the gurudwara, a lopsided iron gate allows entry. The very first building on your left is a magnificent wall mosque. It has seven arched recesses in its façade, the central one being the most well defined. Like the tombs, it may have once been plastered; the plaster is long gone and the random rubble masonry is all too visible. The central *mihrab* stands out with its more pronounced niches and its height.

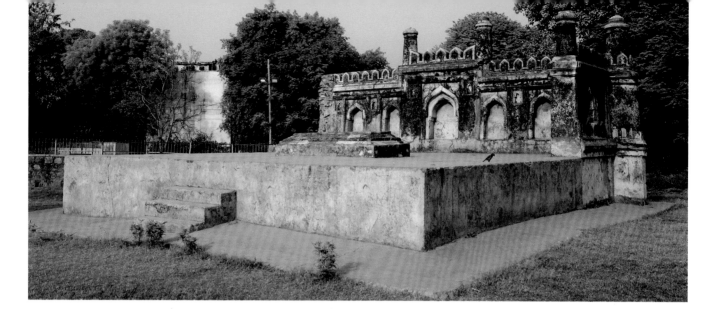

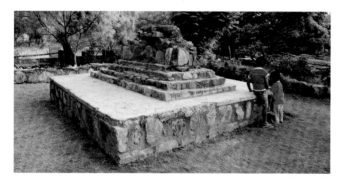

A little ahead lies a beautiful little *baoli*, also belonging to the Lodi period. Its presence here indicates that this area once had a large population. So, obviously, at the time it was built, this was not merely a large and isolated royal graveyard but enough people lived here to warrant a *baoli* for water harvesting and water management. The 30 m x 11.6 m *baoli* is in reasonably good shape though it no longer has water in it. There is a well at the southern end, flanked by domed turrets that contain narrow winding staircases leading to the bottom. Risk life and limb if you wish to explore the deep innards of the *baoli* for its steep stairs can be vertigo-inducing in the faint-hearted. The school at the west end adjoining the *baoli* clearly threatens its conservation.

Standing with your back to the *baoli*, you get a clear view of the magnificent cluster of tombs, five in all and of different sizes. The biggest, called the Wazirpur ka Gumbad, is the cleanest and the best preserved. Like much in South Delhi, why it is called what it is, no one knows. There is no plaque to indicate who might be buried here, or how it acquired its name. Or, for that matter, why is it the only one among its cousins to have a name, since the other tombs and mosques and the lone *baoli*

ABOVE: A wall mosque with a raised platform.

BELOW: No one knows who lies buried here.

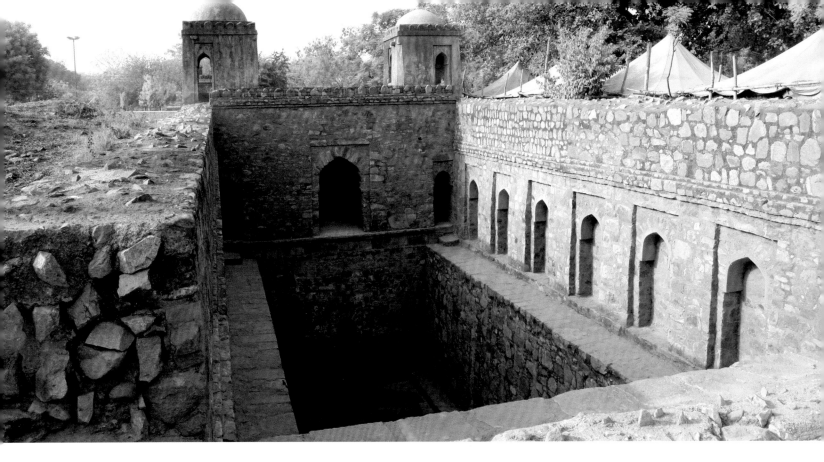

in Sector V of R.K. Puram are nameless! Some, in fact, do not even contain a grave despite having all outward appearances of a tomb.

The Wazirpur ka Gumbad stands on a raised plinth and has a high dome springing from an octagonal drum. There are triple open archways on the north, east and south walls and, as is typical of many tombs of the Lodi period, the façade is decorated with tiers of arched niches and openings. Though nothing is known of the persons who lie buried here, these graves are said to be venerated by villagers from nearby Munirka who often come here and also keep the inside of the building clean.

An unknown grave.

ABOVE: Another view of the baoli.

The other tombs, all in close proximity of the Wazirpur ka Gumbad, are roughly similar, except for one interesting fact—the domes of each are of distinctly different types ranging from squat to low to high to hemispherical. All must have once been plastered, but the plaster has peeled to reveal the random rubble masonry of their walls. Their doorways are spanned by corbelled openings and the walls have arched openings except for the smallest tomb whose three sides have been blocked off.

Facing the Wazirpur ka Gumbad, in its well-kept grounds, is another wall mosque. This one, however, is smaller (having only five *mihrab*s) and more broken down than the one on the other side of the *baoli*. Strangely enough, it is not oriented the same way as the other wall mosque or the tombs in the complex, that is, instead of being west-oriented, it is at a curious incline. Decorated with *guldasta*s and minarets, it is built on a raised platform. Its small size indicates it was built along with one of the smaller tombs to serve as a place for offering prayers for the dead. It retains the return walls on the north, the one on the south having collapsed.

Also in Sector V, located in the Government Senior Secondary School, southwest of the Wazirpur ka Gumbad complex, is another wall

Another unknown Lodi-period tomb in the cluster of tombs in Sector V, R.K. Puram.

INVISIBLE CITY

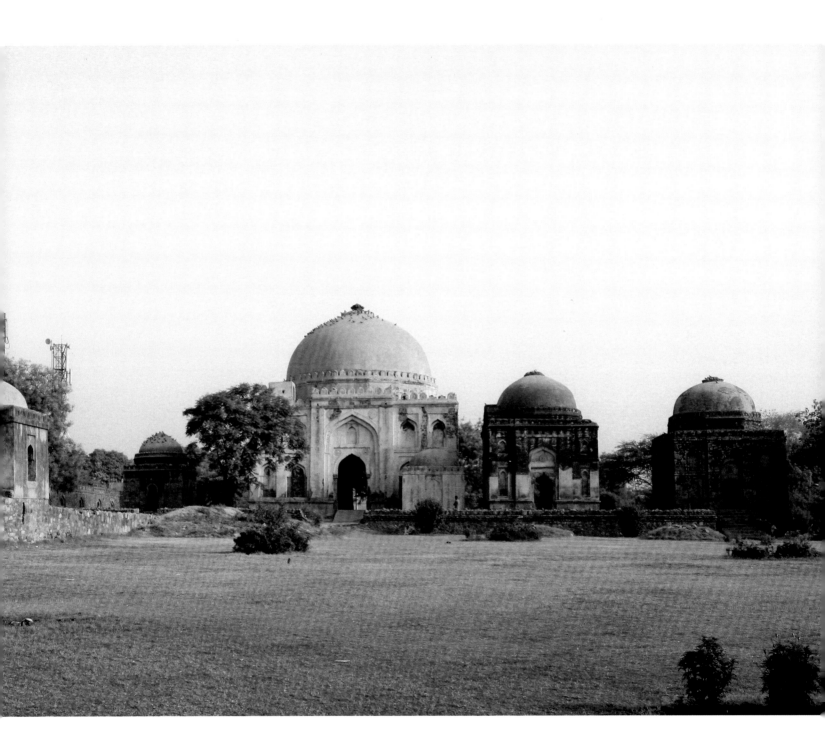

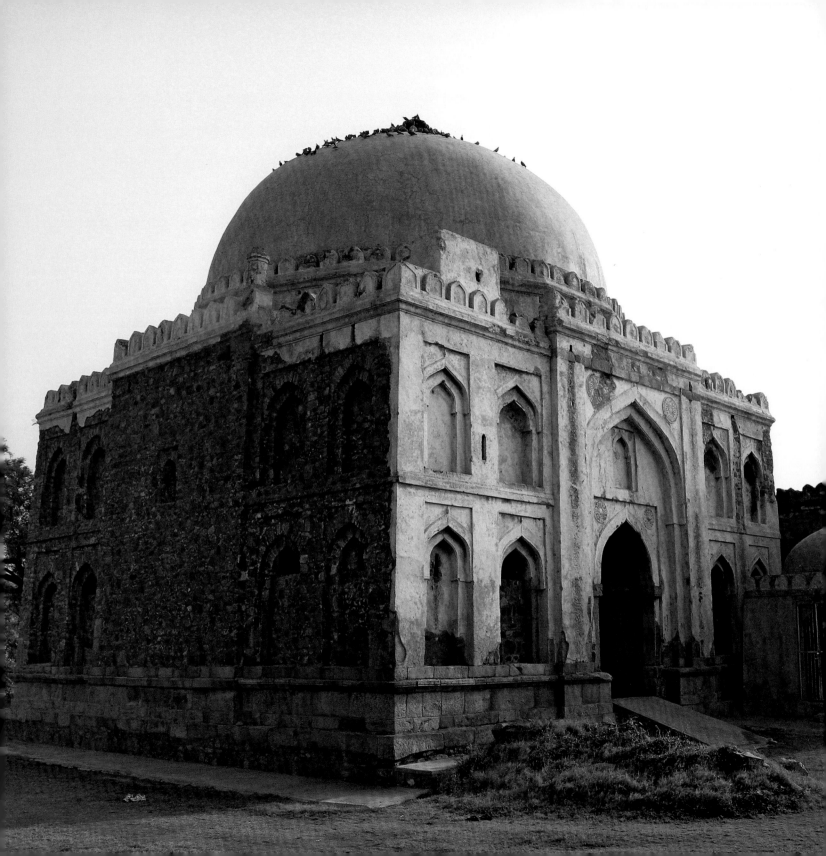

mosque belonging to the same period. Its west wall has seven arches and is flanked by octagonal bastions at either end.

A courtyard is accessed by a flight of steps at the eastern end. Other features include minarets and battlements. The vagaries of time are such that, despite little attempts at conservation, this is the only wall mosque from among six similar structures in this area that still survives in its original condition. Though there are trees and wild vegetation aplenty, somehow no major damage has been done to the monument itself.

In contrast, there is a mosque, a conventional four-sided, closed one and not an open, wall mosque, in the southwest of Sector V adjacent to the shopping area, which has been altered beyond recognition. It stands on a high platform and its plastered façade, its many 'renovations' and numerous 'additions' over the years tell its own tale. In fact, they make you wonder why we cannot adopt a middle path—one that treads between altering historically significant architecture and conserving it in its original shape and form.

Among the cluster of tombs, the biggest is called Wazirpur ka Gumbad.

MUGHAL
DESIGNED TO REMEMBER

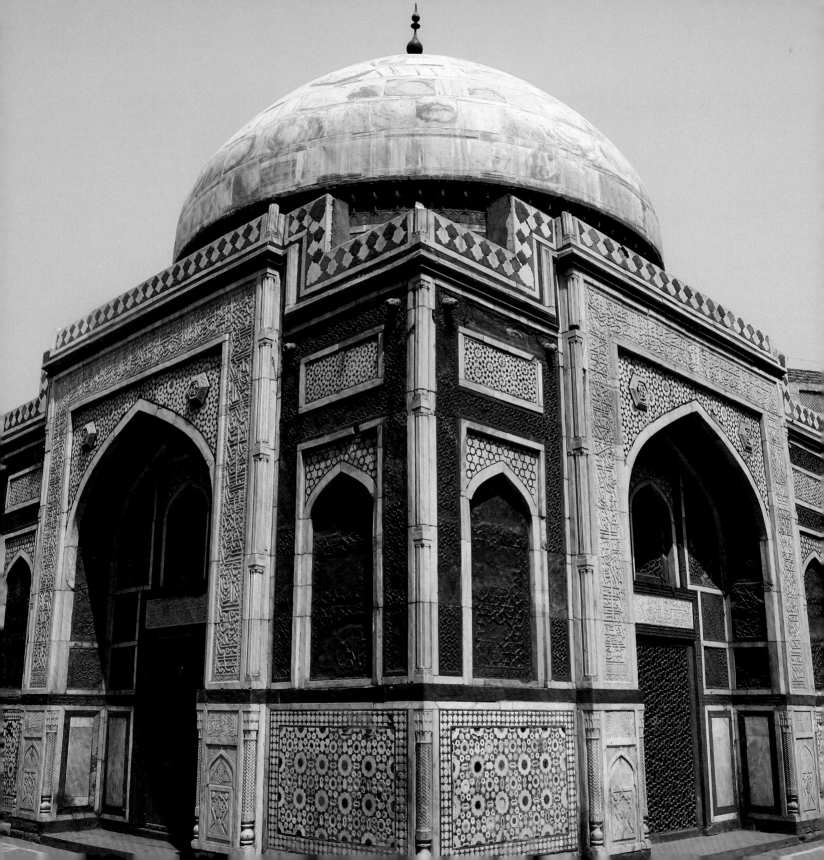

Tombs of Atgah Khan and Adham Khan

Inside the tomb of Adham Khan.

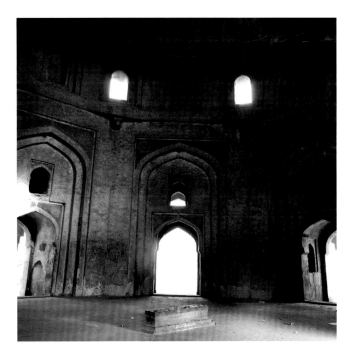

The tombs of Atgah Khan and Adham Khan are linked by a queer quirk of destiny. Belonging to two different people, both nobles in the Mughal court who were unrelated by blood, situated in different parts of Delhi, one in Nizamuddin West and the other in Mehrauli, and built in markedly different architectural styles, they do have one thing in common: that being the towering personality of Emperor Akbar. And thereby hangs a tale ….

Akbar lost his parents while still a lad. He grew up under the tutelage of Bairam Khan and the fostering care of Atgah Khan. His wet nurse, Maham Anagah, too, played an important role in the early years of his life, and more so after the assassination of Bairam Khan. She tended Akbar virtually from the cradle and waited upon him till some years after his accession to the throne. According to contemporary chroniclers such as Abul Fazl, Maham Anagah began to exercise undue influence not just on matters of the harem but also on matters of the state. Like all mothers, she also grew increasingly ambitious about her own son, Adham Khan, who had grown up with Akbar and whom the young Emperor looked upon as a foster brother.

The mother-son duo, fearful of losing their hold over Akbar's affections, grew jealous of the other courtiers. Akbar's love and dependence upon the nobleman called Atgah Khan, husband of yet another wet nurse named Ji Ji Anagah, was a

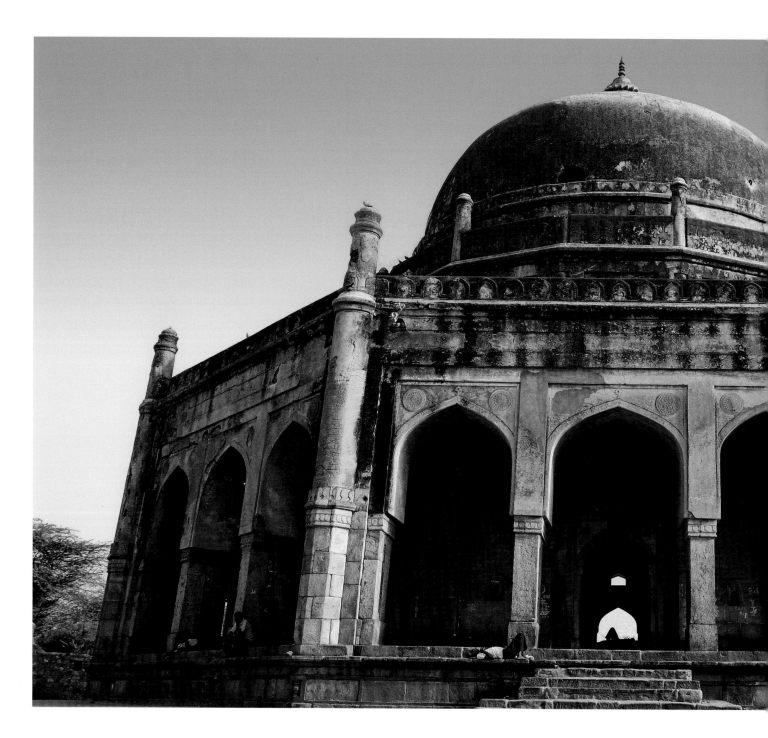

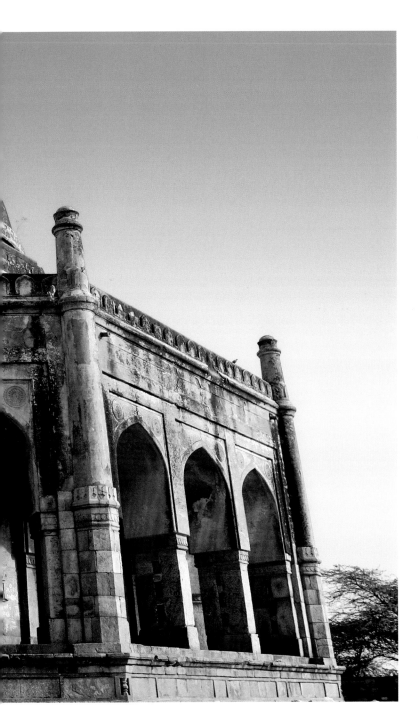

The tomb of Adham Khan.

special thorn in their side. Moreover, Atgah Khan had helped Akbar's father, Humayun, escape after suffering defeat at the hands of Sher Shah Suri. For his loyalty, Humayun had appointed his wife Ji Ji Anagah as wet nurse for Akbar and bestowed several titles upon Atgah Khan. Akbar, therefore, not merely relied upon his sage counsel but also considered him a father figure.

One day Atgah Khan and Adham Khan quarrelled and the latter murdered Atgah Khan. Adham Khan then rushed to Akbar's private apartment with the blood still fresh on his hands. Enraged to hear that the young and foolish Adham Khan had killed a man he loved dearly, Akbar is said to have seized Adham Khan, carried him across the length of the apartment and thrown him over the terrace with his own hands. According to other accounts, Akbar ordered Adham Khan's hands and feet to be bound and then had him flung over the terrace. From that day on, Akbar deposed Maham Anagah and thus ended her brief chapter in the books of history. The grieving mother later built the large, grim-looking tomb in Mehrauli for her foolish, headstrong son. She lies buried close beside her son.

The tomb she had constructed is a bit of an architectural anomaly; a typically Lodi-style structure built during the Mughal period, it arouses some

curiosity because of the peculiarity of its construction. An octagonal building with verandahs on all sides and three arches on each of the eight sides, it is built of grey sandstone and rubble and is reminiscent of Muhammad Shah's tomb in the Lodi Garden.

Situated opposite the bus terminal in Mehrauli, few would know it by its real name. Locally called the Bhul Bhulaiyya, it is more famous for the labyrinthine maze of passages cut in the thickness of its stone walls than the life and times of the man who lies buried here.

It has low round towers on the eight corners of the platform on which the tomb stands, small, slender minarets on each of its eight-cornered verandah, and a wide-bottomed dome springing from a 16-sided drum.

The dome is, inexplicably, surmounted by a red sandstone finial, the only bit of ornamentation in this otherwise severe building. Despite the no-frills architecture, vandalism has taken its toll here, as in most other buildings in the Mehrauli area.

Atgah Khan's tomb, built by his son Mirza Aziz Kokaltash, is as different from Adham Khan's as chalk from cheese. A truly spectacular Mughal-style monument, in fact, one of the few Akbar-period buildings in Delhi, this handsome red-and-white tomb rises majestically from the huddle of its surroundings, refusing to be swamped in the sea of clutter and chaos that marks the Nizamuddin Dargah complex.

The first sight of its façade, worked in elaborate detail with red sandstone and stunning white marble interspersed with colourful tiles, takes your breath away. Standing in a walled enclosure, its four walls are studded with deeply recessed arches, containing latticed stone screens. The ones in the south are left open, allowing access to the inner chamber, which once had beautifully painted plaster work, now marred with age and neglect.

There are three graves inside—Atgah Khan's, Ji Ji Anagah's and that of a third unidentified person. Atgah Khan's tomb stands on hallowed ground, not merely because of its proximity to the grave and hospice of the venerable Hazrat Nizamuddin Auliya, but also because there are the graves and tombs of those singled out by destiny to play special roles.

There is the tomb of Amir Khusrau, regarded by many as the earliest proponent of the *Ganga-Jamuni* culture. He wrote with equal ease in Persian and Hindavi, addressing both, the connoisseur and the common man, with the same flair. Court poet to seven Delhi sultans, he lived through one of the most tempestuous periods of history (1253-1325).

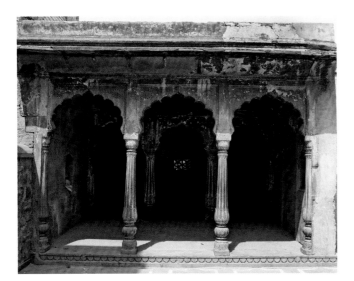

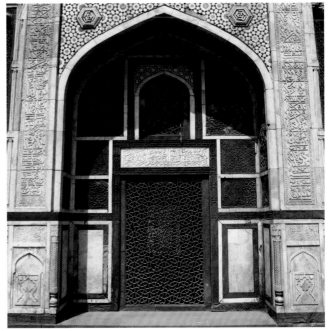

Close to Atgah Khan's tomb is the grave of another famous Delhi poet, the much-loved Mirza Ghalib, and the grave of Princess Jahanara, sister to Aurangzeb, daughter of Shah Jahan and Mumtaz Mahal. The white pavilion was built over Ghalib's simple grave in the twentieth century, while Jahanara's grave is inside a simple marble *jaali* enclosure, open to the sky.

The epitaph in Persian, which she wrote herself, reads as follows:

Let nothing but the green grass cover the grave of Jahanara
For grass is the fittest covering for the tomb of the lowly.

Most days, you will also find some rose petals strewn over the grass, scattered by those who cherish the words of this Mughal princess centuries after her death, reminding us that simplicity and goodness are remembered long after the crimes and passions of men such as Atgah and Adham are forgotten.

RIGHT: Intricate jaalis fitted in the arches of Atgah Khan's tomb.

LEFT: Dalan adjacent to the tomb of Atgah Khan.

FACING PAGE: A carved pillar in Atgah Khan's tomb.

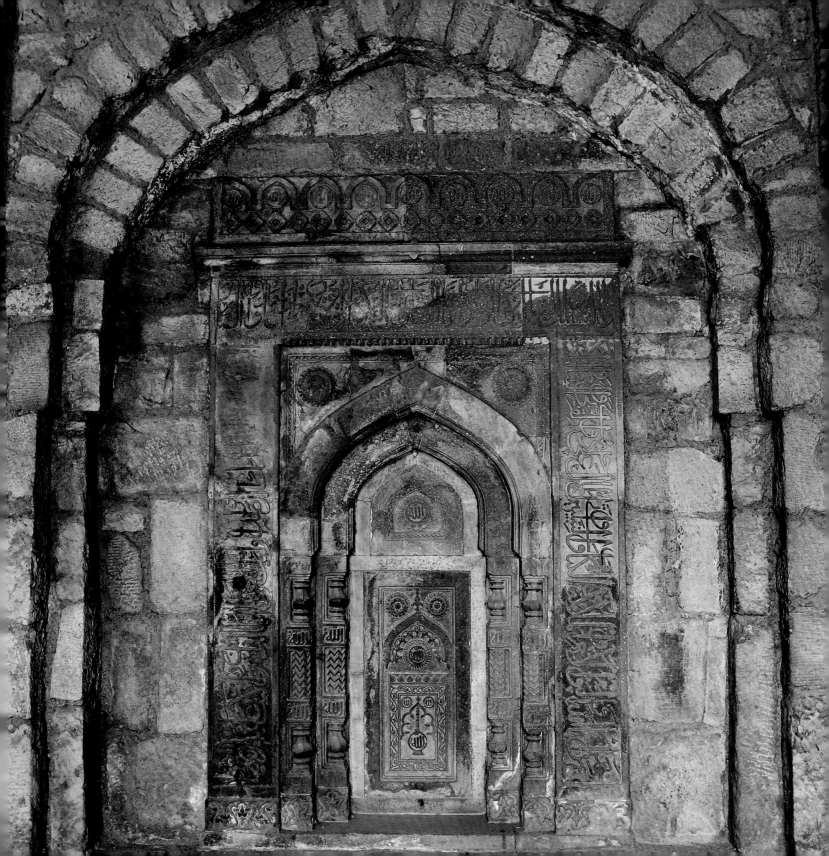

Jamali Kamali

The tomb of Jamali Kamali.

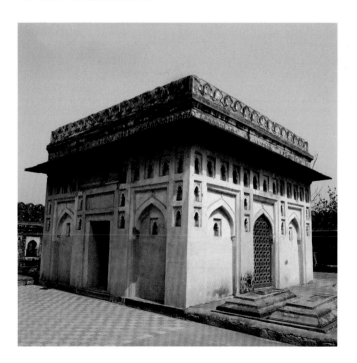

It is not easy to find the tomb of Jamali Kamali. There is just a small insignificant board marking the final resting place of this sixteenth-century poet-saint, tucked away inside the sprawling Archaeological Park. The stream of traffic hurtling down from Gurgaon is more likely to stop at the flower market in a cul de sac right beside Jamali Kamali's gate in search of hothouse orchids at retail prices. For those who commute regularly between Delhi and Gurgaon and zip past this stretch called the Mehrauli-Mahipalpur road, the tomb and mosque of Shaikh Fazlullah, better known by his *nom de plume*, Jamali Kamali, might as well be invisible.

The Archaeological Park, a name given by the ASI to a rocky tract of land around the Qutub complex, literally dotted with monuments in various stages of rack and ruin, offers an embarrassment of riches as far as historical monuments are concerned. Yet, few Delhiites bother to stop and stare let alone stop, enter, see and touch some of these beautifully crafted relics. And the great pity is that unlike the West, entry to almost all these monuments is free.

There is more history in this Archaeological Park per square inch than anywhere else in the world, possibly even more than in Rome and Athens. Several Delhis lie buried here, sometimes overlapping each other, sometimes in layers, occasionally one was cannibalised to build the other. Unlike some of the later Delhis, this area in present-day Mehrauli

has been continuously inhabited since the time of the early Tomar and Chauhan chieftains and built upon ever since. And nestling among these rocks and ruins of the many Delhis is a rare gem—the beautifully preserved mosque and adjacent tomb of Jamali Kamali.

You might think that seeing one old mosque is as good as seeing them all. But each place has a distinctive 'feel' and ambience. The Jamali Kamali

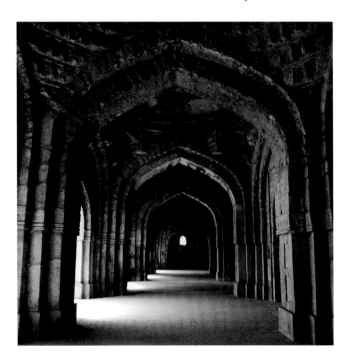

exudes that rare combination of striking beauty and serenity, especially since you least expect to find such a well-preserved monument in the midst of such wilderness. Dreary, disconsolate tombs suffuse the landscape. There is Balban's tomb nearby that

seems a maze of dilapidated arches and little else. There are the ruins of a colonial-style building—the entrance to an estate called Dilkusha built by Thomas Metcalfe, Resident at the Mughal court in 1844—incongruously English in a landscape dominated with mostly Islamic architecture. The DDA Park in which the Jamali Kamali is situated has a profusion of domed buildings, *dalan*s, collapsing mosques and crumbling arches. In the midst of this desolation, the Jamali Kamali catches you unaware.

Built in 1528-29 during Babar's time, by Shaikh Fazlullah himself, the tomb was completed in 1536 and the mosque a little later. Built in the late Lodi style, the mosque is strikingly similar to the Qila-e-Kuhna Masjid in the Purana Qila. This was obviously not a congregational mosque, since it does not have a *sehan*. Probably meant to service the adjacent tomb and graveyard, there is space for the faithful to pray only inside its vaulted five-arched prayer hall. The original gate to the mosque lies to the north, encircling the building in a low compound wall. You enter through a simple gate on the east to face a breathtaking western façade, a striking combination of red and buff decorating its five arches.

The central arch is taller and bigger than the two on either side. It has a *jharokha* above its recessed inner arch and is richly decorated with *mihrab*s.

Profusely ornamented prayer chamber inside the mosque.

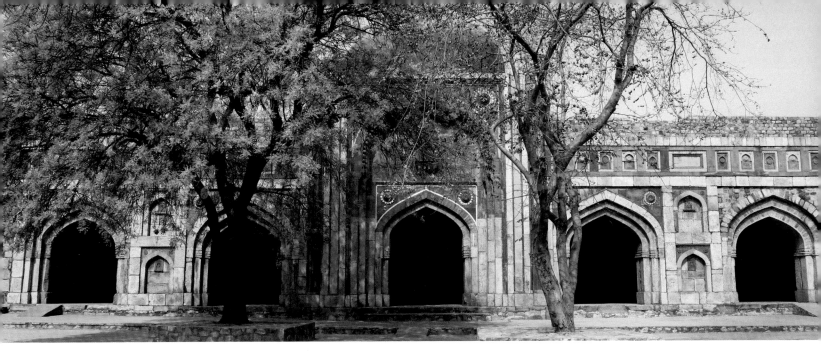

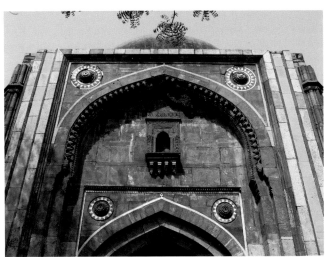

Red sandstone lotuses are set within a geometric pattern of white marble and incised medallions, alternating red and white ones, adorn either side of the recessed arches. The central arch juts out from the others in a row and is flanked by fluted pilasters on either side, a bit like miniature Qutub Minars, to enhance the importance of the central arch. Inside, the prayer chambers are richly ornamented with elaborately carved *mihrab*s. There is no pulpit, again serving to advance the notion that this mosque was not used much, except for funeral prayers at the adjacent tomb. A single cylindrical dome topped with a full-blown lotus sits gracefully above the building. On either end, staircases lead up to a gallery that runs round the mosque. It was from here that the *muezzin* would have made his call. Another set of much narrower stairs on either side lead to octagonal towers that offer excellent views of the surrounding landscape. It is hard to tell

ABOVE: The breathtaking western façade of Jamali Kamali's mosque.

BELOW: Red sandstone lotuses on either side of the central arch.

if these were lookout posts or mere ornamental devices for an otherwise plain outer façade. The outer western wall is simple and sturdy; the north and south walls, however, do have carved *jharokha*s.

The entire structure is a beautiful specimen of the mosque in transition, from late Lodi to early Mughal, completed

as it was during Humayun's reign. The minarets have still not made an appearance. A large single dome has come to replace the row of eggshell mini domes as in the Begumpuri Mosque or the three squat domes as in the Moth ki Masjid. The proportions are becoming more elegant, the carving finer, the use of colour more striking, and the deeply recessed arches more graceful.

From a small gate on the north you enter the funerary enclosure where a small square flat-

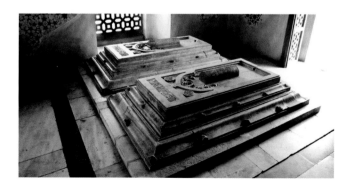

roofed tomb houses two graves. Shaikh Fazlullah or Jamali is believed to be buried in one of these marble graves. Alongside, there is another unmarked grave popularly known as being that of some unknown person called 'Kamali'. By all accounts, the name Jamali Kamali came into being strictly on grounds of euphony—a bit like Jantar Mantar. Whatever be the reason, the poet-saint who lies buried here is destined forever to be known by the double-barrelled Jamali Kamali. Variously known as Jalal Khan Jalali and Shaikh Jamali, he was initiated into Sufism by the charismatic Shaikh Samauddin. At his *pir's* suggestion, he is said to have changed his *nom de plume* from Jalali ('awe-inspiring') to Jamali ('loveable'). Jamali was passionately fond of travelling and often embarked on long voyages. He travelled to Mecca, Medina, Yemen, Syria, Iran, Iraq and, en route to Delhi, visited Ceylon to see the footprint of Adam. Wherever he went, he met Sufis and poets and exchanged stories with them, which

..

ABOVE: Flower motif embedded the blind arches.

BELOW: The graves of Jamali Kamali.

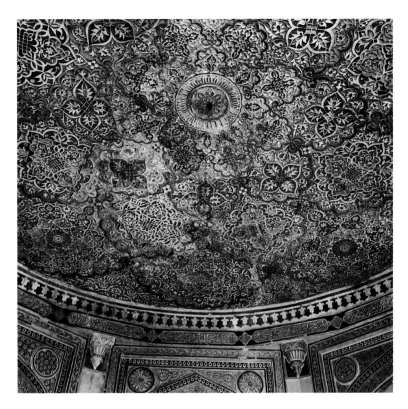

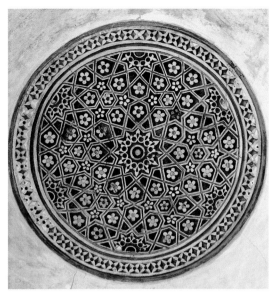

By the cloud of your kindness, the dust of sin has been washed away; but not the blot of our shame.

he later wove into his own *masnawi*s. Contemporary chroniclers compiled many of Jamali's witticisms, especially his exchanges with the Persian poet, Jami. Jamali lived through the reigns of several emperors and wrote a joyful panegyric on Babar's conquest of Hindustan. Later he accompanied Humayun on his expeditions and is said to have died during Humayun's campaign in Gujarat.

Some of his verses can be seen inscribed in bands on the walls above his grave:

If I should have the honour to approach the curtain of your secret, an angel will be proud to act as our porter.

O Jamali! Resort to the friend's door for protection, for our refuge is the door of the beloved.

The inside ceiling is covered with exquisite stucco in blue, green and white. Like the mosque, the tomb, too, is amazingly well preserved. A border of exquisite blue tiles runs on the outer walls. A carved red sandstone *jaali*, surprisingly intact and not vandalised, allows you to peep in on days the chowkidar has locked the heavy wooden door to the tomb and gone away. A canopied grave occupies one corner of the enclosure, probably belonging to a

close disciple, and several simple graves are scattered in the enclosure and in the adjacent graveyard, separated by a wall. The tomb and the funerary enclosure are surrounded on three sides with a wall set with open arches. Sit propped in one of these arches, close your eyes and soak in the atmosphere of the Jamali Kamali. Birdsong wafts in from the dense foliage all around.

A vividly coloured parrot flies low overhead to disappear in the *keekar* bushes behind the compound walls. The only sound is the twitter of birds and the rustle of leaves. There is an amazing peace here—no loiterers, certainly none of the ubiquitous lovers that plague most Delhi monuments and, surprisingly, none of the 'Shalu loves Raju' variety of graffiti that mars the venerable Lodi tombs. There are visitors, and in winter picnickers aplenty in the landscaped lawns and rose garden nearby, but no one seems to come up to the tomb much. Even the ASI does a fair job of keeping the place clean, though it is odd that the janitor seems to think the safest place to house the brooms, buckets and assorted mops is the locked funeral chamber of the poet-saint!

Carved motifs and medallions—a medley in marble.

PAGE 207:
LEFT: Richly decorated inner dome of the tomb.

RIGHT: A brilliantly coloured medallion.

FACING PAGE: The exquisitely decorated funerary chamber of Jamali Kamali's tomb.

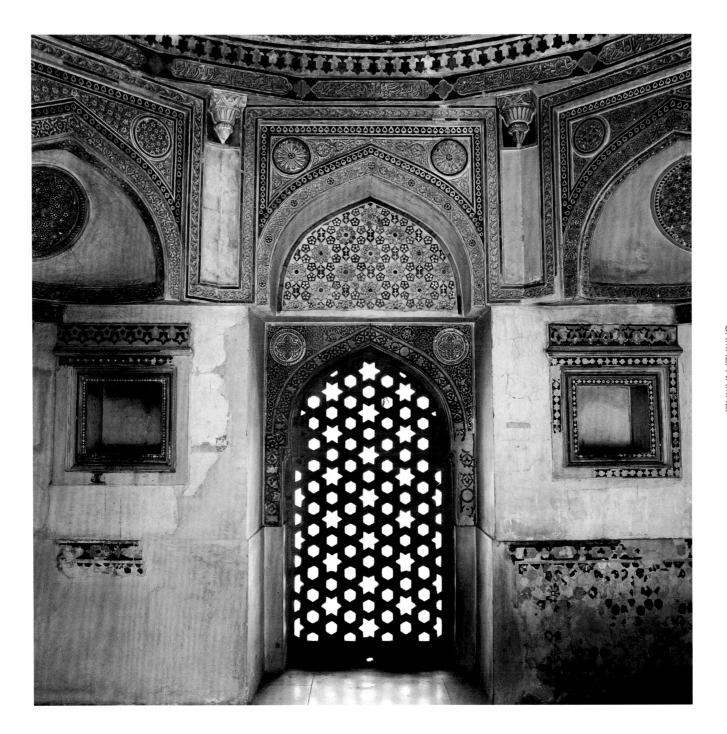

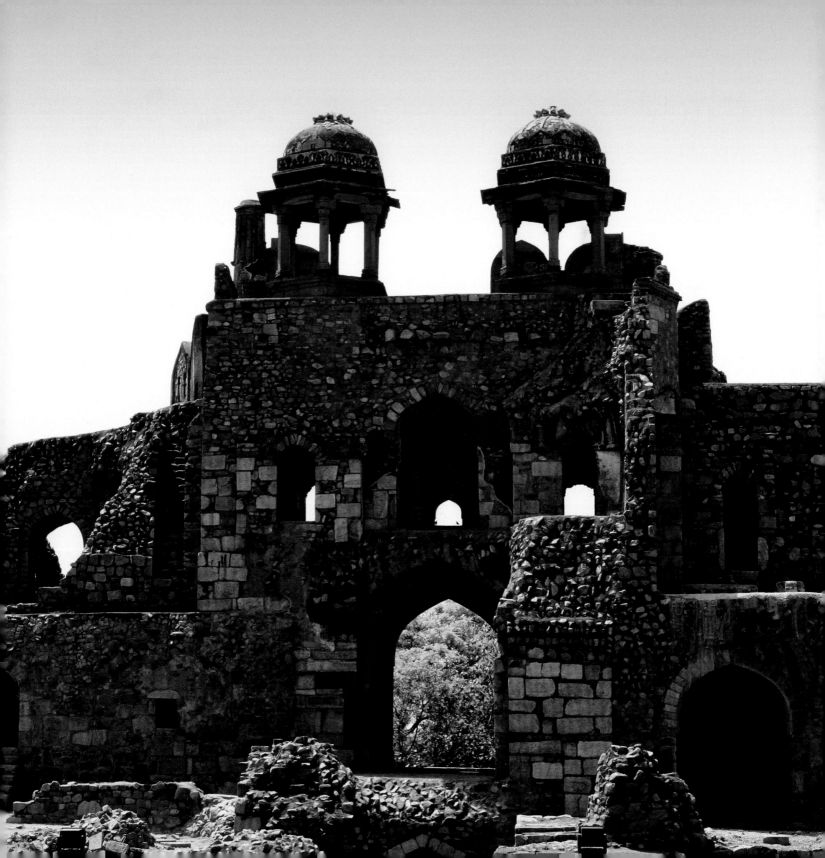

Inside Purana Qila

FACING PAGE: One of the gates leading into Humayun's Dinpanah.

Inside the Qila-e-Kuhna Masjid.

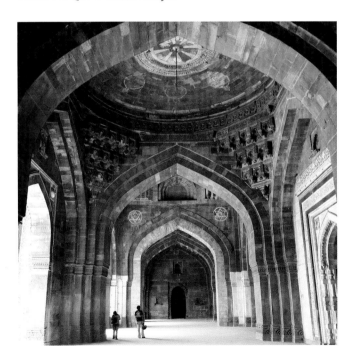

The Qila-e-Kuhna Masjid inside the Purana Qila on Mathura Road is by far the prettiest mosque in all of Delhi. It may not have the scale and grandeur of the Jama Masjid but it certainly has the most pleasing of proportions and the most eye-catching surface decoration in any mosque that I have seen.

A Rs. 5 ticket lets you inside the ramparts of the old fort and allows you to explore the monuments at this ancient site. The fabled city of Indraprastha is said to be located here. Several centuries later, Humayun built his Dinpanah on this very mound beside the Yamuna. The Afghan noble Sher Shah Suri usurped power from Humayun for a brief spell and launched his ill-fated Sher Garh. However, once Humayun returned to reclaim the throne upon Sher Shah's death, Shergarh became assimilated into Humayun's own ambitious building projects. Several buildings that were actually initiated by Sher Shah were either completed during Humayun's reign or put to different use by the new Emperor.

Meaning the 'mosque of the old fort', the Qila-e-Kuhna Masjid was built in 1542. It occupies an important position in the development of mosques. It shows, the transition from the squat, sloping-walled, sturdy Lodi-type mosques to the more refined Mughal-period mosques. It is similar in style to other mosques of roughly the same period—the Moth ki Masjid and the Jamali Kamali—but is larger and, befitting a royal mosque, far more elaborate.

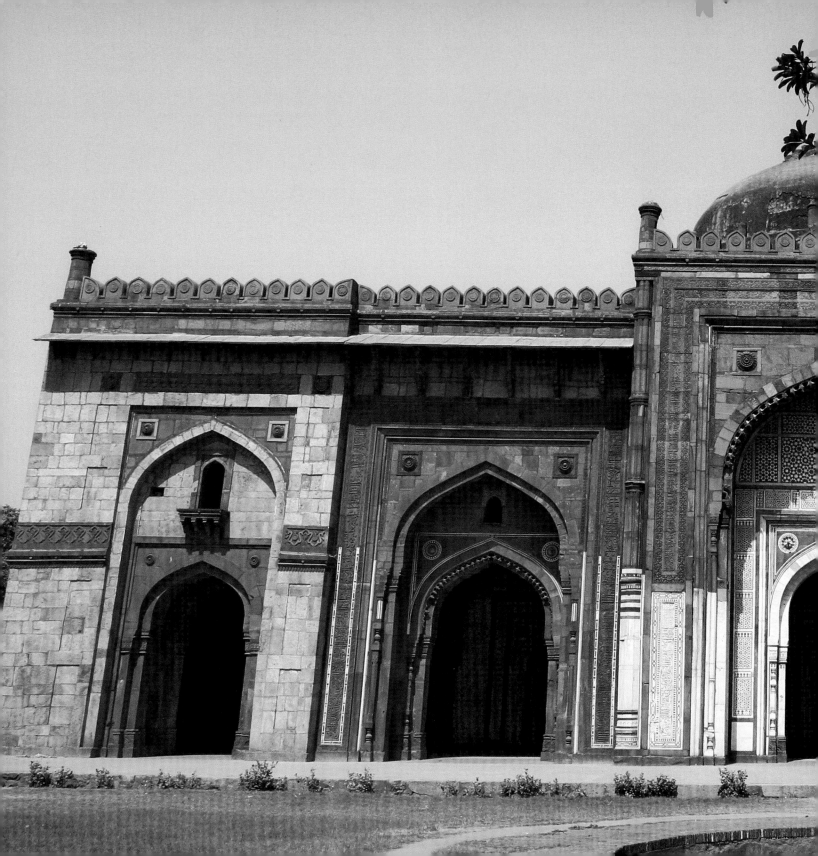

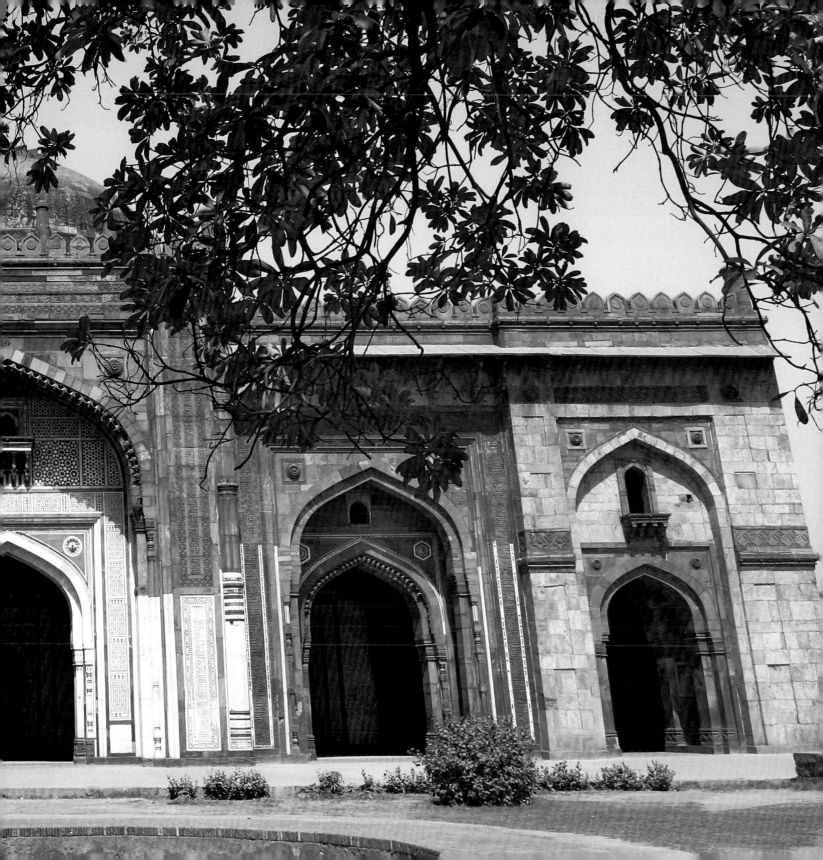

The east-facing rear wall, which is the first thing you see as you walk in from the Bara Darwaza on Mathura Road, is studded with oriel windows and flanked on either side by double-storey semi-octagonal towers topped with *chhatris*. A red-and-white border runs through the outer wall and traces of tile work in startling blue can be seen along the edges of the windows. But nothing prepares you for the stunning visual feast waiting as you turn the corner and look at the splendid western façade. Five perfectly proportioned equal-sized arches, the central one framed within a projection and flanked by narrow fluted pilasters, are decorated by the finest inlay ornamentation seen anywhere except maybe the Taj Mahal. Contemporary historical accounts say: 'much gold, lapis lazuli and other precious material was expended in its ornamentation'. The gold and lapis lazuli are stripped away, of course, but what remains is still spectacular. A variety of colours and materials are used, which create a vibrant, harmonious blend. There is red sandstone, black-and-white marble and an occasional bit of grey slate. Lotus-shaped medallions are interspersed with red sandstone panels inscribed with verses in Nashq and Kufic calligraphy. On a marble slab in the second *mihrab*, an inscription says:

> *As long as the world is populated, may this edifice be frequented and may the people of the world be cheerful and happy in it.*

A 16-sided shallow tank, once with a fountain in it, stands in the middle of the courtyard. Now empty, it must have once served to provide water for ablutions. Inside, the red-and-white colour combination is played out to its fullest. The *qibla*-wall has deeply recessed arches with red-and-white bands and intricate blue-and-white tile work. The central domed ceiling has elaborate blue stucco work. Restoration work is on in full swing under the ASI's directions. Men perched high on scaffolding are busy with buckets of soapy water, scouring away at the accumulated grime of ages.

A short distance from the mosque, across the rolling parkland, stands a very distinctive building. A double-storeyed octagonal tower of

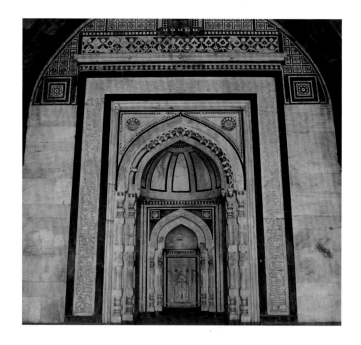

red sandstone, relieved by bands of red-and-white ornamentation, this is the Sher Mandal. Lotus flowers carved in relief decorate the parapet. Unfortunately, the place is kept locked so all you can do is admire its fine proportions and mull over its past. Apparently, it was designed as a pleasure resort by Sher Shah but Humayun later used it as a library. In fact, legend has it that Humayun,

hurrying for his evening prayers, tripped on a corner of his robe and fell to his death down its steep stairs some time in January 1556. The pleasure resort theory is buttressed by the presence of a *hammam* nearby. Broken terracotta ducts for water can still be seen poking out of the brickwork of the small, square *hammam*.

Stairs go down to the underground chamber and one of the walls has a chute, too. You can spend several enjoyable minutes debating the water games that could have been played in this compact little royal bath. To ensure year-round availability of water, there is a *baoli* nearby. It has rough stone steps and eight landings marked by recessed niches on its side walls. Said to be built in the 1540s, it is a long narrow structure, rather functional in appearance, with a well attached to its northeastern end. The well is still in use though now its water is pumped out for watering the lawns; the *baoli*'s own water is murky beyond description.

Above: Remains of the hammam.

Left: Sher Mandal—a two-storeyed octagonal tower.

Facing page: Elaborately worked central mihrab.

Pages 212-213: The elegantly-proportioned and exquisitely-detailed façade of Qila-e-Kuhna mosque.

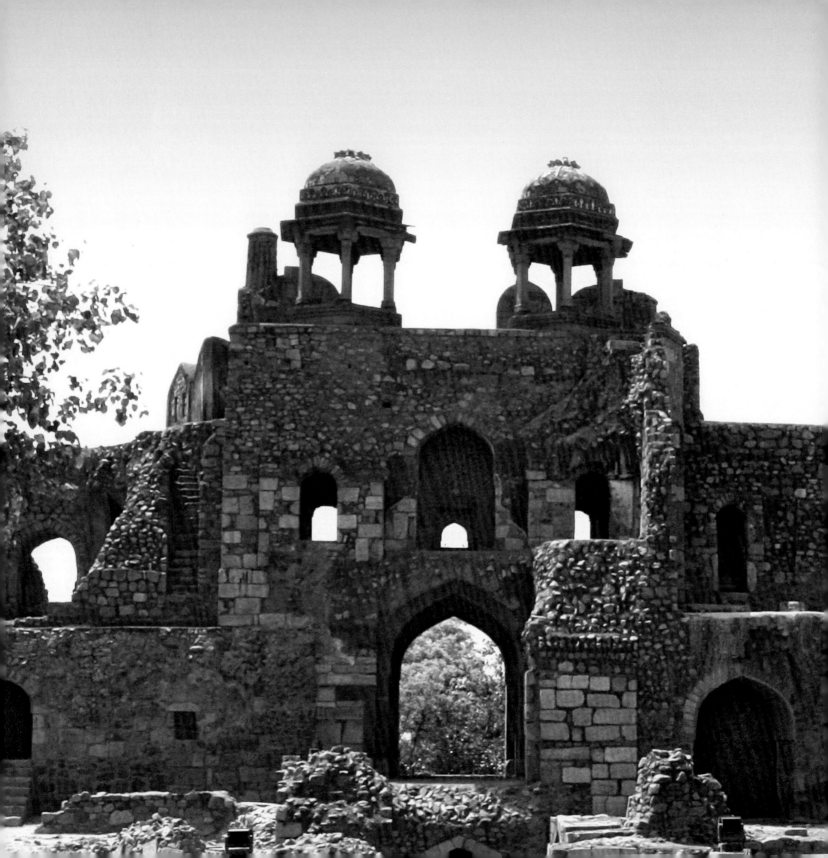

The Department of Tourism would do well to seriously think of putting this entire complex to good use. Imagine sitting in one of the Sher Mandal's recessed arches on a monsoon day to watch the rains and listen to the symphony of the birds against the backdrop of the ruined Purana Qila. Or camping on these emerald lawns on balmy autumn nights. Or a concert on the pavement abutting the Qila-e-Kuhna. Even without these imaginary treats, the place manages to cast a spell. Swallows swoop out of the many oriel windows piercing the mosque and fly past its red sandstone *chhatri*. Kites circle in the bright blue sky overhead.

The roar of traffic in the swollen artery of the Ring Road is hushed by the tall sentinel trees. The twin fingers of the Indraprastha Power Station poke the sky silently. There is utter stillness and lush greenery all around. Try matching this anywhere else in Delhi!

Leading to Humayun's Delhi.

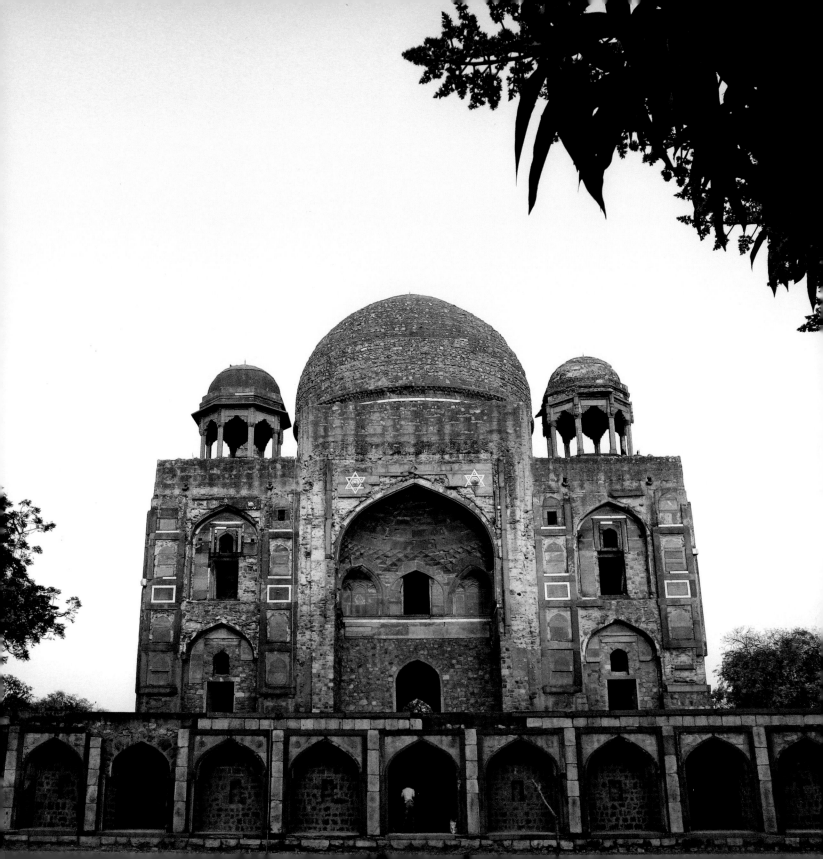

Khan-e-Khanan's Tomb

Sar sookhe, pachchi ure aure saran samae,
Deen meen bin pachch ke, kahu Rahim
kahan jaye?

Birds fly from a drying lake to seek another perch
But where, O Rahim, shall wingless fish flee?

Poet, statesman, soldier, one of Akbar's *navratna*, an early-day proponent of a secular synergistic culture, founding father of the movement to popularise Hindi and patron-saint of modern-day translators—Abdur Rahim Khan-e-Khanan was all this and much more. The son of Bairam Khan, Akbar's uncle, tutor and regent after Humayun's death, Abdur Rahim Khan-e-Khanan (1556-1627), became Akbar's first Prime Minister after Todar Mal's death in 1589. He is also the Rahim Das that most of us have encountered in Hindi textbooks in school, along with the famous triumvirate of medieval Bhakta poets, Sur, Tulsi and Kabir. Clearly a man of many parts, it is difficult to reconcile the *bhakta* Rahim Das, the Servant of Rahim (a name for Allah) and the aesthete-courtier. Yet, such a man existed. He lies buried in a vast and crumbling mausoleum on Mathura Road at the mouth of Nizamuddin East.

A poet and a patron of men of learning, he was also a bit of a linguist himself. He spoke some Portuguese (the first Jesuit mission had already reached Akbar's court) and wrote extensively in Braj, Sanskrit, Arabic

FACING PAGE: The venerable Khan-e-Khanan's tomb stripped of its marble and decorations.

A motif carved in plaster and some latter-day graffiti.

and Persian. He translated Babar's autobiography *Babarnama* from Turkish to Persian. Abdur Rahim was barely four years of age when his father Bairam Khan was assassinated. He, however, grew up into a fine young man under the fostering care of Akbar who later gave him the title of Mirza and made him Commander of Five Thousand with the title Khan-e-Khanan. He was appointed tutor to Prince Salim and one of his daughters was given in marriage to Prince Daniyal. After Akbar's death, he served under Jahangir for 21 years. However, for all his loyalty, he was seen as a threat by Jehangir and treated shabbily. Jehangir ordered the killing of two of his sons at the Khooni Darwaza on the trumped-up charge that they were traitors. In this he was supported by Mirza Raja Man Singh and Mirza Aziz Kokaltash, son of Akbar's wet nurse, Maham Anagah. The bodies of the Khan-e-Khanan's sons were left to rot and eaten by birds of prey, thus providing yet another leaf in the macabre history of the Khooni Darwaza.

Few have ventured inside its sprawling grounds (lately 'protected' by a tall fence and a Rs 5 ticket) or marvelled at its perfect proportions. Originally faced with red sandstone relieved by the use of buff sandstone and marble, most of its finery was stripped for the construction of the Safdarjung's Tomb a century later. Yet, neither neglect nor pillage can rob it of its solemn grandeur, befitting the brilliant poet-statesman who lies buried here.

A massive square edifice rises from a high platform faced by arched cells on all sides. Unlike the Humayun's Tomb, its predecessor and early prototype of the garden-tomb so dearly loved by the Mughals, the plan here is a plain square instead of octagonal. The *charbagh* pattern, too, is here, though simpler, with paths instead of water channels. The lofty double-storeyed mausoleum rises from the centre of what was once a Mughal garden. There is a high, deeply recessed central arch on each side and several shallow arches on the flanks in each storey. The interior of the tomb chamber has remains of beautifully incised designs in plaster and traces of paint work. Four *chhatris* are strategically placed at the corners of the central dome, giving it a perfectly balanced look, unlike, say, the Safdarjung's Tomb that suffers from a peculiarly elongated look. The platform must have once sported waterways and fountains for there are shallow octagonal tanks connected by narrow drains. With the stripping of the marble and red sandstone from its facade, the tomb looks scarred

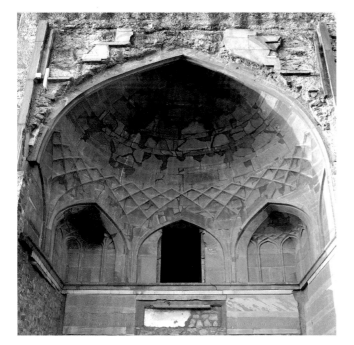

Rahim wrote for every occasion. Here's something on the need to preserve every drop of water, for, a single drop, saved inside the oyster's shell, forms a pearl:

Rahiman pani rakhiye bin pani sab soon,
Pani gaye na ubare moti manus ehoon.

On the innate goodness of character that remains untainted, like the *chandan* tree that retains its purity despite the poisonous snakes twined around it:

Jo Rahim uttam prakrati, ka kar sakat kusang,
Chandan vish vyapat nahin, lipitay rahey bhujang.

and gouged, yet venerable. It is said that together with the Humayun's Tomb, it provided the prototype for Shah Jahan's architects to work on the exquisite Taj Mahal.

ABOVE: Inside the deeply recessed central arch on each side.

LEFT: Recessed arches on all four sides.

FACING PAGE: A rippling pattern in stone.

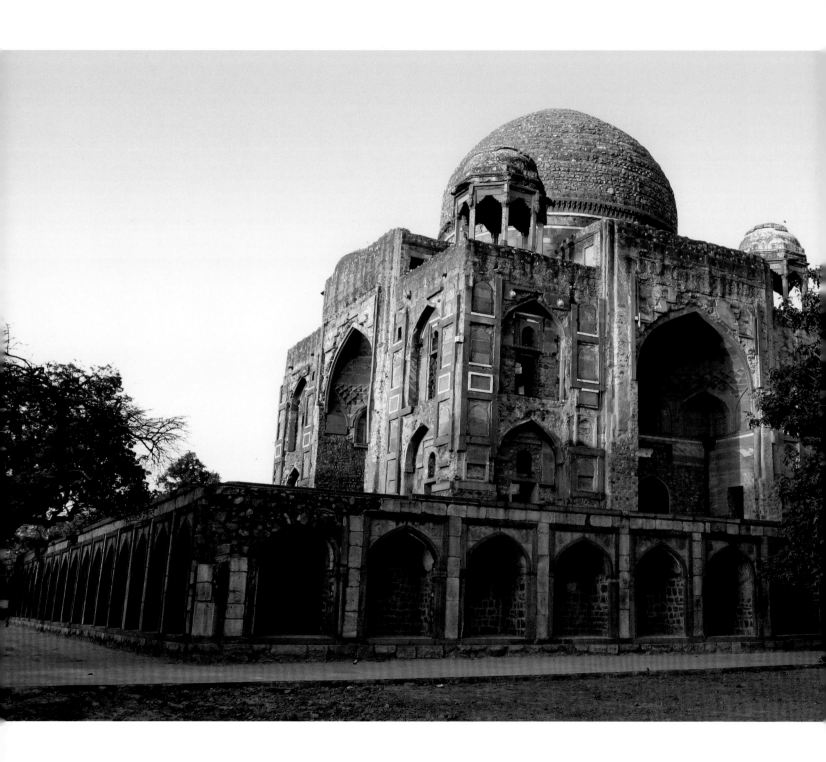

On the transience of both ill and good fortune:
Rahiman vipida ho bhali jo thoray din hoye,
Hit anhit eeh jagat mein, jaan paday sab koi.

On placating, time and time again, those who are good at heart:
Ruthay sujan manaiye jo ruthay sau baar,
Rahiman phir phir poiye jo tootay tootay sau baar.

On the Small vs Big debate and the use of a sword where a needle will suffice:
Rahiman dekh badein ko laghu na dijiye daar,
Jahan kaam awai sui, kahan karey talwar.

And the most famous of them all, on the thread of love that, once snapped, forever bears a knot:
Rahiman dhaga prem ka, mat todu chatkai,
Tootey phir se na milay, milay gaanth padi jai.

While it would be certainly worth your while to drop by and visit Khan-e-Khanan's Tomb the next time you drive past Mathura Road, perhaps it would be equally worthwhile to revisit the *dohas*, *chaupai*s and *kabit*s written by him that transcend their time and age and speak so eloquently of the co-mingling of cultures.

Stately despite its disfigurement.

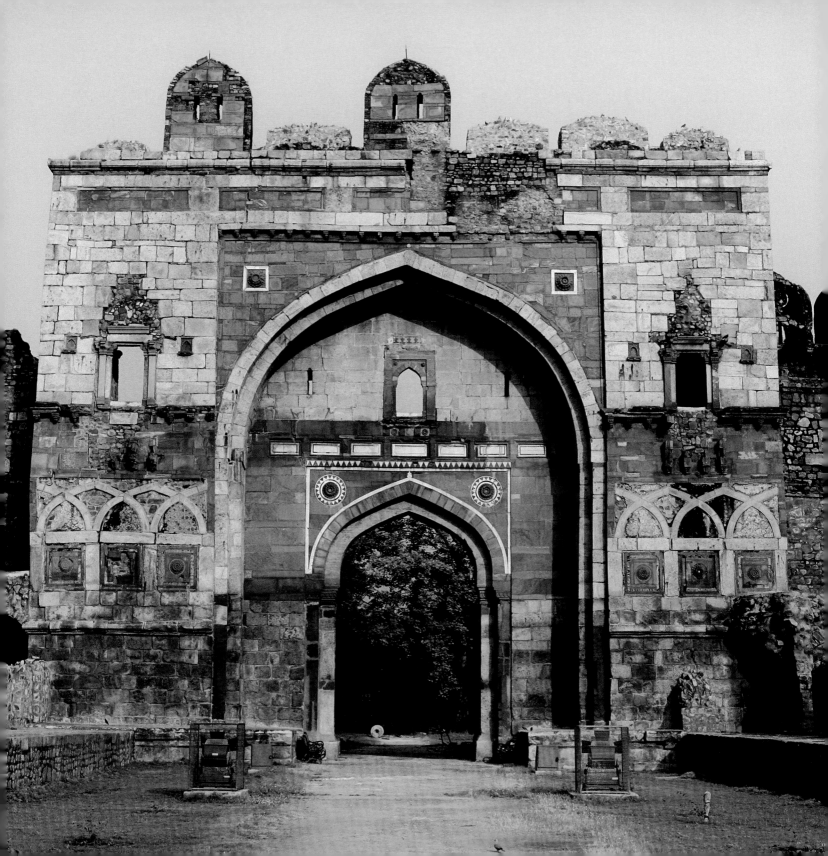

On Mathura Road

FACING PAGE: Gateway constructed by Sher Shah Suri.

Close-up of a lotus emblem studded on the gateway to the mosque.

At the intersection of Subramanya Bharti Marg and Mathura Road, facing the entrance to the Delhi Zoo and the Purana Qila, stand two rather spectacular buildings. I have driven past them umpteen times telling myself that I shall, one day, stop and venture inside. On a late winter afternoon, I take a side street off Subramanya Bharti Marg, leading towards the rear entrance of the Delhi High Court, leave my car under a silk cotton tree in full glory and walk around the corner towards Mathura Road.

The first building on the left is the Khairul Manazil. Literally meaning 'The Most Auspicious of Houses', this was a mosque with a *madarsa* attached to it. It was built in 1561-62 by the wet nurse of Emperor Akbar, Maham Anagah. (There is the instance of another mosque, the Neeli Masjid in A Block of Hauz Khas, built by Kasum Bhil, the wet nurse of Fath Khan, thereby indicating that once upon a time women did exercise control outside the domestic realm.) A marble slab fixed on the central arch of the prayer chamber proclaims:

> *In the time of Jalaluddin Mohammed who is the greatest (Akbar) of just kings, When Maham Anagah, the protector of chastity, erected this building for the virtuous, Shihabuddin Ahmad Khan, the generous, assisted in the erection of this good house …*

The Khairul Manazil is one of the hidden jewels of Delhi, its invisibility all the more bizarre, given its

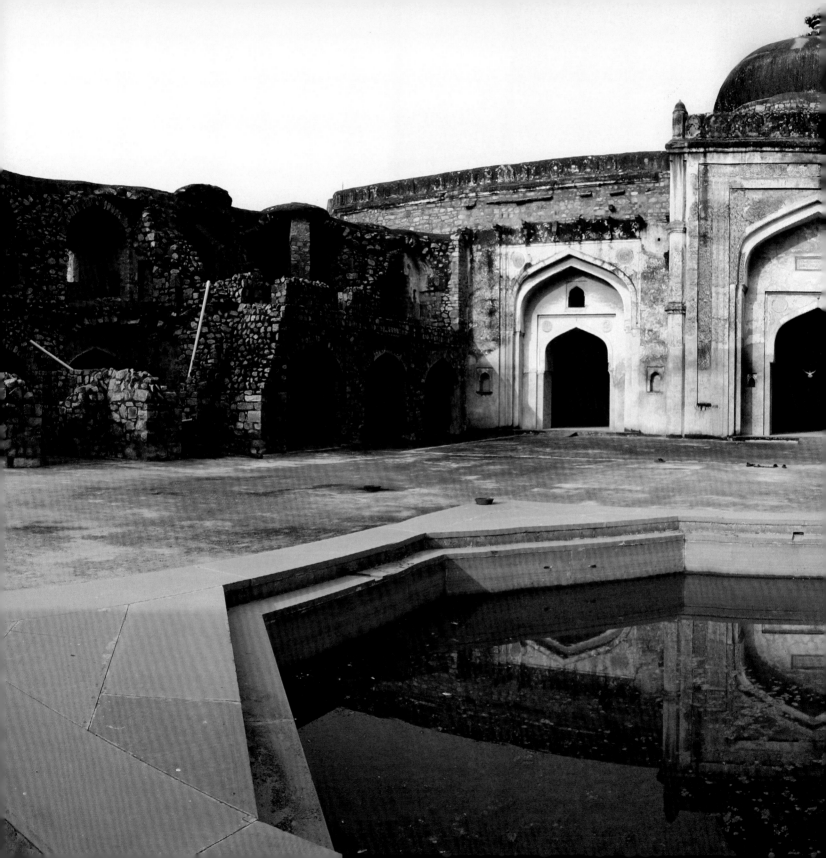

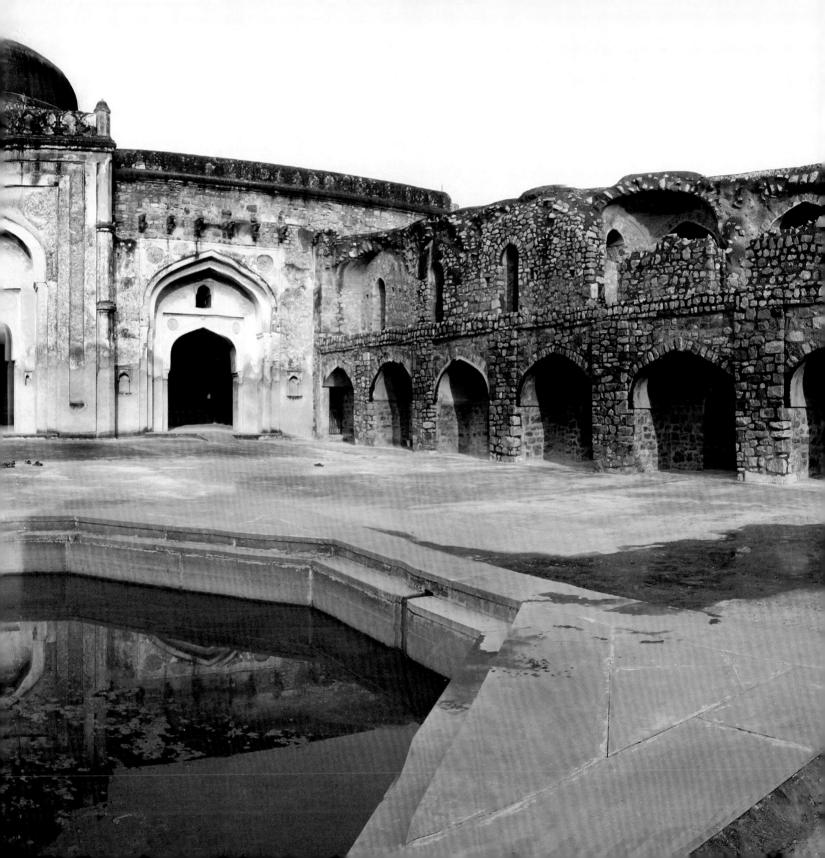

wonderful location. The mosque is surrounded by a wall of masonry, broken in parts, but still serving to mark a boundary. The east-facing gateway is large and imposing with a hollow concavity in its exterior arch. Built of red sandstone, the archway has traces of the decoration it once must have sported. You enter through a massive wooden door (closed at night to secure the mosque from vandals) to enter a spacious courtyard. A well on the right has plentiful water and is used by the faithful for ablutions till this day. I pulled up some water with the help of an old metal pail and a bit of rope, splashed some on my dusty feet and took a sip of the cool, sweet-tasting water. It tasted much better than the stuff we get through our taps.

Though under ASI protection and not the Waqf, prayers three times a day are permitted inside this broken down but still very pretty mosque. Perhaps because it is in use, limited though it is, the place is kept clean. An old man has taken the self-appointed task of sweeping it and tending it as best as he can. But there is not much he can do about the sacks of lime left behind after the last restoration job. Or the planks of wood and assorted odds and ends that the contractors have left stacked in the arches. Nothing, however, can take away from the solemn beauty of the place. Grey pigeons and long-tailed parrots fly off the nooks and crannies as you approach the intricately worked outer wall of the prayer chamber.

Traces of tile work in the most stunning azure blue remain on the outer walls that are decorated with arched niches, pilasters and inscriptions.

A single dome sits grandly over the central arch, topped with a finial, a typical Mughal ornamentation, one that you do not see in the Lodi and Tughlaq buildings. The minaret, however, is still to make its appearance. A staircase leads up to the flat roof from where the *muezzin* would have given his call to prayer. Turrets with arched openings mark each side of the west-facing outer wall. Inside, the prayer chamber consists of five compartments, the central one being

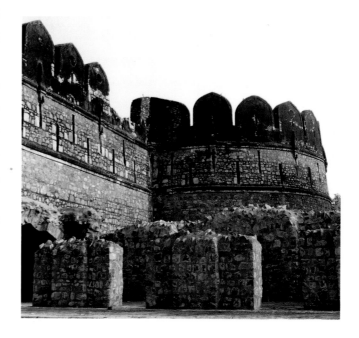

Rounded bastions and curtain walls beside Sher Shah's gateway.

PAGES 226-227: Courtyard of the Khairul Manazil.

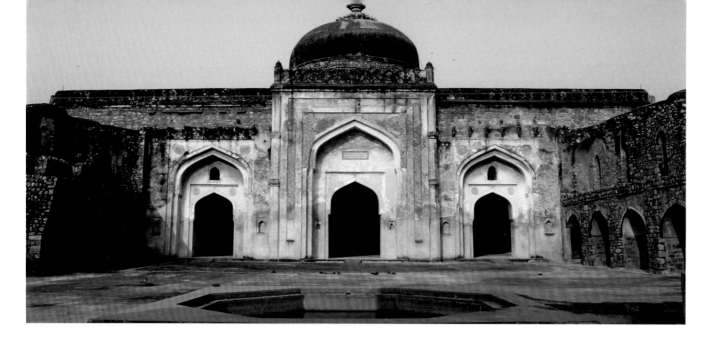

the largest and the grandest, with fine engravings done in pilaster.

While the mosque is in reasonably good shape, the *madarsa* attached to it has fallen on hard times. It was housed in the double-storey colonnades that marked the north, south and east walls. The eastern and southern walls are no more than ruins; the northern wall allows some sense of what the rest of the building must have once looked like. Small cell-like rooms, some little more than arched niches, must have housed the boys sent here to learn to recite from the Koran. The spacious courtyard, with the well on one side and a large octagonal sunken basin in its centre, must have once reverberated with the sound of young voices learning to read and memorise the scriptures.

Next to the Khairul Manazil, standing in its own enclosure, is a spectacular red-and-white gateway and the remains of fat, rounded bastions and curtain walls. Two rows of ruins lead up to the gate, its central arch presently boarded up with bricks. The almost equal-sized ruins are remains of shops that once constituted a bustling bazaar. There are signs of restoration work in progress everywhere. Yet the monument has a strange 'eaten-away' look. Huge chunks of masonry have fallen away, leaving gaping holes. Shoring work done on the rear walls has somehow not been able to check the damage. Remains of tombs and mosques can be seen in the grounds at the rear, too, near the Delhi High Court's parking lot.

The gateway was one of the city gates, demarcating the citadel area from the rest of the city of Shergarh, built by the Afghan noble, Sher Shah Suri. Sher Shah wrested power from Humayun in 1540 and ruled

Inside the courtyard of Khairul Manazil.

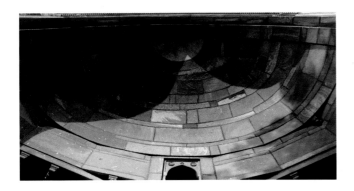

A half-arch nestling inside the eastern gateway to Khairul Manazil.

East-facing gateway of Khairul Manazil.

for five eventful years, during which he not only constructed the Grand Trunk Road, but also started a new city called Shergarh. Not much remains of the city for which he ransacked Humayun's Dinpanah and Firoz Shah's Kotla, as well as the old fortified city of Siri. Sher Shah's own tomb is at Sasaram, near Gaya in Bihar, where he was killed in the siege of Kalanjar in 1545. After his death, his son, Salim Shah, took over. He built Salimgarh (close to the Red Fort) as a bulwark against the forces of Humayun who was biding his time in faraway Persia. In 1555, Humayun did manage to return and recover his empire, thus laying the foundation of Mughal rule in India. While monarchs laid claims and counter-claims to the throne of Delhi, it was the Sufis who stole the hearts of the people. One such saint, a woman, lies buried close beside Sher Shah's ill-fated and short-lived city, hidden behind the *sarkari*

quarters of Kaka Nagar. Her name was Bibi Fatima Sam and she is believed to be a contemporary of Hazrat Nizamuddin Auliya and Baba Farid. She used to say that the divine reward for giving a piece of bread and a glass of water to the hungry was greater than offering countless prayers and keeping thousands of fasts *(Ma'arij-ul-Walayat)*. Her piety was such that Nizamuddin Auliya often came to her grave and prayed for long hours.

The grave that was once a rendezvous for the highest and holiest in the land is unknown and unvisited today.

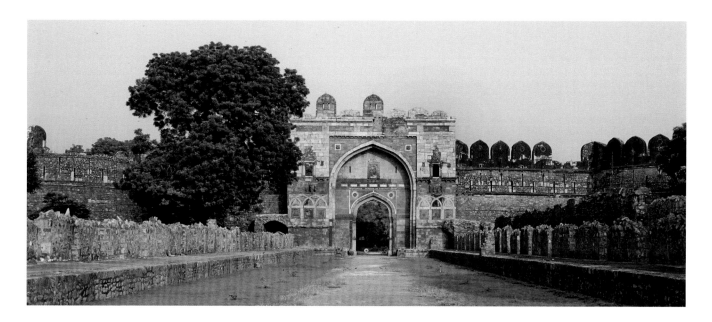

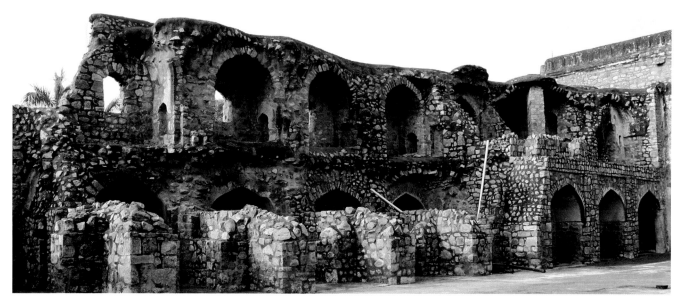

ABOVE: Road leading up to the spectacular red-and-white gateway of Sher Shah's city. The gateway sports a new look after the renovations.

BELOW: The southern wall of the madarsa built by Maham Anagah.

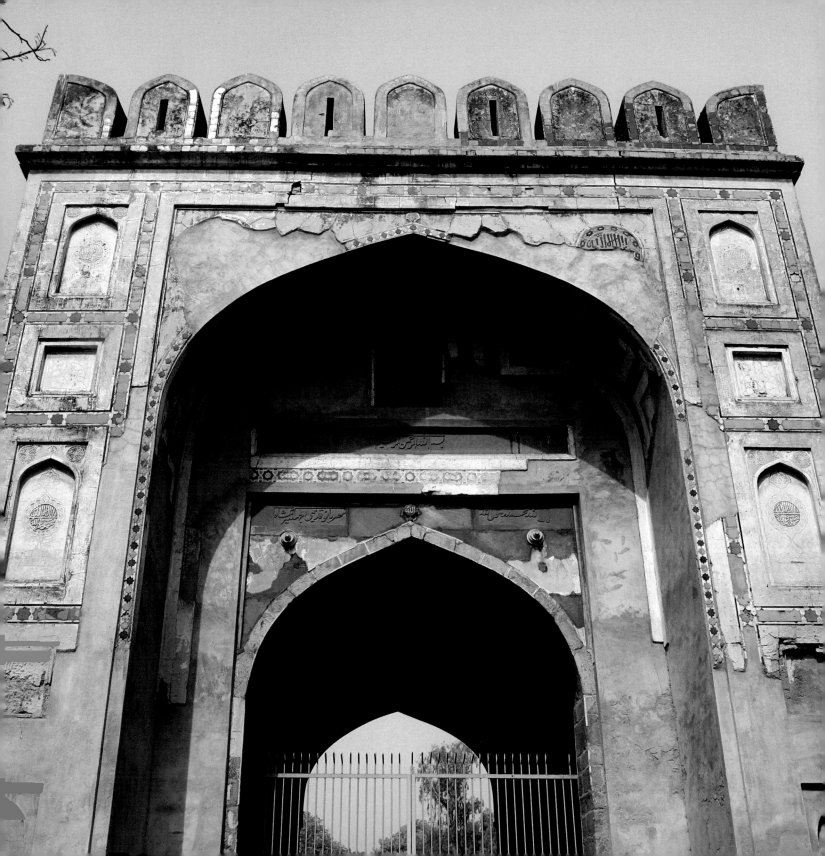

Arab ki Sarai

Men have not been the only ones who have adorned their beloved Delhi down the ages. Women, too, have played a smaller, but significant, role in constructing tombs, pavilions, mosques, temples and caravan *sarai*s. There is, for instance, the Neeli Masjid, the Khairul Manazil and *madarsa* on Mathura Road and the tomb of Adham Khan, built by Maham Anagah. Construction activities, either directly commissioned by women or built under their supervision, gained momentum during the Mughal period. Significant examples include the Darghah Shah-e-Mardan built by Qudsia Begum, wife of Muhammad Shah and mother of Ahmad Shah, who also built the Qudsia Gardens near Inter State Bus Terminus; the Roshanara Gardens built by Princess Roshanara and the Fakhrul Masjid built by Fakhr-e-Jahan Begum in memory of her husband, Shujaat Khan, opposite the St James' Church. Several Mughal princesses built small mosques such as the Zinatul Masjid (Ornament of Mosques), also called the Ghata Masjid because of the black-and-white stripes on its dome, built by Zinat-un-Nisa, one of Aurangzeb's daughters. The Fatehpuri Masjid at the far end of Chandni Chowk was built by one of Shah Jahan's wives.

The most spectacular building in Delhi commissioned by a woman is, of course, the Humayun's Tomb. Built in 1565 by Humayun's widow and Akbar's mother, Hamida Banu Begum,

not only is it one of the most beautiful specimens of Mughal architecture in Delhi but it is, in many ways, the prototype of the garden-tomb that was to later show the way for the Taj Mahal. Much ink has been spilt over the Humayun's Tomb and its inclusion in the World Heritage Sites listing. It does not, therefore, find a mention in a book such as this on the 'invisible' monuments of Delhi. What does appear striking for the purpose of this chapter is the site that came up to house the 300 Arabs who were invited by Hamida Begum.

Also known as Haji Begum because she had made the Haj pilgrimage, which was rare for a woman in those days, Hamida Begum is sometimes referred to as Mariam Makkani (one who has been to Mecca) in contemporary chronicles to distinguish her from Akbar's wife, Mariam Zamani. Hamida Begum commissioned a Persian architect, Mirak

Mirza Ghiyas, to construct the Humayun's Tomb at the exorbitant expense of Rs 15 lakh! She died in 1603, shortly before Akbar, and was buried with great ceremony in one of the unmarked graves in the northeastern chamber beside her husband. The architect Ghiyas is credited with providing India with the first dome in the Persian style, a dome that is a complete semicircle. It is not clear whether the Arabs were invited by him or brought back by Hamida Begum herself upon her return from Mecca. There is dispute also whether the 300 Arabs were artisans engaged in building the Humayun's Tomb or Arab *maulvi*s brought back by Haji Begum as a token of veneration.

Be that as it may, a walled enclosure with three imposing gateways, close beside the southwestern corner of the Humayun's Tomb, came to be known for posterity as the Arab ki Sarai. Historians quibble

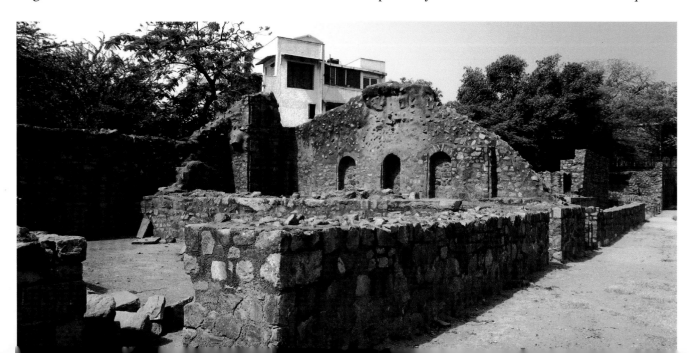

that being a Persian, Ghiyas was more likely to have invited Persian artisans rather than Arab ones. But, misnomer or no, the Arab ki Sarai has always been known as the Arab ki Sarai. Once divided into two quadrangles by a series of cells, the western enclosure is now occupied by the Industrial Training Institute (ITI). At the entrance from Mathura Road to the ITI, are the remains of one of the gateways. With an ornamental cusped arch, hidden under a coat of plaster, it has been encroached upon and an incongruous upper storey added to it. Inside, the 12-pillared domed tomb of Saiyyid Yasin stands forlorn. A Lodi-period building, this was assimilated when the buildings in the Arab ki Sarai were first conceived. The eastern gateway of the Arab ki Sarai, accessed through the Humayun's Tomb complex, bears the following legend:

> *In the name of God who is merciful and clement. There is no God but Allah and Muhammad is His Prophet. Benevolence (Mihr) the old Mistress of Jahangir the King.*

The eastern gateway, built during Jahangir's reign (1605-28), was actually the entrance to a *mandi* added to the Arab ki Sarai by Mihr Banu, who is said to be a eunuch, during Jahangir's time. The play on the words 'Mihr' implies as much. The *mandi* had a series of recessed rooms or cells. The real gateway, to the north, is a handsome building, with medallions in the spandrels of its high, arched doorway. It also has projecting balconies, recessed arches and glazed tiles.

The Garden of Bu Halima, in the Humayun's Tomb complex, is another example of building activity undertaken by a woman. Who Bu Halima might have been is hard to tell, though her dilapidated tomb is tucked away in a corner of the garden ascribed to her. In fact, entry to the Humayun's Tomb is through this gateway to her

FACING PAGE: A wall mosque.

The Garden of Bu Halima.

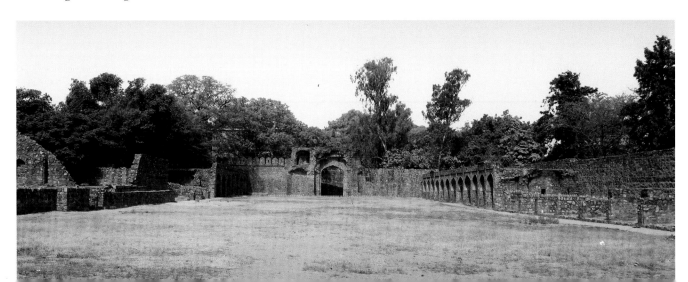

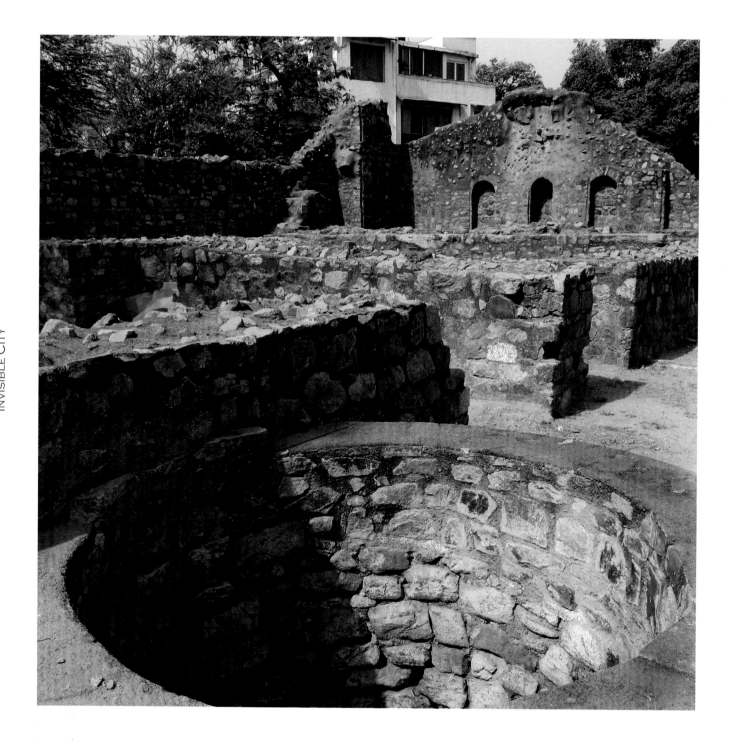

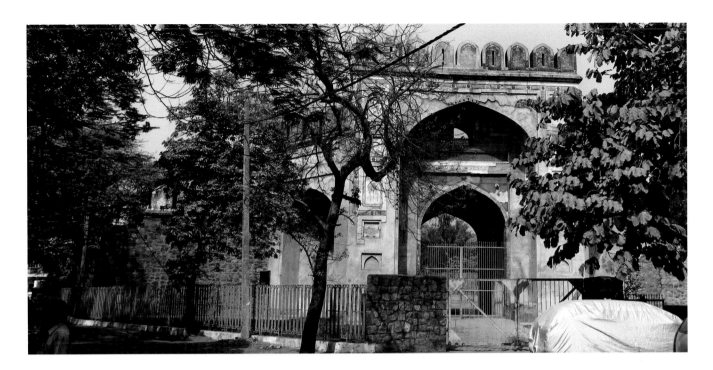

The eastern gateway to Arab ki Sarai.

FACING PAGE: In the foreground, a well, beyond a wall mosque.

garden enclosure. The gateway, where the tickets are checked before final entry into the Tomb, has an unusual angular appearance; its sides are splayed back, there are blind arches on the sides and a small balcony with *jaali* railings in its centre.

Till 1914 a sweepers' *basti* flourished here; the land was subsequently reclaimed by the ASI and some of the buildings restored. Once, Bu Halima's Garden stretched right from the Humayun's Tomb till the area around Delhi Public School. It included the Sundarwala Burj, the Sundarwala Mahal and the Bara and Chhota Batashewala Mahal. The Sundar Nursery has replaced Bu Halima's Garden.

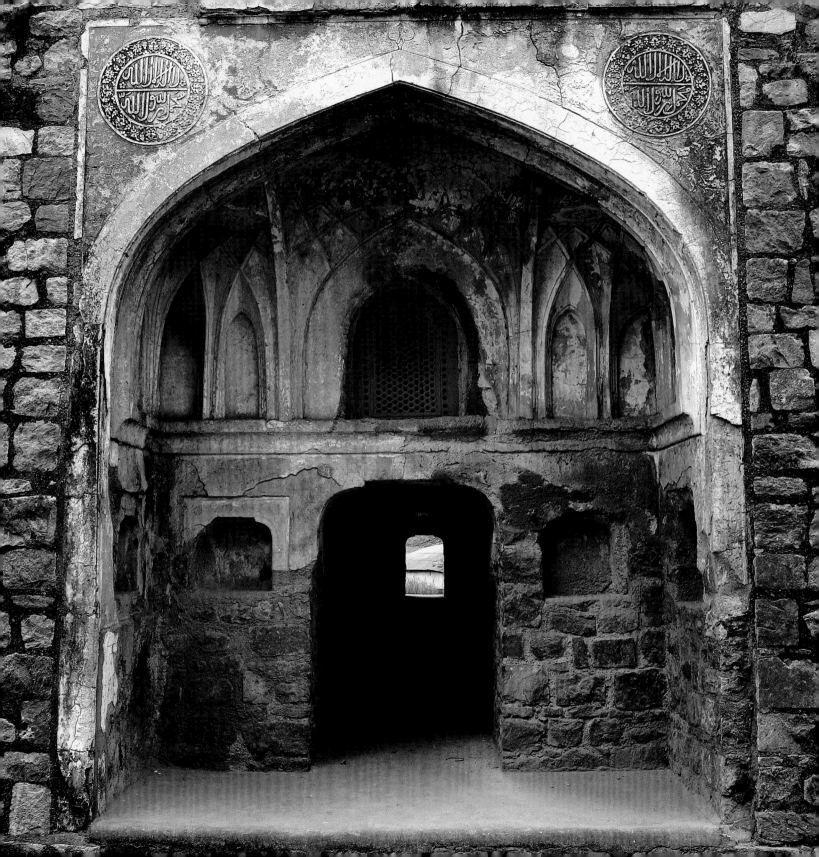

In and About Bharatiyam Complex

An arch leading to the grave of Muzaffar Husain Mirza.

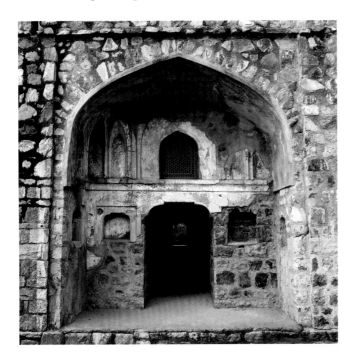

A looping road on the left of the Humayun's Tomb brings you to the Bharatiyam Complex. This road has very little traffic; only those heading towards the Boys' Scouts Camp located inside the complex or to the Gurudwara Dumduma Sahib come here, for beyond there is nothing except the railway tracks and in the distance the shunting sheds of the Nizamuddin Railway Station. Past the Sundar Nursery facing the Humayun's Tomb's parking lot, past the New Horizon School, lies the Bharatiyam Complex and its cluster of oddly-shaped huts and tents. And within its grounds stand the Bara and Chhota Batashewala Mahal.

The Bara Batashewala Mahal is actually not a *mahal*; it is the tomb of Muzaffar Husain Mirza, a grandnephew of Humayun who was married to Akbar's daughter. How it acquired its name is an enduring mystery for there is nothing left now to make the link with *batashe*. It stands on a raised platform and has five arches on each side. From the outside it looks sturdy and simple but the inside walls are beautifully ornamented with incised and painted plaster. At the entrance to the central vaulted chamber a plaque carries the following inscription:

> *Mirza Muzaffar, who was scion of royal stock and the first fruit of the plant of desire, repaired from the mortal world with longings, lamentation and sighs from the heart. When I enquired the date of his death, Wisdom said 'He was an effigy belonging*

to paradise.' The writer of the (above) letters is Abdunabi Al Hussaini, may his end be good.

Built in 1603-04, the building is showing signs of serious deterioration. The 'false tomb' is still there, though the actual grave seems to have disappeared. It resembles the *mahal* inside the Sundar Nursery in shape, size and general plan. It also has the same maze of low-ceilinged arches on its four sides. Its outer arches have beautiful red stone fretwork. Staircases lead up to the roof, but the structures on the first floor are all gone. In the same enclosure, a stone's throw away, stands another early Mughal monument called the Chhota Batashewala Mahal. Here, only the platform and parts of some walls remain. It was once an arcaded octagonal building with domed ceiling and stone *jaali* screens. All of that has disappeared, and the only intact

evidence is the decorative incised plaster on the few surviving portions.

East of the Bharatiyam Complex is a massive well that once provided water for the canals and gardens of the Humayun's Tomb. Close beside, stands a square domed tomb on a high mound. Here, too, there is elaborate ornamentation on the inside walls and the soffit of the dome. There are tiny minarets on the four corners of the square building and the drum of the dome.

With time, this architectural device would be honed and perfected by Mughal architects till they would take the form of slender, tapering minarets as seen in the Taj Mahal and the Jama Masjid. The squat dome has an unusual cross-shaped finial.

This neglected tomb, unvisited and invisible behind a screen of scrub vegetation, is a significant example of the transitional phase of Mughal architecture. It carries in its

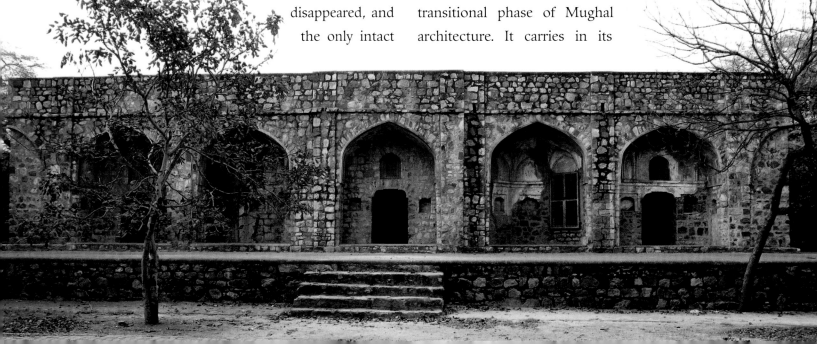

clean, sweeping lines and rounded dome, the promise of the great architectural renaissance that would take place over the next century and reach its culmination by Shah Jahan's time with the building of the grand Jama Masjid. Across the road, just a little before the Gurudwara Dumduma Sahib, is a much-revered building known as the Chilla Nizamuddin. 'Chilla' refers to 40 days of retreat practised by the Sufis during which they would meditate, observe abstinence and offer special prayers. It is believed that the great Sufi saint, Hazrat Nizamuddin Auliya, meditated and prayed in solitude here, far from the hustle and bustle of his hospice in what is known as Basti Nizamuddin, deep inside Nizamuddin West on the other side of Mathura Road. An arched *dalan* stands on a raised platform. The place still radiates an aura of quietude and peace.

Past the Chilla Nizamuddin, past the Border Security Force (BSF) wireless and communication station and Officers' Mess, with its tall forbidding gates, and the gleaming white gurudwara, hugging the far southeastern wall of the Humayun's Tomb, stands the Barber's Tomb. Emperor Humayun is said to have built this exquisitely pretty blue-domed tomb for his favourite barber.

Famous Delhi historian, Narayani Gupta, writes, 'Barbers seem to play a prominent role in the lives of Delhi's rulers. Apart from the honour done to this one by allowing him a tomb next to his emperor, Muhammad Tughlaq's barber appears to have been given his own fort, Nai ka Kot (Barber's Fort) near Adilabad and the Ghiyasuddin's Tomb. It is tempting to draw parallels with the role of the Barber of Seville as confidant and fixer, and the whole tradition of Italian comic opera.'

Early historians, including Sir Syed Ahmad Khan, could not credit an emperor building a tomb for a barber and so attributed this as being the tomb of a

Mughal noble named Fahim Khan who died fighting for Abdul Rahim Khan-e-Khanan. INTACH's *Delhi: The Built Heritage* clearly lists it as the Barber's Tomb, though there is no mention anywhere of the fortunate barber's name. Nothing, however, can take away from its striking visual appeal, coming as one does upon something so singularly beautiful in that wilderness of thorny bushes. Its perfectly proportioned, almost-round dome has spectacular blue tiles. Its outer façade has remains of azure blue, green and yellow tiles. It has no enclosure wall, nothing to protect it from the squatters who seem to have overtaken its grounds. Rickshaw-pullers, who ply their trade in the neighbouring Nizamuddin East, park their rickshaws here; their families have built shanties and makeshift homes. Being outside the enclosure wall of the Humayun's Tomb complex, it has benefitted in no way from the recent makeover lavished upon the Humayun's Tomb since its inclusion in the World Heritage Site listing.

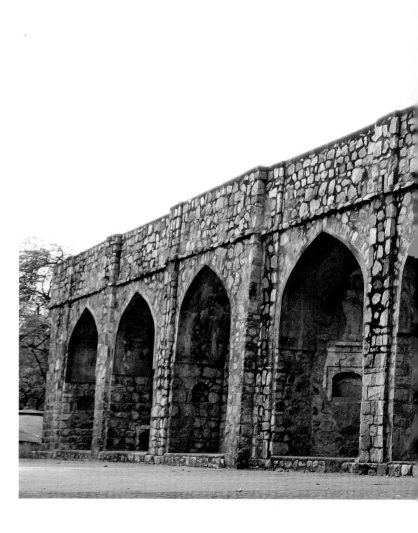

A row of arches on Bara Batashewala Mahal.

PAGE 240: An unsual square tomb atop a platform.

PAGE 241: Remains of Chhota Batashewala Mahal.

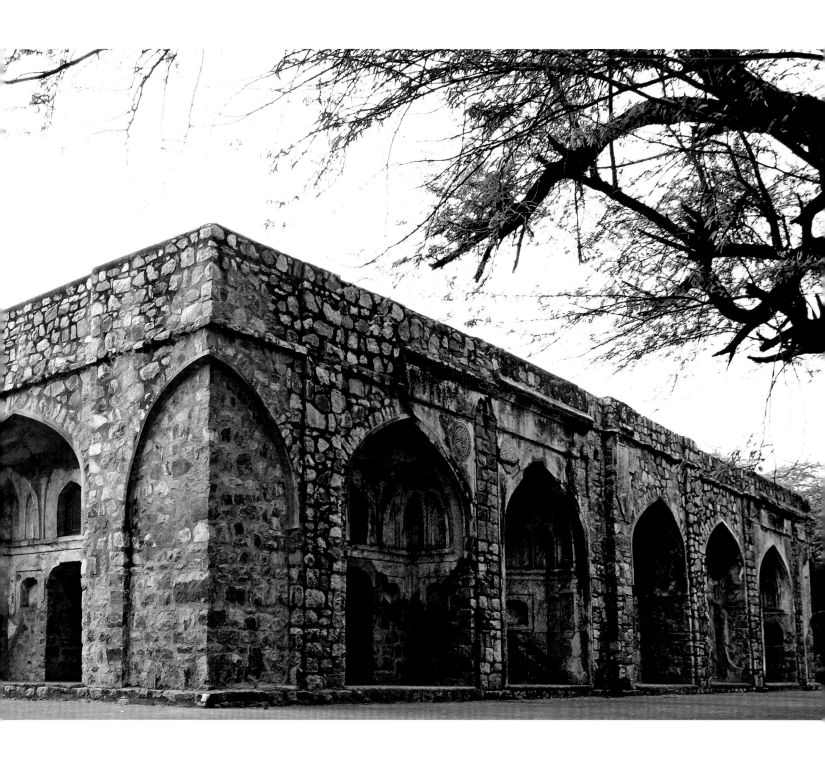

Inside the Golf Course

FACING PAGE: One of the many early Mughal tombs inside the Delhi Golf Course.

Teeing off at the Delhi Golf Course.

How nine late-Mughal tombs and pavilions in the heart of New Delhi have managed to remain one of the city's secrets is by itself an enduring mystery. Perhaps the key to their invisibility lies in their 'exclusive' location. Situated inside the breathtakingly picturesque 27-hole golf course spread over 177 acres, they occupy rarefied ground.

There is the spectacular Lal Bangla at the entrance. Originally, the name Lal Bangla was given to an extensive enclosure containing three domed mausoleums. The enclosure walls have since disappeared, razed perhaps when the golf course first came up in the 1930s. Built by British architects under the supervision of Sir Edward Lutyens, the course was redesigned by Peter Thomson in 1976-77, when much of the landscaping was done. In the process, the grounds of the monuments have shrunk till they seem to stand on virtual islands in the midst of a sea of manicured greens.

Prone to superstition as they are, every golfer worth his iron has his favourite story to tell about each hole and bunker but the strangest of all is the one about the 'presence' that hovers near the Lal Bangla. Described variously as a rustle of silk, a sigh or a sudden breeze, players have been known to feel something in the vicinity of this red building. Though there is near unanimity among historical sources that it was built for a certain Lal Kunwar, who the lady might have been is a mystery. According to

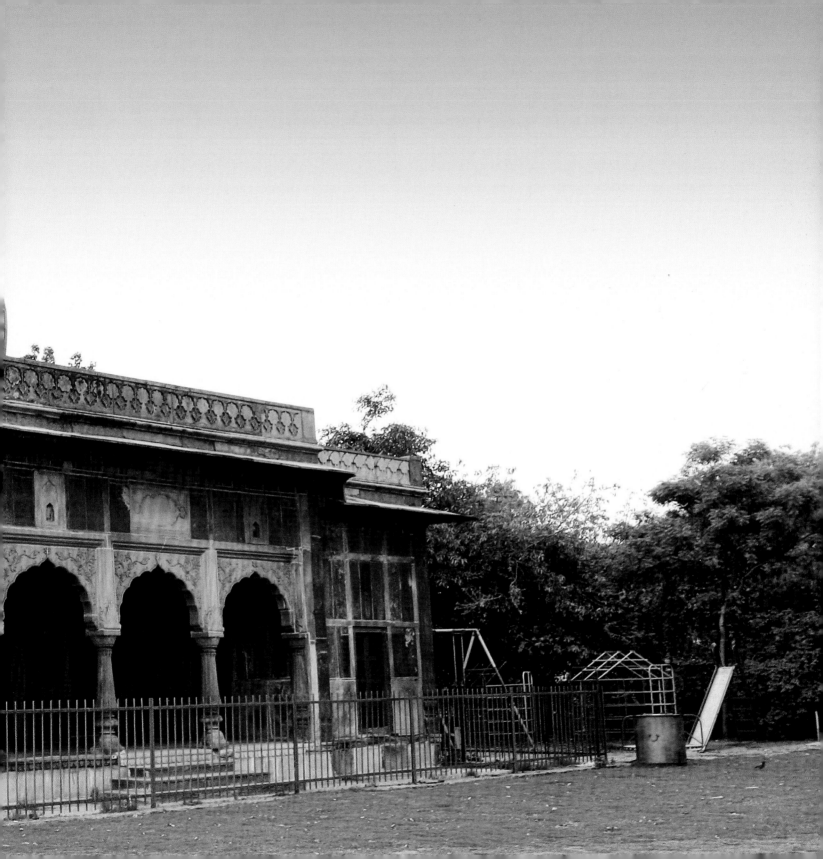

Delhi: The Built Heritage, she was the mother of Shah Alam II, and his daughter, Begum Jan, lies buried in the smaller but similar tomb close by. However, according to more colourful versions, Lal Kunwar was a courtesan. Her beauty was so legendary that Jahandar Shah, a grandson of Aurangzeb, fell in love with her. His infatuation was such that he is said to have appointed Lal Kunwar's brother Inayat Khan, a *sarangi* player, as the Governor of Multan! But when Jahandar Shah was embroiled in a court intrigue and later murdered in the Red Fort, Lal Kunwar, too, died in a neglected corner of the harem. Who built her the grand mausoleum and why is it a mystery? The INTACH version therefore seems more probable.

Lal Kunwar and Begum Jan's tombs are built of Lahori bricks and overlaid with a great deal of red sandstone. Both built in 1779-80, they have a central square double-domed chamber with an arcaded verandah on all four sides. In Lal Kunwar's tomb, bigger and more elaborate, there are cusped arches, fluted columns, *kangura* battlements and small square rooms at the corners of the arched verandah. The upper dome has a small opening in it through which the interior can be reached. White bands run through the dome. The smaller tomb has a disproportionately large dome, making it look like a midget next to the perfectly proportioned Lal Bangla.

Once a garden surrounded the cluster of buildings now known as the Lal Bangla. Only the southern wall remains and a rather splendid gateway. Entering through the gateway built of Lahori bricks you get the feeling of walking into a grand haveli rather than a tomb complex. With a vaulted pointed archway in the centre, topped with an inverted boat-shaped 'Bangali' roof, the gateway has a crumbling, timeworn look. The plaster has fallen off, revealing the brickwork. Elsewhere, modern bricks have replaced the original bricks in the course of inappropriate renovations. But nothing can detract from its perfectly proportioned symmetry. The vaulted pavilion atop the gateway with its three cusped arched openings and octagonal *chhatris* with small rounded domes on either side of the central pavilion make it a pleasure to behold.

A small octagonal tomb near the swimming pool is in crying need of attention and repair. Much of its plaster has fallen off, probably due to the constant dampness from the pool. One of its arches is propped up with ugly modern bricks. To the south of the Lal Bangla is the tomb of Sayyid Abid. Square from inside, it is an irregular octagon from outside with arched openings on every alternate side. It has a dome springing from a high eight-sided drum.

Built in 1626, it contains the remains of Sayyid Abid, companion of a general in Jahangir's army, Khan Dauran Khan Khwaja Sabir Nusrat Jung, who had the tomb constructed. An oblong vaulted tomb stands rather forlornly on a *chabutra* in the middle of a clump of bushes and greenery. Another tomb

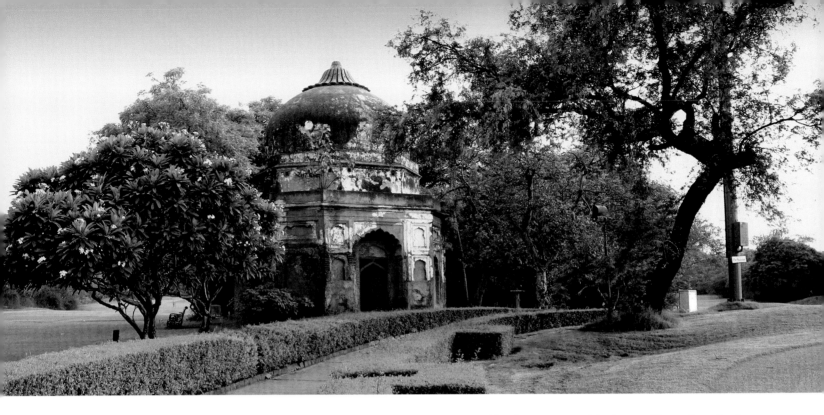

is completely inaccessible due to the impenetrable screen of bushes. Nothing is known of those who lie buried here.

Close beside the canteen is a grand tomb, perhaps the largest. An irregular octagon externally and square internally, it is accessed by a flight of steps. A series of arched niches at the window level bring in ample light to allow you to inspect the decorated squinches and the ochre-and-white incised plasterwork.

Mir Taqi's tomb, another irregular octagonal but this time with a fluted near-perfect dome, stands on a raised platform and has plaster decorations and large arched recesses, though who Mir Taqi might have been is unknown. Of the nine monuments, the Barah Khamba is the most spectacular. Shaped like a crucifix, its eastern side has collapsed and of the 12 original pillars only eight remain. Built in a severe, un-ornamented style, it is older than the other buildings, probably belonging to the Tughlaq period. Four small, perfectly rounded domes crowd around a central dome. Standing in its ruined but stately courtyard you wish that more people could see these wonders.

ABOVE: Tomb of Sayyid Abid.

PAGES 246-247: Lal Bangla—extensive use of red sandstone has given it its name.

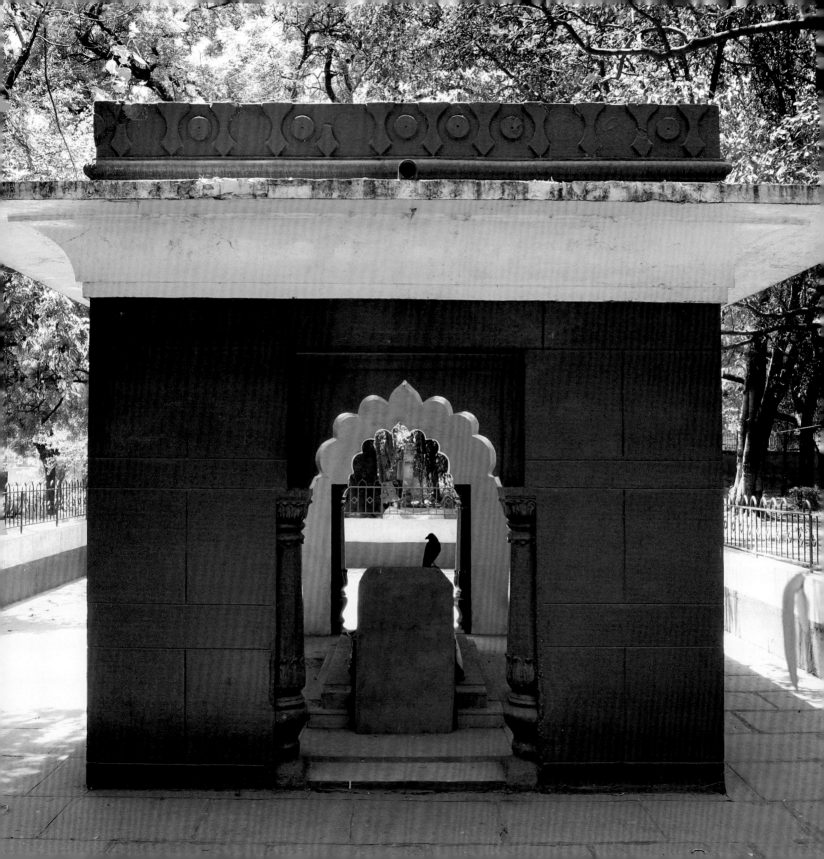

Bagh-e-Bedil

FACING PAGE: The simple grave of Mirza Abdul Qadir Bedil.

Spruced up for a foreign dignitory.

What was till yesterday a tumbledown nondescript *dargah*, one of many that dot Delhi, was virtually overnight given a makeover, thanks to a somewhat unusual request received by the Ministry of External Affairs. The Tajik President, Emomali Rahmanov, conveyed his wish to visit the grave of Mirza Abdul Qadir Bedil in the course of his five-day trip to India in early August 2006, quite apart from the meetings that had been lined up for him with the Indian President, the Prime Minister and various heads of industry. The ASI was instructed to renovate, in this case, plaster and apply a fresh coat of paint over the green-and-white structure, and the DDA, under whose jurisdiction the Bagh-e-Bedil falls, was asked to spruce up the place. A boundary wall was thus erected and a six-feet-tall stone slab installed bearing engravings in five different languages—Tajiki, Persian, Urdu, Hindi and English. The puddle of slush that once marked the entry to the park was miraculously transformed into a concrete walkway, a board prominently displayed at the entrance, and the *bagh* finally given a semblance of a park.

Not many in India would have heard of Bedil, the Mughal poet-philosopher, few in Delhi would be aware of his neglected grave on Mathura Road, close beside the National Sports Club, facing the Matka Pir. Fewer still would have ever set eyes upon this derelict spot. So what drew a visiting Head of

State to a place that few Indians are likely to have heard of?

This question can only be answered by Bedil himself when he speaks from beyond the grave through his immortal couplets:

Why Bedil do you come to call on our heart now,
It was a drop of blood at times, which made gales and
now it's gone.

Born in 1644 in Azimabad, Patna, Mirza Abdul Qadir, known by his *nom de plume* Bedil, belonged to the Barlas tribe from Balkh, in present-day Afghanistan. According to Central Asian sources, however, he was said to have been born in Khwaja Rawash, near Kabul, and subsequently travelled to India where he lived for most of his life and died in 1720.

In his own lifetime he acquired great name and fame as a Persian writer and poet who laid the groundwork of the Indian school of writing in Persian known as *Sabk-e-Hindi*. His style, compressed, elliptic, epigrammatic, influenced generations of Indian poets, especially those who wrote in Persian. His extraordinarily beautiful Persian style of composition known as *tarkib* is said to have influenced

legendary poets such as Momin and Ghalib and later the venerable Iqbal himself. So much so that Iqbal wrote a poem titled *Mirza Bedil* which, to borrow from Shamsur Rehman Faruqui's excellent translation, is as follows:

Is this the Reality, or the mischief wrought
By my false-seeing eye?
The earth, the wilderness, the mountain range,
The dark-blue sky,
Some say: It is; others, it is not,
Who knows if this your world exists at all.
How well Mirza Bedil unknotted this knot
Whose unravelling has been
So hard for the Philosopher:
'If the heart had enough space, this garden
Were sightless: the wine's hue chose to come out
Because the wine-flask didn't have enough room.'

While Indians have forgotten him today and save for the occasional seminar in moth-eaten Departments of Persian or Urdu, no one knows or quotes Bedil; in Central Asia he has a near-cult following. Kabul University has a special department devoted to the study of Bedil's style of poetry known as Bedil Shunasi. In Tajikistan, Bedil is hero-worshipped. At weekly meetings, the devoted gather to study and interpret his poetry, and he has been the poet of choice for many singers (including the most illustrious of all, Ustad Sarahang, who even expressed his desire to be buried beside Bedil's grave).

Bedil's style has spawned an entire school of Tajik-Persian poetry, whose influence can be seen even in post-*perestroika* poets. His sentence structure and use of images often requires time to comprehend, being as difficult for a Dari speaker as Shakespeare is for the modern-English speaker. His extensive writings have been beautifully preserved. His *kulliyat* consist of ghazals, *tarkib-band*s, *mu'amma*s and more. He also wrote four masnawis, the most important being Irfaan, which he completed at the age of 68. It contains many stories and fairy tales, outlining the poet's philosophical views.

Possibly as a result of being brought up in the eclectic environment of Mughal India and being influenced by great proponents of syncretic culture such as Amir Khusro who also wrote in Persian, Bedil had considerably more tolerant views than his poetic contemporaries. He preferred free thought to accepting the established beliefs of his time, sided with common people and rejected the clergy, whom he often saw as corrupt.

As his writings testify, Bedil believed that the world was eternal and in constant motion. He also expressed disbelief in the Day of Judgment and other orthodox tenets of faith. Despite this, he was by no means an atheist or a freethinker in the modern sense. On the contrary, he had complicated views on the nature of God, and was deeply influenced by the Sufis, with whom he spent a great deal of time. Thanks to the Tajiks and their great attachment to Mirza Bedil, the beloved poet of Delhi has been restored to the city. Bedil, who inspired Ghalib to exclaim *Tarz-e-Bedil mein rekhta kehna/Asadullah Khan qayamat hai* (It is a veritable feat to write in rekhta in Bedil's style) calls out to us once again. While many today may not understand the Persian in which he wrote, his words, however, have a universality that transcends time and age:

Bedil az kulfat-e-shikast mun'aal
Bazm-e-hasti dukaan-e-shishagar ast

Bedil, weep not for your losses for / This party that is life is, after all, held in a glass-maker's shop.

...

Dadabari Jain Temple

FACING PAGE: The profusely decorated sanctum sanctorum.

Gateway to the temple.

The Dadabari temple is neither unvisited nor invisible. So, strictly speaking, it does not qualify for this book. It is, however, secluded, tucked away in a nook off the Mehrauli-Gurgaon highway and visited only by those who go looking for it. What is of especial significance for the purpose of this book is the site it occupies. Located on prime architectural property, a hallowed ground of sorts, this area has been constantly venerated and constantly built upon.

The Dadabari temple complex houses the 800-year-old *samadhi* of Guru Jinchanda Suruswarji Maharaj, also known as Dada Gurudev. Born in Jaisalmer in 1176, this child prodigy rose swiftly to become an Acharya at the age of eight, a great Jain scholar, social reformer and preacher of non-violence. After travelling through many parts of India, he came to Yoginipur (present-day Mehrauli in Delhi), which was then ruled by Raja Madanpal. Having heard about his exceptional qualities, Raja Madanpal invited him to pass his *chaturmasa* in Yoginipur. Even though Dada Gurudev foresaw his end, he agreed. Staying at Yoginipur, he preached religious tolerance, *ahimsa* and brotherhood.

He forewarned his disciples that in the event of his death, his funeral procession should not stop at any place on the way to the cremation ghat, and that they must remember to keep a bowl of milk ready to receive the *mani* which would come out of

his forehead at the time of lighting the pyre. But his disciples and the people of Yoginipur, grieving at his untimely and unexpected death at the young age of 26 years, forgot his warnings. On the way to the ghat, his funeral procession stopped at Manik Chowk for *bichlawasa*. When his disciples tried to lift his body for the onward journey, they could not do so. Four elephants were summoned and put to use to shift his body. When even this failed, his last rites were performed and his mortal body consigned to the flames with the permission of Raja Madanpal at Manik Chowk. The flames froze, taking the shape of human feet, causing the spot to be revered for ages to come.

Soon, a temple was built at this spot. Like the nearby Jog Maya temple in Mehrauli, even though the structure of the present-day Dadabari is fairly new, the site of the temple is believed to be ancient and sacred.

As you turn off the Mehrauli-Gurgaon road and go past the crumbling but magnificent Madhi Masjid, you will come upon an impressive marble gateway leading into a sprawling, and immaculately clean, complex, offering a visual and spiritual treat. Directly in front is the sanctum sanctorum dedicated to Dada Gurudev.

The Bhagwan Adinath temple, with its elaborate glasswork and murals, is close beside. First among the 24 Tirthankaras, Adinath is also known as Rishabdev, and the temple dedicated to him depicts the 24 Tirthankaras in an elaborate mural. A pillared corridor leads to the Manidhari Hall with its beautifully decorated glass-domed roof; its cool marble floors seat thousands of faithful during the *viakhan*s.

Delhi has been a centre for Jainism from ancient times. One of the oldest Digambara Jain temples, known as the Lal Mandir, is opposite the Red Fort, on the Netaji Subhas Marg in Chandni Chowk. Constructed in 1658, the temple has undergone many modifications, additions and alterations; it also houses a free bird hospital in its courtyard. Then, there is the Atma Vallabha Sanskriti Mandir on G.T.

Elaborately carved pillars and motifs offer a visual and spiritual treat.

Karnal Road. The complex includes Shri Vasupujaya Temple, Shri Vallabh Smarak, Devi Padamavati Temple and a shrine of Sadhvi Mrigavatiji, a Shastra Bhandar, a Jain Museum and a Research Centre for Indology. The complex also has a school for children, a *dharamshala* and *bhojanalaya*, as well as a free dispensary. Fluted Mughal-style columns in white marble make this an interesting example of syncretic architecture.

There are over 165 places of worship for Jains in the capital, though most are clustered around the Old City. The prettiest and, this being Delhi, the most inaccessible, is the small Jain temple in Chiragh Dilli. Squeezed near House No. 341, close to the tomb of Haji Khanum, it belongs to the late Mughal period and has exquisite wall paintings. Though none of the Delhi temples are as ornate as the ones in Gujarat or Rajasthan, the 14-feet-tall statue of

Carved gateway to tranquility.

ABOVE: Cleanliness and peace above all else.

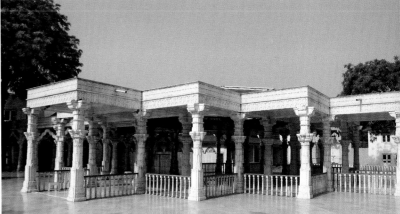

Mahavir, perched atop a hill on the Mehrauli road, is by far the most eye-catching. Spread over three acres of undulating land known as Ahimsa Sthall, the granite statue of Lord Mahavir seated on a lotus draws people from all over.

ABOVE: Gleaming floors and pillars.

LEFT: The Bhagwan Adinath Temple with its elaborate glasswork and murals.

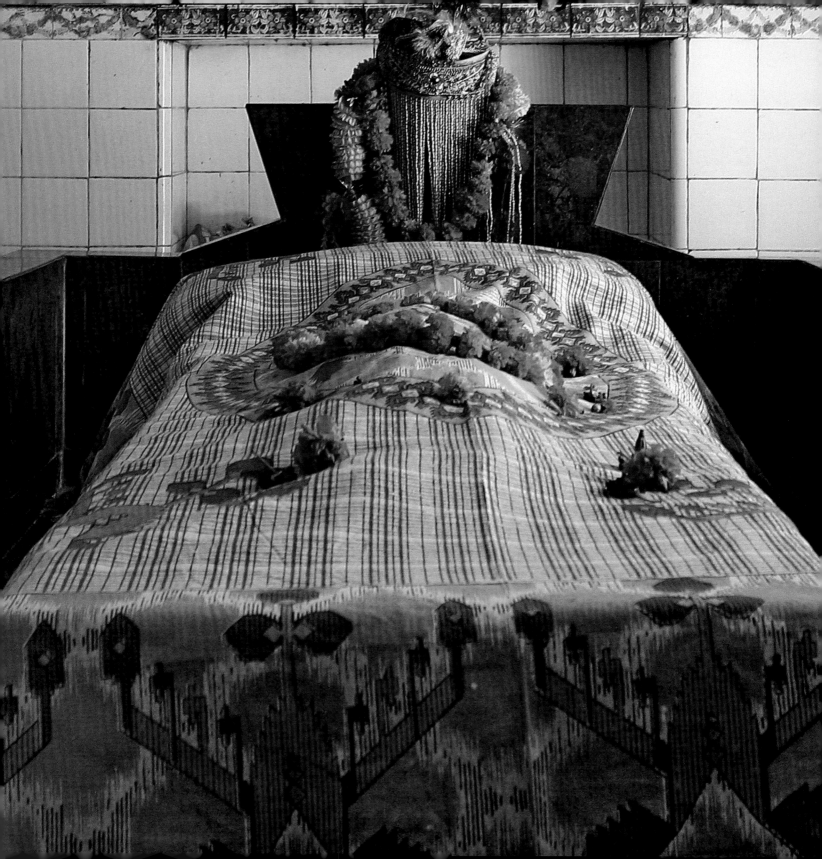

Aliganj

FACING PAGE: Inside Shah-e-Mardan.

Tomb of Arif Ali Shah.

I asked my soul, what is Delhi?
She replied: The world is the body and Delhi its soul.

Mirza Ghalib may have been indulging in hyperbole when he penned these famous lines, but there is no denying that Delhi is a notch above the other great metropolises of India. What sets it apart is the multitude of historic ruins that are almost everywhere, dotted about the landscape at virtually every few yards, especially in some South Delhi neighbourhoods. Every ruler down the ages wished to adorn his beloved Delhi, to leave a mark that would last, and so left behind a landscape that is studded with jewels from the past. One such jewel is the Shah-e-Mardan and the cluster of monuments that came up around it. Hidden in the labyrinth of Lodi Colony, you come upon a historic building that is buzzing with activity and very much in use. Since Delhi has been ruled by Sunni Muslim emperors, unlike other cities such as Lucknow or Hyderabad, there are few Shia monuments here. However, Emperor Ahmad Shah's mother, Qudsia Begum, was a Shia. In 1724 she was said to have received a stone bearing the footprint of Hazrat Ali, the only son-in-law of Prophet Muhammad and revered by Shias as the bravest of warriors, as the King among Men, and hence given the title of Shah-e-Mardan. She placed the footprint referred to as Qadam Sharif at the bottom of a marble tank

fixed on a marble platform. An inscription set in marble reads:

> On the piece of ground where there is a mark of your foot, for years there will be prostrations by men of insight.

Over the next few years Qudsia Begum commissioned a cluster of monuments around it and so came into existence Delhi's holy site for its Shia community. Today, the buildings around Aliganj continue to be kept alive and serve many vital functions—the Majlis Khana serves as an assembly hall for both religious and civic ceremonies, the mosques in this complex are all in good condition and the *karbala* nearby is the burial ground for Shias. (Incidentally, though both Shias and Sunnis profess the same faith, they do observe minor differences in offering prayer and hence have separate mosques and burial grounds.) The enclosure walls of the *karbala* were built by Ashraf Beg, a captain employed by the Scindias and stationed in Delhi during the reign of Shah Alam II.

The Shias trace their lineage to Hazrat Ali. Every year in the month of Muharram, they observe traditional and highly ritualistic acts of mourning

ABOVE: Mosque in Dargah Shah-e-Mardan.

LEFT: Buried in sacred ground.

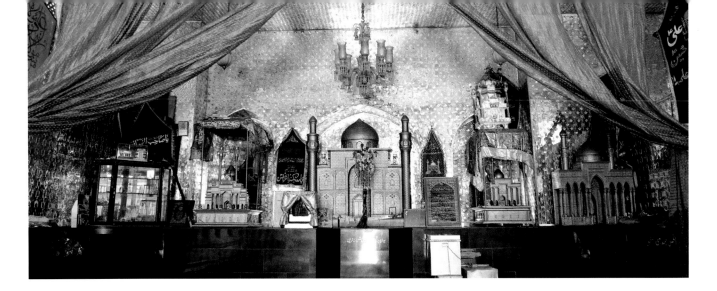

to remember the martyrdom of Hazrat Ali's son, Husain, in the historic Battle of Karbala. In 680, the Battle of Karbala was fought on the banks of the river Euphrates in what is now Iraq. The 10th day of Muharram marks the day when Husain, son of Hazrat Ali and grandson of the Prophet Muhammad, died along with his small and besieged band of supporters, fighting a hopeless battle against the might of Yazid, the usurper to the Caliphate.

The battle was a political one initially as Hazrat Ali was considered the rightful claimant to the Caliphate. Over the years, it acquired a deeply religious significance and every small incident related to the Battle of Karbala is brought alive annually by the recitation of *marsiyas*. These dirges commemorating the deaths of Husain and his brother Hasan list the various *dramatis personae* in the events leading up to the Battle of Karbala, and the martyrdom of Husain, whose head was stuck on a spear and displayed as a trophy.

The Majlis Khana built in 1750 even today reverberates with the doleful recitation of the *marsiya*, presented in its typically stylised and time-honoured manner amid much crying, beating of chests and a cathartic form of remembrance. Its black-and-white chequered floor is packed with people during the month of Muharram and on Hazrat Ali's birth anniversary, so much so that the area around Jor Bagh, Lodi Colony and right up till the Safdarjung flyover is closed for traffic.

Some other buildings of interest inside this compound include the small tomb of Arif Ali Shah, who attained sainthood as a child and was dead by the time he was 12. This square tomb has lost much of its original character because of the rather clinical looking white bathroom tiles that have been used to plaster its façade, edged with a pretty floral border! Then there is the Bibi ka Rauza, a

The chamber housing the taazia's alam and panjas.

symbolic mausoleum of Bibi Fatima, where men are not permitted to enter. The three-domed red-roofed Lal Masjid rises from the huddle of buildings near the Naqqar Khana or drum house where once drums were played to announce the arrival of an important personage or during religious occasions. An Imambara close beside the *dargah* of Shah-e-Mardan houses the many *taazias*, *alams* and *panjahs* that are carried from across the city in the Muharram processions and housed here.

The *alam* is a replica of the one carried by Husain in battle. It is carried at the head of the procession on the 10th day of Muharram. The *panja*, too, is carried in the procession with the *alam*. It signifies the Five Holy Ones—the Prophet, Fatima (his daughter), Hazrat Ali (her husband), Hasan and Husain (their sons). The *taazia* is a replica of Husain's tomb. It is carried in the Muharram procession for 'burial' at the *karbala*. Any city with a sizeable population of Shia Muslims has its own *karbala* that serves both as a place to bury the annual *taazia* and also a burial ground for the Shias. The *karbala* in Delhi faces Jor Bagh. It is a lush place of incredible beauty

The Majlis Khana.

thanks to the venerable Rajdhani Nursery housed on its premises. It had an enclosure wall once built in Shah Alam's reign, but that wall is long gone, gobbled up by the tightly packed government housing blocks of Lodi Colony.

The square, vaulted tomb of Mah Khanam stands in the centre of the *karbala*. Built in 1726, it is constructed of Lahori bricks and has a marble floor. A staircase on the northern wall leads to an underground vaulted chamber where the grave is located. On the gravestone, an inscription bears the following ode to the unknown lady:

Mah Khanam, the sun of the zodiac of chastity, by Heaven's decree hid her face under the cloud of compassion, and turned her heart towards God.

At the eastern end of the *karbala*, is a small, dilapidated mosque belonging to the late Mughal period. It is built on a raised platform surrounded by earth. The chambers said to have once been under the mosque are now quite covered.

The mosque has an east-facing *qibla* wall and small return walls on the north and south ends. It probably served as a place to offer the *namaz-e-janaaza*.

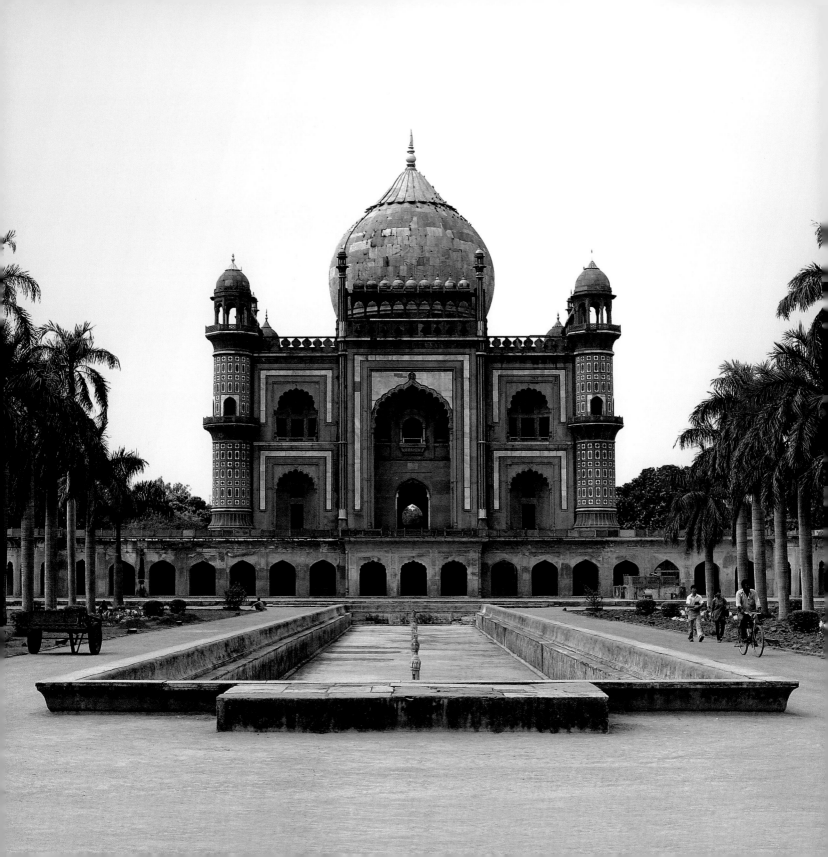

Safdarjung's Tomb

FACING PAGE: The stunning facade of Safdarjung's tomb.

Floral patterns in relief.

Who was Safdarjung? His tomb—large, opulent and richly ornamented—stands in the heart of South Delhi. One of the busiest government-run hospitals is named after him, as are a clutch of colonies, an aerodrome and a flyover. Yet virtually nothing is known of the man himself, or his claim to fame and his contribution to the history of Delhi. That a man should be remembered for his tomb and the area around it, rather than any peculiarities of character, is unusual.

Nephew and successor of the first Nawab Wazir of Oudh, Safdarjung was the power behind the throne during Mohammad Shah Rangeela's long and tempestuous reign and, after him, Ahmad Shah's. Safdarjung's real name was Mirza Muqim Abulmansur Khan. He was appointed Governor of Oudh by Mohammad Shah and later elevated to the post of Wazir by Ahmad Shah. Safdarjung's interests lay not in Oudh, till then a provincial outpost and not quite the centre of gracious living and high culture that it would metamorphose into during the reign of his descendent Nawab Wajid Ali Shah, but in Dilli, that much-abused but still-throbbing heart of Hindustan.

Though not a Mughal by birth, Safdarjung rose to become a powerful figure on the political stage of Delhi that, after Aurangzeb, produced a succession of ineffectual rulers, mere puppets in the hands of wily wazirs. Marathas, Jats, Rohillas jostled for space,

mounting increasingly frequent attacks, pillaging and destroying whatever little was left by marauding Persians and Afghans. Shortly after Nadir Shah's infamous sack of Delhi in 1739, a civil war broke out between the powerful Safdarjung and the equally powerful rival minister Ghaziuddin Imadul Mulk. Imadul Mulk laid claim to Shahjahanabad and Safdarjung to Old Delhi, as the city established by Humayun was then called.

The space between the two cities became a war zone and the skirmishes between their armies lasted six months till finally Safdarjung was defeated, when he retreated to Oudh and died near Faizabad on 25 September 1754. His body was brought back to his beloved Delhi, the scene of his crimes and passions, and buried in the grand mausoleum built by his son, Nawab Shujauddaulah. According to another version, Imadul Mulk plotted against Safdarjung, poisoning Ahmad Shah's mind to such an extent that poor Safdarjung was stripped of his position as Wazir, whereupon he retired to Oudh and died a heartbroken man. With the Mughal Empire coming undone, later years would see Oudh break away and rival Delhi in every way. Already, the Delhi of 1754 was a Delhi in decline, indeed a far cry from the glorious days of architectural achievements.

If the Humayun's Tomb holds out the promise of great beauty yet to unfurl and the Red Fort, the Jama Masjid and the other big and small treasures inside Shahjahanabad symbolise the flowering of everything that was great, noble and majestic in the architecture of the Mughals, Safdarjung's mausoleum embodies the coming together of all the terrible excesses that eventually led to the decline of the empire. In its less-than-pleasing colour combination, its far-from-elegant proportions, its cluttered lines and asymmetrical shape, it is a portent of the beginning of the end. Lutyens' Delhi and the grand imperial design, as evident in the Rashtrapati Bhawan and its environs, can at best be regarded as a pleasant but brief interlude, an affair, no more; the Indo-Islamic marriage, architecturally speaking, was well and truly over by the mid-eighteenth century. Many regard Safdarjung's mausoleum as the last flicker in the lamp of Mughal architecture in Delhi.

A mina work motif.

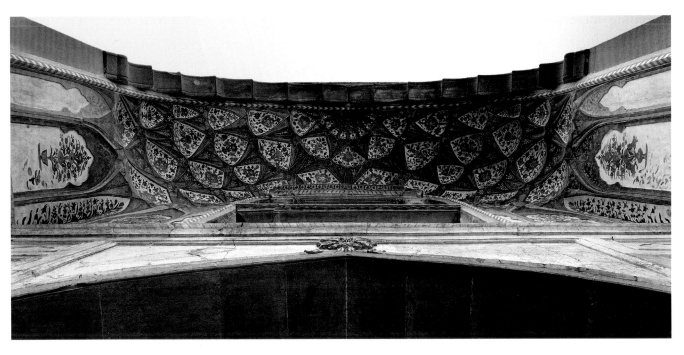

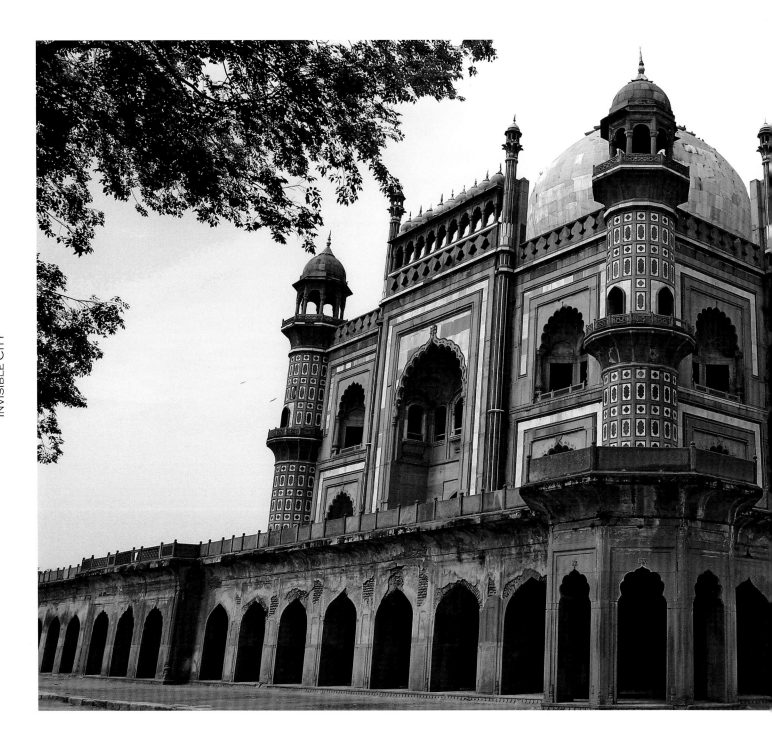

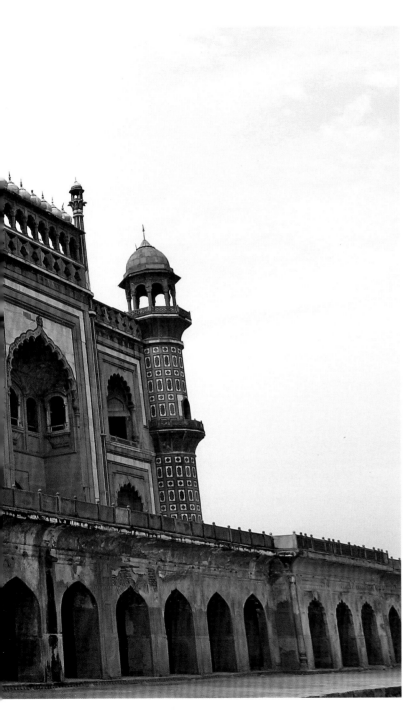

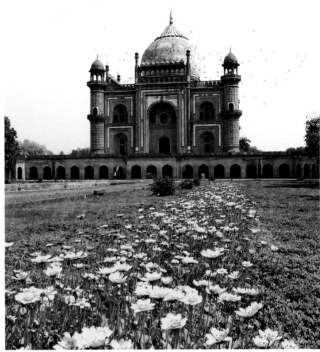

Laid out in the centre of a sprawling garden, the Safdarjung's Tomb is enclosed by a high wall. Planned in a typical *charbagh* fashion, the garden is divided into four squares by walking paths and water tanks, which are further divided into smaller squares by geometrically precise passages that cut each other at right angles. Lined by tall palms and pruned bushes, a waterway with a row of fountains presents a stately vista.

..

ABOVE: The less-than-pleasing proportions.

LEFT: The raised platform covered with arches is reminiscent of the tombs of Humayun and Khan-e-Khanan.

But something is clearly amiss in the building that rises at the far end. For one, it is peculiarly elongated; its length-to-breadth ratio leaves much to be desired. For another, its façade presents a confusing and displeasing jumble of ornamentation. There is too much of everything, the eye can barely take it all. Engrailed arches, square-sided minarets, domed *chhatri*s, profuse plasterwork, a row of miniature marble domes topped by a large bulbous dome combine to present a florid and not altogether harmonious picture. Where rich deep-red sandstone and marble make a striking picture in other Mughal monuments, something about the Safdarjung's Tomb has always failed to impress me.

Maybe it is the combination of a pale red sandstone and beige stone. Or maybe it is the indiscriminate and haphazard use of material from existing monuments. It is said that the venerable Khan-e-Khanan's Tomb was stripped of its marble and sandstone facing to provide the finery for the Safdarjung's Tomb. The only two truly majestic buildings in this complex are the ones visible from the main road—the intricately worked gateway and the elegantly proportioned mosque, built as an after-thought. Entering from the lofty gateway in the east, you will find an assortment of buildings ranged on all three sides—the Jangli

The grave of Safdarjung inside the funerary chamber.

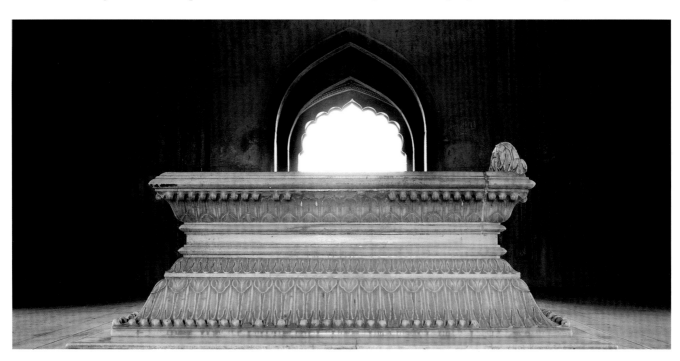

Mahal, the Moti Mahal and the Badshah Pasand. It is said the Nawabs of Oudh maintained the tomb until the Revolt of 1857 and used the apartments and pavilions in the mausoleum complex when they visited Delhi. The British, too, used some parts as a resthouse. The apartments in the Badshah Pasand are now used by the ASI as offices.

ABOVE: Details of the lotus pattern seen on columns.

BELOW: Close up of a leaf and bud pattern.

Metcalfe's Dilkusha

Thomas Metcalfe, English Resident in the Mughal Court in Delhi from 1835-53, was witness to the twilight period of the Mughals. He saw, at first hand, the city shrinking to a fraction of its size, its many gardens and palaces ruined, its elite clutching the remnants of their once-glorious past, and the many old Delhis lying derelict and deserted. The hub of power had begun to shift inexorably from the Qila-e-Moalla, or Exalted Fort as the Red Fort was called, to a small group of nobles, traders, business people and, increasingly, the representatives of the East India Company.

Pre-Mutiny Delhi was a world in decay, peopled by those who looked back rather than ahead. One age was drawing to a close and another was about to be born in the midst of a bloody carnage.

Thomas Metcalfe (1795-1853) first arrived in Delhi in 1813, when his brother Charles Metcalfe was Resident to the Emperor's court. He lived there for the next 40 years and died of suspected poisoning, some say at the hands of the Emperor's wife who resented his intriguing presence. The Metcalfes came from an Anglo-Indian family that had sent many sons to India both before and after Thomas's own long stint. Thomas Metcalfe built himself a new Residency office, complete with castellated Gothic battlements, in the Civil Lines area called, rather grandly, Ludlow Castle, due to its similarity with the castle in Shropshire. Like a good

FACING PAGE: Derelict and deserted.

All the King's horses and all the King's men...

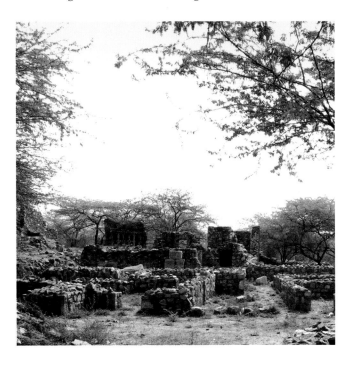

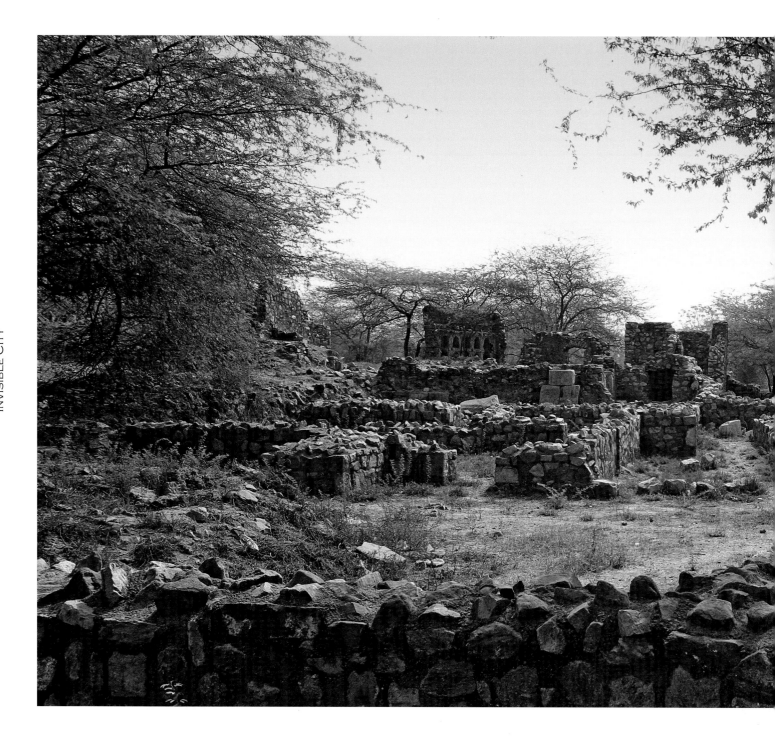

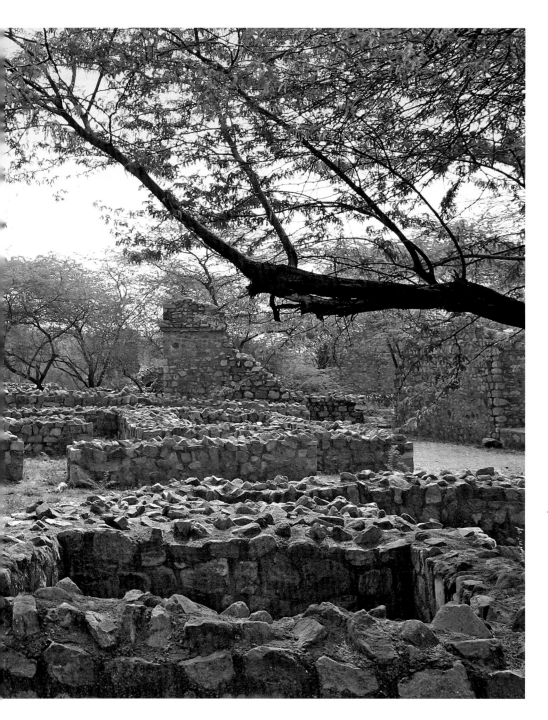

country squire, he also built two mansions for himself. In 1830, he began to build Metcalfe House, his personal residence on the Yamuna north of Delhi, above the Red Fort. (Close to the Delhi University, it now houses the Defence Science Centre and is not accessible to the public. Earlier it was used to train officers for the Indian Administrative Services.) This Palladian bungalow, set amid expansive gardens and cypress avenues, fruit orchards, and flower beds in the style of an English country garden, was meant to challenge the pomp and splendour of the Red Fort. Metcalfe called it the Jahan Numa, meaning 'World Showing'. Here he housed his collection of art treasures and books, as well as a collection of relics of Napoleon. The house was looted by angry mobs during the siege of Delhi in 1857 and most of the treasures destroyed.

Metcalfe also converted a tomb near the Qutub Minar, the octagonal tomb of Muhammad Quli Khan, brother of Adham Khan and foster-brother of Emperor Akbar, and used it as a country house. This he called Dilkusha ('Heart's Delight') where he repaired often to hunt and shoot, especially during the rains. Some say Metcalfe chose the ruined tomb because it was close to the Zafar Mahal, Bahadur Shah's country retreat, so he could keep an eye on the comings and goings of the Emperor's entourage. Again, in a seeming challenge to the Mughal summer palace now fallen on hard times, Metcalfe laid out a *charbagh* garden with channelled rivulets of water leading down to the boathouse. Dilkusha was entered through ornate Georgian gateways, and boasted a lighthouse, a small fort, a pigeon house, a boating pond and a typically English feature called Metcalfe's Folly.

Situated inside the DDA Park in Mehrauli, off Anuvrat Marg, Quli Khan's tomb was built in 1610 or so but in its present state it shows an amalgam of materials dating from the pre-Sultanate to Mughal to colonial times. The tomb is octagonal from outside and square from inside and is said to stand on the original walls of the Lal Kot. There is fine calligraphy on the arched entrances, medallions in the spandrels of the arches and yellow, green and blue tiles on the eastern façade. Some decorative work in plaster survives on the inside walls with traces of blue paint on it and an elaborate circular pattern on the ceiling. Metcalfe let the funerary chamber alone, but used the arched *dalan*s and revamped grounds for his pleasure. He also built an extension on the north, and added a pavilion and many terraces, to enjoy the monsoons. Apparently bored with the Lodi and Tughlaq-period buildings all around, and the singularly Islamic Qutub Minar dominating the landscape, he built a tower known locally as Metcalfe's Battery and modified a Lodi-period tomb into a boathouse.

He added typically colonial semicircular arches to the building that led up to an artificially-created rainwater-fed lake. On an artificial mound he constructed a canopy in the Mughal style to serve as a landscape element. It is said that the house was so well appointed and its ambience so pleasing that Metcalfe often loaned the scenic rooms in Dilkusha to newly-wed couples for their honeymoons.

In the carnage that followed the fall of Delhi to the sepoys, Metcalfe House was gutted and destroyed. Dilkusha, however, fared better. Saved by the looters who targetted properties owned by the British, it eventually fell to time and neglect. You can find its gates, buildings, outhouses, stables and pavilions scattered all over the park in various stages of decay.

PAGES 276-277: The remains of Heart's Delight.

Metcalfe's other claim to fame is his role as a patron of the arts and an avid conservator. He visited most of the great monuments of the past and set up the Delhi Archaeological Society of which the young Sir Syed Ahmad Khan was an enthusiastic member. (Sir Syed Ahmad Khan wrote *Asar-us-Sanadid*, 'Remnants of the Past', a thorough catalogue of Delhi's monuments.) Metcalfe commissioned an album of 120 paintings, *Reminiscences of Imperial Dehlie*, in the early 1940s by Mazhar Ali Khan, the leading topographic artist of the time, and pencil drawings of various local scenes by David Thompson, an Anglo-Indian artist living in Delhi. Watercolours of existing monuments, buildings, shrines, palaces and houses of Delhi are interspersed with deeply personal accounts of the city that Thomas Metcalfe had come to love and made his home. He had the paintings bound in an album, wrote the accompanying descriptive text, and sent it to his daughter Emily in England. Later published as *The Golden Calm*, edited by M. Kaye, it presents a comprehensive pictorial, cultural and architectural record of Delhi in the 1840s. The album also contains verses penned by the last Mughal Emperor Bahadur Shah Zafar (1838-58). A well-known Persian verse, written in Persian script in the Emperor's own hand, was presented to Metcalfe by the Emperor on 29 April 1844. Metcalfe's translation of the verse reads:

A Friend is he, who proffers Friendship's hand
When care or grief our kindred feelings claim
Not he whom prosperous days alone command
And is a Friend or Brother but in name.

Needless to say, some of the buildings illustrated in the album are gone or completely transformed.

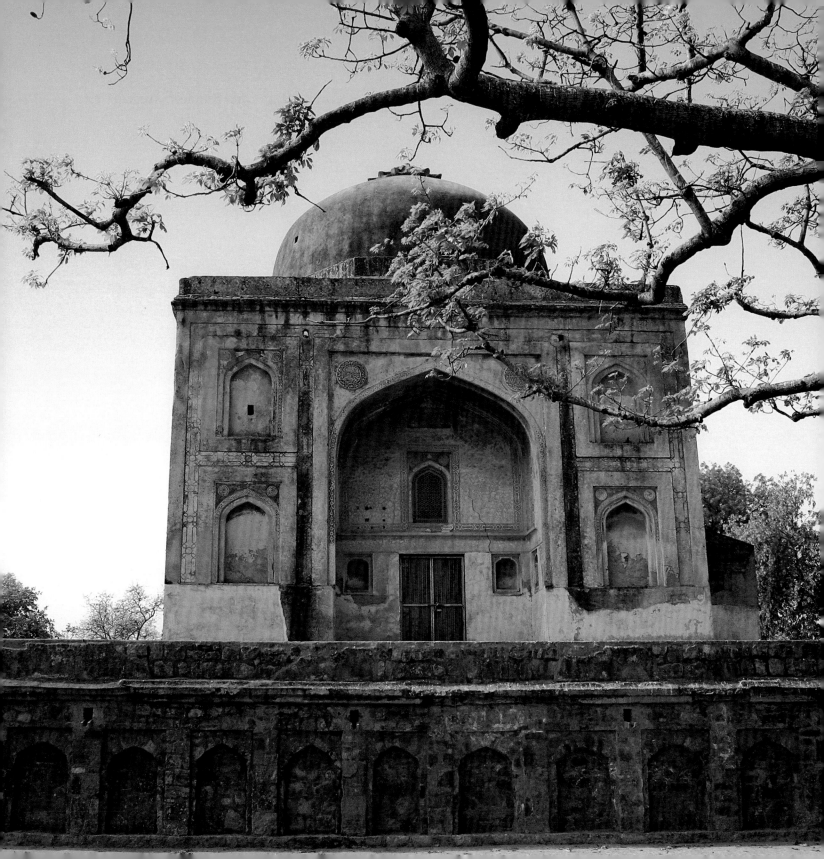

Around Sunder Nursery

FACING PAGE: An early Mughal mosque inside Sunder Nursery.

Sunderwala Mahal.

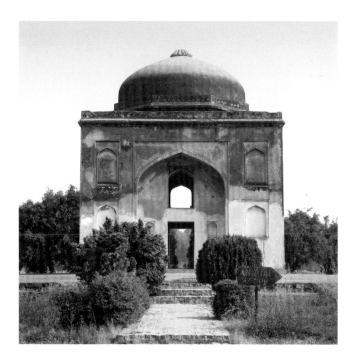

The area around the Sunder Nursery, off Mathura Road, skirting the enclosure wall of the Humayun's Tomb complex, is a treasure trove of tombs and pavilions, some still carrying vestiges of jewel-like craftsmanship and architectural beauty. While most visitors make a beeline for the majestic Humayun's Tomb, drawn to its fame as a World Heritage Site and the first substantial example of the grand style of Mughal architecture, few bother to look beyond the tourist guide's prattle or stray off the beaten track. Yet, if you were to go on a short trip into the unknown, armed with little more than genuine curiosity, you are likely to be amply rewarded.

On the roundabout at the intersection of Lodi Road and Mathura Road stands the Subz Burj, the Green Dome. The elongated neck and blue-topped dome give it a uniquely Central Asian look. Octagonal in shape, this early Mughal building has four wide walls, interspersed with four narrow walls, making it seem both, angular and perfectly symmetrical. The wider faces have large deeply recessed bays, each studded with a doorway. The inner chamber contains the grave of an unknown person. The traffic on this roundabout, being a mad ceaseless rush, you need to risk life and limb to go up for a closer look. The only gate on its fenced periphery is kept bolted, not locked, facing the entrance to the Humayun's Tomb. You can slip

into its grassy enclosure to look at the original red painted fretwork still visible on the arches over the doorways. Or else, simply stand at the verge and look up at the stunning blue, green and yellow tiles on the neck of the dome. I remember cycling past it from my home in Nizamuddin East to the nearby Delhi Public School in the hoary years when it still retained some amazing blue tiles on its dome.

Across the road, stands the Chakkarwali Masjid, so called because it stands at a cross-section. This late Mughal-period mosque with three bulbous domes and three prayer chambers has been much renovated and much encroached upon. A *madarsa*, a *dhaba*, a telephone booth and a gaggle of other 'extensions' have marred the original clean lines of its constructions. But despair not, for the beauties tucked away within the Sunder Nursery make up in more ways than one. Park your car in the Humayun's Tomb's parking lot and stroll in. If the attendants at the gate stop you, suspecting that you do not look like serious plant buyers, flaunt your knowledge of the law by telling them that you have come to see and admire ASI-owned monuments.

Immediately facing the entrance is the exquisite Sunderwala Burj. From a distance, it looks like a simple, unadorned square building with a single, squat dome. A close inspection reveals the most detailed and remarkably unspoilt bands of Koranic inscriptions on the internal walls as well as the underside of the dome. Profuse decorations in incised plaster make you wonder whose tomb this might be.

Over the years, the grave has been levelled and there is no plaque or anything else to suggest whom this fine work was meant for. Nor is there anything else to indicate who might lie buried beneath the *kuchcha* floor of this small but very serene tomb. The sunlight flooding in through the open archways on all four sides makes it refreshingly different from the usually dark, cheerless funerary chambers that one finds in most tombs in Delhi.

To the northeast of the Sunderwala Burj, standing amid a sea of flowering plants and other seasonals, is the Sunderwala Mahal. Like many little-known buildings in Delhi, the 'mahal' is a misnomer. Mahal is used erroneously and interchangeably for any building when the locals do not know the exact name of a monument, or who built it and when. This rectangular rubble-built monument with the corners cut off is actually a tomb—whose, no one knows. Two staircases lead up to the roof where the remains of a square platform suggest that once there must have been another structure here. A barred gate shows steps leading down to a vaulted underground chamber, probably housing the graves, though the fear of snakes and other creepies makes it a less-than-pleasant prospect to investigate. What

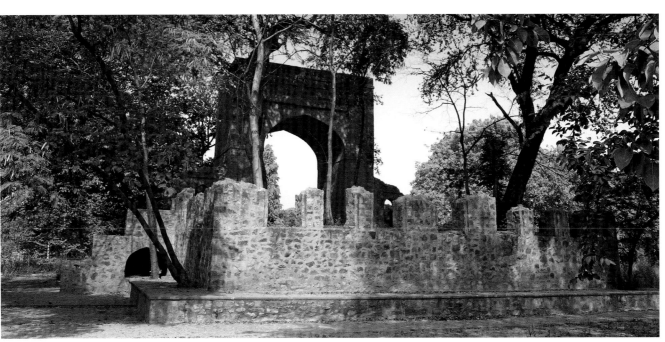

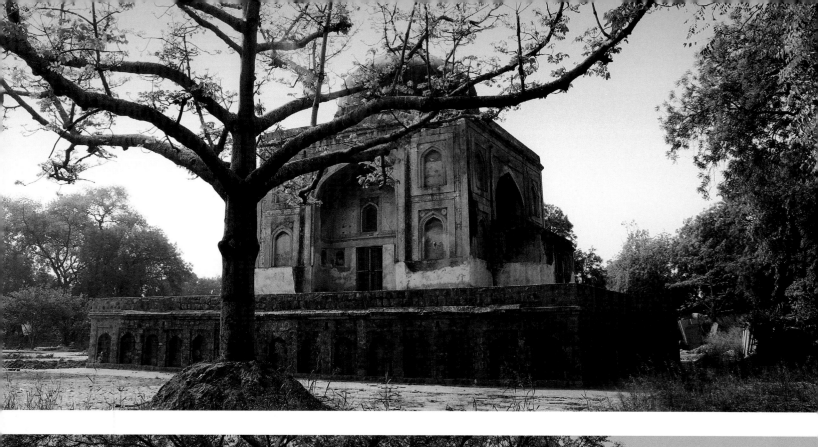

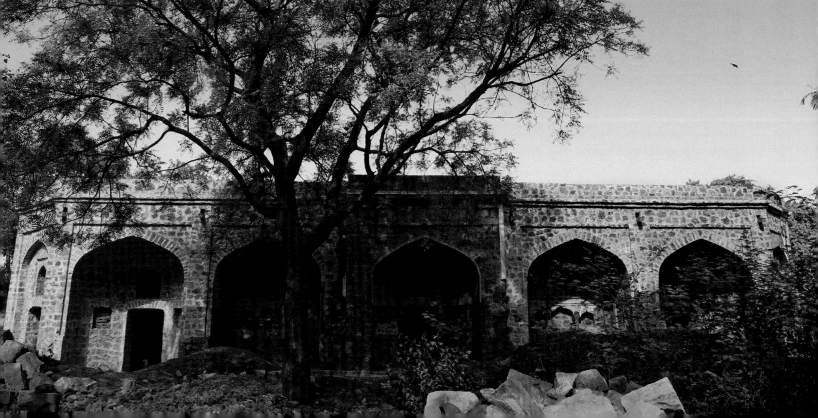

is intriguing and very pleasant is the *bhul-bhulaiyan*-like verandah on all four sides. Low ceilinged, it has five arches on each of its four sides, making it look like a maze.

Along with the Sunderwala Burj, the Mahal apparently stood within an enclosure and was entered by a lofty gateway. The enclosing walls have disappeared, though traces of the gateway remain. Several tombs and graves are scattered about, giving the impression that this entire area was once a vast graveyard. Of the few monuments still intact is a tomb on a high plinth with arched recesses on its outer walls and some fine ornamental stucco plaster on its ceiling. Close beside is a well and a mosque with only one large central mihrab left. From far, it looks like a gateway to something; close inspection reveals nothing but a pile of fallen masonry and a debris of collapsed arches. A tangle of shrubbery threatens to envelop it in a cloak of oblivion.

But let us draw heart from the truism that till places and buildings continue to be visited, they remain visible; the cloak of oblivion descends only when people stop looking at them, making them invisible, as it were. All of you whose hearts beat for Delhi, do not let that cloak fall just yet; go and see some of these beauties before they disappear before our very eyes. Or, worse still, before handmade kiln-fired tiles of the most azure blue are replaced by mass-produced bathroom tiles.

FACING PAGE:
ABOVE: Restored with the help of the Agha Khan Trust.

BELOW: Sunderwala Mahal—after recent restorations.

PAGE 283:
ABOVE: The ruins of a well.

BELOW: The remains of a mosque inside Sunder Nursery.

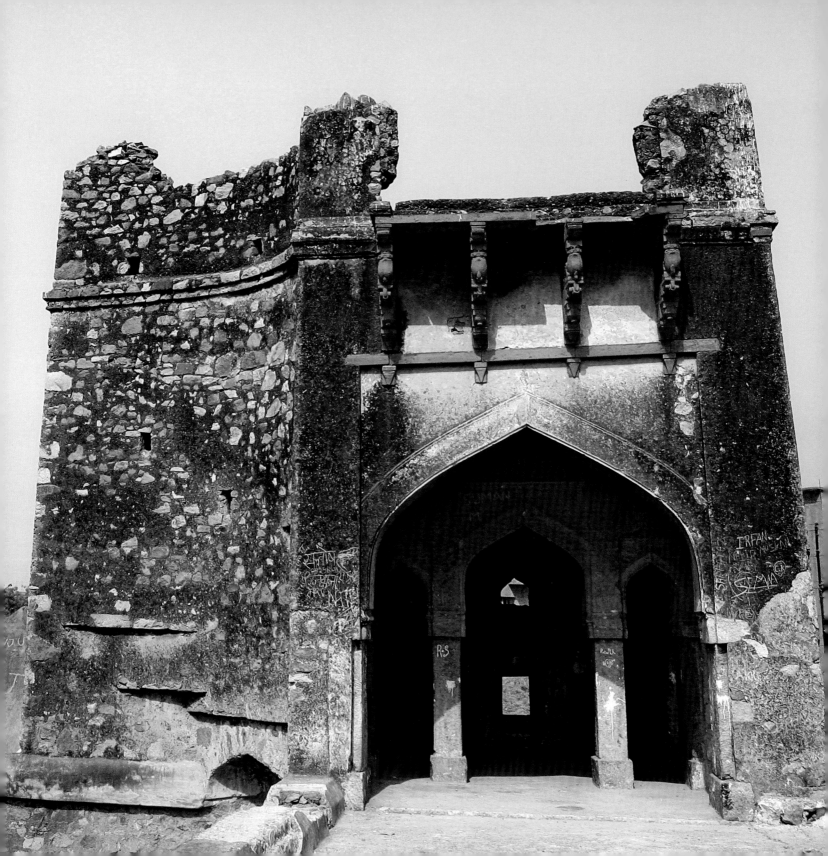

Ruins of Sarai Shahji

South of Panchsheel Park, on the road to Shivalik, lies a patch of land rich in history and hoary with age. Known locally as Sarai Shahji, it has a cluster of monuments, all in the vicinity of Aurobindo College, and all in various stages of dilapidation. Such is the richness of its antiquity that the ASI has carried out several excavations hereabouts and unearthed evidence in the form of old structures, bits of pottery and traces of continued habitation over a long period of time. However, such is also the blanket of oblivion that hangs over Sarai Shahji that it has been rendered practically invisible.

Having read about the place and gone armed with all sorts of local landmarks, it still took close to over two hours of pointless circumambulation within a radius of a kilometre or two before I finally homed in on the ruins of Sarai Shahji. I stopped to ask for directions in the neighbourhood of the MMTC Colony and Shivalik, no one had heard of such a place. But just as I turned dejectedly to return home, a small sign with lettering in Urdu announced the name of a *madarsa*. A dirt track trails off the main road facing C Block of Shivalik and there, behind a large marble factory, can be seen a glimpse of a blackened turret.

Having stumbled upon the once-fabled Barah Khamba and the motley ruins near it, I could understand why the place had been so difficult to find. True to the spirit behind this book, here

lay something that is really invisible. Of all the monuments and sites covered here, Sarai Shahji is more encroached upon, more neglected and by far the most hemmed-in and confined within its own shrinking circle. No wonder it is considered far less worthy of being noticed—by the civic authorities, by the law of the land and most certainly by those who live barely a stone's throw away. In any other country, there would have been some level of awareness about a patch of land that has revealed traces of its past going back to several centuries.

The patch of land directly in front of the monument called the Barah Khamba was once a graveyard. (In fact, there are graves scattered all about and you need to hastily step off one directly in front of the marble shop's front gate when you realise what lies beneath your feet.) Much of the land has been encroached and built upon. The small patch that remains has been converted into a dump of sorts. A strong stench of burning rubber hangs over it. Pigs root about in the filth and an air of desolation shrouds it like a pall. The remnant of a pillar stands in the grounds. A tunnel is said to run from here all the way to Agra. The largest and most significant monument here is the Barah Khamba. Also known as *mahal* for some reason, this was once a *khanqah*. Today it is owned by the ASI and given protected status and grading of Archaeological Value A, yet no effort is made towards its upkeep.

This Mughal-period building has a central courtyard surrounded by an arcade. There are three central compartments on the west that could have been used as a mosque. A pyramidal roof gives the building a very distinctive look and makes it at once different from the usual domed buildings that you see in and around Delhi. At the northwest corner of the building is a two-storey structure that was used for residential purposes. Zafar Hasan, in his seminal study of Delhi's monuments, *The Monuments of Delhi: Lasting Splendour of the Great Mughals and Others* (four volumes), says that till 1914 this structure was used as the office of the Executive Engineer. Before that it was occupied by villagers from the neighbouring areas. From time to time, parts of it served as a *sarai*. Said to contain 40 rooms in all, there was a separate section reserved for women travellers. According to a young boy from the nearby *madarsa*, the building gets its name from the 12 pillars inside. Made of local quartzite stone, the pillars support the vaulted stone roof. A staircase leads up to the second floor that once had rooms with projecting balconies. The second floor is almost all gone now; what remains are the courtyard and the arcades on the ground floor.

Close beside the Barah Khamba is a mosque that now houses a *madarsa*. It has three compartments and a curved upturned boat-shaped roof known as a 'Bengali' roof. This roof made an appearance during

the Mughal period and is very different from the domes of the Lodi and Tughlaq periods. Of the three compartments, the southernmost has collapsed almost entirely and seems to have been absorbed into the clutter of densely packed houses that crowd around its edges, waiting to devour the rest of the building. Boys in skullcaps and *kurta pajamas* hang about, curiously eyeing visitors.

Facing the mosque-turned-*madarsa* is the tiny *dargah* of Farid Murtaza Khan. Dated 1625, it is protected by the ASI. Shaikh Farid was a contemporary of the Emperors Akbar and Jahangir, in whose reign he held the post of Governor of Gujarat, and later Punjab. According to contemporary chroniclers, he was a prolific letter writer and conducted a prodigious correspondence with the leading Sufis of his time, most notably Khwaja Baqi Billah. He is also said to have erected several *sarai*s. Perhaps the one next door was built by him, though how it acquired the name of Sarai Shahji no one knows. The grave of Farid Murtaza Khan has a marble *qalamdan* and a tall, inscribed slab at the headboard. It lies inside an enclosure with several other graves. You enter the enclosure through a dressed stone masonry gateway at the eastern side. The western wall of the enclosure serves as a mosque and is embedded with five *mihrab*s. To the east of the grave lies a partially buried enclosure wall. It, too, must once have been a wall mosque, going by the three *mihrab*s on its

western wall. The two ends of the western wall have low domed chambers. Crowding around it, waiting almost hungrily for the day when it comes crashing down, is a clutter of small, mean-looking houses. In the distance the large apartment blocks of Sarvodaya Enclave look serene and unconcerned, far removed from this blot on the horizon.

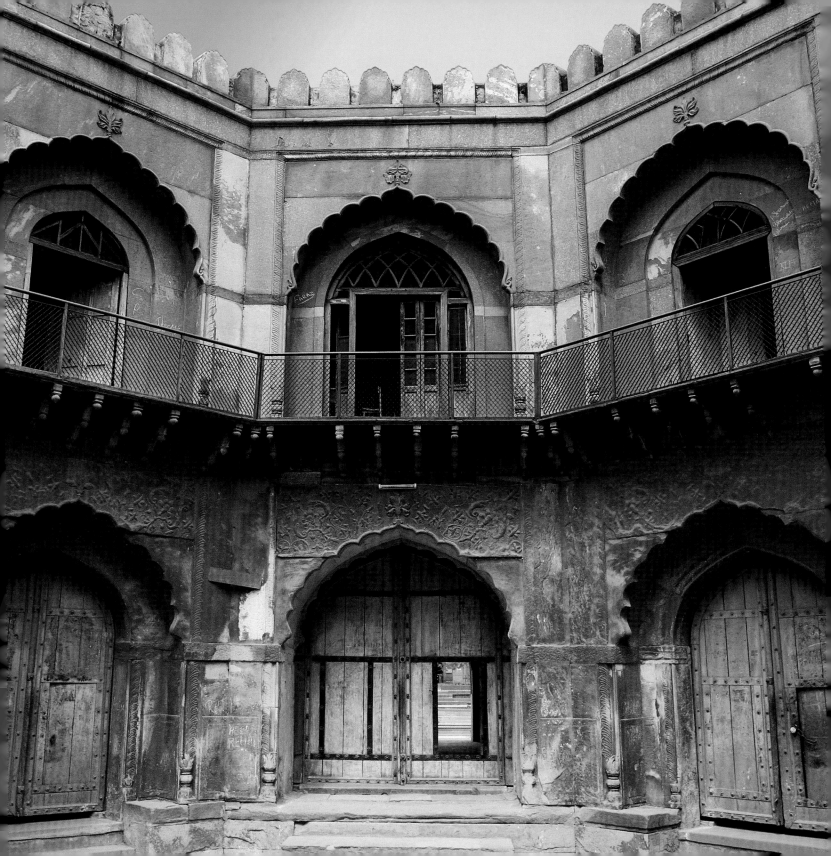

Anglo-Arabic School

A jharokha with a Bengali roof.

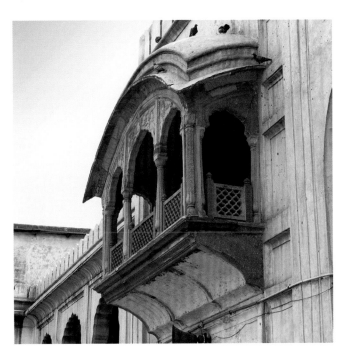

Imagine studying in a school that has been an educational centre for over 300 years. Imagine the likes of Ghalib vying to become a teacher of Persian here, and failing. Imagine a space that witnessed the earliest linguistic and cultural encounter between the East and the West, between English and the languages of the Orient. For, this was no ordinary school; this was the crucible in which one of the most volatile of experiments was conducted—this was the great Anglo-Arabic Madarsa or the Delhi College as it came to be called from 1825 onwards. The best and brightest flocked here to be reckoned among equals. The lamp of *nai taleem* (new education) burnt brightest here, and it was here that the Delhi Renaissance kindled the nationwide debate on the merits of oriental scholarship versus western learning. The finest minds taught here, setting forth an example of a space where the East and the West could indeed meet. Dr Aloys Sprenger, Master Ram Chander and Maulvi Zakaullah were among its leading lights.

Founded by the father of the first Nizam of Hyderabad, Ghaziuddin Khan, in the early eighteenth century, it became a role model for *madarsa*s around the country—both architecturally and academically. Situated on Shraddhanand Marg, opposite Ajmeri Gate, the Anglo-Arabic Public School, as it is now called, has had a chequered past. It has been, in its 300 years of

existence, an Arabic *madarsa*, an oriental college, briefly an artillery barrack and a police station, a hostel, a *madarsa* again; now it is a high school with 1,900 students from Classes VI to XII. The medium of instruction is Urdu, except for Science in the Higher Secondary classes when the teachers adopt English.

Both literally and figuratively, the school that stands on this historic site today has successively built upon the foundations of the traditional *madarsa* built by Ghaziuddin. It began by teaching Arabic and Persian, apart from religious discourses and Koranic instruction, as *madarsa*s usually did; however, with the introduction of English in 1825, the school became divided into two: the Oriental and the English section. The Oriental section benefitted from an endowment by Nawab Eitmadud-Daula of Lucknow in 1829. In 1843 the Delhi Vernacular Translation Society began to share its premises. From 1857 till 1889 it was closed and the building occupied by the police force. The Anglo-Arabic School functioned here till the terrible tides of Partition swept across Delhi once again. The military took over the premises in 1947 and in 1949 a portion of the school was given to refugees who thronged Delhi. At the suggestion of Dr. Zakir Husain and Maulana Abul Kalam Azad, a school was started here once again, first called Anglo-Arabic Higher Secondary School and

shortly re-christened Delhi College. In 1974 it was renamed Zakir Husain College. A few years ago the Zakir Husain College moved to a new building. What remains now is a shell of a building with a grand past but an uncertain future.

High-ceilinged cloisters, called *hujra*s, with typically fluted columns and graceful arches, in the late Mughal style, once meant to accommodate two dozen teachers and an equal number of students, are now bursting at the seams. Classes are held in rooms of rare architectural value but with complete and utter disregard both for their historicity and the physical safety of the staff and students who now crowd into these unkempt rooms. Peeling plaster, exposed brickwork, sagging ceilings, precariously pendulous ceiling fans, missing lights, inadequate ventilation, overgrown grass, heaps of rubbish and a playground run over with grass and vegetation—this venerable *madarsa* now presents a sorry sight.

But nothing can take away from its solemn dignity. A splendid red sandstone entrance leads into a perfectly proportioned interior with arched chambers along two sides and a red mosque at the far end.

A plaque on the central archway that leads into the tree-filled courtyard bears the following legend:
There remains no mark on the tablet, but the reward of an act and a good name.

The Anglo-Arabic School still has a name, one that is immediately recognisable to those who have followed the swirling currents among educational debates in India. Regardless of the name it was known by, the school/college/*madarsa* that occupied this site has been in the business of imparting education. The type of education has varied at different times: it has churned out *alim* or men versed in *Dars-i-Nizami* or the classical languages, philosophy, logic and Islamic jurisprudence.

Then came the White Mughals and the new breed of interpreters who would fill in the cracks between traditional oriental learning and western education as laid down by Macaulay's Minutes. Later, came the sort of hybrid education that would provide the clerks to run the imperial machinery and, finally, after Independence, the University Grants Commission (UGC)-approved Education-for-All.

C.F. Andrews, the British missionary who worked closely with Gandhi and Tagore, saw the Delhi College as both the cause and the symbol of the Delhi Renaissance. Both staff and students of the Delhi College championed the cause of Urdu, the new kid on the block, and used this new language in innovative ways, especially in the emerging field of journalism. During Sprenger's term as Principal, the college also set up a printing press. All these efforts combined to produce an efflorescence, a blossoming

The famous Dilli College.

of mind and spirit. And Delhi College was also the laboratory where enthusiastic teachers initiated bright-eyed students into the mysteries and marvels of modern science and traditional knowledge.

What we have in our midst is not just a building but an institution. And the great pity is that we are allowing it to disintegrate virtually before our eyes. With the onslaught of every monsoon, with the passing of every year, with the accumulation of each fresh layer of debris, we are allowing it to sink into a morass of neglect. In 2003, the University of Erfurt, in collaboration with the Jamia Millia Islamia, began some conservation work on its southern wing. In 2005 the Delhi Development Authority initiated restoration work; they restored a huge basement and repaired a tank in the middle of the courtyard that had been filled with debris and broken bits of masonry. However, a lot still has to be done to reclaim this bit of our city's past.

The Anglo-Arabic School on Shraddhanand Marg, opposite Ajmeri Gate.

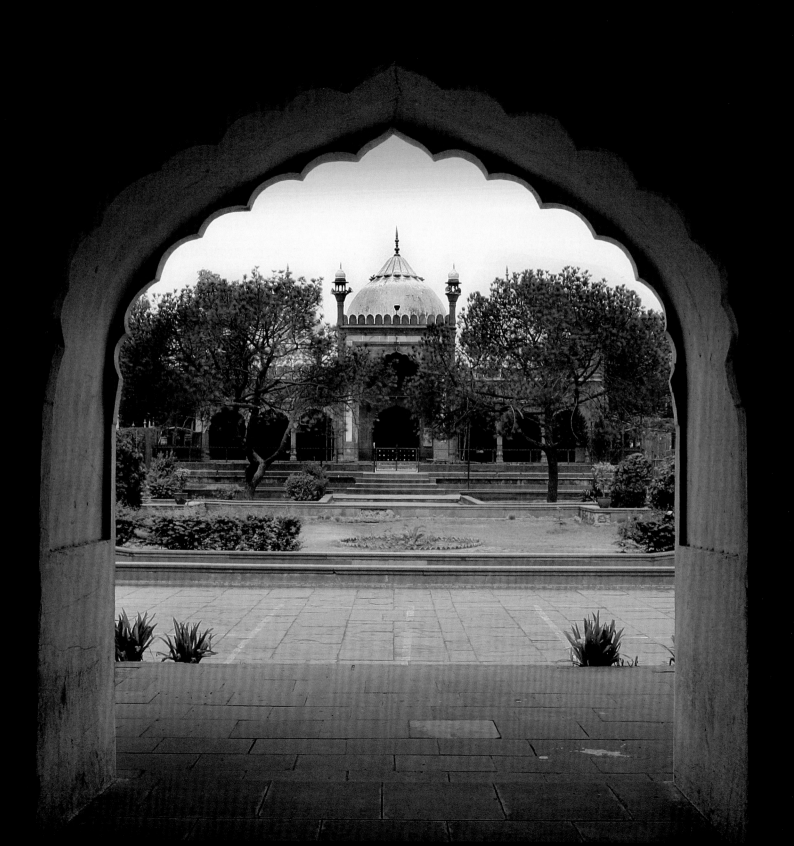

Ghaziuddin Khan's Mosque and Tomb

The same Ghaziuddin who built the *madarsa*, later known as the Anglo-Arabic School, also built a mosque and tomb on its premises. Ghaziuddin Khan Bahadur was the title adopted by Mir Shihabuddin who came to Hindustan from Bukhara in the 1670s. Being from Central Asia, he sought and found service with Aurangzeb, rising through the ranks to earn various titles. His son, Nawab Nizam-ul Mulk Asif Jah, was appointed Governor of Hyderabad, where he founded the famous Nizam dynasty. Ghaziuddin died during a military campaign in Ahmedabad in 1710. His body was brought back to Delhi and buried in the mausoleum he had constructed during his lifetime, next to the *madarsa*.

The most striking thing about the mosque is the visually compelling contrast of red sandstone in the mosque and the plaster facing of the courtyard wings and the school buildings. It establishes a link with the imposing gateway that is similarly faced with red sandstone. Considered one of the most beautiful specimens of the smaller Shahjahani-type mosques in Delhi, it merits comparison with the other mosques built along similar lines in Shahjahanbad. These include the Zinat-un-Nisa and Fatehpuri Masjid as well as the Khairul Masjid inside the Purana Qila.

Ghaziuddin's mosque contains three compartments, each topped by a bulbous dome.

FACING PAGE: The mosque of Ghaziuddin Khan.

View from inside the mosque.

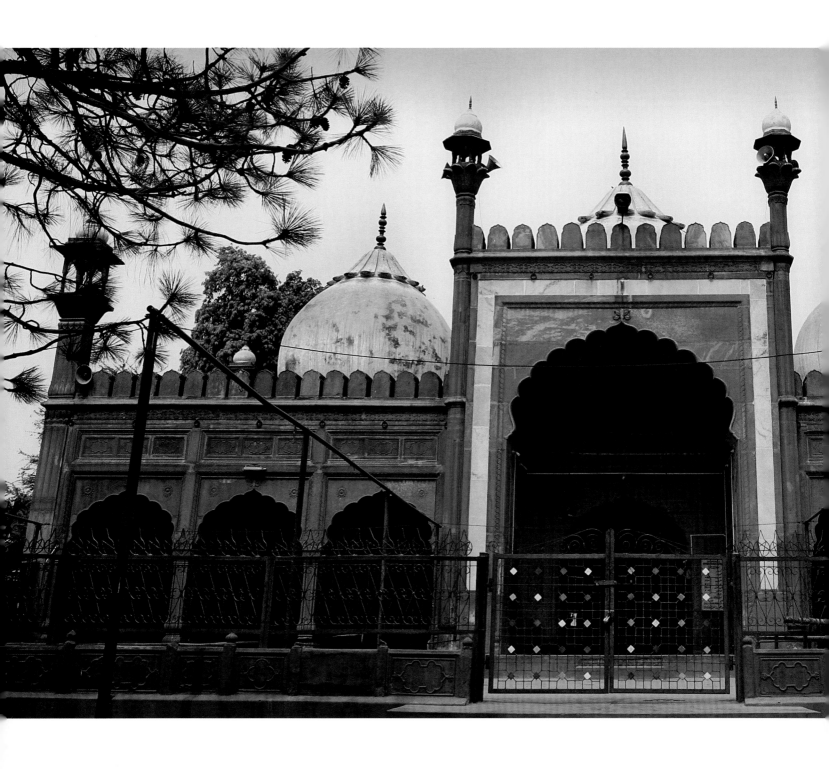

Under the central dome, the floor of the mosque is paved with oblong fawn-coloured stone framed with black marble bands. The central chamber has a pronounced double arch and the two side chambers each have three arcades formed by rectangular pillars. By the late seventeenth century the pillars had acquired an 'organic' life of their own and were not left unadorned by architects. Here they sport a clump of leaves like the calyx of a flower, sprouting more leaves at the juncture where the shaft of the column merges into a delicately scalloped arch. Compare this with the solid blocks of granite that serve as columns in most Lodi and Tughlaq-period mosques and you will marvel at the refinements that were introduced by the Mughals. These were coupled with the increasing attention to details and the near-obsession with symmetrical grace that reached its culmination with the Jama Masjid built by Shah Jahan.

The architects who built Ghaziuddin's mosque were no doubt influenced by Shah Jahan's Jama Masjid as well as the mosque and Mehman Khana of the Taj at Agra (built during 1632-43) and Jahanara's Jami Masjid, also at Agra (1643-48). The *pishatq* or jutting arch adorning the central chamber is more pronounced here. The addition of two chambers on

A beautiful specimen of the smaller, Shahjahani-type mosques in Delhi.

either side allows for more space inside the prayer hall. Oblong bays forming extensions of the north and south wings of the courtyard flank the side domes. Interestingly, the *madarsa* and courtyard served as the setting for Jallianwalla Bagh during the shooting of the film *Gandhi*.

The founder of this magnificent building chose the south corner of the masjid for his burial. Here he lies buried in a simple tomb open to the sky but screened from the world with the most exquisitely crafted floral *jaali*s hewed out of fawn-coloured stone. The trelliswork of flowers, buds and vines is a fine example of the 'naturalistic' style, making it one of the most picturesque corners in Delhi. That a gem like this should exist in the city and be so little known is a great tragedy. In fact, the floral motif of these stone *jaali*s deserves to be the logo of some government agency, like the stone *jaali* of the Siddi Mosque in old Ahmedabad, which features as the logo of the Indian Institute of Management.

These screens have real doors (kept locked) in the south and 'blind' doors in the north, near the mosque. The blind doors contain panels with the same naturalistic flowery plants in sandstone relief. You can peer through these *jaali*s to spot another *jaali*-screened enclosure that houses Ghaziuddin's tombstone. These *jaali*s are much simpler; each side sports a blind door flanked by two panels. The same motifs, as on the outer screens, are taken up again in the south wall of the mosque that has floral patterns set into a frame of rectangular panels.

LEFT: Floral jaalis with a trelliswork of flowers, buds and vines.

Leaves, like the calyx of a flower, adorn the stone pillars.

Like the flower-filled panels of the Taj Mahal, these floral patterns are meant to symbolise blooms that evoke the legendary gardens of paradise as a fitting funerary decoration.

You come away from Ghaziuddin's tomb with an indescribable sense of lightness and delicacy. That something so exquisite, like fine handmade lace, is carved out of stone is hard to imagine.

Jaali-screened enclosure houses the grave of Ghaziuddin Khan.

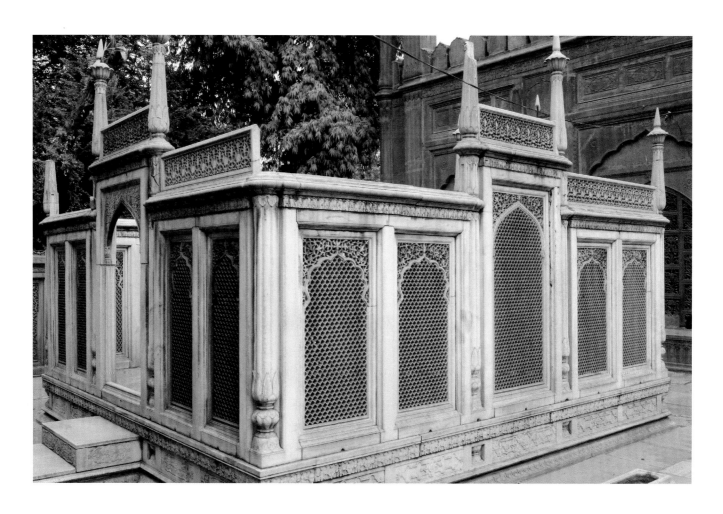

Zafar Mahal

FACING PAGE: Rising nobly above the clutter of its surrounding.

The carved gateway of Zafar Mahal.

Zafar Mahal, the last Mughal palace to be built by the last Mughal emperor in the last days of the waning Mughal empire, lies in ruins. Neglected, encroached upon, hemmed in from all sides by unauthorised constructions, it stands forlorn and empty. After the Revolt of 1857, when the British forces captured Delhi and exiled the frail 82-year-old poet-emperor Bahadur Shah II, better known by his *nom de plume* 'Zafar' (meaning victory), this palace has been steadily encroached upon and also been systematically vandalised.

Situated close to the western entrance of Bakhtiyar Kaki's Dargah in Mehrauli, this was once Bahadur Shah's favourite retreat, especially during the monsoon when he came with his begums and the royal entourage all the way from the Red Fort to enjoy the rains and be a part of the annual festival called *Phoolwalon ki Sair* (the Procession of Flower Sellers), held in the month of August.

Instituted some time in the 1720s, the festival of *pankha*s, as this procession was also called, was a tribute to the Mughal rulers from the Hindu and Muslim flower sellers of Mehrauli. In a lovely display of communal harmony, huge flower-bedecked fans were carried in a procession, first to be blessed at the nearby temple of Jog Maya and Bakhtiyar Kaki's Dargah, and then presented to the emperor.

This beautiful symbol of syncretism was revived after Independence. *Pankha*s are still carried in a

procession comprising both Hindus and Muslims, except that now it usually takes place in the first week of October after the rains have come and washed away the grime of summer and, instead of the Mughal emperor, the patron is the Lt. Governor of Delhi.

Much else has changed too. All the land around Zafar Mahal once belonged to the emperor and, given the increasing penury of the royal privy purse, the *tehsil* of Mehrauli yielded some much-needed revenue. Fond of laying gardens with fruit-bearing trees crisscrossed by waterways, Bahadur Shah Zafar laid out a garden of fig trees and his favourite wife Zeenat Mahal planted a *bagichi*. Sold to a private developer in the late 1980s, this *tehsil* was razed to the ground to make space for residential houses. The pleasure pavilions and gardens are gone, buried under a maze of tarred roads and densely packed houses. What remains is the grand sandstone and marble entrance, appropriately called Haathi Gate for it was from here that the emperor would set out atop the royal elephant, leading to a complex of fluted columns and arched pavilions but few intact rooms.

The palace was originally built by Emperor Akbar II in the 1820s as a summer retreat. Its open, arched *dalan*s and many windows were designed to capture the smallest puff of air, keeping the place cool in the blazing summer heat. Recognising its potential, Zafar had it renovated for his own use; he had the handsome gateway constructed in 1847-48.

Apart from the attraction of visiting the *dargah* of the great Sufi saint buried nearby, Mehrauli had become a favoured destination for quick getaways from the Red Fort. Royal parties would often set out for several day-long excursions, picnics and hunting sprees. The leisurely cavalcade of royal palanquins and horseback riders would halt for lunch at Humayun or Safdarjung's tomb, pay obeisance at the Dargah of Nizamuddin Auliya and proceed towards Bakhtiyar Kaki's Dargah. With the king and his consorts came not just the courtiers but the common folk as well. In one of his letters, the great poet Ghalib writes how life in Delhi came to a standstill for weeks on end when everyone flocked to the festival in Mehrauli during the rains.

The Jahaz Mahal, situated close to the Hauz-e-Shamsi, so called because of its upturned boat-like roof, was the venue of a grand reception for the emperor. From here, the royal party would proceed to the Jharna (once a garden with cascading fountains built by Firozshah Tughlaq). *Kanat*s and tents would be erected in its grounds to afford complete seclusion. The royal party would picnic and loll about in the mango grove called Amarian, close to the Jharna.

After receiving the fans from the citizens of Mehrauli, the emperor and his party would retire to Zafar Mahal for the duration of their stay, enjoying the rain from the many *jharokha*-style windows that overlooked the gardens and plains of Mehrauli.

The crowning feature of the still-intact gateway is the *chhajja* built in the late Mughal style. Entering from the massive wooden doorway, a spacious arcade with arched *dalan*s stretch out on either side. The eastern arcade opens into a courtyard. At one end there is a two-storey building of thin bricks with 'colonial' features such as a fireplace and a wide staircase with low steps.

Within Zafar Mahal, lies a cluster of monuments, each worth a visit. There is the tomb of Allauddin, a nephew of Iltutmish, built during Iltutmish's reign (1210-35), the house of Mirza Babar and several late-Mughal period tombs with quaint upturned boat-shaped 'Bangali' roofs. Shops, shanties and private residences have sprung up in so-called 'protected' properties. The tombs of several members of the Mughal family are built behind a marble *jaali*.

The tombs of Shah Alam Bahadur Shah I and Shah Alam II can be identified among several uninscribed tombs. An empty plot marks the spot identified by Zafar himself where he wished to be buried in proximity to his ancestors and in the shadow of Bakhtiyar Kaki's Dargah. Fate, and the *angrez hukumat*, decreed otherwise. The late lamented Zafar lies in a humble grave in distant Rangoon. Looking at that empty space, the lines penned by him in his years in exile acquire a haunting significance:

Kitna hai badnaseeb Zafar dafn ke liye
Do gaz zameen bhi na mili koo-e-yaar mein

How unfortunate is Zafar, for his burial he couldn't even find
Two yards of land in the home of his loved ones.

Windows set inside the massive arched gateway.

POST-MUGHAL

BEYOND TIME

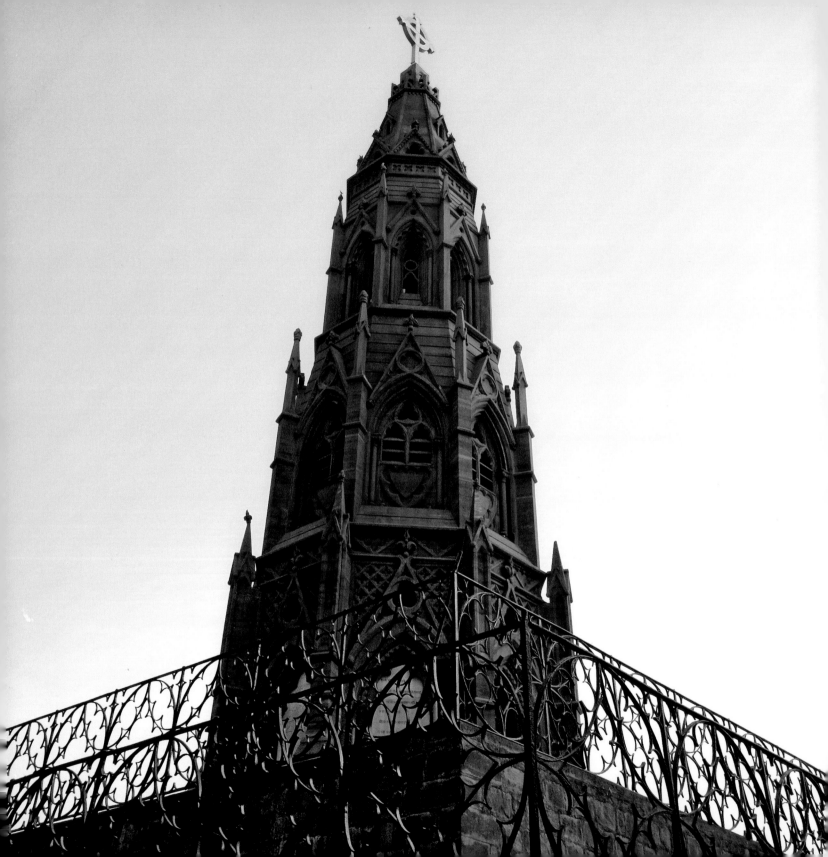

Mutiny Memorial

FACING PAGE: The Mutiny Memorial in all its glory—post renovation.

Illustration beside the entrance to the Mutiny Memorial.

There are two sides to every coin. History too lends itself to different interpretations—depending on who is writing it and when. The accounts of the colonial masters termed 1857 as the year of the Revolt and disparagingly referred to the native soldiers who dared open fire upon their white officers as 'mutineering sepoys'. Later accounts, especially those by revisionist post-colonial historians, labelled the cataclysmic events of 1857 as India's First War of Independence and the rebels—whose numbers soon swelled to include both soldiers and civilians—were elevated to the status of *shaheed* or martyrs.

Built in a typically Gothic style, the Mutiny Memorial is a tapering tower raised on a base with two levels. It sports profuse decorations on its outer walls and wrought iron railings on its lower flight of steps. Inside, the tower is circular and has a staircase leading to the top that is crowned by a red sandstone spire bearing a marble cross. Compared to the grand Gothic buildings and fountains built in Mumbai, Delhi has little to offer of this particular style of architecture.

The Mutiny Memorial's design can only be described as indifferent at best; it has none of the flourish and drama of the Mumbai buildings. Its significance is more symbolic than architectural.

It stands on the site occupied by Taylor's Battery (on the present Rani Jhansi Road close to the Hindu

Rao Hospital) that was blown up during the Siege of Delhi by the English themselves, lest its ammunition fall into the wrong (read native) hands and be put to wrong (read subversive) use.

The tower was erected in 1863 when the heat and dust of the Revolt had subsided, the natives been duly subjected and the rebellion crushed out by the iron hand of the British forces. The East India Company was a thing of the past; the new masters were seasoned British bureaucrats and hardened military men. They needed a memorial, yes, but they were not going to throw away good money to prove a point that had in any case been proved by the massacres and the hangings. The Mughals were gone, and the *angrez* were the new masters. So the memorial was built more to honour their own dead and wounded rather to prove the might of the victorious.

A marble slab in an arched recess near the entrance to the tower bears the following inscription:

In memory of the officers and soldiers, British and Native, of the Delhi Field Force who were killed in action or died of wounds or disease between 30 May and 20 September 1857. This memorial has been built by the comrades who lament their loss and by the Government they served so well.

At the foot of this inscription is a long list of names beginning with Brigadier General J. Nicholson, Commanding Officer of the 4th Infantry Brigade. In all, 46 British officers and 14 native ones, 543 British non-commissioned officers and soldiers and 426 native ones were killed. Among the wounded, the British toll was 140 officers and 1,426 soldiers. Is it any wonder, then, that the reprisals were swift and ferocious? Entire villages were laid to waste, corpses hung from trees and gallows sprang up at virtually every major crossroad.

Delhi and its neighbouring countryside witnessed a horrific saga of brutal cold-blooded slayings, one that was to match the slaughters visited upon the city by foreign invaders from Timur to Nadir Shah.

From the sultry morning of 11 May when sepoys cantered across the bridge of boats on the Yamuna to knock on the gates of the Red Fort or the Quila-e-Mualla (Exalted Fort), as it was then called, till the calamitous day on 20 September—when the British established their authority over the city of Delhi—a lot of water had flown down the Yamuna. From boisterous euphoria to abject defeat—within those four months the citizens of Delhi had witnessed at close quarters the 360 degrees turning of the wheel. From the murder of the English commander inside the Fort and the chaplain who happened to be staying with him to the rapid killings of the Europeans in the Daryaganj locality and the imprisonment of the surviving women and children in the Fort where they were eventually slaughtered to the attack on the

Magazine near the General Post Office, the casualties among the British rose as the summer progressed. Throughout that hot May, English women and children were gathered and sheltered inside the Flagstaff Tower on the Ridge, awaiting the troops from Meerut. When the promised troops did not reach Delhi, the English fled towards Ambala; some reached safely but many were brutally slaughtered on the way. A column led by Sir Bernard arrived from Ambala on 8 June and tried unsuccessfully to take the city by force. It was only on 11 September that the bombardment of Delhi began with the help of a trainload of ammunition from Lahore.

The week of 14-20 September saw horrific scenes on the streets of Delhi. Bahadur Shah Zafar surrendered to Captain Hodson on 21 September, his sons were shot, as were a ragtag bunch of royal retainers. Then followed a period of punitive actions against those who had dared to take English lives and risen in revolt against the foreign masters. Summary trials became routine as daily executions took place in front of the Kotwali in Chandni Chowk. All Muslim residents were banished from the city. The Jama Masjid was 'confiscated'; many of the smaller mosques were demolished, as was the bazaar in front of the Jama Masjid, to allow a clear line of fire to the Red Fort in case of another uprising.

By 1858 some semblance of normalcy returned as Delhi limped back—weaker, shorn of much of its glitter and glamour but much chastened and sobered down. The Mughal court was gone, some of the best families had fled to Hyderabad. Delhi had ceased to be a separate administrative entity; instead it was part of the new province of the Punjab. The English set about putting their stamp on the newly subjugated territory, the Raj as it would be known for posterity. The Mutiny Memorial was raised in memory of those who laid down their lives for Rule Britannia.

History, however, has a way of altering perspectives. In 1972, on the 25th anniversary of Indian Independence, the spotlight fell once again on the Mutiny Memorial. This time it was re-christened Fatehgarh or Ajitgarh. Once again, a plaque was fixed here. But this time the site was converted into a memorial for those who rose against the colonial power. And, unlike the names of the British killed and wounded, these martyrs were nameless and unknown.

THE ENEMY OF THE INSCRIPTIONS ON THIS MONUMENT WERE THOSE WHO ROSE AGAINST COLONIAL RULE AND FOUGHT BRAVELY FOR NATIONAL LIBERATION IN 1857.
IN MEMORY OF THE HEROISM OF THESE IMMORTAL MARTYRS FOR INDIAN FREEDOM, THIS PLAQUE WAS UNVEILED ON THE 25TH ANNIVERSARY OF THE NATION'S ATTAINMENT OF FREEDOM 28 AUGUST 1972

..

In memory of the martyrs for India's freedom, for those who lost their lives in the First War of Independence.

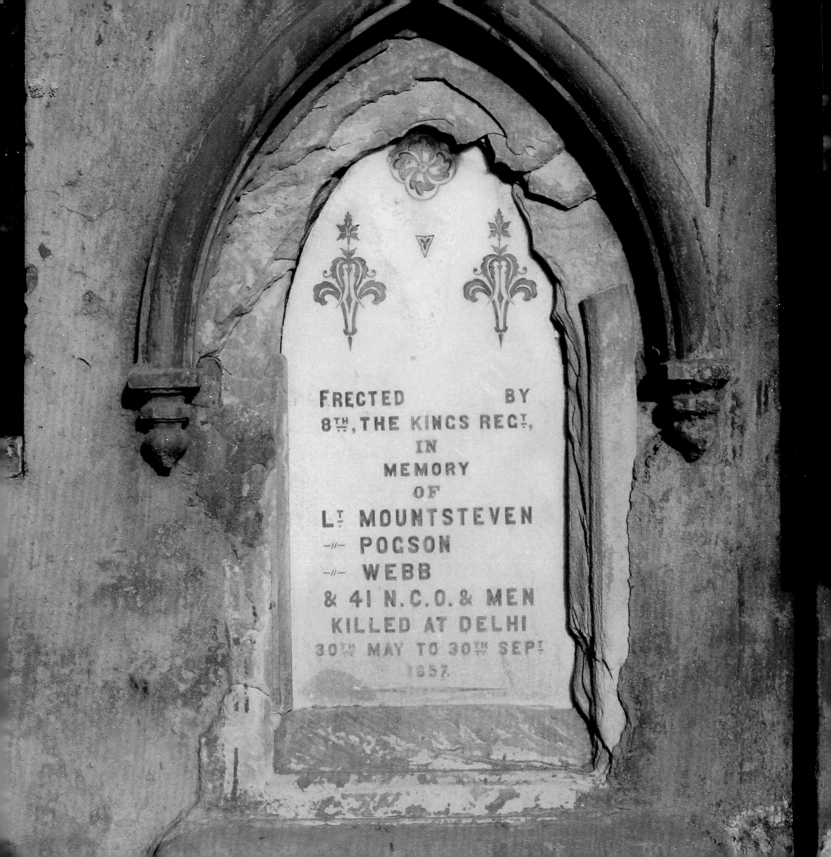

Nicholson's Cemetery

While the British showed a typically British restraint in the building of the Mutiny Memorial, they let themselves go with a vengeance when it came to burying their dead in the immediate aftermath of 1857. A cemetery to house the dead came up at Boulevard Road, close to the St. James' Church at Kashmiri Gate. Named after General Nicholson (1822-57), one of the key figures in the Mutiny of 1857, who was mortally wounded virtually at the hour of British victory, the cemetery became a sort of public space to give vent to personal grief.

Nicholson, an officer in the Bengal Army under the British East India Company, was born in Ulster. He served in the First Afghan War and the First and Second Sikh Wars, proving his mettle as an able commander and an efficient administrator. In the recapture of Delhi after the prolonged siege, he played a stellar role in leading 2,000 men (mostly British, Pathan and Punjabi troops) through the Kashmiri Gate. Known to the native soldiers as Nikhal-sen sahib, this 6 foot 4 inches tall Irishman was revered by his troops and contemporary records speak of grown men crying like babies at his funeral.

Located on the northeastern end of Boulevard Road, a few metres from the Inter State Bus Terminus, the cemetery is spread over almost nine acres. It is entered through a cross-shaped gateway with a sloping roof. Inside, an enchanted wilderness of tumbledown tombstones, profusely carved and

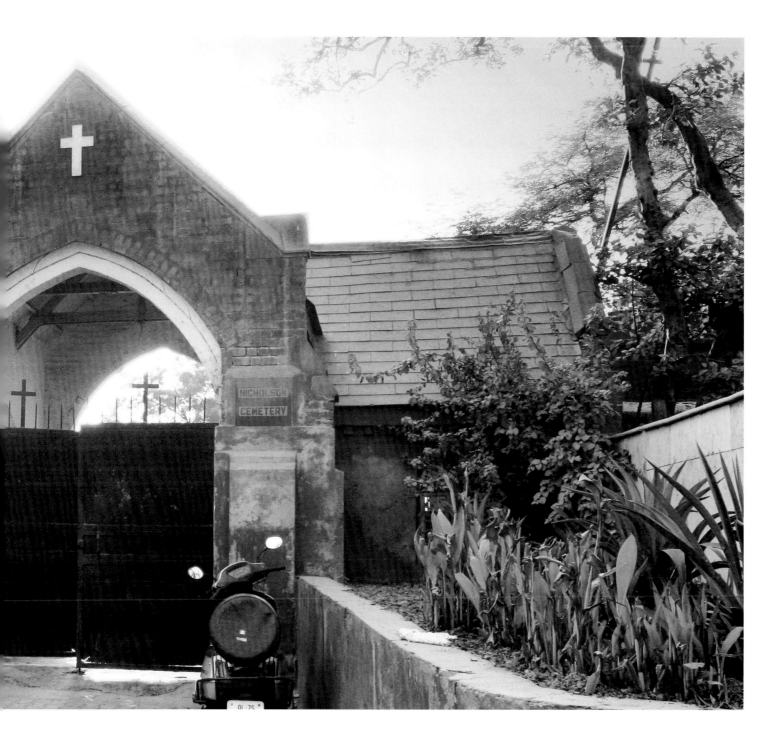

embellished crucifixes and cenotaphs awaits. It is just the sort of place where you can stop, stare, linger or gently pass. Should you wish to linger, beware of the monkey menace and remember not to carry anything in your hands, least of all any food items in transparent wrappers. And having chosen to linger, you can easily spend an hour or two walking around among the tangled weeds and creepers, taking in not just the handsomely carved graves but also reading the epitaphs. General Nicholson's grave occupies pride of place immediately to the right as you enter. His epitaph (written on a stone slab taken from the Emperor's palace) reads simply and soberly. Close by is the tomb of Harvey Greathead, Commissioner and Political Agent with the Delhi Field Forces who died of cholera four days after the fall of Delhi.

This is said to be the first grave made here though a number of memorial tablets from an earlier graveyard are placed in a wall to the left of the entrance.

Then there are the graves of the numerous other officers, administrators, their wives and children. There is, for instance, the memorial of a certain Mr. Clifford who was killed in Gurgaon in October of that fateful year when the firangis were being killed indiscriminately in the countryside around Delhi. Close beside lies his sister—among the British casualties inside the Red Fort on the 11 May when the mutineers from Meerut stormed the Fort and slaughtered all the Europeans inside.

The filigreed letters and ornate script record the loss of human lives; those that mark the tombstones of little children are especially haunting, such as the one commemorating Harriet Taylor's infant daughter, Elizabeth, and the other of a mother whose son had written the following evocative epitaph:

Passing Stranger, call this not a place of dreary gloom. I love to linger near this spot. It is my beloved mother's tomb.

Neither time nor history can take away the solemn dignity and the heart-wrenching poignancy of these words engraved on stone. Close by is the grave of Norma Nicholson, no relative of General Nicholson but a latter-day animal rights activist. Around are graves in various stages of neglect; some have even been vandalised, possibly for bits of their expensive marble.

Till the 1990s the cemetery boasted some magnificent old trees—soaring neem, tamarind and peepul that spread their arms over the tombs like a grand old cathedral. They made it a place of serenity and refuge for countless varieties of birds: mynas, owlets, parakeets, coppersmiths, barbets, doves, orioles, woodpeckers, hornbills, peacocks, partridges, minivets, wild parrots and crested serpent eagles. Unfortunately, since the roots of these trees were causing havoc to the graves, they were chopped down indiscriminately, leaving amputated stumps

and virtually no green cover. The grand old trees are long gone and with them most of the bird life. The tombs lie exposed under the scorching sun and lashing rain.

In October 2006, under the initiative of INTACH, a restoration drive was launched to spruce up the cemetery and its pathways. Some conservation work was done on the graves and tombstones at a cost of Rs. 5 lakh. A delegation comprising Sir Michael Arthur, then British High Commissioner, Father Valentine D'Silva, Chairman of the Delhi Cemeteries Committee, David I. Hudson of Group 4 Securicor (G4S, a company providing security services) and O.P. Jain, Convener of INTACH, opened up the newly-restored cemetery to the public. The monkey brigade went away for a while. Groups of British tourists, keen to trace the tombs of their long-dead ancestors, began to trickle in. (In fact, several search engines on the Internet help locate old tombs in cemeteries all over India, including Nicholson's Cemetery.)

For a short while Nicholson's Cemetery basked in the warmth of public attention and stopped being the favourite haunt of louts and drug addicts. But this being Delhi,where the city has a way of effacing history, it soon lapsed into anonymity and invisibility. Given its location in the maddening maze leading to the ISBT, now only dedicated visitors seek out its sanctuary.

ABOVE AND BELOW: Groups of tourists trickle in occasionally in search of long-dead ancestors.

PAGES 314-315: Business as usual—outside the gates of Nicholson's Cemetery.

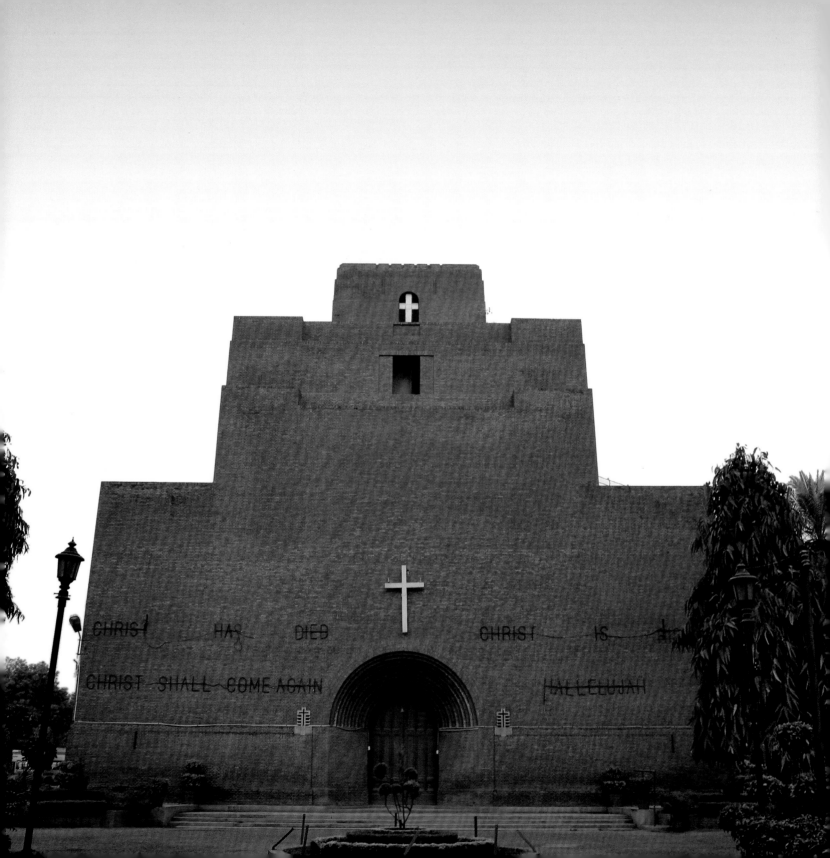

St. Martin's Church

FACING PAGE: Austere, brick-built facade.

Tree-flanked path leading upto St. Martin's Church.

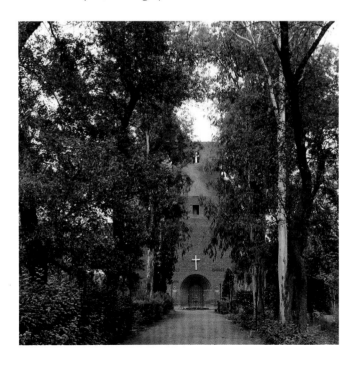

Imperial Delhi was built between 1911 and 1931, shortly after the Delhi Durbar in 1911. The story of the building of New Delhi is largely the story of one man's vision, and much of Central Delhi is remembered for posterity as Lutyens' Delhi. However, for all his individual brilliance and innovativeness, Edwin Lutyens worked with a team of highly talented, and trained, individuals who seem to have been overlooked by history.

There was, of course, Lutyens' friend and colleague Herbert Baker, apart from others such as R.T. Russell who designed Connaught Place and Flagstaff House; Henry Medd, the designer of the Cathedral Church of Redemption and the Anglican Church and the brilliant Arthur Shoosmith who designed the Cantonment Church of St. Martin. While Lutyens' dream of a grand cathedral for the new city of Delhi to rival the great churches of London and Paris remained a dream, several churches were constructed for the new imperial capital. *Delhi: The Built Heritage* lists 18 big and small churches. Of these, the Sacred Heart Cathedral, the Cathedral Church of Redemption and St. James' Church are big bustling churches. St. Martin's Church, in comparison, is smaller and in a sense less 'visible'. One reason could be its location inside the Cantonment area; the other could be its austere, almost grim appearance. Also called the Garrison Church, it has a certain gravitas and a solemn grandeur. Built in 1929, its clean

straight lines capture the spirit of its age, the austerity and quiet strength that the British imperial ideology had begun to proclaim as personal virtues. Befitting its location in a cantonment, it has a no-frills air of severity. While there is a studied air of dignity, there is also a powerful statement of simplicity and virility in its simple and straightforward design, entirely appropriate for a military outpost. There is also, to my mind, an air of brooding sadness as though it carried, from its birth, a prophecy of the end of the Raj and the burst of building activities associated with imperial Delhi.

Arthur Gordon Shoosmith (1888-1974) was born in St. Petersburg in 1888. He grew up in Russia and Finland and was educated in England at Haileybury. In 1920 he won the Soane Medallion and was appointed as Edwin Lutyens' representative in New Delhi, where he worked from 1920-31. He was nominated by Lutyens for the commission of

the design of St. Martin's Garrison Church in New Delhi (1928-30). His other major work is the Lady Hardinge Serai in New Delhi (1931). Shoosmith returned to England in 1931, where he made a career of teaching and as an inspector with the Ministry of Town and Country Planning. He retired in 1957 and died in 1974.

It was a rather unpromising landscape that Shoosmith had to work on—the dusty plain was virtually treeless and burnt tawny by the sun. The flat stony site lay beyond the bungalows and barracks of the new cantonment designed by John Begg and the Military Works Department. Lutyens offered the following advice to his protégé: 'A building of one material is for some strange reason more noble than one of many. It may be the accent it gives of sincerity, the persistence of texture, and definite unity.' Warning Shoosmith of the perils of fussy ornamentation, he wrote, 'Don't use—whatever you do—bricks on edge and any fancy stuff; it only destroys scale and promotes triviality … get rid of all mimicky Mary-Anne notions of brick work and go for the Roman wall.' Britons, he believed, ought to put the brick, unadorned and simple, to good use, just as the Romans had done.

Shoosmith lived up to Lutyens' expectations. He used large, blank surfaces of unadorned bricks

Depicting the quiet strength of British imperialism.

arranged in stepped setbacks pierced only sparingly with small windows. It is said that the church used three-and-a-half million bricks for its construction. The other significant example of similar construction using just bricks is the St. Thomas Church on Mandir Marg. This was originally built for 'Dalit' Christians or those who had converted to Christianity from the 'untouchable' castes. The edifice has only bricks; there is no steel or reinforced concrete in its fabric. There is also the chapel inside the St. Stephen's College built in a somewhat similar style, though on a much smaller scale. Shoosmith's design shows the combination of Western classicism with traditional Indian methods. Here was a building that took Lutyens' ideas onward. Lutyens' method of geometric design and massing was abstracted by Shoosmith into something timeless and uncompromising in its austerity, touched with modernism in details such as the pulpit and lectern, recalling Frank Lloyd Wright. The result was a building that defied descriptions and labelling—neither modern nor traditional; not Eastern or Western—St. Martin's Church has a timeless quality. The 128-feet-tall square tower adds to a sense of massiveness and monumentality. The theme of pared-down classicism continues inside; there is no overt iconic ornamentation and the interior reflects the severity of a cantonment.

In fact, given the exigencies of the times and the fortress-like appearance, the church was considered a good place to seek refuge. The thick walls and tiny windows made it a good place to hold in an emergency. Back 'home', the design of St. Martin's earned laurels for its architect; one reviewer going so far as to suggest that it may even have been the work of a French or German architect.

..

The entrance that betrays none of the sense of massiveness and monumentality that lies beyond.

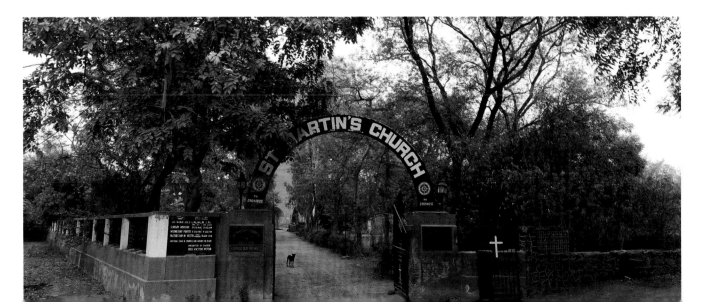

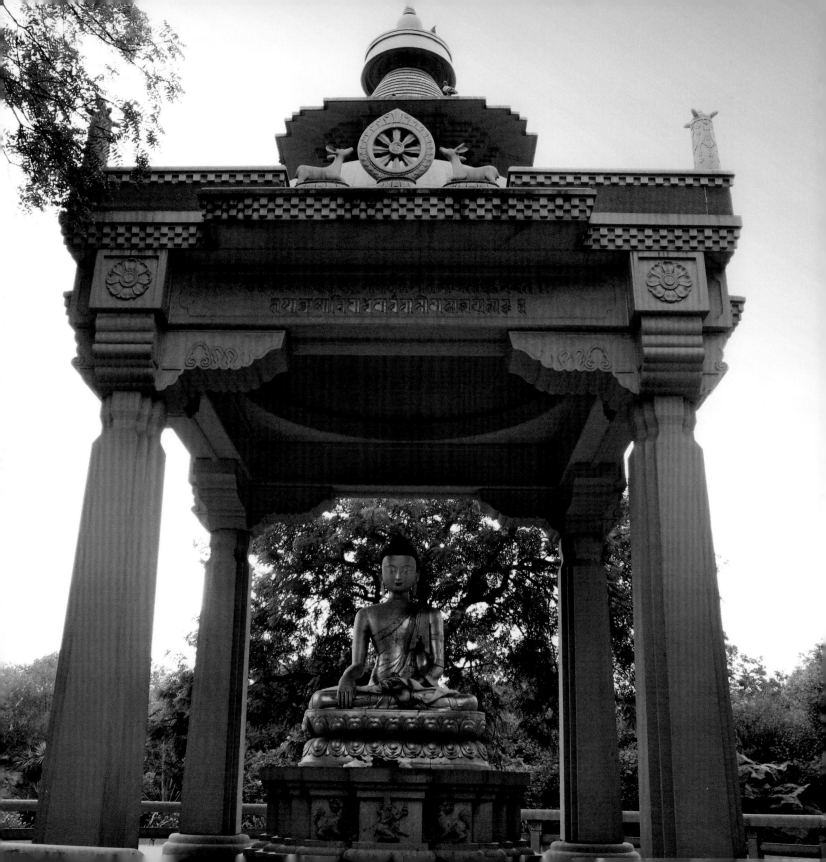

Buddha Jayanti Park

FACING PAGE: Eight-feet tall image of the Buddha seated on a lotus pedestal.

A stone obelisk.

The Buddha Jayanti Park, with the serene statue tucked away in its sylvan grounds, presents a pretty sight. Despite its sprawling acres, the Park itself is not such a hot favourite as the Lodi Gardens where avid walkers come to see and be seen. Not many know of the gilded copper statue of Gautama Buddha sitting in the *Bhumisparsh mudra* beneath a carved canopy. Fewer still would know that stored in the statue are tightly rolled sheets inscribed with thousands of *dharani*s from Buddhist scriptures.

The Park was set up in 1956, the year that marked 2,500 years of the Buddha's *Mahaparinirvana*. Parts of the Ridge were tamed and landscaped with waterways set amid beautiful trees, flowering shrubs and vines. Though it served the vital function of a 'green lung' for the burgeoning new city, the Park remained, for the most part, a deserted and largely unsafe retreat for lovers meeting on the sly. Vestiges of the once magnificent Aravalli Range that jab Delhi's otherwise flat topography can be seen in the many rocky outcrops scattered throughout the Park. They lend drama and an air of mystery to what would otherwise be just another pretty green belt. In 1983, the Dalai Lama conveyed his wish to install a statue of the Buddha in the land of the Buddha's birth and present it to the Indian people on behalf of the Tibetan community as a token of affection and gratitude. The gift also symbolised the

common cultural heritage of the people of Tibet and India. The Buddha Jayanti Park was identified as a suitable site to house that gift.

It took years to gain permission from the various authorities, such as the Urban Arts Commission and the National Architecture Authority, before the statue could finally be installed in 1993. Amid chanting of shlokas, the *bhumi pujan* was done in 1990 on Buddha Purnima. The master craftsman from Dharamshala, Penpa Dorje, worked for over a year to create the likeness of the Buddha out of beaten copper plates. This eight-feet-tall image, bearing the 32 signs and 80 attributes of an enlightened being, is seated on a lotus pedestal. The right hand is pointing downwards to the earth. The left hand holds a *kalasa*. Placed on an altar beneath the statue are offerings of fresh flowers, a lamp and seven bowls filled to the brim with water.

Intrigued by the white scarf bandaged about the bowl, I made enquiries with the gentle caretaker who works silently, brushing away fallen leaves, sweeping the immaculate floor several times over and keeping the lamp lit and the flowers fresh at the altar. The explanation was perfectly simple—to keep pesky squirrels from getting inside the bowl!

Next, I asked about the empty cage lying in a corner. He said that a lot of people, Buddhists and others, bring birds and small animals here to set them free. *Jeevan daan* is integral to Tibetan Buddhism.

Often when a bird is too feeble to fly away, the caretaker keeps it in the cage, tends it and then, when it is stronger, sets it free. The moat surrounding the statue is teeming with fish similarly brought here, only to be released.

There is a symbolism in everything—in the canopy, in the Bodhi trees, in the choice of stones. The statue is surrounded by a circumambulatory path, its edges marked by a border of five different coloured stones. The five colours represent the *panchatatva*—fire, water, wind, earth and ether. The orientation of both the statue and the canopy is east facing, just as Prince Siddhartha sat in deep meditation facing east, on the eve of attaining enlightenment. The statue rests on a throne bearing an engraving of Bhumidevi, the Earth Goddess, representing man's responsibility towards Mother Earth. Embellished with intricate Tibetan motifs, the red and yellow stone canopy symbolises enlightenment. Its stone was quarried in Bansi Paharpur in Rajasthan and carved by artisans from Rajasthan.

Nearby grow two tender Bodhi trees, their saplings brought from the Bodhi tree at Gaya. A stone obelisk bears the Dalai Lama's message of love and gratitude to the people of India, engraved in Tibetan, Hindi and English. Stone engravings are found all along the winding path leading up from the main Park entrance. One, from a Tibetan Buddhist sutra, says:

Who is not terrified of death?
Who loves not life?
Since all love life, as I do,
I will kill not, nor let others kill.

Birdsong wafts down from the trees. A flock of geese steps out of the water to waddle across the lawns. A sudden flight of pigeons takes off from the domed canopy. And a stone bears the following inscription:

A mind untainted by evil
With compassion from the elements
With love for all sentient beings,
Does not encounter vindictiveness.

Udanvarg Sutra

A flock of geese in the serene waters.

PAGE 324-325: The moat surrounding the statue is teeming with fish.

Chronology

More often than not, the exact date of construction of a monument is not known. In fact, the more 'obscure' a monument, the greater the unreliability about its date.

Where the building offers no clue as to who built it, when or why, its historicity is gauged from the architectural features typical of a particular period, for example, slope or batter in the walls is usually associated with the Tughlaq period, a *guldasta* in a corner with the Saiyyids, the garden-tombs with the early Mughals and so on. Similarly, in this book, it was felt that a period-wise arrangement would be most suitable. The periods, known by the ruling dynasties, are roughly as follows:

Tomar: Eleventh century
Major architectural feats: The Lal Kot, the Qila Rai Pithora and Suraj Kund.

Sultanate: 1191 onwards
Major architectural feats: The Qutub Minar, Sultan Garhi and the tomb of Iltutmish.

Khalji: 1290-1320
Major architectural feats: Siri, the Hauz-e-Shamsi and the Alai Darwaza.

Tughlaq: 1320-1393
Major architectural feats: Tughlaqabad, the tomb of Ghiyasuddin Tughlaq, the mosques of Begumpuri, Khirki and Firoz Shah Kotla.

Saiyyid: 1414-1451
Major architectural feats: Mubarakabad and Kotla Mubarakpur.

Lodi: 1456-1526
Major architectural feats: The tombs of Bahlol Lodi, Sikandar Lodi, Bara Gumbad and others in the Lodi Garden.

Early Mughal: 1526-1628
Major architectural feats: The Jamali Kamali, Dinpanah and the Humayun's Tomb complex.

Sur Interlude: 1540-1555
Major architectural feats: Shergarh, the Sher Mandal, the Qila-e-Kuhna Masjid and Salimgarh.

Middle Mughal: 1628-1707
Major architectural feats: The Khan-e-Khanan's Tomb, Shahjahanabad including the Jama Masjid, the Fatehpuri Masjid and the Lal Qila.

Late Mughal: 1707-1857
Major architectural feats: The Safdarjung's Tomb, the Jantar Mantar, the Sunehri Masjid and the Moti Masjid.

Emperors of Delhi

A list of the Muslim rulers who occupied the throne of Delhi after power slipped from the hands of the Tomar and Chauhan chieftains finds mention ahead. The Muslim rulers declared themselves 'sultans' and gradually their rule extended beyond Delhi to distant parts of Hindustan. As you will see in the list, in a few cases the date of an emperor's death is not available. Often, the emperors did not die while on the throne; some abdicated or were deposed. Often, there are gaps in the chronology for which no satisfactory explanation can be found. One can only surmise that while no single claimant to the throne emerged, groups of noblemen fought to stake their claim and sit on the throne of Delhi. For long spells, Delhi was ruled not by a king but either a single powerful chieftain or general, or by several members of a powerful family. This list is meant to serve as a general indicator of who ruled when in the context of the monuments included in this book; it is by no means entirely accurate. It does, however, serve to illustrate one very useful lesson in the context of Delhi and its chimeral landscape: power is illusory and temporary.

Turks

Qutubuddin Aibak: 1206-1210
Aram Shah: 1210-1210
Shamsuddin Iltutmish: 1210-1235
Ruknuddin Firoz I: 1235
Raziya Sultan: 1236
Muizuddin Bahram: 1239
Alauddin Masud: 1241
Nasiruddin Mahmud I: 1246-1265
Ghiyasuddin Balban: 1265-1287
Muizuddin Kaiqubad: 1287-1290
Shamsuddin Kaimurs: 1290

Khaljis

Jalauddin Firoz II: 1290-1295
Ruknuddin Ibrahim I: 1295
Alauddin Muhammad II: 1295-1315
Shihabuddin Umar: 1315
Mubarak Khan: 1316-1320
Nasiruddin Khusrau: 1320-1321

Tughlaqs

Ghiyasuddin Tughlaq: 1321-1325

Muhammad Bin Tughlaq: 1325-1351

Firoz Shah Tughlaq: 1351-1388

Tughlaq Shah II: 1388-1388

Abu Bakr: 1388

Muhammad Ibn-i-Firoz: 1389-1392

Sikandar I: 1392-1392

Mahmud II: 1392-1412

Daulat Khan Lodi: 1412

Saiyyids

Khizr Khan: 1414-1421

Mubarak Shah: 1421-1433

Muhammad Ibn-i-Farid: 1433-1443

Alam Shah: 1443

Lodis

Bahlol: 1451-1488

Sikandar II: 1488-1517

Ibrahim II: 1517-1526

Mughals

Babar: 1526-1530

Humayun (defeated and exiled in 1539): 1530

Suris

Sher Shah: 1539-1545

Salim Shah: 1545-1552

Muhammad Adil: 1552-1553

Ibrahim III: 1553-1554

Sikandar III: 1554-1555

Mughals

Humayun: 1555-1556

Akbar: 1556-1605

Jahangir: 1605-1627

Shah Jahan (deposed 1658): 1628-1666

Aurangzeb: 1658-1707

Shah Alam Bahadur Shah: 1707-1712

Jahandar Shah: 1712-1713

Farrukh Siyar: 1713-1719

Rafi-ud-Darajat: 1719-1719

Rafi-ud-Daulah: 1719-1719

Mohammad Shah Rangeela: 1719-1748

Ahmad Shah: 1748

Alamgir II: 1754-1759

Shah Alam II: 1759-1806

Akbar Shah II: 1806-1837

Bahadur Shah II: 1837-1857

Glossary

Ahimsa: non-violence

Alam: standard or pennant

Alim: men versed in the classical languages

Angrez hukumat: British rule

Atta chakki: flour mill

Badal: cloud

Badshah: emperor

Bagh: garden

Bagichi: small garden

Baoli: step well

Baradari: a 12-pillared, multi-purpose pavilion

Baraka: focus of grace

Basti: colony

Batashe: round, puffed discs of crystallised sugar

Bhakta: devout

Bhojanalaya: place to eat

Bhul bhulaiyan: labyrinth

Bhumi pujan: consecration of land

Bhumisparsh mudra: earth-touching posture

Bichlawasa: rest

Bismillah: a part of a verse from the Koran, meaning 'I begin in the name of Allah…'

Bund: embankment

Burqa: veil worn by Muslim women

Chabutra: raised platform

Chappal: slipper

Chana: gram

Chandan: sandalwood

Charbagh: a rectangular garden laid out in four equal and rectangular sections

Chaturmasa: four months of the rainy season that wandering Jain ascetics spend in one place

Chaupal: assembly-place in a village

Chhajja: projecting balustrade

Chillahgah: meditation room

Chhatri: canopy

Choona: mixture of lime mortar, particularly harmful to old monuments

Dalan: verandah, open gallery

Dargah: place where the person buried is attributed with saintly qualities

Dars-i-Nizami: classical languages

Darya: river

Dhaba: roadside restaurant

Dharamshala: resthouse

Dharani: meditation verse

Doha: two-lined couplet

Firangi: foreigner

Gaddha: pit

Garh: fortress

Ghunghat: veil

Gujjar: nomadic tribe; keepers of cattle

Guldasta: bouquet of flowers

Gumti: small, domed structure

Gur: jaggery

Halwai: sweet seller

Hammam: bath

Hujra: cloister

Idgah: congregational mosque

Iwan: arched entrance

Jaali: screen, made of wood or stone, usually with geometric pattern

Jagir: land or estate

Jalebi: sweet Indian dish

Jeevan daan: gift of life

Jharna: waterfall

Jharokha: projecting balcony

Kabadi-wallah: person selling trash

Kak: bread

Kalasa: begging bowl

Kanat: tent

Kangura: scalloped edge

Karamati: miraculous powers

Karbala: name of the place in Iraq where Husain, the grandson of the Prophet, was killed and buried. Any city with a sizeable Shia population has a karbala where the *taazia* is buried annually

Katora: bowl-shaped concavity

Kazi: judge, magistrate, priest

Keekar: name of tree

Khanqah: place for retreat and meditation

Khirki: window

Kos: unit of measurement

Kotla: fort

Kuchcha: unplastered

Kulliyat: complete works

Kund: pool

Kurta pajama: shirt and loose trousers

Lal Dora: Indian revenue term dating to the British period, literally signifying a border marked with a red pen to demarcate the jurisdiction of a village settlement

Madarsa: school for religious instruction, seminary where the Koran was taught as well as other subjects such as Islamic law, jurisprudence, etc (plural: madaris)

Maghrib: catapult used during battle

Mahal: palace, but increasingly used for any grand old building

Mahaparinirvana: passing away of a great soul

Mandi: marketplace

Mani: gem

Manjarik: catapult used during battle

Mansabs: ranks

Maqbara: mortuary chamber

Marsiya: song of lament

Masnawi: narrative or allegorical verse

Matka: clay pot

Maulsari: flower

Maulvi: teacher of Islamic scriptures

Mazaar: tomb, grave, shrine

Mihrab: decorative arch in a wall

Mimbar: pulpit

Moth: pulse

Muezzin: person who summons the faithful to prayer

Mu'amma: riddle

Nai taleem: new education

Namaz-e-janaaza: Prayers for the dead

Navratna: nine jewels

Neel gai: large antelope

Panchatatva: five elements

Panjah: emblem in the shape of an open palm

Pankha: fan

Press-wallah: person who makes a living by ironing clothes

Pir: holy man

Pishatq: jutting arch

Pucca: masonry

Qalamdan: tablet on a grave that is fashioned like a pen-and-ink stand

Qalandar: wandering mystic

Qibla: direction for prayer

Qila: fort

Rakab: iron ring

Rauza: a saint's grave

Rawda: funerary garden

Rekhta: early Urdu

Sahn: rectangular

Sama: gathering

Samadhi: grave

Sarai: caravan halts or rest houses for travellers

Sarangi: musical instrument

Sarkari: pertaining to government

Sehan: central courtyard

Shaheed: martyr

Shakar dane: small, crunchy sweet balls

Shikargah: hunting lodge

Shloka: verse

Silsila: master-pupil chain in a Sufi sect

Sir: head

Surkhi: brick dust

Taal tallaiya: lakes and ponds

Taazia: elaborate construction of paper, tinsel and other fineries meant to symbolically replicate the tomb of Ali and Husain

Tahkhana: sub-structure, underground vault

Takhti: writing tablet

Tarkib: Persian style of composition

Taslim: surrender

Tehsil: revenue district

Ulema: the learned, Islamic theologians

Vanar sena: army of monkeys

Viakhyan: spiritual discourse

Wuzoo: ritual ablution before prayer

Bibliography

Asar-us-Sanadid, Sir Syed Ahmad Khan (in Urdu, Delhi, 1846, revised 1854), reprinted in 3 volumes in 1991, edited by K. Anjum. A selective translation by R. Nath in English published as *Monuments of Delhi: Historic Study*, Delhi, 1979.

Cambridge History of Islam, Cambridge, 1970.

Delhi and its Neighbourhood, Y.D. Sharma, Archaeological Survey of India, New Delhi, first edition 1964, reprinted 2001.

Delhi: City of Djinns, W. Dalrymple, London, 1993.

Delhi: Its Monuments and History, T.G. Perceval Spear, first published 1943. Updated and Annotated by Narayani Gupta and Laura Sykes, Oxford University Press, 1994.

Delhi: Past and Present, H.C. Fanshawe, London, 1902.

Delhi: The Built Heritage: A Listing (Vol. 1 & 2), Consultant: Ratish Nanda, INTACH, Delhi Chapter, 1999.

Historic Delhi, H.K. Kaul (ed.), Delhi, 1985.

Monuments of Delhi: Lasting Splendour of the Great Mughals and Others, Vol.1-4 (in 3 bindings), Compiled by Maulvi Zafar Hasan, first published 1916, reprinted 1997, Aryan Books International.

Muraqqa-e-Dehli, The Mughal Capital in Muhammad Shah's Time, Dargah Quli Khan, English translation by Chander Shekhar and S. M. Chenoy published in 1989.

Our City, Delhi, Narayani Gupta, Delhi, 1987.

Rediscovering Delhi, M. Dayal, Delhi, 1975.

Seven Cities of Delhi, G. Hearn, London, 1906.

The Archaeology and Monumental Remains of Delhi, Stephen Carr, Calcutta, 1876.

Index